BACH THE BORROWER

BY NORMAN CARRELL

THE BRANDENBURG CONCERTOS

BACH
THE BORROWER

by

NORMAN CARRELL

PREFACE BY BASIL LAM

London
GEORGE ALLEN & UNWIN LTD
RUSKIN HOUSE · MUSEUM STREET

FIRST PUBLISHED IN 1967

PRINTED IN GREAT BRITAIN
in Baskerville type
BY NOVELLO AND COMPANY LIMITED
BOROUGH GREEN · KENT

DEDICATION

This book is dedicated to my wife who has had to imbibe Bach with every meal and hear about him and his works through almost every hour of the day for years!

He is so much one of the family that we are often quite surprised he does not come home for weekends.

FOREWORD

The rediscovery of Bach has been in progress for a century and a half, yet researches made in the years following 1950 are causing radical changes in the received impression of his development. Theories about the growth of an artist's mind are always dangerous, but when they are based on erroneous information the results are especially misleading. Among the casualties inflicted by the new chronology are Bach's 'late chorale cantatas' and some hitherto puzzling reversions in his maturity to a manifestly earlier style.

For Mr Carrell's purpose, which is to explore and document Bach's borrowings and adaptations within his own œuvre, chronology is of the essence, and this book, scrupulously uncontroversial in its manner, contains evidence subversive of many established judgements.

Unlike Handel whose incorporation in his own music of vast quantities of material by other composers presents a problem unique in music, Bach, with certain exceptions, reworked and adapted his own compositions and his seeming indifference to the medium employed can now be fully explored with the aid of the present work.

Much of the research now being pursued in musicology has small relevance to the only important aim in such matters —the better understanding and more faithful interpretation of the music itself. From this aspect all serious Bach students will welcome the publication of Mr Carrell's book. Whether we are concerned with Bach's artistic personality or with details of performance, this voluminous record, with commentary, of his adaptations, recompositions or transcriptions, will be an essential work of reference.

From the point of view of the performing musician many points of interpretation may be settled by reference to Bach's different versions, a familiar example being the clavier concerto in F and Brandenburg No. 4.

The author's publication of instrumental works restored from cantatas ought to encourage the further search for buried treasure with the aid of this most thorough and carefully documented book.

<div align="right">BASIL LAM</div>

ACKNOWLEDGMENTS

My grateful thanks are due to the following:

John Davies, Music Librarian of the BBC, for making many works of reference available to me and for his professional advice on the whereabouts of certain MS.

Basil Lam, Editor, Pre-Classical Music, BBC, who gave such valuable advice on layout and suggested many items and examples.

J. W. Lugg, copyist, for his magnificent music examples.

Oxford University Press for kindly allowing so many quotations from W. Gillies Whittaker's two volumes of *The Cantatas of Johann Sebastian Bach* published by them in 1959.

Harold Thomson, until recently Head of Scottish Music of the BBC, who shared the reading of this MS in varying stages of its preparation with Basil Lam, for most helpful advice in general and scholarly information on many points in particular and for undertaking the chore of proof reading.

INTRODUCTION

Bach was a great borrower. Not only did he derive creative stimulus from the works of such famous composers as Vivaldi and Corelli, but minor figures like Dieupart also provided him with useful ideas.

He was a careful man and believed in extracting every ounce of goodness from a work or movement of a composition which he felt was worthy of more than one immediate appearance.

He saw nothing incongruous in adapting a secular work to sacred use. A good example is Mary's aria, Seele, deine Specereien, in the Easter Oratorio (1736) which first appeared as Hunderttausend Schmeicheleien sung by Doris the shepherdess in a Birthday Cantata (BWV 249a) Entfliehet, verschwindet, entweichet, ihr Sorgen in 1723. The notes are identical in both versions but the words, mood and atmosphere could not be more different. One is forced to conclude that the labour of finding words of a given rhythmic pattern which will fit (and fit fairly well) an existing melody is less than that involved in composing a fresh melody to suit a script already prepared. Or did Bach realise, in all humility, that certain of his works were immortal and too great to be tied to any one place or occasion? It is unfortunate and, perhaps, inevitable, that quite a number of new word settings do not suit the original melodies particularly well. In fact, scholars are prepared to go so far as to say that if a given aria has words which are inclined to fit less well than one expects of Bach that, in itself, is almost enough to prove that the movement is an adaptation of an earlier setting.

In this book I propose to trace as many as possible of Bach's second, third, or even fourth, thoughts on the suitability of certain compositions in whole or part to their first surroundings and to try to show what a truly magnificent arranger or adapter he was.

The dates given to various compositions are, in most cases, those suggested by Schmieder or Besseler. I am well aware of the chronological research being carried out by Alfred Dürr and Georg von Dadelsen but, in view of the fact that their

claims and findings are not yet fully substantiated or accepted
—they are, moreover, being disputed by Prof. Smend—have
not adopted their proposed revisions to the total exclusion of
those suggested earlier.* I have noted them when they change
the general picture rather noticeably.

The choice of language presented a problem. I have decided
to retain the German titles of Cantatas, Arias, Motettes, Choral
Preludes etc., but to employ the more usual English versions
for Christmas, Easter, Whitsun and other Festivals. Certain
terms, for example: —

Huldigung
Trauungs
Trauermusik
Trauerfeier
Jagdkantate
Schäferkantate

have been rendered as: —

Homage
Wedding, marriage
Mourning music i.e. music written for a funeral
Funeral celebration, e.g. memorial music
Hunt(ing) cantata
Pastoral cantata.

I have retained the term 'Ratswahl' as being much more
concise than 'election to or for the town or borough council'
and the word 'Chor' where it has the same meaning as the
English 'Chorus'.

Ranks have been translated into English as follows: —

König	King
Königin	Queen
Kurfürst	Elector
Kurfürstin	Electress
Fürst	Prince

*See *Studien über die frühen Kantaten J. S. Bachs* (1951) and *Zur Chronologie der Leipziger Vokalwerke J. S. Bachs* (1957) by Alfred Dürr and *Bemerkungen zur Handschrift Johann Sebastian Bachs, seiner Familie und seines Kreises.* (1957) and *Beiträge zur Chronologie der Werke Johann Sebastian Bachs.* (1958) by Georg von Dadelsen.

Kurprinz	Princess
Fürstin	Hereditary (crown) prince
Reichgraf ⎫	Earl or Count
Graf ⎭	
Herzog	Duke
Gemahlin	Consort (f)
Erbherr	Heir

The English spelling (i.e., with 'C' instead of 'K') has been used for Cantata, Clavier, Concerto, Cöthen, etc. I have adopted Schmieder's system of numbering but have substituted the abbreviation 'Appx' in place of his 'Anhang'.

There is one further problem which is difficult to solve,— to differentiate clearly between works which are definitely borrowed from and/or adapted for a different medium— although one which requires one or more keyboards—and those which are improvements or re-furbishings.

I have decided to separate these where possible and to list the second group on its own in Table 1a. It will consist largely but not exclusively of works in the '48', and their early versions. One must strive to differentiate between legitimate borrowings and passing resemblances. Spitta was inclined to regard any co-incidental similarity as a 'borrow' even when, in some cases, the similarity was so slight as to be virtually untraceable.

A re-use of an existing phrase, theme, section, movement or work which I regard as intentional I call a 'borrowing'. An unintentional quote from or accidental allusion, either in general shape or harmony, to something which has appeared before is a 'resemblance'.

A third category which has to be kept separate from the other two is the later revision such as occured in many pieces contained in the '48'.

N.B. The word *clavier* was used for any keyboard instrument—it does not mean clavichord in every case although it may do so. Where possible I have given the exact instrument required or intended.

Finally a word on the use of quotes. Titles of movements,

including those from Cantatas which are, in many cases, the first few words or line of the text or poem, are not in quotes. On the other hand Cantata titles are; e.g. Choral (No. 4), Christe, du Lamm Gottes, from Cantata No. 23, 'Du wahrer Gott und Davids Sohn'.

CONTENTS

PART I

SELF-BORROWINGS

CHAPTER I

THIS 'keyboard to keyboard' is the second largest group of borrowings and is exceeded in numbers only by that containing 'vocal to cantata' (see chapter IX).

One is forced to wonder why Bach made certain arrangements. For instance during the period when first he was perfecting his technique of transferring instrumental concertos or concerti grossi to keyboard he chose the harpsichord as his vehicle. Yet he was a magnificent organist and some of his greatest keyboard works were for that instrument. Had he wished to imitate orchestral texture or colour surely the organ would have been a more appropriate instrument. A harpsichord, it must be remembered, has no sostenuto, therefore any note of length has to be repeated or ornamented or trilled upon in order to give an effect of sustaining power – none of these artificial aids is necessary on an organ, when all that is required is a finger available to keep the key depressed. Later, of course, he did transfer to organ – see Schmieder's BWV 952 – 7 etc.

I have opened Table IA with a few choral preludes. It is impossible to go into these in exhaustive detail in a work of this size but I trust that the few noted will be enough to arouse interest and to tempt readers to make a further investigation into this fascinating section of Bach's vast output. One cannot, of course, consider each of these different versions of the same tune as a separate 'borrowing' – they have to be looked upon more as variations on a theme. They are, however, quite captivating in their infinite variety. The order in which they appear in this chapter is not alphabetical but

numerical being based on the Schmieder number of the first reference.

The history of Bach's choral collection is, I feel, of interest. He made a collection of approximately 240 hymns or choral melodies in general use in Leipzig and figured their basses. The collection as a whole has been lost but fragments have survived, e.g. one group comprises settings of 'Christ lag in Todesbanden'; 'Herr Christ, der ein'ge Gottessohn'; 'Jesu meine Freude' and 'Wer nur den lieben Gott lässt walten'.

A second group, which came from an organ book belonging to Bach's pupil, Johann Ludwig Krebs, contained four Christmas hymns, 'Gelobet seist du, Jesu Christ'; 'In dulci jubilo'; 'Lobt Gott, ihr Christen allzugleich' and 'Vom Himmel hoch'. A possible third source is the collection prepared by George Christian Schemelli. His son, Christian Friedrich Schemelli, entered the University in Leipzig in 1735 and it is thought that he persuaded Bach to act as arranger of the musical portion of the work which was published in 1736. The collection contained 69 melodies of which 40 are by various 16th, 17th and 18th century composers.* A note in the preface stated that a further 200 melodies would appear in a 2nd edition. It can be assumed that 29 of the 1st group were by Bach. We know without any doubt that 'Dir, dir, Jehovah, will ich singen' and 'Vergiss mein nicht, vergiss mein nicht, mein allerliebster Gott' were his, and the majority of the others are in his style. Of the 29 by Bach, 7 appear to have been written specifically for the Schemelli book.

Anna Magdalena's 2nd book (1725) contains amongst others: Crasselius' hymn, 'Dir, dir, Jehova, will ich singen' and Gerhardt's 'Gib dich zufrieden und sei stille' both set by Bach.

Bach continued to work at choral tunes after the publication of Schemelli's book and added 88 to his own private copy. This book passed to C. P. E. Bach and is now lost.

After J. S. Bach's death as many as possible of his choral melodies were assembled and in 1764 Breitkopf had a collection of 150. Birnstiel, of Berlin, agreed to publish this in

*They are listed in Schmieder's book as *Die geistlichen Lieder und Arien* BWV 439—507.

1765 and engaged C. P. E. Bach to revise the MS. The same publisher brought out a second collection in 1769 but without the assistance of C.P.E. who, however, assembled a collection of chorals from the church compositions which totalled 307 melodies. This was published in 4 sections by Breitkopf.

TABLE 1

FROM KEYBOARD TO KEYBOARD

Source	*New Version &/or Position*
1 Praeludium of Praeludium and Fugue in D for organ. (17 bars) BWV 532. Dated 1709 or even earlier—Arnstadt (?).	Presto. (1st Movt.) in Toccata in D for clavier. BWV 912. Dated about 1710.
2 Fugue of Praeludium & Fugue in D for organ. BWV 532.	Fugue in D for organ. BWV 532a.
3 Einen ruhigen Zwischensatz (a calm 'between movement') from Prelude & Fugue in G for organ. BWV 541. Dated 1724 or 25.	Andante (3rd Movt.) in No. 4 of Six Sonatas. BWV 528. Dated 1727 – or, perhaps, 1723.
4 An early version.	Praeludium (Fantasie) & Fugue in G minor for organ. BWV 542. Dated 1720.
5 Prelude of Prelude & Fugue in A minor for organ. BWV 543. Dated 1709.	Prelude (Fantasia) in Fantasia & Fugue in A minor for clavier. BWV 944. Dated 1720.
6 Fugue from Prelude & Fugue in E flat. BWV 552. Published 1739.	Choral Prelude on 'Kyrie, Gott Vater in Ewigkeit'. BWV 669. Published 1739.
7 Counterpoint to Fugal Theme in Allabreve in D for organ. BWV 589. Dated 1709.	Fugal Theme of Fugue in D for organ. BWV 580. Date unknown.

8 Work for organ (148 bars). BWV 592. Dated 1708-17.	Work for clavier (147 bars). BWV 592a. Date unknown but later than 592.
9 Choral-Prelude Komm, Gott Schöpfer, Heiliger Geist from 'Orgel-Büchlein für Wilhelm Friedemann'. BWV 631. Dated 1708-18 and 1717-23.	Choral-Prelude Komm, Gott Schöpfer, Heiliger Geist in 'Achtzehn Choräle'. BWV 667. Date of autograph 1747-49.
10 Organ Trio-Sonata Herr Jesu Christ, dich zu uns wend from 'Achtzehn Choräle'. BWV 655. Dated during Weimar period.	Prelude from Prelude & Fugue in A minor. BWV 894. Dated 1717(?).
11 Partita No. 1 of 'Sechs Partiten' (Klavierübung, Part I). BWV 825. Dated 1726-31.	Birthday offerings for Prince Emanuel Ludwig of Anhalt-Cöthen. Dated 12th September 1726.
12 Fugue from Fantasia & Fugue in A minor for clavier. BWV 944. Dated 1720.	Fugue from Prelude & Fugue in A minor for organ. BWV 543. Dated Leipzig period(?).
13 An arrangement for clavier of 'Concerto for Violin with two Violins, Viola and Bass Viol or Harpsichord' by Duke Johann Ernst of Sachsen-Weimar. BWV 984. Dated 1708-17.	Version for organ. BWV 595. Dated 1708-17.
14 Capriccio in B flat. (Third Movement). BWV 992. Dated 1704.	Toccata in F sharp minor. BWV 910. Dated 1720 or from the end of Weimar period.

NOTES ON TABLE 1

1 It is instructive to speculate on the reasons for this transfer (organ to clavier). The composer's interest in the

harpsichord as a solo instrument was not aroused until about
1720. (Brandenburg No. V etc.). BWV 532, 912
Friedemann was born in 1710 and would hardly require a
piece of the difficulty of BWV 912 at the age of 5! Was it
merely to provide Bach the keyboard virtuoso with an inter-
esting technical difficulty or problem? (See Exes. 1 & 2.).

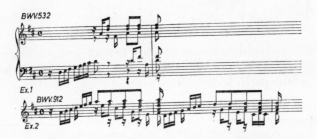

2 Spitta is of the opinion the BWV 532a appeared subse-
quently to 532 and that in it the composer 'stripped the too
luxuriant growth of brilliant executive passages and greatly
condensed the whole'. Certainly 532a is 39 bars shorter than
532. On the other hand Schmieder thinks that probably the
shorter version came before 'the greater and virtuoso
arrangement'. BWV 532, 532a

3 Schmieder dates BWV 541 as 1724 or 5 and BWV 528
as 1727 (perhaps 1723). We cannot be quite sure, therefore,
as to which way round the borrowings are! If the possible
date (1723) assigned to BWV 528 is found to be correct then
we must assume that BWV 541 was borrowed from it and not
vice versa. BWV 528, 541

4 The early version was given to organ candidates by
Mattheson as a test theme on which to extemporise as early
as 1725 or, possibly, soon after 1720. Spitta points out that the
fugue, as known in its present form, must be a remodelling
of this earlier and inferior version which was greatly improved
by some small alterations, eg. changing the position of the
bar lines and therefore, the rhythm and the shape of certain
note groups. Mattheson states in his *Exemplarische Organisten-
Probe* (Hamburg, 1731) 'that he knows very well with whom

the idea (of the theme) originated and that he chose it because it was wiser to take something familiar'. (See Ex. 3.). ʙᴡᴠ 542

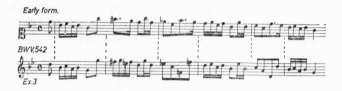

5 Bach not only remodelled his earlier compositions but combined parts or sections of them with his later works. In this case the prelude dates from around 1709. (See Ex. 4.).

ʙᴡᴠ 543, 944

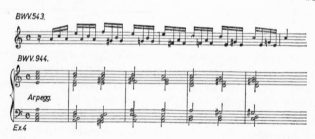

6 Some scholars have wondered if there is an affinity between the Fugue of ʙᴡᴠ 552 (which has Kyrie, Gott Vater in Ewigkeit as its C.F. in the Soprano) and Choral prelude ʙᴡᴠ 669 on Allein Gott in der Höh' sei Ehr'.
The likeness, to my mind, is only that which is inevitable between themes containing a group of rising or falling notes. For example, bars 26 – 31 of the Fugue contain the phrase: — Lah, Lah, Soh, Lah, Te, Doh, Te, Lah, Soh, and bars 21 – 25 of ʙᴡᴠ 669 as given in the Appx. to BG XL (Orgelwerke) have the passage: — Ray, Me, Fah, Soh, Fah, Me, Ray, Me. A similar passage is in bars 13 – 16 of the Prelude as it appears in BG III (Clavierwerke). ʙᴡᴠ 552, 669

7 The date of composition of ʙᴡᴠ 580 is unknown and the very authenticity of the work is doubtful. It is possible that if it is not by Bach himself it is the work of a pupil to whom the theme was given as an exercise. There is no suggestion that the theme is not one of Bach's own. ʙᴡᴠ 580, 589

8 BWV 592 is itself based on a concerto composed by Duke Johann Ernst. Schmieder is of the opinion that BWV 592a represents 'one of Bach's own "ready-made" clavier arrangements'. (See Ex. 5.). BWV 592, 592a

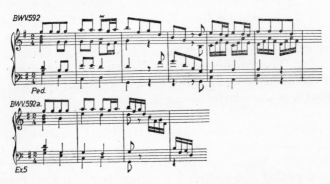

Ex.5

9 Schweitzer was sure that towards the end of his life Bach revised and partly rewrote compositions of the Weimar period. Rust, in his preface to BG XXV, maintains that these are Leipzig works but both Schweitzer and Spitta are convinced that they are older works repolished. In fact Schweitzer says that 'the brilliant and animated 'Gott Schöpfer' reminds us of Buxtehude'. BWV 631, 667

10 Schmieder dates the Prelude as about 1717. Spitta, not quite so positive, says 'written before 1725, internal evidence suggests late Weimar'. It is interesting to watch Bach becoming more ornate, filling in his chords and extending his florid passages. How much stronger the 1st half-bar of 894 is in its new form and its minor mode! (See Ex. 6.). BWV 655, 894

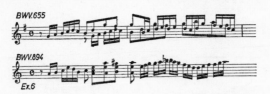

Ex.6

It is very probable that BWV 928 (No. 5 in F of Neun kleine Präludien (BWV 924 – 932) from the Little Clavier Book)

dated 1720–21 is also derived from BWV 655. Certainly the rhythm and general shape of the opening bars would lead one to suppose that Bach had the one firmly in his mind when writing the other!

11 If the present for little Prince Emanuel Ludwig is really derived from Partita No. 1 (as Schmieder believes) then the piece must have been in existance for some time prior to the birthday. The Partitas were produced at the rate of one per year commencing in 1726 and the six works gathered together as Part 1 of the Klavierübung in 1731. BWV 825

12 This provides one of those interesting occasions when the experts differ. Schmieder dated 543 as 'Leipzig period' (i.e. after 1723). Spitta, on the other hand, ascribes it to the Cöthen period and considers it to pre-date 944. One cannot, however, deny that 543 is far more interesting rhythmically. (See Ex. 7.). BWV 543, 944

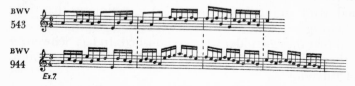

Ex.7.

13 BWV 984—the clavier version—contains 66 bars whereas BWV 595 (for organ) is extended to 81 bars. Spitta feels that this fact, if no other, entitles us to regard the harpsichord version as being the original. (See Ex. 8.). BWV 984

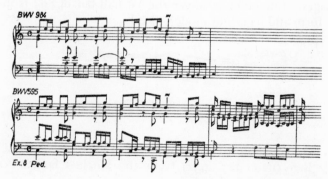

Ex.8 Ped.

14 Spitta claims to see a resemblance between the bass of the *Adagissimo* theme from the Departure of a Beloved Brother (BWV 992) and the ending of the Toccata in F sharp minor for clavier (BWV 910) dated from 1720 (or towards the end of the Weimar period) and part of a Fugue in A minor for Clavier. I regret that I cannot find anything which constitutes a legitimate borrowing—only the use of a common formula of which more later. (See Ex. 24.). BWV 910, 992

TABLE 1 A
KEYBOARD REVISIONS

Source	New or revised version
1 'Vom Himmel hoch da komm ich her'.	BWV 243, 606, 700, 701, 738, 738a, 769. Appx. 63, 64, 65.
2 'Allein Gott in der Höh'.	BWV 260, 662, 663, 663a, 664, 664a, 675, 676, 676a, 677, 711, 715, 716, 717, 771. Appx. 48.
3 'In Dulci Jubilo'.	BWV 368, 608, 729, 729a, 751.
4 'Lobt Gott, ihr Christen allzugleich'.	BWV 375, 376, 609, 732, 732a.
5 'Nun komm, der Heiden Heiland'.	BWV 599, 659, 659a, 660, 660a, 660b, 661, 661a. Cantatas 61 & 62.
6 'Gelobet seist Du, Jesu Christ'.	BWV 314, 604, 697, 722, 722a, 723. Cantata 91.
7 'An Wasserflüssen Babylon'.	BWV 653, 653a, 653b.
8 An early keyboard work?	Sonata (No. 3) in D minor (BWV 527) of Six Sonatas. BWV 525-530. Dated 1727 or 1723.
9 Largo of Sonata (No. 5) in C. BWV 529. (see 8).	Middle movement of Prelude and Fugue in C for organ. BWV 531.

10 Prelude and Fugue in A for organ. BWV 536. Dated about 1716.

Prelude and Fugue in A. Dated after 1723.

11 Prelude and Fugue in F for Organ. BWV 540. Dated about 1716.

Prelude and Fugue in F. Dated between 1717 & 23(?).

12 Präludium und Fugue in G for organ. BWV 541. Dated 1724 or 5.

Sonata No. 4 in E minor. BWV 528. Dated 1727(?).

13 Fugue in A minor for clavier. BWV 944. Dated about 1720.

Prelude and Fugue in A minor for organ. BWV 543. Dated after 1723.

14 Fantasia and Fugue in C minor for organ. BWV 546. Dated about 1716.

Prelude and Fugue in C minor for organ. BWV 546.

15 Toccata and Fugue in D minor for organ. BWV 565. Dating from Weimar period?

A clavier work(?).

16 Choral-Prelude 'Liebster Jesu, wir sind hier'. BWV 633.

BWV 706.

17 Choral-Prelude 'Wer nur den lieben Gott lässt walten'. BWV 642. Dated 1706(?).

BWV 690.

18 Choral-Prelude 'Wer nur den lieben Gott lässt walten'. BWV 690. Dated 1708-17.

BWV 691a.

19 Choral-Prelude 'Wer nur den lieben Gott lässt walten'. BWV 691a. Dated 1720.

BWV 691.

20 Choral-Prelude 'Wer nur den lieben Gott lässt walten'. BWV 691. Dated 1725.

Appx. 60.

21 Choral-Prelude 'Valet will ich dir geben'. BWV 736.

22 Partite Diverse on 'Sei gegrüsset Jesu gütig' (Eleven small Partitas). BWV 768.

23 Klavierbüchlein for W. F. Bach (Later). BWV 722-801. Dated 1723.

24 Five French Suites. BWV 812-816. 1722.	Anna Magdalena's 1st notebook.
25 Two French Suites. BWV 812, 813. Dated 1725.	Anna Magdalena's 2nd notebook.
26 Partita in C minor. BWV 813.	
27 French Suite (No. 3) in B minor. BWV 814.	BWV 927.
28 French Suite (No. 4) in E flat. BWV 815.	
29 French Suite (No. 6) in E. BWV 817.	
30 Suite in A minor for clavier. BWV 818. Dated about 1722.	BWV 818a of later date.
31 Suite in E flat for clavier. BWV 819. Dated about 1722.	BWV 819a of later date.
32 Prelude & Minuet in Anna Magdalena's 2nd notebook. Dated 1725.	Fantasia and Burlesca. BWV 827. Dated 1728.
33 Prelude & Gigue in Anna Magdalena's 2nd notebook. Dated 1725.	Toccata, Air & Gigue. BWV 830.
34 Menuette in G in Friedemann's clavier book. BWV 841. Dated 1720-21.	Menuette in G in Anna Magdalena's 1st notebook. Dated 1725.

35 Scherzo in D minor. BWV 844.	Scherzo in E minor. BWV 844a.
36 Eleven Preludes in Friedemann's clavier book. Dated 1720.	Preludes Nos. 1, 2, 3, 4, 5, 6, 8, 9, 10, 11 & 12 in Book I of the "48".
37 Prelude in C. BWV 846a.	Prelude (No. 1) in C. BWV 846.
38 ?	Prelude (No. 2) in C minor. BWV 847.
39 A two-part Invention(?).	Prelude (No. 3) in C sharp. BWV 848.
40 An organ work(?).	Prelude (No. 4) in C sharp minor. BWV 849.
41 Friedemann's book.	Prelude (No. 5) in D. BWV 850.
42 Friedemann's book.	Prelude (No. 6) in D minor. BWV 851.
43 A work for violin(?).	Prelude (No. 8) in E flat minor. BWV 853.
44 French Suite No. 6.	Prelude (No. 9) in E. BWV 854.
45 A trio for violin, lute and harpsichord(?).	Prelude (No. 10) in E minor. BWV 855.
46 ?	Prelude (No. 11) in F. BWV 856.
47 ?	Prelude (No. 12) in F minor. BWV 857.
48 ?	Prelude & Fugue (No. 14) in F sharp minor. BWV 859.
49 ?	Prelude (No. 15) in G. BWV 860.
50 ?	Prelude (No. 17) in A flat. BWV 862.

51	?	Fugue (No. 20) in A minor. 865.
52	An organ Toccata(?)	Prelude & Fugue (No. 21) in B flat. BWV 866.
53	Prelude & Fugue. No. 1a, BWV 870a. Dated 1718-19. No. 1b, BWV 870b.	Prelude & Fugue (No. 1) in C (Part II of "48"). BWV 870. Dated 1744.
54	Fugue for organ.	Fugue (No. 2) in C minor. BWV 871.
55	Prelude & Fugue. No. 3a in C. BWV 872a.	Prelude & Fugue (No. 3) in C sharp. BWV 872.
56	Praeambulum (No. 6a). BWV 875a.	Prelude (No. 6) in D minor. BWV 875.
57	?	Fugue (No. 10) in E minor. BWV 879.
58	A work for organ(?).	Prelude & Fugue (No. 11) in F. BWV 880.
59	A harpsichord work(?).	Prelude (No. 12) in F minor. BWV 881.
60	(i) Praeludium (one of Two Preludes) to Fughetta in G. BWV 902a. (ii) Fughetta in G. BWV 902. Dated about 1720.	Prelude & Fugue (No. 15) in G. BWV 884.
61	Fughetta from Präludium und Fughetta in F. BWV 901.	Fugue (No. 17) in A flat. BWV 886.
62	A work for harpsichord(?).	Prelude (No. 18) in G sharp minor. BWV 887.
63	Prelude of 1st English Suite in A. BWV 806.	Prelude (No. 19) in A. BWV 888.
64	?	Fugue (No. 20) in A minor. BWV 889.

B

65 A work for harpsichord(?).	Prelude (No. 21) in B flat. BWV 890.
66 An early harpsichord work or movement(?).	Prelude (No. 22) in B flat minor. BWV 891.
67 An early keyboard work (?).	Prelude (No. 23) in B. BWV 892.
68 ?	Prelude (No. 24) in B minor. BWV 893.
69 ?	Chromatic Fantasia. BWV 903.
70 Adagio (No. 3) in Toccata in D for clavier. BWV 912. Dated 1720.	Adagio. BWV 912a.
71 'Col Discrezione'. BWV 912 and	Movement (No. 5) in Toccata in D. BWV 912a.
72 Prelude & Fugue in C minor.	Toccata (No. 2) in E minor. BWV 914. Dated about 1710.
73 Fugue in B minor for clavier. BWV 951a and 951. Dated 1709.	
74 Sarabande in Anna Magdalena's own hand in her 2nd notebook. BWV 990. Dated 1725.	Aria in Goldberg Variations. BWV 988.
75 Adagio (3rd Movt.) in Sonata (No. 5) for violin and clavier. BWV 1018 & 1018a.	

NOTES ON TABLE 1A

1 'Vom Himmel hoch da komm ich her'.
This tune appears at least ten times during the course of Bach's life.

The first is in the Magnificat in D. (BWV 243) dated 1723 wherein it is Nachtrag A-choral.

Then follows BWV 606 in the organ book; BWV 700 & 701 both in Kirnberger's collection; three more choral preludes BWV 738, 738a and 769 and, finally, three in the Appx.—63, 64 and 65.

2 The various settings of Allein Gott are extremely instructive.

They demonstrate Bach's fondness for and interest in a well-loved tune and his ability to vary his treatment of it. His keys range between F, G & A; his metre between 6/8, 3/2, C and 12/8 and the lengths of the settings between 17 and 127 bars. The original melody appeared in Val. Schumann's G.B. of 1529/36. Bach's No. 1 setting (BWV 260) is a four-part choral in G; common time.

No. 2 (BWV 662) a choral in A; common time, 53 bars, Cantus firmus in Sop.

No. 3 (BWV 663) a choral in G; 3/2 time, 127 bars, Cantus firmus in Tenor.

No. 4 (BWV 663a) is an early version of 663. It is one bar shorter than its original.

No. 5 (BWV 664) is a Trio in A; common time, 96 bars,

No. 6 (BWV 664a) is an early version of 664.

No. 7 (BWV 675), a *Choral-Prelude a 3* in F; 3/4 time, 66 bars, C.F. in Alto.

No. 8 (BWV 676) a *Choral-Prelude a 2 clav e Ped.* in G; 6/8 time, 126 bars. Dated 1739. appeared in 3rd part of *Klavier-übung*

No. 9 (BWV 676a) a Choral Prelude in G; 6/8 time, 47 bars.

No. 10 (BWV 677) a Fughetta in A; Common time, 20 bars.

No. 11 (BWV 711) Choral-Prelude (*Bicinium*) in G; 3/4 time; 84 bars. Appeared in Kirnberger's collection.

No. 12 (BWV 715) Choral Prelude in G; Common time, 17 bars.

No. 13 (BWV 716) Fuga (a 4) in G; 3/2 time, 89 bars.

No. 14 (BWV 717) Choral Prelude in G; 12/8 time, 63 bars.

No. 15 (BWV 771) 17 variations.

No. 16 (Appx 48) Choral-Prelude in G; 3/4 time, 48 bars. C.F. in Bass.

There is a certain amount of doubt regarding the authenticity of BWV 771. Spitta says that the internal evidence against its authenticity is much weakened if we consider it as an early work, remembering how very nearly Bach approached at this time (1702/3) to the style of Böhm and Kuhnau. (See Ex. 9.).

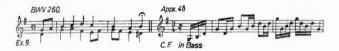

3　In Dulci Jubilo brought forth only five settings. A choral (BWV 368), a choral prelude (in the organ book) (BWV 608) and three other choral preludes.

4　Lobt Gott. BWV 375 & 376 are two chorals. 609 is a choral prelude in the organ book, 732 and 732a are two further choral preludes.

5　Ten settings of this tune varying between 10 & 92 bars.

No. 1 (BWV 599) 10 bars in length, is in the organ book.

No. 2 (BWV 659) is 34 bars long.

No. 3 (BWV 659a) (Fantasia) also 34 bars, is an older version of 659.

No. 4 (BWV 660) (Trio) 42 bars long.

No. 5 (BWV 660a) also 42 bars, is an early version of 660.

No. 6 (BWV 660b) 42 bars, has the C.F. in Pedals.

No. 7 (BWV 661) 92 bars, has the C.F. in Pedals.

No. 8 (BWV 661a) 46 bars, is an older version of 661.

No. 9 is in Cantata 61 'Nun komm, der Heiden Heiland' (1st Sunday in Advent) dated 1714.

No. 10 is in Cantata 62 'Nun komm, der Heiden Heiland' (1st Sunday in Advent) dated 1734-44. Dürr-1724.

These settings are so full of variety that they will bear noting as examples. (See Ex. 10. a – f).

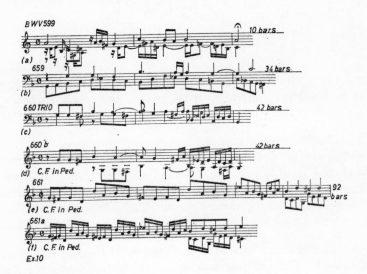

Ex.10

6 Cantata 91, 'Gelobet seist du, Jesu Christ' (1st day of Christmas) dates from between 1735 and 44.

BWV 314 is a choral.

604 a choral prelude in the organ book.

697 a choral prelude in Kirnberger's collection.

722, 722a and 723 are three more choral preludes.

7 'Babylon' is an interesting exercise.

BWV 653a, an *Alio Modo* (*a 4 voci*) *a 2 Clav. e Ped.* is the first version. It contains 77 bars and Spitta doubts if it can have been written later than 1712. BWV 653, with 83 bars, is a later version and BWV 653b, *a 2 clav. e Pedale doppio* (77 bars) comes later still.

In his very skilful remodelling (653b) Bach adds a 4th part to the accompaniment by his constant use of the double pedal. (See Ex. 11.).

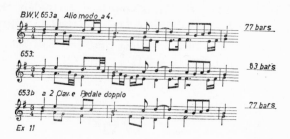

Ex 11

8 The 1st movement, (*Andante*) of BWV 527 dates from 1722. It is, therefore, anything from one to five years earlier in origin than the other movements of the work. BWV 527

9 Schmieder mentions the transfer of movements between BWV 528 and 541 (see item 12). The same type of transfer occurred in this instance between BWV 529 and 531 (now known only as a two-movement work) which yielded up its 'between movement' to become the Largo of the Sonata.

BWV 529, 531

10 The revision this work underwent in Leipzig was quite thorough. The prelude was recast, made fuller in tone and more complete structurally. The fugue was shortened by three bars, its time signature was changed from 3/8 to 3/4 and high pedal points were added. BWV 536

11 The present prelude dates from the Cöthen period (1717 −23) and was substituted for the original.
Spitta points out regarding this prelude (and also BWV 546) that their structure is almost too grand and provides too great a contrast with their fugues. He feels that 546 must date from the period of Bach's highest and most complete mastery.

BWV 540

12 BWV 541 seems to have started its life as a 3-movement work, Prelude, Andante & Fugue. In his Weimar and Cöthen days Bach had the idea of creating an organ sonata and was still experimenting with the triple form even as late as 1724 or 5. Later he abandoned the idea and finally transferred this Andante to Sonata No. 4. BWV 528. BWV 528, 541

13 This work, BWV 543, is rather a mixture. The Prelude is a Weimar one and dates from 1709. The first version of the Fugue was for clavier in 1720 (Cöthen), BWV 994. The second, for organ, dates from Leipzig. The Prelude is strongly reminiscent of the Buxtehude school. BWV 543, 994

14 The new prelude to BWV 546 dates from Leipzig, about 1730. Peters Edition 243 No. 12 gives the early version (called *Fantasia*). BWV 546

15 Spitta dates this work as early Weimar, and says that in bar 137 of the Fugue there is a figure which Bach used as the chief groundwork of a clavier piece. I regret, however, that I can find no trace of such a work.
Schmieder gives 1709 or even Arnstadt (1703 – 1707) as a possible date. BWV 565

16 This choral-prelude from the little organ book (dated about 1706) appears again under the same title in Kirnberger's collection as BWV 706 1 and 2 dated 1708 – 17. BWV 633

17 This also is in the organ book and in Kirnberger's collection as BWV 690 dated 1708 – 17. BWV 642

18 The position is now reversed somewhat for BWV 690 in Kirnberger's collection of 1708 – 17 appears in W. F. Bach's clavier book dated 1720 as BWV 691a. BWV 690

19 Bach and his family must have been fond of this tune for it re-appears once more in Anna Magdalena's 2nd note book of 1725 as BWV 691. BWV 691a

20 Still one further appearance. This time in Schmieder's BWV as Appx 68. BWV 690

21 Walther is supposed to have loved this piece and to have copied it several times. Bach, too, liked it very much himself and revived and copied it at a later period.
(See BWV 415, 735 and 735a). BWV 736

22 This is a wonderful example of mixed styles and periods, mature and immature work.

Nos. 1, 2, 4 & 10 date from Lüneburg or Ohrdruf.

Nos. 3 & 5 date from Mühlhausen.

Nos. 6, 7, 8, 9 & 11 date from Weimar.

Nos. 1, 4 & 7 strongly resemble the works of Böhm. Nos 5, 6, 9, 10 & 11 are regular organ chorals in style with forms similar to those in the little organ book and No. 10 also reminds us of Buxtehude.

Bach worked on this little collection at three different times. The first version, very short, was contemporary with two other early chorals. In the second he revised the first variation as No. 2, added a four-part choral to open and closed with variation four. The third version added a second group. Two older and, up to now, discarded variations were revised and became Nos. 7 and 8. Subsequently No. 8 was further revised and had pedal notes added. A MS belonging to Kreber contained only the choral (added in the second version) and the first four variations. BWV 768

23 The little clavier book for Friedemann was begun on January 22nd 1720. It included 2-part Inventions (called *Preambles*) and 3-part Sinfonias. There are at least three different autographs. BWV 772, 801

 i. The clavier book – this contains first all the Inventions and then all the Sinfonias in ascending and descending key order.

 ii. Keys in the same order but each Invention followed immediately by its corresponding Sinfonia.

iii. All the Inventions and then all Sinfonias (as in i) but in ascending key order (similar to the '48') only.
 Schmieder numbers the 1723 version as BWV 772 – 801.

24 Five of the six 'French' Suites appeared in Anna Magdalena's first note book of 1722. It is interesting to compare the Courante of the second Suite as it appeared in 1722 with later versions. (See Ex. 12a.). BWV 813

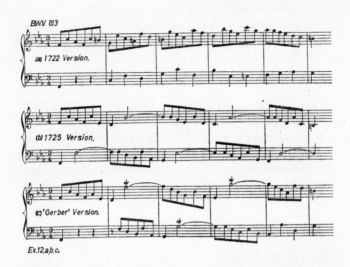

BWV. 813

(a) 1722 Version.

(b) 1725 Version.

(c) 'Gerber' Version.

Ex.12,a,b,c.

25 Suite No. 1 (complete) and part of No. 2 re-appeared in Anna Magdalena's second note book of 1725. (See Ex. 12b & c.).

BWV 812, 813

26 This Partita entitled *Overture nach Französischer Art vor ein Clavicymbel mit zweyen Manualen* appeared in Klavierübung Book II, dated 1734. Originally it was in C minor; most probably being transposed into its present key as there was a Partita in C minor already in existence.

BWV 813

27 One item in G minor from Nine Little Preludes (BWV 927) in Friedemann's book dated 1720 – 21) is used as a second Minuet or Trio in a copy in the British Museum. (BB Mus. ms Bach p.514).

BWV 814

28 The Berlin Music Library possesses a MS which gives the 1st movt. of the Suite as a Prelude and, in addition, presents it with a second Gavotte. Fuller-Maitland, in his *Keyboard Suites of J. S. Bach* (Oxford University Press 1928) doubts if the Prelude is really one of Bach's own compositions and wonders if it has found its way into this MS by accident.

BWV 815

29 The 'Gerber' MS of this Suite opens with Prelude No. 9 in E from Book I of the '48'. (BWV 854).
Fuller-Maitland suggests the possibility that the Courante of Suite No. 6 was intended originally as a piece for an unaccompanied violin. BWV 817

30 The 1st version of this Suite (BWV 818) appears in Berlin as one of *Sex Suiten pur le clavesin compossee par Mos. J. S. Bach.* It contains two Sarabandes (Simple and Double) but no Prelude.
The second version (BWV 818a) in Kellner's collection has a 58-bar Prelude and a Minuet in place of Sarabande No. 2 (Double). (See Ex. 13.). BWV 818, 818a

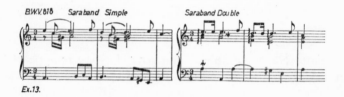

Ex.13.

31 This Suite has been quite enterprising as regards its placing. The Rust MS groups it with four of the French Suites and the Suite in A minor (BWV 818).
Another MS (in Berlin) shows it as French Suite No. 6.
The Rust MS contains two Allemandes; later versions, including 818a, have one or the other but not both. BWV 819, 819a

32 The six Partitas, collected together and published as the *'Klavierübung'* (part I) in 1731, were written one per year commencing in 1726. 'Written' is, perhaps, the wrong word, 'assembled' might be more correct. Certainly the *Fantasia* (Movt. No. 1) and *Burlesca* (No. 5) appeared in Anna Magdalena's book in 1725 as Prelude and Minuet. BWV 827

33 Similarly the Toccata (Movt. No. 1) and fugue (No. 7) were in Anna's book in 1725. The Air (No. 4) of Partita No. 6 is a later addition: and the fugue (in Anna's version) is written in notes of half the value of the later version.
 BWV 830

34 Evidently Bach decided that this 48-bar piece contained
good teaching material and that, if it had helped Friedemann,
there was no good reason why it should not prove equally
useful to the composer's young pupil-wife. BWV 841

35 There does not seem to be any particular reason for this
revision. The D minor version contains 80 bars and the E
minor 84. The technical problems remain the same and the
small transposition does not complicate or change finger
position or grouping to any great extent. (See Ex. 14.).

 BWV 844, 844a

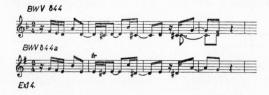

BWV 844

BWV 844a

Ex 14.

36 Were the pieces contained in Friedemann's book intend-
ed to be played on the harpsichord or clavichord?
(N.B. the term 'clavier' can refer to any keyboard instrument).
Certainly the pieces contained in Book I of the '48' were, so
far as we know, intended (with certain exceptions) for the
clavichord.
Spitta mentions that a few of the Fugues bear clear traces of
an earlier origin. The A minor, (No. 20) for example, was
clearly written for a pedal harpsichord and is an imitation
of an organ work in the same key by Buxtehude. In all prob-
ability it dates from 1707 or 8. Fuller-Maitland in the *Musical
Pilgrim* says: — 'a good many preludes seem to have had an
educational purpose and were turned into works of art by the
addition of some passage'. And of book II 'A certain number
of the 2nd set of Preludes and Fugues were actually composed
in Bach's earlier life and were incorporated in the later
collection, being transposed where the original key did not
suit the scheme'. Two Preludes and Fugues missing from the
British Museum MS have been restored – still missing are
Nos. 4, 5 & 12 from Book II.

37 Prelude BWV 846 is best known as No. 1 of the '48', dated

1722. It appears however in many versions. Forkel's, from Friedemann's book as printed in BG XIV is, perhaps, the earliest and that in Anna Magdalena's 2nd note book of 1725 the latest.

It is, I think, generally agreed that the bass G which appears in Schwenke's MS between the F sharp of bar 22 and the A flat of bar 23 is false. Perhaps added by a copyist who thought to 'improve' upon Bach's progression? BWV 846, 846a

38 I will not attempt to cover all the Preludes and Fugues in the '48' in any great detail, but will content myself by noting points of special interest. The bibliography on the subject is enormous – Schmieder lists 109 books and/or articles up to 1948! BWV 847

39 The C sharp major Prelude in its earliest form was a sketch for a 2-part invention which, subsequently, was extended to nearly 40 bars.

There is an early version of the Prelude given by Forkel which contains 69 bars but that which appears in the '48' is 104 bars in length. BWV 848

40 Differing view-points and ideas on interpretation are always of interest. Here are three concerning this piece – the C sharp minor Prelude : —

i. 'It is possible that Bach intended to transfer this to the harpsichord and so added extra ornaments.'

ii. 'This, with its gorgeous fugue, is sublime organ music . . . This prelude might have been born on the *soft stops of the choir organ*' (Wilkinson).

iii. 'It should be played *forte throughout*' (Schweitzer).
 BWV 849

41 Short versions of the Prelude in D (without the cadenza passages) are given in Friedemann's book and by Forkel. The '48' version contains 35 bars. BWV 850

42 An early version of this Prelude in D minor appears in Friedemann's book (1720). BWV 851

43 Forkel gives an early and shortened version of the E flat minor Prelude – now 40 bars in length. Wilkinson, see his 'How to play Bach's 48 Preludes & Fugues, feels that the theme of the Prelude is so impassioned and sustained that it calls for a sensitive violin bow to do it justice. BWV 853

44 This is the Prelude which in one MS found itself in French Suite No. 6 (See note 25). BWV 854

45 This Prelude, in E minor but without its Presto, is in Friedemann's book. What we have now is the working out of that little piece, intended, presumably, as a left hand exercise. Wilkinson thinks that the melody reminds one of a violin sonata and that the original idea was a Trio for violin, lute and harpsichord. Hugo Riemann is of the same opinion.
 BWV 855

46 This Prelude in F, also, is in Friedemann's book. BWV 856

47 Forkel gives a shortened version of the F minor Prelude.
 BWV 857

48 Spitta likens the counter-subject of this Fugue in F sharp minor to part of a theme in Capriccio for a Brother. The resemblance seems a little far-fetched to me – it is almost inevitable that groups of semiquavers ornamenting repeated notes should resemble other and similar groups but this resemblance does not constitute either revision or borrowing. (See Ex. 15.). BWV 859

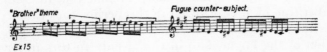

Ex 15

49 Wilkinson sees a resemblance between the new melody introduced in bars 5 and 9 and the theme of Prelude No. 3 in C sharp. Forkel gives a short early version. Riemann agrees with Wilkinson. (See Ex. 16.). BWV 860

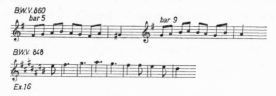

Ex.16

50 Again Forkel quotes an early version of the A flat Prelude.

<div align="right">BWV 862</div>

51 This work – the A minor Fugue – must have been written for a pedal harpsichord. See notes on 36.

<div align="right">BWV 865</div>

52 Forkel gives an early version of this Fugue in B flat. Riemann says of the Prelude that 'the running passages appear as if they were borrowed from a Bach organ Toccata'.

<div align="right">BWV 866</div>

53 The Prelude and Fugue in C saw life over quite a long period before coming to rest in Part II of the '48'. Its earlier version is that in J. P. Kellner's clavier book. Next comes a longer version, the MS of which is now in the British Museum and thirdly, a MS of Altnikol's which is a revision of version 2. Also there is a short version of the Fugue in 4/4. Riemann feels that it may be 'an old piece revised and extended'.

<div align="right">BWV 870, 870a, 870b</div>

54 It is thought that this Fugue in C minor was originally for organ. It is very similar in style to the Fugue in C maj. BWV 547 BG XV P.232. (See Ex. 17.).

<div align="right">BWV 871</div>

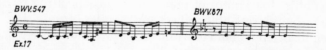

Ex.17

55 There is a MS of this C sharp Prelude (but in C) in the handwriting of J. C. F. Bach in the Berlin State Library. It gives the music in plain 5-part chords marked *arpeggio*. A version of the Fugue, also in C and only 19 bars in length, is in the British Museum. The one in the '48' is 35 bars long.

<div align="right">BWV 872, 872a</div>

56 An early form of this Prelude in D minor appears in BG XXXVI. That contained in the British Museum MS is of a later date.

<div align="right">BWV 875, 875a</div>

57 The version of the E minor Fugue we know in the '48' extends to 86 bars whereas that in the British Museum MS is only 71 bars in length. BWV 879

58 Cecil Gray says 'The style and feeling of the piece (Prelude and Fugue in F) in general suggest the possibility, or, rather, the probability, that Bach had the organ in mind when composing it rather than the clavichord'. Parry, too, says that its severe contrapuntal style is more like that of organ than clavier music. One grants the possibility of this applying to the Prelude but surely the broken chords in the Fugue are very suggestive of the chavichord. Riemann, also, refers to it as written in 'organ style'. BWV 880

59 This piece (Prelude in F minor) gives the impression of having been composed for the harpsichord and not the clavichord. This suggests that its original home was not amongst the '48'. BWV 881

60 Wilkinson feels that the likeness in style and mood to the Prelude in C sharp (Bk. 1) suggests that Bach 'had, at that time, a spare sketch in his portfolio which he could not do better than insert here'. He says of the Fugue in G, 'the brilliant bravura scale reminds one of his organ works' and 'they, the Prelude and Fugue, are souvenirs of his young days'. Riemann makes the same comment. (See Ex. 18.).
 BWV 884, 902, 902a

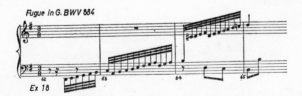

Ex 18

61 BWV 901 is published in Peters Ed. 214. The '48' version was transposed into A flat in order to fit into the key-scheme. The early version is 24 bars in length and the latter 50.

62 The alternating pianos and fortes (see bars 3, 5 etc) seem

to indicate that the work, Prelude in G sharp minor, was intended originally for a harpsichord with two keyboards.

<div align="right">BWV 887</div>

63 The resemblance between these two pieces in A is, I feel, too close for it to be quite accidental. On the other hand I must quote a remark made by Harold Thomson (who saw Whittaker's *Cantatas* through the Press after the writer's death): — 'I wonder if sometimes he wrote the same kind of music in the same key and so occasionally got an unconscious plagiarism'. (See Ex. 19.).

<div align="right">BWV 806, 888</div>

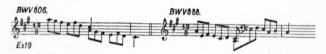

64 There is an early version, possibly written for a pupil, of this piece. Wilkinson said of the A minor prelude that it is an excellent practising piece 'especially for the acquirement of independent handwork and fingering'. Compare the fugal theme with : —

i No. 4, Part II, Messiah
ii Final chorus of Handel's Joseph
iii Kyrie Eleison of Mozart's Requiem
iv Finale of String Quartet, Op. 20, No. 5. Haydn.
 (Who borrowed which and from whom?)
(See Ex. 20.).

<div align="right">BWV 889</div>

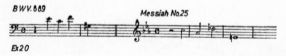

65 Both Tovey and Gray suggest that the crossing of hands in bars 13 – 16 and 37 – 40 indicates a two manual harpsichord and not a clavichord as the original. (See item 59.)

<div align="right">BWV 890</div>

66 This Prelude in B flat minor is very similar to the three-part Inventions in style and differs very little from a Fugue. Is

it a movement discarded from BWV 787 – 801 or an early
Fugue separated from its Prelude? BWV 891

67 Wilkinson is not quite sure about this Prelude in B. He
says: — 'Is this the old Bach rejuvenated or an earlier work
resuscitated?' It is a fine, young-sounding work whether old
or new and requires a finger dexterity equal to the Inventions.
 BWV 892

68 An Altnikol copy of this work (Prelude in B minor)
changes Bach's *Allegro* to *Andantino* and halves all the note
values. BWV 893

69 There are several versions of this piece. As is the case
in some of Chopin's compositions for the piano it is difficult
to decide which reading is the definitive one.
Two, BWV 903 and 903a, for example, date from 1720 and
another from 1730. (See Ex. 21.). BWV 903

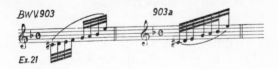

70 BWV 912 contains 13 bars and its successor only 12.
Furthermore the later version (912a) is far less complex.
(See Ex. 22.). BWV 912, 912a

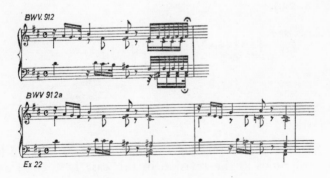

71 Second thoughts certainly cut out a lot of what, in a lesser composer, might be regarded as padding or waffle. The BWV 912 movement contains 59 bars but that in 912a only 15!

<div align="right">BWV 912, 912a</div>

72 The C minor Prelude and Fugue dating from the Arnstadt period doubtless provided the basis for BWV 914.

<div align="right">BWV 914</div>

73 Spitta points out that Bach added a 'grand and imaginative' Prelude to this Fugue. For a long time, however, this Prelude was thought to be the work of Wilhelm Hieronymus Pachelbel. Spitta is of the opinion and correctly, I think. that as the work appears after the final Fugue in the Fischhoff autograph of Part I of the '48' (now in the Berlin Library), and also the first 14½ bars are in the same handwriting as the '48' and the work is headed *Prelude di J. S. Bach* we can accept it as being by the Master himself. As Spitta so rightly says: — 'We may credit a very careful copyist of 24 of Bach's Preludes and Fugues with having assured himself of the genuineness of what he transcribed'.

<div align="right">BWV 951, 951a</div>

74 Spitta is quite certain that the Sarabande (BWV 990) must have been written especially for Anna Magdalena. What is not so certain is the connection between it and the Goldberg Aria. Certainly musicologists accept that the one is derived from the other but the likeness between the two is not strong — there is, perhaps, more resemblance between the descending basses than the melodies.
(See Ex. 23.).

<div align="right">BWV 988, 990</div>

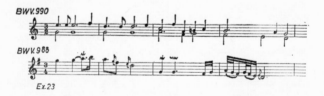

Ex.23

75 I included this piece of chamber music in a list of keyboard revisions as the revision in this case is to the clavier

part. BWV 1018a (the first version) has its arpeggio accompaniment in semiquavers whereas version 2 (BWV 1018) has demisemiquavers. (See Ex. 24.). BWV 1018. 1018a

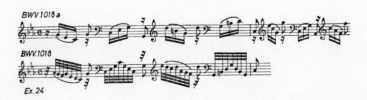

Ex. 24

Dürr does not condemn Spitta's habit of dating works by the watermarks or their MS completely—only when it is known that the MS under consideration is obviously a later copy.

In his Kritischer Bericht, Series 1, Book 35, (1964) Dürr confirms that the use of certain types of paper with known watermarks means that some chorals in the little organ book, for example, must have originated prior to 1714 at the very latest!

CHAPTER II

A short group – in fact Table IIA contains only one item – but an interesting item as it shows a borrowing in a reverse order; instead of violin to organ or clavier this one is organ to violin.

TABLE II

FROM SOLO INSTRUMENT (NON-KEYBOARD) TO SOLO INSTRUMENT

Source	New Version &/or Position
1 Fugue in G minor for solo violin. BWV 1001. Dated 1720.	Fugue in G minor for lute. BWV 1000. Dated 1720.
2 Fugue in G minor for solo violin. BWV 1001.	Fugue from Prelude and Fugue in D minor for organ. BWV 539. Dated 1724-5.
3 Sonata No. 2 in A minor for solo violin. BWV 1003.	Sonata in D minor for clavier. BWV 964.
4 Adagio from Sonata No. 3 in C for solo violin. BWV 1005.	Adagio in G for clavier. BWV 968.
5 Partita No. 3 in E for solo violin. BWV 1006.	Suite for lute or harp. BWV 1006a.

| 6 Suite No. 5 in G minor for solo cello. BWV 1011. Dated 1720. | Suite in G minor for lute. BWV 995. Dated 1720 or after 1723. |
| 7 Violin Work(?). | Suite in C minor. BWV 997. |

NOTES ON TABLE II

1 This lute arrangement of the violin fugue was made soon after the original was written and is two bars longer than its model. It is for the Baroque lute, a larger and somewhat clumsier version of the instrument normally used by present-day lutenists, which, in fact, is earlier in origin. The Baroque lute was fitted with more bass strings to carry the compass downwards and so made the deep bass line required by the composer possible. It has been said that Bach wrote his lute works in normal notation leaving to a copyist the chore of translating them into lute tablature. A MS in French lute tablature is in the state library of Leipzig.
On the other hand it is scarcely possible to write for the lute unless one is completely familiar with its technique and limitations. Bach knew and used the far more difficult organ tablature; surely, therefore, he would have had the same knowledge of lute writing? BWV 1000, 1001

2 The organ version in D minor of the violin fugue came 4 or 5 years later. It, too, is two bars longer than the violin version but the added two bars are not the same as those added to the lute arrangement. The work is of great interest as finger technique on the keyboards makes it possible for Bach to fulfil his ideas in a way which could only be hinted at on the bowed or plucked instruments. BWV 539, 1001

3 I must quote Spitta in full in order to disagree with him the more thoroughly!
He says: — 'Although it does not exist in Bach's writing the

wonderful genius displayed in the arrangement leaves no room for doubting that it is from the composer's own hand. In its clavier form it is so much richer in treatment that, at times, the original appears a mere sketch beside it.' To my mind the arrangement is unworthy of the composer's name! He appears to become increasingly bored with the whole exercise until, by the time the last movement is reached, he is content with a literal transfer of the original material to the keyboard. There is no attempt at rearrangement or re-creation, merely a laying out of the notes for two hands. It may be that Bach had certain things in his mind which he didn't trouble to write down; but if all he needed was a reminder, then he might just as well have played the work from the violin copy. BWV 964, 1003

4 In this instance the case is reversed. Whereas in No. 3 the so-called arrangement is often so simple as to be almost unworthy of Bach's name, here the setting is so complex as to suggest a later hand. Spitta says:— 'When played on the clavier in that enriched form which the composer himself gave it, it is discovered to be one of the most marvellous productions of Bach's genius'. Basil Lam, however, is of the opinion that the arrangement might be ascribed to the hand of Johann Gottfried Müthel, one of Bach's outstanding pupils.
 BWV 968, 1005

5 Here one must cross swords with Fuller-Maitland who says that:— 'the characteristic devices for the violin succeed so well on the keyboard. The joyful Prelude has the alterations of *piano* and *forte* which tell us that a harpsichord with two manuals was meant to be used and of course, the 'echo' effects which abound are far more effective on the harpsichord than on the violin!' He goes on to say that 'the transcription seems to have consisted in dropping the pitch an octave and adding various ornaments considered indispensable in harpsichord music'.

Now, in the first place, the 'characteristic devices' do not succeed on the keyboard! Those readers familiar with the organ version of this work will remember that many of them have been changed slightly in order to fit them to keyboard technique. BWV 1006, 1006a

Secondly it is very doubtful whether 1006a was ever intended for harpsichord! Certainly the BG prints it in with other keyboard works but the lute (or, maybe, the lute-harpsichord invented by Bach) is its true medium. Also the Baroque harp must be borne in mind.

Thirdly, key. Did Bach drop his organ version down to D because he knew that that key was more comfortable on a keyboard or was it merely because he wanted the Cantata in that key especially for the clarini? If the former, then there would appear to be no point in retaining the original key of E for the harpsichord. In any case as the pitch of the organ was very different from the other instruments the organist probably played his part in C.

Finally – pitch. Fuller-Maitland's remark that all Bach did was to drop the pitch an octave gives the clue to the problem. A characteristic of lute (or harp) music is its seeming low pitch. Dr. Howard Ferguson says in the preface to his edition of one of Bach's lute works arranged for piano: — 'The interesting point about this lute version of the Suite (Suite in C minor (BWV 997)) is that in it the equivalent of the right-hand part is throughout written an octave lower than in any of the versions for clavier The low tessitura which results is very characteristic of Bach's lute music'.

Also of interest is the fact that certain works written in lute-style also had the same low tessitura. See, for example, Couperin's harpsichord pieces 'L'Enchanteresse' and 'La Garnier'. (We must remember that Couperin's keyboard music was well known to Bach and this knowledge may be the reason for the extremely low layout of the Gavotte II and Bourree II in his French Overture BWV 831.

6 No one has suggested that BWV 995 was intended for clavier. Luckily, when Bach made the arrangement after moving to Leipzig, sometime, that is, after 1723, he described his work as 'Lute pieces for Mons. Schouster'. The new arrangement is masterly – the added bass line and extra passage work – especially in the final Gigue – improve even upon the magnificent original. In fact the cello version sounds almost like a simplified edition of the lute at times.

7 Fuller-Maitland is sure that this Suite began life as a
work for violin. He says: — 'It is quite certainly a transcrip-
tion. The Gigue and its Double are clearly from violin pieces'.

<div style="text-align: right">BWV 997</div>

TABLE IIA

KEYBOARD TO SOLO INSTRUMENT

Fugue(?) for organ.

Fugue in Suite No. 3 for solo
violin. BWV 1005. Dated 1720.

NOTES ON TABLE IIA

The first seven notes of this fugal theme are the same as in
the opening part of the choral tune Komm, Heiliger Geist,
Herre Gott. Mattheson, in his *Grosse Generalbass-schule,*
quotes a theme from another organ fugue by Bach and tells
how he set this theme as an organ test exercise on the 8th
October, 1727, but he makes no mention of the solo violin
sonatas until 10 years later — in 1737.
Spitta hints at the possibility of Mattheson's having become
acquainted with the theme at the time of Bach's visit to him
in Hamburg and considers that any music Bach took with
him would have been for organ or voice — not for solo violin —
the violin version may not, in fact, have existed at that date.
(See Ex. 25.).

<div style="text-align: right">BWV 1005</div>

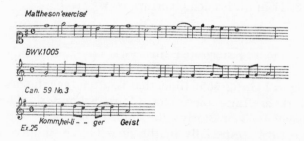

Ex.25

CHAPTER III

TABLE III

FROM KEYBOARD TO CANTATA

Source	New Version &/or Position
1 An organ work.	Bass Aria (No. 1) Wahrlich, wahrlich, ich sage euch and Soprano Choral (No. 3) Und was der ewig güt'ge Gott in Cantata 86 'Wahrlich, Wahrlich, ich sage euch, so ihr den Vater etwas bitten werdet'. Written for Rogation Sunday 1723 to 27.
2 Fugue in G minor for organ. BWV 131a. Dated prior to 1707.	Allegro of chorus (No. 5) Und er wird Israel erlösen in Cantata 131 'Aus der Tiefe rufe ich, Herr, zu dir'. Dated 1707.
3 Sonata in E minor. No. 4 of Six Sonatas for organ. BWV 528. Dated soon after 1727 or before 1723.	First item (No. 8) of Part II of Cantata 76. 'Die Himmel erzählen die Ehre Gottes'. 2nd Sunday after Trinity 1723.
4 Fugue of Prelude & Fugue in G. BWV 541.	First Chor. in Cantata 21 'Ich hatte viel Bekümmernis' 3rd Sunday after Trinity 1714 or 'any day'. Dürr 13.6.1723.

5　Trio-Sonata in G minor. BWV 584. Dated 1723.

Tenor Aria (No. 2) Ich will an den Himmel denken in Cantata 166 'Wo gehest du hin' dated 1723-7 and written for the 2nd Sunday after Easter.

6　Fugue in A minor. BWV 865. Dated 1722.

Bass Aria (No. 1) Bisher habt ihr nichts gebeten in meinem Namen in Cantata 87 (same title). Written for Rogation Day 1735.

7　Sarabande in 1st English Suite in A. BWV 806. Written prior to 1722.

Alto Aria (No. 19) Schlafe, mein Liebster in Christmas Oratorio. BWV 248. Dated 1734.

8　Variation No. 30 Quodlibet. BWV 988. Dated 1725 and 1742.

Recit (No. 3) Nu, Miecke, gib dein Guschel immer her in Peasant Cantata 212. 'Mer hahn en neue Oberkeet'. Dated 1742.

9　An instrumental (keyboard?) work(?).

Alto Aria (No. 1) Gott, man lobet in Cantata 120. 'Gott, man lobet dich in der Stille'. Schmieder – 1728. Whittaker – 26.6. or end Aug. 1730. Dürr 'about' 1728.

10　An instrumental (keyboard?) movement(?).

Organ obbligato to Alto Aria (No. 3) Unerforschlich ist die Weise in Cantata 188. 'Ich habe meine Zuversicht' 21st Sunday after Trinity. 28 Oct. 1730 or 31. Durr – 'about' 1728.

11　Capriccio for Departure of a Beloved Brother. BWV 992.

First chorus Nach dir, Herr in Cantata 150. 'Nach dir, Herr, verlanget mich'. 1712.

NOTES ON TABLE III

1 Spitta says of the bass aria : —

' he (Bach) has entangled the song in a regular 4-part instrumental fugue and so worked it out that, for the most part, it constitutes an independent fifth part' and of the choral ' it reveals a form borrowed from the organ'.

Our problem here is : — Did Bach borrow or draw upon an already existing instrumental four-part fugue as the basis of the Bass aria and only the likeness of the *form* of such a work for the soprano choral or was the fugue-like accompaniment to the aria composed especially for this cantata? BWV 86

2 This appears to be borrowing in reverse – 'from' not 'by'. Ernst Naumann, in his preface to BG XXXVIII of Oct. 1891, quotes Spitta as saying, and rightly so, that this organ arrangement of the choral Fugue is not by Bach and that it is, in fact, inferior to the original. Schmieder says that Bach's authorship is doubtful and the assumption that the organ fugue is an earlier version of the chorus has not remained unchallenged. Whittaker states that the chorus parts are found, arranged, possibly, by Bach's pupil Johann Christian Kittel, amongst the organ works. The MS is in his handwriting and the arrangement is, in fact, in BG XXXVIII.

It would seem, therefore, that not only does the organ fugue not precede the Cantata chorus (and so should not be dated as pre-1707) but that, most probably, it is not even by Bach. It is quite possible that he gave the chorus theme to Kittel as a fugal exercise more than 30 years after the composition of the cantata. BWV 131, 131a

3 The order of adaptation or borrowing depends entirely on the date assigned to the organ work. Spitta says that Bach unhesitatingly adapted the Adagio and Vivace of the Sonata and used them to provide an instrumental opening to Part II of the Cantata whereas Schmieder says that Bach used the Sinfonia as the first movement of the Organ Sonata.

If we accept the 'before 1723' date then Spitta may be correct but if the 'soon after 1727' Schmieder wins the day. BWV 76, 528

4 This is almost a straight transfer of the fugal theme. The
change to minor mode does not seem to weaken it in any way.
(See Ex 26.). BWV 21, 541

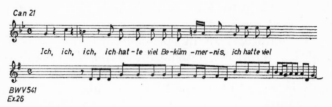

5 This is thought to be the first instance of a deliberate
borrowing from a Trio sonata. The Aria is an interesting
one as Bach utilises the top line for the voice part and the
bass of the organ work as his continuo. (See Ex. 27.).
 BWV 166, 584

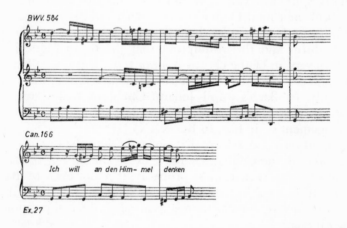

6 Parry dismisses Cantata No. 87 in a very few words. He
says that it has some beautiful qualities and is probably a late
revision of an early work. Although Schmieder dates it as 1735
Dürr redates it as 1725. The A minor fugal theme which
Bach incorporates into the first (Bass) aria is from Bk. 1. of the
'48' and, therefore, written prior to 1722 – possibly as early
as 1707 or 8.
Schweitzer includes the work amongst 'the Cantatas after

1734' and says of the Bass aria merely that it is as effective as it is simple.

There can be no two opinions as to the effectiveness of incorporating an organ or clavier fugue (written nearly 20 years previously) into the accompaniment of an aria but neither the operation nor its effect can really be described as 'simple'

BWV 87, 86₅

7 It is a far cry from the Sarabande of a clavier Suite to a slumber song in an Oratorio. One is tempted to wonder if Bach consciously remembered the theme of the Sarabande 12 years later or whether the extremely close resemblance was purely coincidental – unconscious or subconscious in fact! (See Ex. 28.). BWV 248, 806

Ex.28

8 The tune of the Aria in the Goldberg Variations of 1742 is derived from or based upon an Aria which appeared in Anna Magdalena's 2nd notebook of 1725.

We cannot be quite certain of the order of borrowing here. It is known that Bach used a couple of popular song tunes in the Quodlibet of the Goldberg Variations – dated as approx. 1742. Dürr dates Cantata 212 as 1742 also. One must assume that Bach borrowed from his Quodlibet for this Recitative in the secular cantata but without being 100% sure that the borrow was that way round; ie. it is just within the bounds of possibility that he took the song 'Ich bin so lang nicht bei' for the Peasant Cantata and borrowed from that for his Quodlibet. BWV 212, 988

9 Whittaker is of the opinion that some of the demisemiquaver flourishes in the very difficult solo line are more instrumental than vocal and wonders if the aria is borrowed from an instrumental work. In his *Bach in Köthen* Friedrich

Smend touches on the possibility of it having originated as the slow movement, (Adagio) of a now last violin concerto of about 1720. (See Ex. 29.). BWV 120

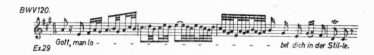

10 Schweitzer reminds us that the old view that Bach wrote the eight organ Cantatas to show off the new Rückpositiv of St. Thomas's organ in 1730 was proved to be wrong by B. F. Richter in the Bachjahrbuch in 1908. He points out that if Richter's chronology is correct Cantata 188 was performed in St. Nicholas's church and that the object of writing or assembling the work was to give the organist, Johann Schneider, an opportunity of showing what he could do!

Parry, on the other hand, says that Bach 'seems to be gladly availing himself of alterations which had been made in the organ at St. Thomas's in 1730 or so'.

Dürr, however, redates the work as about 1728 i.e. two years prior to the spending of 50 thalers on cleaning and revoicing the St. Thomas's organ.

Schweitzer goes on to mention that the eight Cantatas contain many movements taken from instrumental works, most being derived from clavier concertos. BWV 188

11 A point of interest is the use of the bass of 'A General Lamentation by Friends'. (See Ex. 30.).

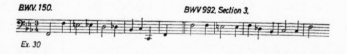

Further references to this theme and its derivatives will be made during the course of this book. BWV 150, 992

CHAPTER IV

TABLE IV. SOLO INSTRUMENT (NON-KEYBOARD) TO CANTATA

NOTES ON TABLE IV.

The smallest group so far.

TABLE IV

FROM SOLO INSTRUMENT (NON-KEYBOARD) TO CANTATA

Source	New Version &/or Position
1 Prelude to 3rd Partita in E for solo violin. BWV 1006. Dated 1720.	(i) Sinfonia in D to Ratswahl Cantata 29. 'Wir danken dir, Gott'. Dated 1731 and (ii) Sinfonia to Part II of Cantata 120a. 'Herr Gott, Beherrscher aller Dinge'. Dated either 1728 or between 1732 and 33.
2 Solo violin sonata?	Violin obbligato to Tenor Aria (No. 4) Ich traue seiner Gnaden in Cantata No. 97. 'In allen meinen Taten'. 1734.

NOTES ON TABLE IV

1 i. In this version (BWV 29) Bach has transferred the solo violin part to an obbligato organ, added a bass line, re-

arranged certain note groups which did not transfer com-
fortably to the keyboard, added an orchestral accompaniment
consisting of two oboes, three trumpets and timpani plus the
usual strings and transposed the whole down a tone into the
key of D. So much for Forkel, who in his work on Bach said:—
'. . . . he has combined in a single part all the notes required
so that a second part is neither necessary nor possible'.
How very fond J. S. B. was of achieving the impossible!
ii: BWV 120a is a straight transfer of the other cantata (No. 29)
material with no further rearrangement. BWV 29, 120a, 1003

2 This is one of the most elaborate and carefully bowed of
all violin obbligati. It is very easy to imagine it to be an
adaptation of a movement from a solo sonata. BWV 97

CHAPTER V

TABLE V

FROM CHAMBER MUSIC TO CANTATA

Source	*New Version &/or Position*
1 Chamber music movement.	Sinfonia of Cantata No. 18. 'Gleich wie der Regen'. Sexagesima 1713/4.
2 Sonata for viola da gamba and clavier.	Alto Aria (No. 3). Willkommen! will ich sagen in Cantata No. 27. 'Wer weiss, wie nahe mir mein Ende'. 16th Sunday after Trinity, 1731. Dürr, 1726.
3 Sonata for violin and clavier.	Tenor Aria (No. 3). Halleluja, Stärk, und Macht in Cantata No. 29 .'Wir danken dir'. 27 Aug. 1731.
4 Sonata or Concerto for two violins.	Alto Aria (No. 2). Wo Zwei und Drei versammlet sind in Cantata No. 42. 'Am Abend aber desselbigen Sabbats'. 1st Sunday after Easter, 1731. Dürr, 1725.
5 'Cantabile ma un poco Adagio' from Sonata No. 6 in G for violin and clavier. BWV 1019a. Dated 1720(?).	Soprano Aria (No. 4). Heil und segen in Cantata No. 120. 'Gott, man lobet dich in der Stille'. 1728/30.

c

6 Lost instrumental work.	First Chor Nach dir, Herr in Cantata No. 150. 'Nach dir, Herr, verlanget mich'. Weimar. (1712).
7 Sonata No. 2 in A for violin and clavier. BWV 1015. Dated 1720.	Alto Aria (No. 4). Jesu, lass mich finden in Cantata No. 154. 'Mein Liebster Jesus ist verloren'. 1st Sunday after Epiphany, 4 Jan. 1724.
8 Siciliano of Sonata No. 4 in C minor for violin and clavier. BWV 1017. Dated 1720.	Alto Aria (No. 47). Erbarme dich in Matthew Passion. BWV 244. Dated 1728/9.

NOTES ON TABLE V

1 The Sinfonia is scored for two recorders, four violas, bassoon and cello continuo. Does this suggest an even earlier origin—possibly chamber music in type? BWV 18

2 Whittaker thinks that the Alto aria is adapted from a viola da gamba and clavier sonata movement. On the other hand Spitta feels that it is original. BWV 27

3 This whole Cantata is one grand borrow! Other movements and aspects will be dealt with in their appropriate chapters. This Aria runs for 232 bars – this, in itself, seems to suggest an instrumental origin and the very opening bars of the voice part strengthen this feeling. BWV 29

4 Whittaker is of the opinion that the Aria may be an adaptation of the slow movement of a sonata or Concerto.
 BWV 42

5 This also, like so many Ratswahl Cantatas, is made up of movements collected together for the occasion and there can be no doubts as to the origin of this particular Aria.
(See Ex. 31.). BWV 120, 1019a

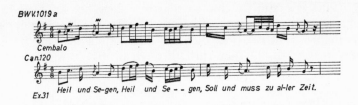

Ex.31

6 Here, again, I must quote Spitta in full. Regarding the end of this 1st chorus he says:— 'The polyphonic treatment is very rich and skilful; the two violins are always, and the fagotto very frequently, obbligato. If any further evidence for the thoroughly instrumental origin of this first choral were required it would be found in the fact that Bach used the idea created here again in his Toccata in F sharp minor for clavier'. (See Ex. 32.). BWV 150

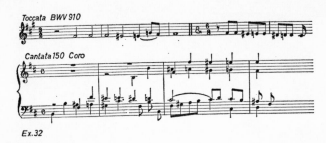

Ex.32

7 Spitta sees a resemblance between the semiquavers of the sonata and the instrumental introduction to the Aria. One must admit that certain notes are identical but is it a conscious borrowing or is the resemblance merely coincidental? I must confess to inclining strongly towards the latter view. (See Ex. 33.). BWV 154, 1015

Ex.33

8 This is a similar case in that one does not know if the likeness is by accident or design. Did the mood engendered by the words of Erbarme dich put Bach into a *Siciliano* frame of mind and did he then riffle through all his old MS until he found something vaguely suitable? (See Ex. 34.). BWV 244, 1017

Ex. 34

CHAPTER VI

TABLE VI

FROM CONCERTO OR CONCERTO GROSSO TO CANTATA

Source	New Version &/or Position
1 Concerto Grosso(?).	Cantata No. 7 'Christ unser Herr zum Jordan kam, for John the Baptist 1735-44. Dürr 1724.
2 Siciliano from now lost violin work.	Soprano Aria (No. 5) Gedenk' an uns mit deiner Liebe in Cantata No. 29. 'Wir danken dir, Gott, wir danken dir'. 1731.
3 Instrumental Concerto(?).	Sinfonia to Cantata No. 42. 'Am Abend aber desselbigen Sabbats'. 1st Sunday after Easter, 1731. Dürr, 1725.
4 1st movement of Brandenburg Concerto No. 1 in F. BWV 1046. Dated 1717/8.	1st movement (Sinfonia) in Cantata No. 52. 'Falsche Welt, dir trau' ich nicht'. 23rd Sunday after Trinity, 1730. Dürr, 1726.
5 3rd Movement (Allegro) and Trio II of Brandenburg No. 1.	(i) 1st Chorus, Vereinigte Zwietracht in Cantata No. 207 (Dramma per Musica) (same title). 11 Dec. 1726. (ii) Ritornello (No. 7) in same work.

6 Lost instrumental Concerto.	Cum Sancto Spiritu in Mass in B minor. BWV 232. 1733.
7 Two movements from lost violin(?) Concerto.	(i) Alto Aria (No. 1) Erfreute Zeit. (ii) Tenor Aria (No. 3) Eile, eile in Cantata No. 83 'Erfreute Zeit im neuen Bunde'. 2 Feb. 1724.
8 1st Movement of Brandenburg Concerto No. 3 in G. BWV 1048. Dated 1718/9.	Sinfonia to Cantata No. 174. 'Ich liebe den Höchsten von ganzem Gemüte'. 2nd day of Whitsun, 1729.
9 Two movements (Allegro and Adagio) from Concerto for violin &/or clavier in D minor. BWV 1052 and 1052a. Dated (Vln) 1720(?). (Clav.) 1730/33.	(i) Introduction. (ii) Chor (No. 2) Wir müssen durch viel Trübsal in Cantata No. 146 (same name). 3rd Sunday after Easter. 'about' 1740.
10 Allegro from above.	Introduction to Cantata No. 188. 'Ich habe meine Zuversicht'. 21st Sunday after Trinity. 14 Oct. 1731 or 29 Oct. 1730. Dürr, 'about' 1728.
11 1st Movement and Siciliano from clavier concerto No. 2 in E. BWV 1053. Dated 1730/33.	Sinfonia and Alto Aria (No. 5). Stirb in mir in Cantata 169. 'Gott soll allein mein Herze haben'. 18th Sunday after Trinity, 1731/2. Dürr, 1726.
12 3rd Movement from above.	Sinfonia to Cantata No. 49. 'Ich geh' und suche mit Verlangen'. 20th Sunday after Trinity, 1731. Dürr, 1726.
13 Movement from lost Concerto for two violins.	Choral (No. 4) Nun lob, mein Seel, den Herren in Cantata No. 51 'Jauchzet Gott in allen Landen'. 15th Sunday after Trinity, 1731/2. Dürr, 1730.

14 Largo from Concerto for violin &/or clavier No. 5 in F minor. BWV 1056. Dated (Vln.) 1720(?). (Clav.) 1730/33.	Sinfonia (Adagio) in Cantata No. 156 'Ich steh' mit einem Fuss im Grabe'. 3rd Sunday in Epiphany, 1729/30.
15 Unfinished clavier Concerto in D minor. BWV 1059. Dated about 1730.	Sinfonia in Cantata No. 35. 'Geist und Seele wird verwirret'. 12th Sunday after Trinity, 1731. Dürr, 1726.
16 Instrumental Concerto(?).	First three items in Easter Oratorio. BWV 249. 1736(?) for Easter, 6 Apr. 1738. Dürr, 1725.
17 Violin Concerto in C.	Soprano & Bass Duet (Final) Ich hab' vor mir ein' schwere Reis' in Cantata No. 58 'Ach Gott, wie manches Herzeleid' Circumcision, 4 Jan. 1733. Dürr, 5 Jan. 1727.
18 Movement from a Concerto for oboe(?).	Bass Aria (No. 6) Nun, du wirst mein Gewissen stillen in Cantata No. 78. 'Jesu, der du meine Seele'. 14th Sunday after Trinity, 1735-44. Dürr, 1724.

NOTES ON TABLE VI

1 Spitta is of the opinion that the cantata is, in fact, a concerto grosso; the concertino consists of a violin and two oboi d'amore and the ripieno, the tutti violins, violas and bass with organ. Can it be that this is taken or derived from an early concerted work? BWV 7

2 Is this aria based on yet another Siciliano from a lost work? It was a form which appealed to Bach very strongly. BWV 29

3 This cantata opens with a Sinfonia which is thought by Spitta to be in the form of a concerto first movement cleverly combined with the three-section aria which follows. It,

together with the opening of the Alto aria (No. 3), Wo Zwei und Drei versammlet sind, must have been adapted from a secular instrumental composition. BWV 42

4 This is a straight transfer. No change is made in the orchestration but ornaments (turns) implied (though not written) in the Brandenburg version are written out in full in the Cantata Sinfonia. BWV 52, 1046
See bars: — 5, 23, 51 and 76.

5 i. This is a very different matter from item I. The Allegro itself is an after-thought (although not a borrowing) and was added to Brandenburg No. I. about 1720. The work involved in adapting the now borrowed movement to Cantata use was enormous, although, perhaps, not quite as much as would be required in writing a completely new movement. 1) The two horns were changed to three trumpets; 2) two timpani (as almost always when three trumpets are involved) were added; 3) two transverse flutes (not recorders) reinforced the oboe d'amore parts; 4) a four-part chorus was added (some of the rather episodic material played by the piccolo-violin in the concerto was given to the chorus sopranos); 5) the whole movement was transferred into the key of D.
NB. The key of D usually means trumpets. Did Bach choose this key because he wanted to use trumpets or did he have to change to trumpets because he wanted a work in D?
ii. Trio II also underwent a major change. Readers will remember that in its concerto form it is for two horns accompanied by three oboes in unison. Now it is written for two trumpets, the accompaniment is for two oboes d'amore and a taille in unison and strings are added in the last four bars of each section. Needless to say, the whole movement is now in D. BWV 207, 1046

6 Tovey, in his *Essays in Musical Analysis* (part V (1937)) says: — 'I am as sure as I can be of anything that this is an arrangement of a lost work and that voices have been adapted to its opening ritornello' He does not say whether the lost work was concerto or orchestral – on the contrary, he refers

to 'the unknown original chorus' which suggests that the lost work was a Cantata.

Friedrich Smend makes a masterly analysis of the Mass in the *Kritischer Bericht* published by Bärenreiter in 1956 and, in it, gives a chart setting out the various sources from which certain movements in the Mass are derived. He mentions a lost instrumental concerto dating from 1717 – 23 (ie. the Cöthen period) as the origin of the Gloria but does not mention anything similar for the Cum sancto spiritu. On the other hand Tovey, in his turn, does not suggest an instrumental origin for the Gloria. BWV 232

7 The accompaniment to the Alto aria, Erfreute Zeit, requires 2 oboes, 2 horns (very high), an obbligato violin and the usual strings. This obbligato violin part is the solo of the original concerto and is almost unchanged – the accompaniment would, of course, have been for strings and the wind parts were added at the time of the adaptation. The passages involving stopped and open D, A and E strings prove that even the key of the original is also unchanged – these open strings would not be available in other keys – say E or G – and the passages would have to be changed quite drastically.

The finale of the concerto provided the basis of the Tenor aria. The obbligato violin is almost a moto perpetuo in triplets and ornaments the orchestral 1st violins to a great extent. Every now and again the upper strings stop playing and the Tenor is left with continuo accompaniment only. Whittaker says of these phrases that the Tenor has deprived the solo violin of its original matter.

Spitta is of the opinion that the Cantata does not contain adapted matter and thinks that just as Cantata 194 is in the form of an orchestral Suite so this Cantata has assumed the form of a complete Italian concerto! The phrase wherein the Tenor tries to imitate a solo violin on the word 'Freu' and, at the end of this long passage, discovers that he is left with 'digkeit' which he has to pop in as unobtrusively as possible on two repeated A's prove this theory to be incorrect. Details such as this point unmistakably to an adaptation. BWV 83

8 This is a truly magnificent example of Bach's contrapuntal

genius. Not being content with the nine string parts (in addition to the continuo) of the concerto version he now adds five more parts, two corni da caccia, two oboes and taille plus a bassoon to reinforce the bass of the continuo. The corni da caccia parts are very nearly the highest in existence – the first player goes to top A (sounded pitch)!

Although Schmieder dates it as 1729 Spitta suggests either 14th May, 1731, or 2nd June, 1732. Dürr confirms 1729.

BWV 174, 1048

9 The D minor clavier concerto itself probably began life as a violin concerto, written possibly, around 1720 – the period of Bach's greatest interest in the violin. Schmieder says of 146 that its authenticity is doubtful and Whittaker says that it has been attributed to Carl Philip but that 'the spaciousness of the alto aria (No. 3) and the soprano aria (No. 5) points more to the hand and heart of the father in his later days'.

The transfer of the Allegro of the concerto in its clavier form to cantata use involved allotting the solo line to an obbligato organ. The Adagio was a different proposition. The original accompaniment is practically unchanged. The solo line is given to the obbligato organ (so much more satisfactory as a sustaining instrument than the harpsichord) and a beautiful 4-part chorus is added. These new parts are partly independent and partly ornamented versions of the accompanying lines. Whittaker describes this adaptation as a remarkable one and considers that it has produced one of the most deeply moving numbers in the cantata. He goes on to say that the Tenor and Bass Duetto (No. 7), Wie will ich mich freuen, also is possibly an adaptation of an instrumental number. (See Ex. 35.).

Ex.35

Professor Thurston Dart has suggested that not one single clavier concerto which began life as a concerto for a different instrument and of which, therefore, the clavier work is an

adaptation, is by J. S. Bach. This, of course, is quite possible but it is hard to believe that he would have lavished such loving care on someone else's slow movements as he did for Cantatas 146 and 156. The chorus in 146 and the Sinfonia to 156 are amongst his most treasured gems. Would he have done so much with them if he had not adapted them for clavier in the first instance? BWV 146, 1052, 1052a

10 Our old friend the D minor concerto turns up again, but this time it is transposed into C minor. Spitta says: — 'The fact that the whole concerto is placed at the beginning reveals an intention of letting the congregation hear to full advantage the improvement in the organ'. (In 1730 the Rückpositiv of St. Thomas' organ was fitted with its own manual and so could be used independently of the great organ) and goes on to say: — 'The upper part is taken down an octave, but is not otherwise altered from the original form of the clavier concerto as it is given in BG XVII. We may suppose that this older form lay at the root of the re-arrangement for the cantata since there is too much in it which is properly suited only to the clavier'.
Spitta thinks that the whole of the D minor concerto was played before the cantata and that Bach indicated this should be done on a later occasion. It is interesting to note that Scheyer attributed parts of the cantata to Wilhelm Friedemann. Dürr dates 188 as 'about' 1728. BWV 188, 1052, 1052a

11 & 12 The clavier concerto No. 2 in E undoubtedly began life as a violin concerto – probably in D as all the solo material suits the stringed instrument perfectly in that key. The material has had an adventurous career. The solo material must in the first instance, have been adapted for clavier – perhaps about 1720. The first movement was then re-adapted as Sinfonia to Cantata 169 in 1726. The slow movement became the aria No. 5 in the same cantata and ten weeks later the finale found itself in cantata 49 in E and with an oboe d'amore added to the obbligato organ. At a still later date, Bach seems to have made a fresh clavier arrangement based on the cantata material and there is a very early version of the Siciliano for solo harpsichord.
Dürr dates both 169 and 49 as 1726.

Whittaker is of the opinion that the single organ manual
accompaniment to alto aria (No. 3), Gott soll allein, was
undoubtedly derived from some lost instrumental work and
suggests the possibility of an andante for clavier. He says:
'. . . one can never forget that one is listening to an arrange-
ment'. The freedom of the obbligato organ in the Bass aria
(No. 2), Ich geh' und suche, suggests that it comes from a lost
keyboard work and some of the material in the soprano and
Bass duet (No. 6), Wie bin ich doch so herzlich froh, seems to
be derived from an instrumental work. BWV 49, 169, 1053

13 It is thought that this choral fantasia is based on, or began
its life as, a work or movement from such a work for two
violins. BWV 51

14 One is surprised to read Spitta's suggestion that cantata
156 opens with a Sinfonia in the style of 'the first adagio of a
chamber sonata'. In fact it opens with an adaptation of the
slow movement of the F minor concerto. Incidentally the
oboe (cantata) version is much more satisfactory than the
harpsichord's in spite of the latter's ornamentations.
(See Ex. 36.). BWV 156, 1056

15 The Sinfonias to Parts I and II are the 1st and 3rd
movements of a (lost) concerto; the alto aria (No. 2), Geist
und Seele, may have come from the concerto's 2nd movement
– an Adagio Siciliano. The unfinished original (if the clavier
form was the original) exists only as a 9-bar fragment and is
for 'cembalo solo, una oboe, due violini viola e continuo'.
For its transfer to Cantata 34 it was arranged for organ
obbligato with 2 oboes and taille, 2 violins, viola and continuo.
Dürr dates the cantata as 1726. This suggests that if the lost
concerto is correctly dated as 1730 what Bach borrowed from

must have been a still earlier, possibly violin, version. Was this the original dating, perhaps, from Cöthen?
Whittaker thinks that the whole work is one large adaptation.
The alto aria (No. 2) is a *Siciliano* derived from an early violin work.
Alto aria (No. 4) with organ obbligato, comes, probably, from a cello or gamba sonata.
Alto aria (No. 7) is the finale of yet another lost violin concerto.
It is interesting to note that the cantata had no final chorale and that while it opened in D, it ends in C. BWV 35, 1059

16 Schmieder is of the opinion that the first two movements are the opening and closing movements of an instrumental concerto and that the Duet (No. 3) constitutes the slow movement. Spitta, too, thinks that the first two movements of the Sinfonia together with the duet, make a complete instrumental concerto and Forkel says: — 'In his (Bach's) day it was usual to play a concerto or instrumental Solo during the Communion Office. Bach composed many of these pieces himself'. Schweitzer, however, has this to say in reply: — 'Forkel has a notable passage to the effect that Bach had instrumental soli played during Communion and wrote most of them himself. The theory is only mentioned here to be scouted. It is pure conjecture of Forkel's who confesses that he knew hardly anything of the instrumental works'. Schweitzer goes on to observe that the Largo from the Concerto for two violins could have been so used.
On the other hand it is of interest to note that Bach himself wrote '*Concerto da Chiesa*' on the original MS of Cantata No. 42. We know, of course, that in Italy instrumental church music had been written for very many years – the *Sonate da Chiesa* of Corelli provide very good examples. BWV 249

17 Whittaker points to the strong resemblance between the character of this duet and the E major violin concerto – the first 3 notes are the same – and suggests that Bach must have adopted the same method of construction as in the last movement of cantata 49 i.e. fitted a choral and bass to some existing instrumental concerto movement. Much of the passage work is violinistic. (See Ex. 37.). BWV 58

Can.58

Ex.37

18 It has been suggested by Whittaker that this aria may
have been adapted from an oboe concerto. It is thought that
the music has little connection with the text which is crudely
written. Great prominence is given to the oboe, and the string
material and treatment are commonplace. There is a possi-
bility that the voice and continuo represent a well-developed
tutti and the oboe obbligato the original oboe solo. BWV 78

CHAPTER VII

TABLE VII. SUITE OR ORCHESTRAL WORK (OTHER THAN BRANDENBURG CONCERTOS) TO CANTATA

NOTES ON TABLE VII.

TABLE VII

FROM SUITE OR ORCHESTRAL WORK (OTHER THAN BRANDENBURG CONCERTOS) TO CANTATA

Source	New Version &/or Position
1 Lost Orchestral Suite(?).	Cantata No. 97. 'In allen meinen Taten'. 4th Sunday after Easter, 1734.
2 Overture to Suite No. 4 in D. BWV 1068. Dated 1717-23 or 1727-36.	Introduction and Chorus in Cantata No. 110 'Unser Mund sei voll Lachens'. 1st Day of Christmas, 1734 or earlier. Dürr, 1725.
3 Early Instrumental work(?).	Cantata No. 170 'Vergnügte Ruh', beliebte Seelenlust'. 6th Sunday after Trinity, 1731 or 32. Dürr, 1726.
4 Lost Orchestral Suite.	Cantata No. 194. 'Höchsterwünschtes Freudenfest'. For dedication of new organ at Störmthal. 2 Nov. 1723.

5 Early Instrumental work(?).	Et resurrexit in Mass in B minor. BWV 232. Dated 1733.
6 Suite(?).	Final Chor. Guter Hirte, Trost der Deinen in Cantata No. 184. 'Erwünschtes Freudenlicht'. Dated 1724 or 31. Dürr – the former.
7 Bourree from an Orchestral Suite.	Soprano Aria (No. 6). So schau' dies holden Tages Licht in Cantata No. 173a. 'Durchlaucht' ster Leopold'. 1717.

NOTES ON TABLE VII

1 Whittaker says of the first movement of Cantata No. 97 that: – 'It almost looks as if Bach had here adapted the first movement of some now-lost Orchestral Suite, working the Choral into the Vivace section and leaving out the reprise of the Grave'. He points out that the movement contains Trios for two oboes and bassoon such as are found in the Suites. One cannot, of course, be sure of this borrowing but it is a possibility. BWV 97

2 It is assumed that Suites I and II were written during the Cöthen period but some musicologists wonder if the others were written then or later in Leipzig. Martin Bernstein submitted a paper to the International Musicological Society meeting in New York in 1961 in which he proposed that the 1st Suite was composed by Fasch. Also he cast doubts on the date of No. 2 on the grounds that the music was too difficult for the Cöthen flautist and considered it far more probable that it was written for the French player, Buffardin, who was employed at the Dresden court. The latter school of thought is elastic in its dates, giving 1727 – 36 as a possible period. The fact that the 1st movement of No. 4 was used in a Cantata originally dated 1734 or earlier should help to narrow the gap

by a few years – especially as Dürr re-dates the Cantata in question (No. 110) as 1725!

Bach does little to the orchestra in this arrangement – he merely adds two transverse flutes to double the oboes so far as the slow opening and closing sections are concerned. He goes to town, as it were, in the central Allegro. Here he adds a splendidly rousing four-part chorus.

Whittaker makes an extraordinary statement in connection with this transfer. 'The effect is magnificent. As with the rescoring of the first movement of the third Brandenburg Concerto in Cantata 174, so much is added by the reconstruction that one feels no desire to hear the music again in its original form'.

One might just as well say that having heard Weingartner's arrangement of Beethoven's Grosse Fuge (Op. 113) for string orchestra one would never wish to hear it played again as a string quartet. BWV 110, 1068

3 Steinitz thinks that it is probable that some at least of this Cantata uses material borrowed from earlier instrumental works. BWV 170

4 This cantata contains at least four movements which are, quite obviously, derived from an orchestral suite. These are the Overture, a Gavotte en Rondeau, Minuet, and Gigue en Rondeau. The Sinfonia and 1st chorus of the cantata are very similar in style to the Introduction, a quick fugal section with 4-part chorus and then a return to the opening. The Gavotte became a long and rather involved aria for soprano.

The Gigue material was used for a bass aria – very high and tiring to the voice.

The Minuet provided the ground work for a delightful duet for soprano and bass. BWV 194

5 Tovey considers that Et resurrexit is an adaptation for in his *Essays in Musical Analysis*, (Pt V) he says: — '. . . I believe he (Schweitzer) would readily entertain the supposition that there is a lost original work behind the chorus which, perhaps, was originally much more formal than it appears

now'. Smend, too, in his *Kritischer Bericht* on the Mass
gives a lost instrumental concerto of the 1717 – 1723 period as
its source. BWV 232

6 It is difficult to say whether this Chor is adapted from an
instrumental movement or is merely written in instrumental
style. Spitta says: — 'At the same time there can be no doubt
of the fact that it is a remodelling of a secular cantata. Not a
trace of the original remains'. He goes on to point out that this
is evident from the popular dance-like character of the duet
and still more from the gavotte measure of the final chor.
Schweitzer, on the other hand, contradicts Spitta and main-
tains that he was wrong to assume that the cheerful character
of the cantata shows it to be an arrangement of a secular work.
Parry comments on its 'singularly cheerful vein even
secular in style' and continues with the remark: — ' the
last movement of this cantata, oddly enough for a sacred work,
is in gavotte rhythm and on the lines of a gavotte with an
alternative quasi-trio'.
Terry separates Cantata 184 (sacred) from Cantata 184 (secu-
lar) and says: — 'The Cantata in its 1724 form perhaps was a
secular work'. He assumes 1731 to be the correct date for the
sacred version and attempts to prove his assumption in these
words: — 'Spitta dates it vaguely as 1724 or later. Its date is
established by the printed '*Text zur Leipziger Kirchen-Musik
auf die heiligen Pfingst Feyertage und das Fest der H. H.
Dreyfaltigkeit Anno 1731*' in the Leipzig Stadbibliothek'.
Dürr, however, gives Whit-Tuesday 1724 as the performance
date. BWV 184

7 Schweitzer believes Cantata 173a itself to be an adaptation
as well as the source of Cantata 173. He points out that the
declamation is so curious it leads us to believe that originally
the music was written for a different text and goes on to say
'In order that the charming music might not be wasted he
used it for the church Cantata 173' and observes that the aria
Es dünket mich, ich seh dich kommen in Cantata 175 also
comes from 173a.
Spitta, too, mentions that the composer thought it a pity to

leave 'this noble music' wedded to its text and so made use of it for the Whitsun Cantata 173.

Parry thinks that the Cantata can be compared with some of the duties Bach carried out in Cöthen – that is the composition of secular and instrumental works. He says: — 'Then come features which are interesting from the point of view of the special line of work which occupied him while he was at Cöthen. (It includes) a very lively aria in dance rhythm, after the manner of a bourrée the texture and treatment of details being essentially in the manner Bach adopted in the lighter movements of his Suites and Overtures'.

This does not, of course, prove that the aria is actually derived from a Suite or similar work but underlines the possibility of such an adaptation having taken place. BWV 173, 173a

CHAPTER VIII

TABLE VIII

FROM ORCHESTRAL WORK, INSTRUMENTAL CONCERTO OR CANTATA TO CONCERTO OR ORCHESTRAL WORK

Source	*New Version &/or Position*
1 Concerto No. 1 in A minor for violin. BWV 1041. Dated 1720.	Concerto No. 7 in G minor for clavier. BWV 1058. Dated 1730-33.
2 Concerto No. 2 in E for violin. BWV 1042. Dated 1720.	Concerto No. 3 in D for clavier. BWV 1054. Dated 1730-33.
3 Brandenburg Concerto No. 4 in G. BWV 1049. Dated 1719-20.	Concerto No. 6 in F for clavier. BWV 1057. Dated 1730-33.
4 Concerto in G minor for violin. BWV 1056a. Dated 1720 (?).	Concerto No. 5 in F minor for clavier. BWV 1056. Dated 1730-33.
5 (i) Early Orchestral Work. Dated prior to 1717. (ii) Sinfonia in F. BWV 1071. Dated 1730.	Brandenburg Concerto No. 1 in F. BWV 1046. Dated 1718.

6 Concerto in D minor for two violins. BWV 1043. Dated 1720.

Concerto in C minor for two claviers. BWV 1062. Dated 1736.

7 Sinfonia of Cantata (now lost).

Concerto in D for violin (unfinished). BWV 1045. Dated 1720(?).

8 Concerto for violin (now lost).

Concerto No. 1 in D minor for clavier. BWV 1052 and 1052a.

9 Concerto for violin (now lost). (Tovey's oboe d'amore).

Concerto No. 4 in A for clavier. BWV 1055.

10 Concerto for violin (now lost).

Concerto No. 2 in E for clavier. BWV 1053.

NOTES ON TABLE VIII

Soon after the death of Johann Sebastian his library was divided, some manuscripts went to Carl Philip and some to Wilhelm Friedemann. Carl Philip treasured his and amongst those which have survived are the concertos in E, A minor and the Double in D minor (parts, not the score). Wilhelm Friedemann, however, was not so careful and the share of his father's library which he inherited was soon lost to the world. This share included violin works, two for one violin and one for two which have come down to us only in their keyboard arrangements.

It was Bach's usual custom to lower the pitch of his violin to clavier arrangement by a tone – see, for example, the A minor violin to G minor clavier; the E major violin to D major clavier; the G minor violin to F minor clavier; the G Brandenburg to F clavier; the E major Partita to D major for organ, etc. This custom was not, however, inevitable as will be seen in certain instances.

1 A minor to G minor. It is assumed that Bach arranged so many of his earlier works for clavier in order to provide

concertos or concerto-type works for Carl Philip Emanuel around the period 1730 – 33.

The A minor violin is as full of 'fiddle' tricks or idioms as is the E major Prelude of the 3rd solo Partita (BWV 1006) and as difficult to transfer to a keyboard successfully. Fast moving or florid movements are easier than the slow which point out the harpsichord's lack of sostenuto quite unmercifully.

Schweitzer says of these transfers to clavier: — 'The arrangements are often made with quite incredible haste and carelessness violin effects to which he could easily have given a pianistic turn are not re-modelled at all'.　　BWV 1041, 1058

2　This, again, is a real string concerto and, one must admit, sounds, as does the A minor, much better in its original setting than in its clavier arrangement.　　BWV 1042, 1054

3　If for no other reason this transfer to clavier is most useful as it provides a wonderful demonstration of Bach's theories on ornamentation. Ex. 38 shows what he did with one section of the slow movement.

It is very probable, although he does not state traversière specifically, that Bach intended the cross flute here – the recorder had been almost outdated by the 1730s. (See Ex. 38.).　　BWV 1049, 1057

Ex 38

4　The lost(?) G minor violin concerto has been reconstructed by Josef Szigeti. Just as the A minor and E major seem a little odd when played on a keyboard instrument because we are more used to the string version so this concerto sounds equally odd when played on the violin because we know the keyboard version better but there is no doubt that the slow movement sounds much happier on the stringed instrument.　　BWV 1056 1056a

5　There can be no doubt that the Brandenburg Concerto

No. 1 as we know it today is a revision or refurbishing of an earlier work. This early version is assumed to have consisted of the opening quick movement, a slow movement and a Minuet with two Trios. There was no 6/8 Allegro, no Polacca or concertino and no violino-piccolo. These movements and the extra instrument were added when Bach was making his fair copy for the Duke of Brandenburg. The similarity between the chordal style of the new Allegro and the solo sonatas written in 1720 suggests that the 6/8 movement dates from about that year.

The closing of a concerto by a Minuet and Trio(s) is, however, so extremely unlikely that I am sure this early version (if it really existed) must, itself, have had an even earlier original. This would have been a normal, three-movement, (quick – slow – quick) Italian-style concerto. At some time Bach must have substituted the Minuet and two Trios for the more usual Finale – possibly replacing a lost movement by something taken from a Suite of dance-type movements in order to perform the otherwise incomplete work at short notice.

<div align="right">BWV 1046, 1071</div>

6 This work suffers badly from its transfer. The glorious cantilena of the slow movement is quite lost on the keyboards. No amount of ornamentation or filigree work can disguise their complete lack of sostenuto. BWV 1043, 1062

7 The composition of the accompaniment is in itself enough to prove that this concerto must have originated as an orchestral work. Two oboes, three trumpets, strings, timpani and continuo represent forces which we would expect to see used in a concerto accompaniment 50 or more years later.

It is known that Bach added instruments to his normal string accompaniment when adapting from solo concerto to Cantata Sinfonia or Aria – see, for example, the Alto aria, Erfreute Zeit, in Cantata No. 83. In the present case it looks as though the 50 bars of the existing fragment represent a short-score version of a movement similar to Brandenburg No. 1, i.e. written for a large instrumental group which includes an obbligato – almost concertante – violin. Remember that the Brandenburg movement was turned into a Cantata Sinfonia

(No. 52) and there is no reason to suppose that the same type
of treatment was not employed in this instance. BWV 1045

8 Several wizards of the violin have attempted the task of
reconstructing the lost violin(?) original of this concerto. One,
fairly well known, is by David; another, much more recent,
is by Szigeti.

Bach must have liked the work, for, as we saw in Chapter VI,
he readapted the clavier version for organ, transposed the
whole into C minor and made it the Sinfonia to Cantata 188.
A point of interest arises here. If a reconstructor decided that
the violin original was a tone higher than its keyboard adapta-
tion should he put it in E minor (a tone above the harpsichord
version) or in D minor – a tone above the organ cantata?

Dr Paul Hirsch's article in the *Jahrbuch* for 1929 provides
various clues to suggest that Bach's harpsichord version (BWV
1052) is derived from a violin original. This is confirmed by
Wilhelm Rust in his preface to BG XVII. Hirsch points out
also that the 'other' version – BWV 1052a – is, according to
Adolf Aber, most probably not by Bach. In addition he makes
quite clear that the 'original' violin version was derived from
an earlier work not of Bach's composition. That source will be
considered in the appropriate chapter in Pt. 11.

Hirsch sums up the situation in these words: — 'Since, how-
ever, they (BWV 1052 and 1052a) are all arrangements of a
violin concerto and since, as will be shown hereafter. the
original was not a violin concerto, it is very probable that the
Bach harpsichord version (1052) and the 'other' version
(1052a) had one and the same violin arrangement of the
concerto as their forerunner'.

Aber considers that the 'other' version may have been by
C. P. E. Bach. BWV 1052, 1052a

9 Professor Donald Tovey is convinced that the original
version of this work was not for violin but for oboe d'amore
and his reconstruction for that instrument has been played by
Leon Goossens. BWV 1055

10 W. Gillies Whittaker and Schweitzer are of the opinion
that this concerto began life as one for violin.

(Whittaker – ' . . . the E major clavier Concerto, originally for violin').

(Schweitzer – ' . . . the majority of the seven clavier Concertos are not primarily planned for the clavier – almost all are arrangements; six probably come from Violin Concertos').

Spitta, however, says: 'A fourth (concerto) in E major bears no undoubted signs which point to a Violin Concerto as its original, so that we must, for the present, assume it to have been originally written for the clavier'.

Wilhelm Rust, on the other hand, is of the opinion that the concerto is an adaptation of the Cantata! (Cantatas 169 and 49) (see chapter VI).

The problem of determining the key of the original Violin concerto (if it ever existed) is a difficult one. Assuming that, as usual, Bach dropped the keyboard version a tone below its original we would have a violin concerto in F sharp major – unthinkable! If, on this occasion, he kept to the original key, we should have then two violin concertos in E – possible but, I think, unlikely – especially as E is not the most comfortable of keys on a stringed instrument. I incline towards the theory that this is one case in which he reversed his usual procedure and that the original was a tone lower, ie. in D. I have prepared a reconstruction of the concerto and found the solo material to be more comfortably under the fingers in that key than in E or F. BWV 1053

CHAPTER IX

TABLE IX

FROM CANTATA OR ORATORIO TO CANTATA OR ORATORIO

Source	*New Version &/or Position*
1 Chorus (No. 1) in Cantata No. 2, 'Ach Gott, vom Himmel sieh darein'. 1735-44 or 1724. (Dürr, 1724).	Choral 'Ach Gott, vom Himmel sieh darein'. BWV 741.
2 Cantata No. 3 'Ach Gott, wie manches Herzeleid'. 1734-44(?). (Dürr, 1725).	Cantata No. 58 'Ach Gott, wie manches Herzeleid'. 4th Jan. 1733. (Dürr, 1727 and 1733 or 4).
3 Early work(?).	Sinfonia of Cantata No. 4 'Christ lag in Todesbanden'. 9th April, 1724. (Dürr, 1724 and 5).
4 Cantata No. 8 'Liebster Gott, wann werd' ich sterben'. (Dürr, 1724 and 1735-50).	Later version in E.
5 Alto Aria (No. 4) Ach, bleibe doch from Cantata No. 11 'Lobet Gott in seinen Reichen'. 1730-40. (Dürr, 1735).	Agnus Dei in Mass in B minor. BWV 232, dated 1733.

6 Cantata No. 12 'Weinen, Klagen'. 1714. (Dürr, 1724).

Cantata No. 12 'Weinen, Klagen'. 3rd Sunday after Easter. 30th April, 1724. (Dürr, 1724).

7 First Chor. of Cantata No. 12. 30th April, 1724.

Crucifixus in Mass in B minor. BWV 232.

8 Passacaglia Bass of First Chor. in Cantata No. 12. 22nd April, 1714.

First Chor. Jesu, der du meine Seele in Cantata No. 78 'Jesu, der du meine Seele'. 1735 – 44. (Dürr, 10th Sept. 1724).

9 Cantata No. 15 'Denn du wirst meine Seele nicht in der Hölle lassen'. 1st day of Easter, 1704. (Dürr, 1726).

Cantata No. 189 'Meine Seele rühmt und preist'. 1707 – 1710. (Dürr, 'Not by Bach).

10 Cantata No. 15.

Cantata No. 15 'Denn du wirst meine Seele nicht in der Hölle lassen'. 1735. (Dürr, 1726).

11 Opening Chorus Wer Dank opfert from Cantata No. 17 'Wer Dank opfert, der preiset mich'. 14th Sunday after Trinity, 1737 or 32. (Dürr, 1726).

Final Chorus Cum Sancto Spiritu in Mass in G. BWV 236. Written in 1737/8. (Dürr, 1735-50).

12 First Chor. Es erhub sich ein Streit from Cantata No. 19 (same title), Michaelmas, 1725/6. (Dürr, 1726).

Opening Chor. of the Gloria in Mass in F. BWV 233. 1737.

13 First Chorus O Ewigkeit, du Donnerwort from Cantata No. 20 'O Ewigkeit, du Donnerwort'. 1st Sunday after Trinity, 1723-27. (Dürr, 1724).

First Duet (Alto and Tenor) O Ewigkeit, du Donnerwort in Cantata No. 60 (same title). 29th Sunday after Trinity, 1732. (Dürr, 1723).

14 Cantata No. 21 'Ich hatte viel Bekümmernis'. 3rd Sunday after Trinity, 1714, or 'any festival'.

Cantata No. 21. (Dürr, 1723).

15 Final Chorus (No. 4) Christe, du Lamm Gottes from Cantata No. 23 'Du wahrer Gott und Davids Sohn'. 1723.

Choral (No. 52) Christe, du Lamm Gottes in John Passion. BWV 245. 1723 – revised 1727 and 1740. (Dürr, 1724, 25, 28/31 plus one before and another after 1742).

16 Choral (No. 4) Christe, du Lamm Gottes from Cantata No. 23. (Dürr says 1723 doubtful).

Choral (No. 52) In meines Herzens Grunde in John Passion. BWV 245.

17 First Chorus Nun lob, mein Seel, den Herren from Cantata No. 28 'Gottlob! Nun geht das Jahr zu Ende'. 1st Sunday after Christmas between 1723 and 27 or 1736. (Dürr, 1725).

Motette (a capella) 'Sei Lob und Preis mit Ehren'. BWV 231. Dated between 1723 and 27.

18 First Chorus Wir danken dir, Gott from Ratswahl Cantata No. 29 'Wir danken dir, Gott'. 1731.

(i) Gratias (No. 6). (ii) Dona Nobis Pacem (No. 25) in Mass in B minor. BWV 232.

19 Tenor Aria (No. 3) (in A) Halleluja, Stärk' und Macht in Cantata No. 29. 1731. (see 18).

Alto Aria (No. 7) (in D) Halleluja, Stärk' und Macht in Cantata No. 29.

20 Cantata No. 30a (Dramma per Musica) 'Angenehmes Wiederau'. 28 September, 1737.

Cantata No. 30 'Freue dich, erlöste Schar'. John the Baptist, 1738. (Dürr, 1735/50; ? before 1742).

21 Elster's Aria (Tenor) (No. 11) So wie ich die Tropfen solle from Cantata No. 30a. (see 20).

Soprano Aria (No. 8) Grosser Gönner, dein Vergnügen in Cantata No. 210 'O holder Tag, erwünschte Zeit'. 1734/5 or 40. (Dürr, 'in Bach's last years).

22 Cantata No. 31 'Der Himmel lacht'. Easter Sunday, 24th April, 1715. (Dürr, 1724(?) and 1731).

Revised throughout in 1731.

23 Cantata No. 34a 'O ewiges Feuer, o Ursprung der Liebe'. November 1728 (unfinished). (Dürr, 1726).

Cantata No. 34 'O ewiges Feuer, o Ursprung der Liebe'. Whitsun 1740/41. (Dürr, 1735/50; ? before 1742).

24 Soprano Aria from (now lost) Cantata No. 36a 'Steigt freudig in die Luft'. Birthday of Princess Charlotte Friederike Wilhelmine. 30th Nov., 1726. (Dürr, 1726).

Aria in Cantata No. 36 'Schwingt freudig euch empor'. 1st Sunday in Advent, between 1728 and 36. (Dürr, 1st form – before 1731). (Dürr, 2nd form – in 1731).

25 Cantata No. 36 'Schwingt freudig euch empor'. 1st Sunday in Advent 1728-36. (Dürr – see 24).

Items in Cantata No. 36b 'Die Freude reget sich'. Birthday of Prof. Florens Rivinus. 28th July, 1733. (Dürr, 1732/5).

26 Cantata No. 36 'Schwingt freudig euch empor'. Ist Sunday in Advent. 1728-36 (see 24).

Items in Cantata No. 36c 'Schwingt freudig euch empor'. Birthday of Rector Gesner(?) 1733/4. (Dürr, 1725(?)).

27 An early Cantata movement(?).

Tenor Aria (No. 3) Ich höre mitten in dem Leiden in Cantata No. 38 'Aus tiefer Not schrei' ich zu dir'. 21st Sunday after Trinity. Schmieder – 1735-44. Whittaker – 'about' 1740. (Dürr, 1724).

28 First Chorus from Cantata No. 40 'Dazu ist erschienen der Sohn Gottes'. Christmas 1723. (Dürr, 1723).

Cum Sancto Spiritu in Mass in F. (BWV 233). 1737.

29 Choral Dein ist allein die Ehre from Cantata No. 41

Final Choral (No. 6) Dein ist allein die Ehre' in Cantata No.

'Jesu nun sei gepreiset'. Circumcision, 1735/6. (Dürr 1725, and 32/35).

171 'Gott, wie dein Name, so ist auch dein Ruhm' — begun about 1730. (Dürr, 1729(?)).

30 Tenor Choral (No. 4) Ach Gott, wie manches Herzeleid from Cantata No. 44 'Sie werden euch in den Bann tun'. 6th Sunday after Trinity. (Dürr, 1724).

4-part Chorus Ach Gott, wie manches Herzeleid in Cantata No. 3 (same title). 2nd Sunday after Epiphany, 1735-44. (Dürr, 1725).

31 Chorus Schauet doch und sehet from Cantata No. 46 'Schauet doch und sehet'. 1723-27. (Dürr, 1723).

Qui Tollis in Mass in B minor. (BWV 232). 1733.

32 Cantata No. 47 'Wer sich selbst erhöhet, der soll erniedriget werden'. 17th Sunday after Trinity, Cöthen (1720). (Dürr, 1726).

Leipzig, 1726.

33 Michaelmas Cantata(?)

Cantata No. 50 'Nun ist das Heil und die Kraft'. Michaelmas, 1740.

34 Soprano Aria Alleluja in Cantata No. 51 'Jauchzet Gott in allen Landen'. 15th Sunday after Trinity, 1731/2. (Dürr, 1730).

Michaelmas, 1737.

35 Alto Aria (No. 1) Widerstehe doch der Sünde from Cantata No. 54 (same title). About 1730. (Dürr dates as Weimar with no Leipzig performance traceable).

Aria (No. 53) Falsche Welt, dein schmeichelnd Küssen in Mark Passion. BWV 247. Good Friday, 1731. (Dürr, 1731).

36 Two Choral settings in Cantata No. 58 'Ach Gott, wie

Recit. (mit Choral) (No. 2) and Choral, (No. 6) in Cantata

manches Herzeleid' 1733. (Dürr 1727 and 33 or 4).

No. 3 'Ach Gott, wie manches Herzeleid'. 1735-44. (Dürr, 1725).

37 Duet for Soprano and Bass (No. 1) Wer mich liebet from Cantata No. 59 'Wer mich liebet, der wird mein Wort halten'. 1st day of Whitsun, 31st May, 1716. (Dürr, 1724 and, possibly, 1723).

First Chorus Wer mich liebet in Cantata No. 74 (same title). 1st day of Whitsun, 1731 or 35. (Dürr, 1725).

38 Bass Aria (No. 4) Die Welt mit allen Königreichen from Cantata No. 59. (see 37).

Soprano Aria (No. 2) Komm, komm, mein Herze, steht dir offen in Cantata No. 74 (see 37).

39 Choral (No. 3) Komm, Heiliger Geist from Cantata No. 59. (see 37 above).

Choral (No. 7) Nun, werter Geist in Cantata No. 175 'Er rufet seinen Schafen mit Namen'. 3rd day of Whitsun, 1735/6. (Dürr – 1725 and 35/ 50).

40 First Chorus Nun komm, der Heiden Heiland from Cantata No. 61 (same title). 1st Sunday in Advent, 1714. (Dürr, 1723).

First Chorus Nun komm, der Heiden Heiland in Cantata No. 62 (same title). Also Choral (No. 6). 1st Sunday in Advent, between 1735 and 1744. (Dürr, 1724 and 32/5).

41 Choral (No. 2) Das hat er Alles uns getan from Cantata No. 64 'Sehet, welch' eine Liebe hat uns der Vater erzeiget'. 3rd day of Christmas, 1723. (Dürr, 1723 and 35/50).

Choral (No. 6) Das hat er Alles uns getan in Cantata No. 91 'Gelobet seist du, Jesu Christ'. 1st day of Christmas between 1735 and 1744. (Dürr, 1724, 32/5 and 35/50).

42 Choral (No. 4) Was frag' ich nach der Welt from Cantata No. 64. (see 41).

First Chorus Was frag' ich nach der Welt in Cantata No. 94 'Was frag' ich nach der Welt'.

9th Sunday after Trinity, 1735. Used again as Final Choral (No. 8). (Dürr, 1724, 32/5 and 35/50).

43 Cantata No. 66a 'Der Himmel dacht auf Anhalts Ruhm und Glück'. 10th Dec. 1718.

Cantata No. 66 'Erfreut euch, ihr Herzen'.
Monday in Easter Week, 1731 or 35. (Dürr, 1724-31).

44 Aria (No. 6) and Chorus Friede sei mit euch from Cantata No. 67 'Halt im Gedächtnis Jesum Christ'. 1723-27. (Dürr, 1724).

Gloria in Mass in A. BWV 234. 1737/8. (Dürr, 1735/50).

45 Cantata No. 69 'Lobe den Herrn, meine Seele'. 1st version 12th Sunday after Trinity, 27th Aug. 1724. 2nd version Ratswahl (Cantata No. 69a). 28th Aug. 1724.

3rd Version, Ratswahl. 27th Aug. 1730. (Dürr, (No. 69) – 1743/5. (No. 69a) – 1723 and 27).

46 Recitative (No. 2) Wie gross ist Gottes Güte doch from Cantata No. 69. (see 45).

Recitative (No. 2) Ach, dass ich tausend Zungen hätte in Cantata No. 69a (see 45).

47 Alto Aria in G (No. 3) Meine Seele, auf, erzähle from Cantata No. 69. (see 45).

Tenor Aria in C (No. 3) Meine Seele, auf, erzähle in Cantata No. 69a (see 46).

48 Choral (No. 6) Es danke, Gott, und lobe dich in Cantata No. 69. (see 45).

Choral (No. 6) Was Gott tut, das ist wohlgetan in Cantata No. 69a (see 46).

49 Choral (No. 6) Was Gott tut, das ist wohlgetan from Cantata No. 69a 'Lobe den Herrn, meine Seele'. (see 45).

First Chorus Was Gott tut in Cantata No. 100 'Was Gott tut'. 15th or 21st Sunday after Trinity. 1733 or 35. (Dürr, 1732/5 and 1735/50).

50 Cantata No. 70 'Wachet, betet, seid bereit allezeit'. 1st version – 2nd Sunday in Ad-

vent, 6th Dec. 1716.
2nd version – 26th Sunday after
Trinity, 1723.

3rd version, 1728 or 31. (Dürr,
1723 and 1731).

51 Theme from Chorus (No.
6) from Rathswechsel Cantata
No. 71 'Gott ist mein König'.
4th February, 1708. (Dürr –
Mühlhausen, no Leipzig performance traceable).

Second Chor. Weinen, Klagen
in Cantata No. 12 'Weinen,
Klagen, Sorgen, Zagen'. 3rd
Sunday after Easter, 1724.
(Dürr, 1724).

52 First Chorus Alles nur
nach Gottes Willen from Cantata No. 72 'Alles nur nach
Gottes Willen'. 3rd Sunday in
Epiphany, 1723 or 25. (Dürr,
1726).

Gloria in Mass in G minor.
BWV 235. About 1737.

53 Cantata No. 73 'Herr, wie
du willt, so schick's mit mir'.
3rd Sunday after Epiphany between 1723 and 27. (Dürr,
1723 and 32/5(?)).

Revised version. (1732 – 5).

54 Chorals (Nos. 7 and 14)
Was Gott tut from Cantata
No. 75 'Die Elenden sollen
essen'. 1st Sunday after Trinity, 30th May, 1723. (Dürr,
1723).

Choral (No. 6) Was Gott tut
in Cantata No. 100 'Was Gott
tut, das ist wohlgetan'. 15th or
21st Sunday after Trinity. 1735
or 33. (Dürr, 1732/5 and 1735/
50).

55 Cantata No. 76 'Die Himmel erzählen die Ehre Gottes'.
1st version – 2nd Sunday after
Trinity, 6th June, 1723. (Dürr,
1723).

2nd version — Revised as
Reformation Cantata, 1745.
(Dürr, 1724 or 5(?)).

56 Choral (No. 7 (end of Part
I) Es woll uns Gott genädig
sein from Cantata No. 76. (see
55).

Choral (No. 6) Es danke, Gott,
und lobe dich in Cantata No.
69 'Lobe den Herrn, meine
Seele'. 12th Sunday after
Trinity, 27th Aug. 1724, and
Ratswahl, 28th Aug. 1724.
(Dürr, 1743/50).

57 Bass of 1st Chor. from Cantata No. 78 'Jesu, der du meine Seele'. (Dürr, 1724).

Crucifixus in Mass in B minor. BWV 232. 1733.

58 First Chorus and Alto Aria (No. 2) Gott, der Herr, ist Sonn und Schild from Cantata No. 79 (same title) 1735. (Dürr, 1725 and 1728/31).

Gloria in Mass in G. BWV 236. 1737/8. (Dürr, 1735/50).

59 Alto Aria (No. 2) Gott ist unser Sonn und Schild from Cantata No. 79. (see 58).

Alto Aria (No. 5) Quoniam tu solus in Mass in A. BWV 234. 1737/8. (Dürr, 1735/50).

60 Soprano and Bass Duet (No. 5) Gott, ach Gott from Cantata No. 79. (see 58).

Soprano and Alto Duet (No. 4) Domine Deus in Mass in G. BWV 236. 1737/8. (Dürr, 1735/50).

61 Cantata No. 80a 'Alles, was von Gott geboren'. 3rd Sunday in Lent, 15th March, 1716. (Dürr – Weimar, no Leipzig performance traceable).

Reformation Cantata No. 80 'Ein' feste Burg ist unser Gott'. 1730 or 1739. (Dürr – possible in 1724 in an earlier version).

62 Cantata No. 82 'Ich habe genug'.

63 Tenor Aria (No. 3) Man halte nur ein wenig still from Cantata No. 93 'Wer nur den lieben Gott lässt walten'. 5th Sunday after Trinity.

Soprano (Miecke) Aria (No. 14) Kleinzschocher müsse so zart und süsse in (Peasant) Cantata No. 212 'Mer hahn en neue Oberkeet'. 1742.

64 Early Cantata (or Suite) ?.

Cantata No. 97 'In allen meinen Taten'. 1734.

65 First Chor. Was Gott tut, das ist wohlgetan from Cantata No. 98 (same title). 21st Sunday after Trinity, 1731/2. (Dürr, 1726).

First Chor. Was Gott tut, das ist wohlgetan and Choral (No. 6) (same title) in Cantata No. 99 (same title). 15th Sunday after Trinity, 1733. (Dürr, 1724).

66 First Chor. and Choral (No. 6) Was Gott tut from Cantata No. 99 'Was Gott tut, das ist wohlgetan'. 15th Sunday after Trinity, 1733. (Dürr, 1724).

First Chor. and Choral (No. 6) Was Gott tut, das ist wohlgetan in Cantata No. 100 (same title). 15th or 21st Sunday after Trinity, 1735 or 33. (Dürr, 1732/5 and 35/50).

67 First Chor. Herr, deine Augen sehen from Cantata No. 102 (same title). 10th Sunday after Trinity, 1731/2. (Dürr, 1726).

Kyrie in Mass in G (BWV 235). 1737.

68 Alto Aria (No. 3) Weh! der Seele from Cantata No. 102 'Herr, deine Augen sehen'. 16th Sunday after Trinity, 1731/2. (Dürr, 1735/50; (?) 1737).

Qui Tollis in Mass in F. (BWV 233). 1737.

69 Tenor Aria (No. 5) Erschrekke doch from Cantata No. 102. 1731/2 (see 67).

Alto Aria Quoniam in Mass in F. 1737.

70 Cantata (Motette) No. 118 'O Jesu Christ, mein's Lebens Licht'. 1737/40. (Dürr, 1735/50).

Revised version.

71 Chor. (No. 2) Jauchzet from Cantata No. 120 'Gott, man lobet Dich'. 1728/30.

Et expecto Resurrectionem (Credo) in Mass in B minor. (BWV 232). 1733, (1747-50).

72 First Chorus Herr Gott, Beherrscher from Cantata No. 120a 'Herr Gott, Beherrscher aller Dinge'. 1728 or 1732/3. (Dürr, 1730).

Chorus (No. 2) Jauchzet in Ratswahl Cantata No. 120 'Gott, man lobet dich'. 1728/30. (Dürr – about 1728).

73 Soprano Aria (No. 3) Leit, O Gott, durch deine Liebe from Cantata No. 120a see 72).

Soprano Aria (No. 4) Heil und Segen in Cantata No. 120 (see 72).

74 Alto and Tenor Duet, (No. 6) Herr, fange an und sprich den Segen from Cantata No. 120a (see 72).

Alto Aria (No. 1) Gott, man lobet dich in Cantata No. 120 (see 72).

75 Choral (No. 8) Lobe den Herren from Cantata No. 120a (see 72).

Choral (No. 5) Lobe den Herren in Ratswahl Cantata No. 137 'Lobe den Herren'. 25th Aug. 1732 and between 1732 and 1747. (Dürr, 1725 and 1744/50).

76 An early Cantata movement.

Tenor Aria (No. 2) O du von Gott in Cantata No. 121 'Christum, wir sollen loben schon'. 2nd day of Christmas, 1735-44. (Dürr, 1724).

77 Cantata No. 125 'Mit Fried' und Freud' ich fahr' dahin'. 1735-44. (Dürr, 1725).

First Chor. Mit Fried und Freud' ich fahr' dahin and Final Chorale Er ist das Heil und sel'ge Licht . See BWV 382 and 616.

78 Bass Recitative and Aria (No. 4) from Cantata No. 127 'Herr Jesu Christ, wahr'r Mensch und Gott'. Estomihi, 1735-44. (Dürr, 1725).

Chor. (No. 33). Sind Blitze, sind Donner in Matthew Passion (BWV 244). 1728/29.

79 Cantata No. 130 'Herr Gott, dich loben alle wir'. Michaelmas, 1735-44. (Dürr, 1724).

Choralgesänge.

80 Cantata No. 132 'Bereitet die Wege, bereitet die Bahn'. 4th Sunday in Advent, 22nd Dec. 1715.

Cantata No. 132. Leipzig, 1724.

81 Cantata No. 134a 'Die Zeit, die Tag und Jahre macht'. 1719. (Dürr, 1719).

Cantata No. 134 'Ein Herz, das seinen Jesum lebend weiss'. 1 Between 1719 and 1726.

2. 3rd Day of Easter, 1731.
(Dürr – 1724, 31 and 35(?)).

82 An early Cantata move-
ment.

Tenor Aria (No. 3) Tröste mir,
Jesu, mein Gemüte in Cantata
No. 135 'Ach, Herr, mich ar-
men Sünder'. 3rd Sunday after
Trinity. Schmieder, 1735-44.
Whittaker, 'about' 1740. Dürr,
1724.

83 First Chor. Erforsche mich,
Gott from Cantata No. 136
'Erforsche mich Gott, und
erfahre mein Herz'. 1723/7 or
1737/8. (Dürr, 1723).

Section, In Gloria Dei Patris,
of Final Chor. Cum Sancto
Spiritu in Mass in A. (BWV
234). 1737/8. (Dürr, 1735/50).

84 Choral (No. 5) Lobe den
Herren from Cantata 137 'Lobe
den Herren.' Ratswahl, 1725
and 12th Sunday after Trinity,
31.8.32 or 32-47.

Choral (No. 8) Lobe den Her-
ren in Wedding Cantata No.
120a 'Herr Gott, Beherrscher
aller Dinge'. (Dürr, 1730).

85 Bass Aria (No. 5) Auf
Gott steht meine Zuversicht
from Cantata No. 138 'Warum
betrübst du dich, mein Herz'.
15th Sunday after Trinity,
1737/8 or 1732. (Dürr, 1723).

Bass Aria (No. 3) Gratias in
Mass in G. BWV 236. 1737/8.

86 Vocal Duet of Early Work.
circa. 1720.

First Chor. in Cantata No. 141
'Das ist je gewisslich wahr'.
3rd Sunday in Advent, 1720.
(Dürr – not Bach – probably by
Telemann).

87 A Slumber song?

Cantata 144 'Nimm, was dein
ist, und gehe hin'. Septua-
gesima, 1723-7.

88 A Secular Cantata. 1717-
23.

Cantata No. 145 'Auf, mein
Herz, des Herren Tag', some-
times known as 'Ich lebe, mein

Herze, zu deinem Ergötzen'.
Easter, 1729/30. (Dürr, 1729
(?)).

89 Cantata No. 147 'Herz
und Mund, und Tat und
Leben'. 4th Sunday in Advent,
20th Dec. 1716.

Cantata No. 147 'Herz und
Mund, und Tat und Leben'.
Visitation of BVM. 1727. (Dürr,
1723 and 28/31).

90 Cantata No. 149 'Man
singet mit Freuden vom Sieg'.
29th September, 1731. (Dürr,
1728 or 29(?)).

Cantata No. 201 'Der Streit
zwischen Phoebus und Pan'.
1731. (Dürr, 1729(?)).

91 Theme of opening Fugal
Chorus from Cantata No. 150
'Nach dir, Herr, verlanget
mich'. 1712. (Dürr – Weimar,
no Leipzig performance trace-
able).

Passacaglia Bass in First Chorus
of Cantata No. 12 'Weinen,
Klagen, Sorgen, Zagen'. 1st
1714, 2nd 1724. (Dürr, 1719 and
1724).

92 Soprano Aria (No. 4)
Stein, der über alle Schätze
from Cantata No. 152 'Tritt
auf die Glaubensbahn'. 30th
December, 1714.

Bass Aria (No. 6) O du ange-
nehmes Paar in Wedding
Cantata No. 197 'Gott ist unsre
Zuversicht'. 1737 or 8.

93 Chor. O Schwert, das
durch die Seele dringt in Can-
tata No. 154 'Mein liebster
Jesus ist verloren'. 1st Sunday
after Epiphany, 9th January,
1724. (Dürr, 1724 and 35/50).

Chor. in Cantata No. 20 'O
Ewigkeit'. 1st Sunday after
Trinity, 1724. (Dürr, 1724).

94 Chor. O Schwert das
durch die Seele dringt in Can-
tata No. 154 (see 93).

Chor. in Cantata No. 60 'O
Ewigkeit'. 24th Sunday after
Trinity, 1732. (Dürr, 1723).

95 Tenor Aria in Cantata
No. 154 (see 93).

Soprano and Bass Duetto (No.
5) Nun verschwinden alle
Plagen in Cantata No. 32
'Liebster Jesu mein Verlangen'.
1st Sunday after Epiphany,
1738/40. (Dürr, 1726).

96 Cantata No. 157 'Ich lasse dich nicht, du segnest mich denn'. 2nd February, 1727 and 6th February, 1727. (Dürr, 1727).

97 Cantata No. 158 'Der Friede sei mit dir'. Purification and 3rd Day of Easter, 1708-17.

Second version. 1724.

98 Alto Aria (No. 1) in Cantata No. 161 'Komm, du süsse Todesstunde'. 16th Sunday after Trinity, 6th Oct. 1715.

Soprano Aria in Cantata No. 161 Purification, 2nd Feb. 1735.

99 Final Chorus in Cantata No. 162 'Ach ich sehe, jetzt da ich zur Hochzeit gehe'. 20th Sunday after Trinity, 3rd Nov. 1715.

Cantata No. 162. 1724. (Dürr, 1723).

100 Cantata No. 163 'Nur jedem das Seine'. 23rd Sunday after Trinity, 24th Nov. 1715.

Later reconstruction, 'possibly' 1723.

101 An early version dating from the Weimar period.

Cantata No. 164 'Ihr, die ihr euch von Christo nennet'. 13th Sunday after Trinity, 22nd Aug. 1723. (Dürr, 1725).

102 A 'Weimar' work?

Cantata 168 'Tue Rechnung! Donnerwort'. 9th after Trinity, 1723 or 4. (Dürr, 1725).

103 An early Cantata (or instrumental work?).

Alto Aria (No. 5) Mir ekelt mehr zu leben in Cantata No. 170 'Vergnügte Ruh', beliebte Seelenlust'. 6th Sunday after Trinity, 1726.

104 Cantata No. 170 'Vergnügte Ruh', beliebte Seelenlust'. 1st version (in D), 6th Sunday after Trinity, 1731/2. (Dürr, 1726).	Cantata No. 170. 2nd version (in C), 2nd July 1742. (Dürr, 1735/50).
105 First Chor. Gott, wie dein Name from Cantata No. 171 'Gott, wie dein Name, so ist auch dein Ruhm'. Circumcision, 1730. (Dürr, 1729(?)).	Patrem Omnipotentem in Mass in B minor. (BWV 232). 1733 and 1745.
106 Final Chor. (in D) Dein ist allein die Ehre from Cantata No. 171 (see 105). (Dürr, 1729).	Final Choral (in C) Dein ist allein die Ehre in Cantata No. 41 'Jesu, nun sei gepreiset'. Circumcision, 1735/6. (Dürr, 1725 and 32/5).
107 Cantata No. 172 'Erschallet ihr Lieder'. 1st 20 May, 1724. (Dürr, 1724). 2nd 1724/5.	Soprano and Alto Duet (No. 5) Komm, lass mich nicht länger warten in Cantata No. 172. 1730/31.
108 Soprano Recitative (No. 1) Durchlaucht'ster Leopold from Birthday Cantata No. 173a (same title). 1717. (Dürr – Cöthen).	Tenor Recitative (No. 1) Erhöhtes Fleisch und Blut in Cantata No. 173. 2nd day of Whitsun, 1730. (Dürr, 1724(?); 'about' 1728, 31 and 1732/5).
109 Soprano Aria (No. 2) Güldner Sonnen frohe Stunden from Cantata No. 173a (see 108).	Tenor Aria (No. 2) Eingeheiligtes Gemüte in Cantata No. 173.
110 Bass Aria (No. 3) Leopold's Vortrefflichkeiten from Cantata No. 173a.	Alto Aria (No. 3) Gott will, o ihr Menschenkinder in Cantata No. 173.
111 Soprano and Bass Aria (Duett) (No. 4) Unter seinem Purpursaum from Cantata No. 173a.	Soprano and Bass Aria (Duett) (No. 4) So hat Gott die Welt geliebt in Cantata No. 173.

112 Soprano and Bass Recitative (No. 5) Durchlauchtigster, den Anhalt Vater nennt from Cantata No. 173a.

Soprano and Tenor Recitative (Duett) (No. 5) Unendlichster den man doch Vater nennt in Cantata No. 173.

113 Soprano and Bass Coro (No. 8) Nimm auch, grosser Fürst from Cantata No. 173a.

S.A.T.B. Coro (No. 6) Rühr, Höchster, unsern Geist in Cantata No. 173.

114 Bass Aria (No. 7) Dein Name gleich der Sonnen geh' from Cantata No. 173a.

Tenor Aria (No. 4) Es dünket mich, ich seh' dich kommen in Cantata No. 175 'Er rufet seinen Schafen mit Namen'. 3rd day of Whitsun, 1735/6. (Dürr, 1725 and 1735/50).

115 Cantata No. 175 'Er rufet seinen Schafen mit Namen' 1. 3rd day of Whitsun, 1735 or 6; 1735 & 1738; 1725 & 1735/50.

says Schmieder
„ Spitta
„ Dürr.

116 First Chor. Siehe zu, dass deine Gottesfurcht nicht Heuchelei sei from Cantata No. 179 (same title). 11th Sunday after Trinity, 1724. (Dürr, 1723).

First Chor. Kyrie in Mass in G. BWV 236. Dated 1737/8. (Dürr, 1735/50).

117 Tenor Aria (No. 3) Falscher Heuchler Ebenbild können Sodoms Äpfel heissen from Cantata No. 179 (see 116).

Tenor Aria (No. 5) Quoniam in Mass in G (see 116).

118 Soprano Aria (No. 5) Liebster Gott, erbarme dich from Cantata No. 179.

Soprano Aria (No. 4) Qui Tollis in Mass in A. BWV 234. 1737/8. (Dürr, 1735/50).

119 Secular work – (possibly instrumental).

Final Chor. (No. 8) Lass, Höchster, uns zu allen Zeiten in Cantata No. 181 'Leichtgesinnte Flattergeister'. Sexage-

sima, 1723-27. (Dürr, 1724 and 35/50).

120 Cantata No. 182 'Himmelskönig, sei willkommen'. (i) Palm Sunday, 25th March, 1714. or Annunciation, 14th April, 1715.

Cantata No. 182.
(ii) 25th March, 1725. (Dürr, 1724 and 1728/31 (28?)).

121 Early Secular Cantata, (Cöthen period). (184a).

Cantata No. 184 'Erwünschtes Freudenlicht'. 3rd day of Whitsun, 1724. (Dürr, 1724 and 31).

122 First 24 bars from Final Chor. (No. 6) Guter Hirte, Trost der Deinen from Cantata No. 184 'Erwünschtes Freudenlicht'. 3rd day of Whitsun, 1714 or 31. (Dürr, 1724 and 31).

Final Chor. (No. 13) Lust der Völker, Lust der Deinen in Cantata No. 213 'Lasst uns sorgen, lasst uns wachen'. 5th Sept. 1733. (Dürr, 1733).

123 Cantata No. 186 'Ärgre dich, o Seele, nicht'. (i) 3rd Sunday in Advent, 1716.

Cantata No. 186.
(ii) 7th Sunday after Trinity, 1723. (Dürr, 1723).

124 First Chor. Es wartet alles from Cantata No. 187 (same title). 7th Sunday after Trinity, 1732. (Dürr, 1726).

Chor. (No. 6) Cum sancto spiritu in Mass in G minor. BWV 235. Dated about 1737.

125 Alto Aria (No. 3) Du Herr, du krönst allein from Cantata No. 187 (see 124).

Alto Aria (No. 4) Domine Fili in Mass in G minor. BWV 235.

126 Bass Aria (No. 4) Darum sollt ihr nicht sorgen from Cantata No. 187.

Bass Aria (No. 3) Gratias agimus in Mass in G minor (see 124).

127 Soprano Aria (No. 5) Gott versorget alles Leben from Cantata No. 187.

Tenor Aria (No. 5) Qui Tollis in Mass in G minor (see 124).

128 Cantata No. 189 'Meine

Later version.

Seele rühmt und preist'. 1707-10.

129 Cantata No. 190 'Singet dem Herrn'. (i) Circumcision, 1724. (Dürr, 1724).

Cantata No. 190. (ii) Augsburg Confession, 25th June, 1730. (Dürr, 1735/50).

130 First Chorus Ihr Häuser des Himmels from Cantata No. 193a (same title). 3rd August, 1727. (Dürr, 1727).

First Chor. Ihr Tore zu Zion in (unfinished) Ratswahl Cantata No. 193 (same title). About 1738. (Dürr, 1726).

131 Aria (No. 7) Herr, so gross als dein Erhöhen from Cantata No. 193a (see 130).

Soprano Aria (No. 3) Gott, wir danken deiner Güte in Cantata No. 193 (see 130).

132 Aria (No. 9) Sachsen, komm zum Opferherd from Cantata No. 193a (see 130).

Alto Aria (No. 5) Sende, Herr from Cantata No. 193.

133 Secular Cantata No. 194a. (Cöthen).

Cantata No. 194 'Höchsterwünschtes Freudenfest'. (i) 2nd November, 1723. (ii) Trinity. (Dürr, 1723, 24, 26 and 31).

134 Cantata No. 195 'Dem Gerechten muss das Licht'. (i) 1724. (Dürr, 1728/31 (?).

Cantata No. 195. (ii) 1730. (Dürr, after 1737 and 1737/50).

135 Alto Aria (No. 1) Schatz, O du angenehmer Schatz from (unfinished) Cantata No. 197a 'Ehre sei Gott in der Höhe'. 1st Day of Christmas, 1728-32. (Dürr, about 1728).

Bass Aria (No. 6) O du angenehmes Paar in Cantata No. 197 'Gott ist unsre Zuversicht'. 1737/8. (Dürr, about 1735/50, before 42(?)).

136 Bass Aria (No. 3) Ich lasse dich nicht from Cantata No. 197a (see 135).

Soprano Aria (No. 8) Vergnügen und Lust in Cantata No. 197 (see 135).

137 A lost (Christmas?) Cantata (?).

Alto Aria (No. 3) Schläfert aller Sorgen Kummer in Cantata No. 197.

138 Chorus (No. 1) Lass Fürstin, Lass noch einen Strahl from Cantata No. 198 (same title). 17th October, 1727. (Dürr, 1727).

Chorus (No. 1) Geh, Jesu, geh in Passion of St. Mark. BWV 247. Good Friday, 1731. (Dürr, 1731).

139 Chorus (No. 1) Lass Fürstin, Lass noch einen Strahl from Cantata 198 (see 138).

Adagio in Kyrie from Mass in B minor. BWV 232. 1733. (Dürr, 1733).

140 Soprano Aria (No. 3) Verstummt, ihr holden Saiten from Cantata No. 198 (see 138).

Soprano Aria (No. 49) Er kommt, er ist vorhanden! in Passion of St. Mark. BWV 247.

141 Alto Aria (No. 5) Wie starb die Heldin so vergnügt from Cantata No. 198 (see 138).

Alto Aria (No. 27) Mein Heiland, dich vergess ich nicht in Passion of St. Mark.

142 Tenor Aria (No. 8) Der Ewigkeit saphirnes Haus from Cantata No. 198 (see 138).

Tenor Aria (No. 59) Mein Tröster ist nicht mehr bei mir in Passion of St. Mark.

143 Chor. (No. 10) Doch, Königin! du stirbest nicht from Cantata No. 198 (see 138).

Chor. (No. 132) Bei deinem Grab und Leichenstein in Passion of St. Mark.

144 First Chorus Lass Fürstin, lass noch einen Strahl from Cantata No. 198 (see 138).

First Chorus Klagt, Kinder, klagt es aller Welt in Cantata No. 244a (same title). 24th March, 1729.

145 Bass (Pan) Aria (No. 7) Zu Tanze, zu Springe, so wakkelt das Herz from Cantata No. 201 (Dramma per musica) 'Geschwinde, geschwinde, ihr wirbelnden Winde). 1731. (Dürr, 1729) (?).

Bass Aria (No. 20) Dein Wachstum sei feste und lache vor Lust in (Peasant) Cantata No. 212. 1742.

146 Final Chor. Labt das

Final Chor. in Thomas School

Herz, ihr holden Saiten from Cantata No. 201 (see 145). 1729.

Cantata. 'Thomana sass annoch betrübt'. BWV Appx. 19. 21st November, 1734.

147 Soprano Aria (No. 7) in D from Cantata No. 202 'Weichet nur, betrübte Schatten'. Cöthen period.

Bass Aria (No. 4) (in A) in Cantata No. 8 'Liebster Gott, wann werd' ich sterben'. 16th Sunday after Trinity, about 1724.

148 Soprano Aria (No. 8) Himmlische Vergnügsamkeit from Cantata No. 204 'Ich bin in mir vergnügt'. Prior to 1728. (Dürr, 1726 or 7).

Soprano Aria (No. 3) Angenehme Hempelin in Wedding Cantata No. 216 'Vergnügte Pleissenstadt'. 5th February, 1728.

149 Cantata No. 205 'Zerreisset, zersprenget, zertrümmert die Gruft' (Dramma per musica) 'Der zufriedengestellte Aeolus'. 3 Aug. 1725. (Dürr, 1725 & 34).

Cantata No. 205a 'Blast Lärmen, ihr Feinde'. (Dramma per musica). 17th Jan. 1734. (Dürr, 1734).

150 Opening Chor. from Cantata. No. 205.

Credo in Mass in B minor. BWV 232.

151 Soprano (Pallas) Aria (No. 9) Angenehmer Zephyrus from Cantata No. 205 (see 133).

Soprano Aria (No. 4) Jesus soll mein erstes Wort in dem neuen Jahre heissen in Cantata No. 171 'Gott, wie dein Name, so ist auch dein Ruhm'. Festival of Circumcision, 1729/30 and 1736. (Dürr, 1729(?)).

152 Alto (Pomona) & Tenor (Zephyrus) Duet (No. 13) Zweig' und Äste from Cantata No. 205 (see 133).

Soprano (Neisse) and Alto (Pleisse) Duet (No. 7) Heil und Segen in Cantata No. 216 'Vergnügte Pleissen-Stadt'. 5th February, 1728. (Dürr, 1728).

153 Cantata No. 206 'Schleicht, spielende Wellen'. (i) 7th

Cantata No. 206. (ii) 3rd August, 1736 or 7. (Dürr, 1736(?)).

October, 1733. (Dürr, 1735/
50).

154 Chor. (No. 2) Vereinigte
Zwietracht from Cantata No.
207 (same title). 11th Decem-
ber, 1726. (Dürr, 1726).

Chor. (No. 1) Auf schmettern-
de Töne in Cantata No. 207a
(same title). 3rd August, 1734.
(Dürr, 1734 and 35(?)).

155 Tenor Aria (No. 4) Zieht
euren Fuss from Cantata No.
207 (see 154).

Tenor Aria (No. 3) Augustus
Namenstages Schimmer in Can-
tata No. 207a.

156 Soprano and Bass Duet
(No. 6) Den soll mein Lorbeer
from Cantata No. 207 (see 154).

Soprano and Bass Duet (Ehre
und Glück (No. 5) Mich kann
die süsse Ruhe laben in Can-
tata No. 207a.

157 Alto Aria (No. 9) Ätzet
dieses Angedenken from Can-
tata No. 207 (see 154).

Alto (?) Aria (No. 7) Preiset,
späte Folgezeiten in Cantata
No. 207a.

158 S.A.T.B. Recit. (No. 10)
Ihr Schläfrigen, herbei from
Cantata No. 207 (see 154).

S.A.T.B. (?) Recit (No. 8) Ihr
Fröhlichen, herbei in Cantata
No. 207a.

159 Chor. (No. 11) Kortte
lebe, Kortte blühe from Can-
tata No. 207) (see 154).

Chor. (No. 9) August lebe,
lebe König in Cantata No.
207a.

160 Soprano (Pales) Recit.
(No. 8) Soll dann der Pales
Opfer hier das letzte sein from
Cantata No. 208.

Recit. (No. 8) Mein Opfer soll
gewisslich nicht das letzte sein
in Cantata No. 208a 'Was mir
behagt'. 3rd August, 1735.

161 Soprano (Diana) and
Tenor (Endymion) Duet (No.
12) Entzükket uns beide, ihr
Strahlen der Freude from Can-
tata No. 208 (see 160).

Duet (No. 12) Ihr Strahlen der
Freuden vertreibt die Leiden
in Cantata No. 208a (see 160).

162 Bass Aria (No. 7) Ein
Fürst ist seines Landes Pan
from 'Hunting' Cantata No.

Bass Aria (No. 4) Du bist
geboren mir zu Gute in Can-
tata No. 68 'Also hat Gott die

208 'Was mir behagt'. 1716. (Dürr, perhaps 35) (see 208a). (160).

Welt geliebt'. 1735. (Dürr, 1725).

163 Continuo to Soprano (Pales) Aria (No. 13) Weil die Wollenreichen Herden from Cantata No. 208 (see 160).

Piccolo-cello obbligato to Soprano Aria (No. 2) Mein gläubiges Herze in Cantata No. 68.

164 Soprano Aria (No. 13) Weil die Wollenreichen Herden from Cantata No. 208 (see 160).

Soprano Aria (No. 2) Mein gläubiges Herze in Cantata No. 68. 1735.

165 Chor. (No. 15) Ihr lieblichste Blikke from Cantata No. 208 (see 160).

First Chor. Man singet mit Freuden in Cantata No. 149. 1731. Dürr, about 1728-29(?).

166 Wedding Cantata No. 210 'O holder Tag, erwünschte Zeit'. 1734/5. Dürr, in Bach's last years.

Cantata No. 210a 'O angenehme Melodei'. 1738/9. Dürr, 1738/40 (other dates possible).

167 Aria (No. 8) Grosser Gönner, dein Vergnügen muss auch unsern Klang besiegen from Cantata No. 210.

Grosser Flemming, alles Wissen and Werte Gönner, alles Wissen in Cantata No. 210a.

168 Chor. (No. 1) Lasst uns sorgen from Birthday Cantata (Dramma per Musica) No. 213 'Lasst uns sorgen'. 3 Sept 1733. (Dürr, 1733).

Chor. (No. 36) Fallt mit Danken, fallt mit Loben in Christmas Oratorio. BWV 248. 1734. (Dürr, 1734).

169 Soprano (Wollust) Aria (No. 3) Schlafe, mein Liebster from Cantata No. 213 (see 168).

Alto Aria (No. 19) Schlafe, mein Liebster in Christmas Oratorio.

170 Alto (Hercules) Aria (No. 5) Treues Echo from Cantata No. 213 (see 169).

Soprano Aria (No. 39) Flösst, mein Heiland in Christmas Oratorio.

171 Tenor (Tugend) Aria

Tenor Aria (No. 41) Ich will

(No. 7) Auf meinen Flügeln from Cantata No. 213 (see 169).

nur dir zu Ehren leben in Christmas Oratorio.

172 Alto (Hercules) Aria (No. 9) Ich will dich nicht hören from Cantata No. 213 (see 169).

Alto Aria (No. 4) Bereite dich, Zion in Christmas Oratorio.

173 Alto (Hercules) and Tenor (Tugend) Duet (No. 11) Ich bin deine from Cantata No. 213 (see 169).

Soprano and Bass Duet (No. 29) Herr, dein Mitleid, dein Erbarmen in Christmas Oratorio.

174 Chor. (No. 1) Tönet, ihr Pauken from Birthday Cantata No. 214. (Dramma per Musica) 'Tönet, ihr Pauken'. 8 Dec. 1733. (Dürr, 1733).

Chor. (No. 1) Jauchzet, frohlocket in Christmas Oratorio.

175 Alto Aria (No. 5) Fromme Musen, meine Glieder! from Cantata No. 214 (see 174).

Tenor Aria (No. 15) Frohe Hirten, eilt, ach eilet in Christmas Oratorio.

176 Bass Aria (No. 7) Kron' und Preis', gekrönte Damen from Cantata No. 214 (see 174).

Bass Aria (No. 8) Grosser Herr und starker König in Christmas Oratorio.

177 Chor. (No. 9) Blühet, ihr Linden in Sachsen from Cantata No. 214 (see 174).

Chor. (No. 24) Herrscher des Himmels in Christmas Oratorio.

178 Soprano Aria (No. 7) Durch die von Eifer entflammeten Waffen from Cantata No. 215. (Dramma per Musica) 'Preise dein Glücke'. 5 Oct. 1734. (Dürr, 1734).

Bass Aria (No. 47) Erleucht' auch meine finstre Sinnen in Christmas Oratorio.

179 Osanna (First Chor.) from Cantata No. 215 (see 178).

Osanna in Mass in B minor. BWV 232. 1733. Dürr, 1745-50.

180 Alto Aria (No. ?) Frommes Schicksal from Birthday Cantata No. Appx.

Alto Aria (No. 5) Treues Echo dieser Orten in Cantata No. 213 'Lasst uns sorgen' (see 168).

11 'Es lebe der König, der Vater
im Lande'. 3 Aug. 1732.

181 ? Aria (No. ?)
Ich will ihn hegen from Can-
tata No. Appx. 11 (see 180).

Bass (Schicksal) Aria (No. 7)
Ich will dich halten, und mit
dir walten in Cantata No. 30a
'Angenehmes Wiederau'. 1737.

182 Soprano (Neisse) and
Alto (Pleisse) Duet from Wed-
ding Cantata No. 216 'Verg-
nügte Pleissen-Stadt'. 5 Feb.
1728. (Dürr, 1728).

Tenor (Apollo) and Alto (Mer-
cury) Duet in Cantata No.
216a 'Erwählte Pleissenstadt'.
Dated ?

183 Gloria (No. 4) from Mass
in B minor. BWV 232.

Cantata No. 191 'Gloria in ex-
celsis Deo'. 1740. (Dürr, 1734/
5 or after 1742).

184 Soprano and Tenor Duet
(No. 7) Domine Deus from
Mass in B minor (see 183).

Soprano and Tenor Duet (No.
2) Gloria Patri in Cantata No.
191.

185 Cum Sancto Spiritu
from Mass in B minor (see 183).

Chor. (No. 3) Sicut erat in
Cantata No. 191.

186 Ostinato Bass of Cruci-
fixus (No. 16) from Mass in B
minor (see 183).

Ostinato Bass of first Chorus
in Cantata No. 78 'Jesu, der
du meine Seele'. 1735-44.
(Dürr, 1724).

187 Kyrie eleison, Christe du
Lamm Gottes from BWV 233a.
1734.

Kyrie eleison in Mass in F.
(BWV 233). 1737.

188 Magnificat in E flat. BWV
243a. 1723 (?). (Dürr, 1723).

Magnificat in D. BWV 243.
(Dürr, 1728/31).

189 Soprano and Bass Duet
Virga Jesse floruit. BWV 243,
Appx. D. approx. 1723.

Soprano and Tenor Duet (No.
5) Ehre sei Gott in Cantata
No. 110 'Unser Mund sei voll
Lachens'. 1734(?). (Dürr, 1725
and 1728/31).

190 Alto Aria (No. 10). Buss' und Reu' from Matthew Passion. BWV 244. 1728/9. (Dürr, (perhaps) 1727, 29, 1736 and 1735/50).

Aria (No. 2).
Weh und Ach in Funeral Cantata No. 244a 'Klagt, Kinder, klagt es aller Welt'. March, 1729.

191 Alto Aria (No. 47) Erbarme dich, mein Gott from Matthew Passion (see 190).

? Aria (No. 4).
Erhalte mich, Gott in Cantata No. 244a.

192 Soprano Aria (No. 58) Aus Liebe from Matthew Passion (see 190).

? Aria (No. 5).
Mit Freuden in Cantata No. 244a.

193 Bass Aria (No. 66) Komm, süsses Kreuz from Matthew Passion (see 190).

? Aria (No. 6).
Lass, Leopold in Cantata No. 244a.

194 Bass Aria (No. 29) Gerne will ich from Matthew Passion (see 190).

? Aria (No. 7).
Wird auch gleich in Cantata No. 244a.

195 Tenor Aria (No. 26) Ich will bei meinem Jesu wachen from Matthew Passion (see 190).

Aria a 2 Chöre (No. 8) Geh' Leopold, zu deiner Ruh' in Cantata No. 244a.

196 Bass Aria (No. 75) Mache dich, mein Herze from Matthew Passion (see 190).

? Aria (No. 9).
Bleibet nur in eurer Ruh' in Cantata No. 244a.

197 Soprano Aria (No. 19) Ich will dir mein Herze schenken from Matthew Passion (see 190).

? Aria (No. 10).
Hemme dein gequältes Kränken in Cantata No. 244a

198 Chor. (No. 78) Wir setzen uns mit Tränen nieder from Matthew Passion (see 190).

Tutti Aria (No. 11) Die Augen sehn nach deiner Leiche in Cantata No. 244a.

199 Chorale a 2 Chori (No. 35) from Matthew Passion (see 190).	Part I of opening Chor. in Cantata No. 46 'Schauet doch und sehet'. 1723-7. (Dürr, 1723).
200 Alto Aria (No. 47) Erbarme dich from Matthew Passion (see 190).	Soprano and Bass Aria (Duetto) (No. 3) Wann kommst du, mein Heil in Cantata No. 140 'Wachet auf, ruft uns die Stimme'. 27th Sunday after Trinity, 1731 or 1742. (Dürr, 1731).
201 Choral (No. 63 O Haupt voll Blut und Wunden from Matthew Passion (see 190).	Choral (No. 5) Wie soll ich dich empfangen in Part I of Christmas Oratorio. BWV 248.
202 Chor. (No. 10) O Mensch, bewein dein Sünde gross from John Passion. BWV 245. 1722/3. (Dürr, 1724).	Choral a 2 Chori (No. 35) in Matthew Passion. 1740.
203 Soprano and Bass Aria & Choral 'Himmel reisse'. BWV 245a. 1723.	Mark Passion. BWV 247. (Dürr, 1731).
204 Tenor Aria, 'Zerschmettert mich, ihr Felsen und ihr Hügel'. BWV 245b.	Tenor Aria (No. 19) Ach, mein Sinn, wo willt du endlich hin in John Passion. 1723 (see 202).
205 Tenor Aria 'Ach windet euch nicht so'. BWV 245c.	Bass Aria (No. 31) Betrachte, meine Seel' and Tenor Aria (No. 32) Erwäge, erwäge in John Passion.
206 Early work, about 1712.	Luke Passion. BWV 246. 1732-4. (Dürr, 1730(?)).
207 Chor. (No. 14) Pfui dich, wie fein zerbrichst du den Tempel from Mark Passion. BWV 247. 1731.	Coro. (No. 45) Wo ist der neugeborne König der Juden in Christmas Oratorio. BWV 248. 1734.

208 Aria (No. 53) Falsche Welt, dein schmeichelnd Küssen from Mark Passion (see 207).

Alto Aria (No. 1) Widerstehe doch der Sünde in Cantata No. 54 'Widerstehe doch der Sünde' about 1730. (Dürr, Weimar, no Leipzig performance traceable).

209 Seven movements from an otherwise unknown Cantata No. 248a.

Nos. 54, 56, 57, 61, 62, 63 and 64 in Part VI of Christmas Oratorio. (See 201).

210 Tenor (Menalcas) & Bass (Damoetas) Aria à Duetto (No. 3) Entfliehet, verschwindet, ihr Sorgen from Birthday Cantata No. 249a 'Entfliehet, verschwindet, ihr Sorgen'. 23 Feb. 1725.

Tenor and Bass Duetto e Coro (No. 3) Kommt, eilet und laufet in Easter Oratorio. BWV 249. 1 Apr. 1725, 1732/5.

211 Soprano (Doris) Aria (No. 5) Hunderttausend Schmeicheleien from Cantata No. 249a (see 210).

Soprano Aria (No. 5) Seele, deine Specereien in Easter Oratorio.

212 Tenor (Menalcas) Aria (No. 7) Wieget euch ihr satten Schafe from Cantata No. 249a (see 210).

Tenor Aria (No. 7) Sanfte soll mein Todeskummer nur ein Schlummer in Easter Oratorio.

213 Alto (Sylvia) Aria (No. 9) Komm doch, Flora, komm geschwinde from Cantata No. 249a (see 210).

Alto Aria (No. 9) Saget, mir geschwinde, saget, wo ich Jesum finde in Easter Oratorio.

214 Aria à Quartetto, Soprano (Doris), Alto (Sylvia), Tenor (Menalcas), Bass (Damoetas). (No. 11). Glück und Heil from Cantata No. 249a (see 210).

Coro (No. 10) Preis und Dank in Easter Oratorio.

215 Cantata No. 249a (see 210).

Cantata No. 249b 'Verjaget, zerstreuet, zerrüttet, ihr Sterne'. 25th Aug. 1726.

216 Birthday Cantata 'Der Himmel dacht, auf Anhalts Ruhm'. 10 Dec. 1718. (66a).

Cantata No. 66 'Erfreut euch, ihr Herzen'. 1731. Dürr, 1724 (?).

217 Ratswahl Cantata, BWV Appx. 4. 'Wünschet Jerusalem Glück'. 1st Performance. (Ratswahl). 25 Aug. 1727. 2nd Performance (Jubilee of the Augsburg Confession). 27 June 1730. (Appx. 4a).

3rd Performance (Ratswahl). 18 Aug. 1741.

218 First Chor. from Cantata BWV Appx. 10. 'So kämpfet nun, ihr muntern Töne'. 25 Aug. 1731.

Chor. (No. 54) Herr, wenn die stolzen Feinde schnauben in Part VI of Christmas Oratorio.

219 Aria Ich will ihn hegen from Cantata BWV Appx. 11. 'Es lebe der König, der Vater im Lande'. 3 Aug. 1732.

Bass Aria (No. 7) Ich will dich halten und mit dir walten in Cantata No. 30a 'Angenehmes Wiederau, freue dich'. Sept. 1737. (Dürr, '35/50; before '42).

220 Aria Frommes Schicksal, wenn ich frage from Cantata BWV Appx. 11 (see 219).

Alto Aria (No. 5) Treues Echo dieser Orten in Cantata No. 213 'Lasst uns sorgen'. 5th Sept. 1733.

221 Aria Geist und Herze sind begierig from Thomasschool Cantata BWV Appx. 18. 'Froher Tag, verlangte Stunden'. 5 June 1732.

Bass Aria (No. 3) Domine Deus in Mass in F. BWV 233.

222 Movement from Cantata BWV Appx. 18 (see 221).

Credo in Mass in B minor. BWV 232.

223 First Chor. from Cantata BWV Appx. 18 (see 221).

First Chor. in Cantata No. 11 'Lobet Gott in seinen Reichen'. 1730-40. (Dürr, 1735).

224 First Aria from Cantata BWV Appx. 18 (see 221).

Alto (Glück) Aria (No. 5) Was die Seele kann ergötzen in Cantata No. 30a (see 219).

225 Cantata BWV Appx. 18 'Froher Tag, verlangte Stunden' (see 221).

Cantata BWV Appx. 12 'Frohes Volk, vergnügte Sachsen'. 3rd Aug. 1733.

226 ? Aria. Himmel, und wie lange noch from Thomas-school Cantata BWV Appx. 19 'Thomana sass annoch betrübt'. 21 Nov. 1734.

Alto Aria (No. 2) Hochgelobter Gottessohn in Cantata No. 6 'Bleib' bei uns'. 'Possibly' 1736. (Dürr, 1725).

227 Final Chor. Himmel streue deinen Segen from Cantata Appx. 19 (see 226).

Final Chor. Labt das Herz, ihr holden Saiten in Cantata No. 201 'Der Streit zwischen Phöbus und Pan'. 1731. (Dürr, 1729(?)).

228 Lost 'Emmaus' Cantata ?

Sinfonia to Cantata No. 42 'Am Abend aber desselbigen Sabbats'. 1st Sunday after Easter, 1731. (Dürr, 1725).

229 Nos. 1, 2, 3, 4, 5 and 6 of Cantata No. 248a.

Nos. 1, 3, 4, 8, 9 and 10 in pt. 6 of the Christmas Oratorio. 1735.

This is the longest and most complex of all the Tables, it is, in fact, almost a book in itself. When one studies the subject of this chapter in detail one realises that the non-cantata borrowings are a mere drop in the ocean. Of the 250 – 275 known cantatas, both sacred and secular, not less than 163 or about 65%, show traces of borrowing to a greater or lesser extent. Further reference to this subject will be made in the corresponding chapter in Part II of this book.

Although I pointed out in my general introduction that I was not adopting Alfred Dürr's chronology for the time being, I feel, in view of the vast amount of research he has carried out already, that very considerable notice must be taken of his findings. I have prepared at Table A, therefore, a list of cantatas appertaining to each Sunday and/or Feast day set out in accordance with the particulars given in his *Zur Chronologie der Leipziger Vokalwerke J. S. Bach* (1957).

With regard to Table A one must emphasize that the dates given by Alfred Dürr relate to performances. It is reasonably safe to assume that a work is written before it is performed therefore one can presume the date of composition to precede the performance by anything from a few hours to a few weeks — but I cannot believe that Bach would keep some of his works waiting several years for a hearing as is suggested by certain of the revised dates.

I do not propose to comment on these datings in detail — such is not the purpose of this book, but will deal with those instances where new dates will, if adopted, alter the pattern of a hitherto accepted borrowing. For example, if Cantata A is dated 1725 and Cantata B, using some of the same music, is dated 1735 it is a reasonable assumption that B is borrowed from A. If, however, it can be proved beyond all doubt that B is dated 1715 then we must accept the fact that A is borrowed from B!

There is, of course, just one important point to be considered. What if both A and B are borrowed or derived from an unknown or now-lost X?

RE 'BORROWINGS' FROM SECULAR WORKS.

Spitta says: — 'In the face of the inexhaustible inventive wealth, and the profound sense of artistic responsibility, testified in Bach's works, no one would dare to assert that such transfers were made for mere convenience sake, or for lack of time. They were made with a perfect feeling that the compositions in question would not be seen in their right place till they were set for Church use'.

TABLE A

N.B. J.L.B. = Johann Ludwig Bach.

	1723	1724	1725	1726	1727	1728
New Year		190	41	16	225(?)	
Sunday after New Year		153	?	?	58	
Epiphany		65	123	?	?	
1st Sunday after Epiphany		154	124	32	?	
2nd ,, ,, ,,		155	3	13	?	
3rd ,, ,, ,,		73	111	72	?	
4th ,, ,, ,,		81	?	J.L.B.1	?	
Purification		83	125	J.L.B.9	⎫ 82/83	
5th Sunday after Epiphany				J.L.B.2	⎭	
Septuagesima		144	92	J.L.B.3	84	
Sexagesima		181	126	J.L.B.4	?	
Quinquagesima Estomihi	22	?	127	?	?	
(Quadragesima (1st in Lent))		23		J.L.B.5	?	
Annunciation		182	1	?	?	
2nd in Lent						
3rd ,, ,,						
4th ,, ,,						
Palm Sunday						
Good Friday	Passion(?)	245	245	Mark Passion 232 III(?) or 15	Passion(?)	
Easter I		4	249/4	J.L.B.10	232 III	
,, II		66	6	J.L.B.11	?	
,, III		134	4	J.L.B.6	?	
Quasimodogenite (Low Sunday)		67	42		?	

	1723	1724	1725	1726	1727	1728
Misericordias (2nd after Easter)		104	85	J.L.B.12	?	
Jubilate (3rd after Easter)		12	103	J.L.B.8	?	
Cantate (4th after Easter)		166	108	J.L.B.14	?	
Rogation Sunday		86	87		?	
Ascension Day		37	128	43	?	
Exaudi (Sun. after Ascension)		44	183	?	?	
Whitsun I	59	172	74	?		
,, II		173	68	?		173
,, III		184	175			
Trinity Sunday		194/165	176	129? or 194	129(?)	
Corpus Christi						
1st Sunday after Trinity	75	20	?	39		
2nd ,, ,, ,,	76	2	76(?)	?		
3rd ,, ,, ,,	21	135	?	?		
4th ,, ,, ,,	24	10	?	J.L.B.17		
St. John.	167	?				
5th Sunday after Trinity	?	93	?	88		
6th ,, ,, ,,	?	?	?	170/J.L.B.7		
7th ,, ,, ,,	186	107	?	187		
8th ,, ,, ,,	136	178	?	45		
9th ,, ,, ,,	105	94	168	?		
10th ,, ,, ,,	46	101	?	102		
11th ,, ,, ,,	179	113	?	J.L.B.15		
12th ,, ,, ,,	69a	?	137	35	69a	
13th ,, ,, ,,	77	33	164	J.L.B.16	?	
14th ,, ,, ,,	25	78	?	17		
15th ,, ,, ,,	138	99	?	19		
16th ,, ,, ,,	95	8	?	27		
17th ,, ,, ,,	148(?)	114		47		

	1723	1724	1725	1726	1727	1728
18th ,, ,,	?	96	?	169		
Michaelmas	?	130	?		149	
19th Sunday after Trinity	48	5	?	56		
20th ,, ,, ,,	162	180	?	49		
21st ,, ,, ,,	109	38	?	98	188	
Reformation		76	79	?		
22nd Sunday after Trinity	89	115	?	55		
23rd ,, ,, ,,	163(?)	139	?	52		
24th ,, ,, ,,	60	26	?			
25th ,, ,, ,,	90	116	?			
26th ,, ,, ,,	70		?			
27th ,, ,,						
Advent Sunday	61	62	?	?		
2nd Sunday in Advent						
3rd ,, ,, ,,						
4th ,, ,, ,,						
Christmas I	63	91	110	232(?)III	1	197a
,, II	40	121	?	?		
,, III	64	133	?	?		
1st Sunday after Christmas		122				

	1729	1730	1731	1732	1733	1734	1735
New Year	171(?)			41(?)	41(?)	41(?)	248[IV]
Sunday after New Year					58(?)	58(?)	248[V]
Epiphany							248[VI]
1st Sunday after Epiphany							
2nd ,, ,, ,,							
3rd ,, ,, ,,	156(?)			73(?)	73(?)	73(?)	73(?)
4th ,, ,, ,,							14
Purification		82(?)	82(?)				82
5th Sunday after Epiphany							
Septuagesima							
Sexagesima							
Quinquagesima Estomihi	159(?)						
Quadragesima							
Annunciation							
2nd in Lent							
3rd ,, ,,							
4th ,, ,,							
Palm Sunday							
Good Friday	244[b]	246(?)	247				66(?)
Easter I			31	249(?)	249(?)	249(?)	249(?)
,, II			66				66(?)
,, III	145(?)		134				66(?)
Quasimodogenite (Low Sunday)			42				
Misericordias (2nd after Easter)			112				
Jubilate (3rd after Easter)			103				
Cantate (4th after Easter)							
Rogation Sunday							
Ascension Day			37				11
Exaudi (Sunday after Ascension)							

	1729	1730	1731	1732	1733	1734	1735
Whitsun I			172				
,, II	174		173	173(?)	(173(?))	173(?)	173(?)
,, III			184				
Trinity Sunday			194	129(?)	129(?)	129(?)	129(?)
Corpus Christi							
1st Sunday after Trinity		190					
2nd ,, ,, ,,	2						
3rd ,, ,, ,,							
4th ,, ,, ,,				177			
St. John							
5th Sunday after Trinity				93(?)	93(?)		
6th ,, ,, ,,				9(?)	9(?)	9(?)	9(?)
7th ,, ,, ,,							
8th ,, ,, ,,							
9th ,, ,, ,,				94(?)	94(?)	94(?)	94(?)
10th ,, ,, ,,							
11th ,, ,, ,,							
12th ,, ,, ,,							
13th ,, ,, ,,							
14th ,, ,, ,,							
15th ,, ,, ,,		51					
16th ,, ,, ,,							
17th ,, ,, ,,							
18th ,, ,, ,,						96	
Michaelmas							
19th Sunday after Trinity				5(?)	5(?)	5(?)	5(?)
20th ,, ,, ,,							
21st ,, ,, ,,							
Reformation		192(?)					

	1729	1730	1731	1732	1733	1734	1735
22nd Sunday after Trinity							
23rd " " "							
24th " " "							
25th " " "							
26th " " "							
27th " " "							
Advent			140	62(?)	62(?)	62(?)	62(?)
2nd Sunday in Advent			36				
3rd " " "							
4th " " "	63			91(?)	91(?)	248$^{\mathrm{I}}$ 248$^{\mathrm{II}}$ 248$^{\mathrm{III}}$	91(?)
Christmas I							
" II							
" III							

N.B.
Circumcision	. . .	= New Year
Estomihi	. . .	= Quinquagesima
Quasimodogeniti	. .	= 1st Sunday after Easter
Misericordias Domini		= 2nd " " "
Jubilate	. . .	= 3rd " " "
Cantate	. . .	= 4th " " "
Rogate	. . .	= 5th " " "
Exaudi Sunday after Ascension

WORKS ASSIGNED TO MISCELLANEOUS DATES.

1	Before July 1723	BWV 237
2	Feast of Visitation (2.7.23)	147
3	Birthday of Friedrich II of Sachsen-Gotha (9.8.1723)	20
4	Ratswechsel (30.8.23)	119
5	New organ at Störmthal (2.11.23)	194
6	Around Whitsun 1724	Appx. 24
7	Ratswechsel (28.8.24)	?
8	Wedding (12.2.25)	Appx. 14
9	Birthday of Christian of Sachsen-Weissenfels (23.2.25)	249a
10	Birthday of a teacher (April/May 1725)	36c
11	University Festival (3.8.25)	205
12	Ratswechsel (27.8.25)	?
13	Wedding at Hohenthal (27.11.25)	Unnumbered
14	Bridal Mass (6.3.26)	34a
15	Feast of Visitation (2.7.26)	JLB 13
16	Rathswechsel (26.8.26)	193
17	Birthday of Princess of Anhalt-Köthen (30.11.26)	36a
18	University Festival (11.12.26)	207
19	(Secular) 1726 or 27	204
20	Funeral Service (von Ponickau) (6.2.27)	157
21	Birthday of August II (12.5.27)	Appx. 9
22	Nameday of August II (3.8.27)	193a
23	Ratswechsel (25.8.27)	Appx. 4
24	University Festival (17.10.27)	198
25	Wedding (Wolff-Hempel) (5.6.28)	216
26	Ratswechsel (around 1728)	120
27	Funeral (Leopold of Anhalt-Köthen) (24.3.29)	244a
28	Funeral (Rector Ernesti) (24.10.29)	226
29	Wedding? (1729)	120a
30	„ („)	250/252
31	Augsburg Confession I (25.6.30)	190
32	„ „ II (26.6.30)	120
33	„ „ III (27.6.30)	Appx. 4
34	Ratswechsel (25.8.30)	Appx. 3
35	Birthday. Countess Flemming (25.8.31)	Appx. 10
36	Rathswechsel (27.8.31)	29
37	Wedding (?)	195

38	Consecration Thomas school	(5.6.32)	BWV Appx. 18
39	Nameday August II	(3.8.32)	Appx. 11
40	Church Service	(21.4.33)	232¹
41	Nameday August III	(3.8.33)	Appx. 12
42	Birthday of ? Prince	(5.9.33)	213
43	Birthday of Queen	(8.12.33)	214
44	Coronation Feast of August III	(17.1.34)	205a
45	Nameday of August III	(3.8.34)	207a
46	Anniversary of August III	(5.10.34)	215
47	Greetings to Rector Ernesti	(21.11.34)	Appx. 19
48	Undated		97
49	Nameday of August III	(3.8.35)	207a(?)
50	Birthday of Prof. Rivinus	(28.7.35)	36b
51	Birthday of August III	(7.10.36)	206(?)
52	Greetings in Wiederau	(28.9.37)	30a
53	Greetings to August III	(27.4.38)	Appx. 13
54	Ratswechsel	(31.8.39)	29
55	Greetings Klein-Zschocher	(30.8.24)	212
56	Ratswechsel	(24.8.49)	29

NOTES ON TABLE IX

1 Our very first entry in this chapter provides a good example of a chronological puzzle. Spitta ascribes Cantata No. 2 to the 1735–44 period. Schmieder keeps to the same date period but Alfred Dürr brings it forward to 1724! Schmieder, however, attributes the composition of the Choral, Ach Gott, (BWV 741) to Johann Christoph, son of Heinrich Bach. If this is correct we have here a case of an outside borrowing from Bach – only justice in view of the amount J. S. B. borrowed from others!

Whittaker feels that No. 5 (Tenor aria) Durch's Feuer wird das Silber sein may, possibly, come from another source.

BWV 2, 741

2 Cantata No. 3 is relegated to that mysterious period 1735 – 44 which contains all the works of doubtful date. In all probability it, too, will be found to have originated somewhere between 1724 and 30 and it is because of this possibility that it can be considered as the forerunner of Cantata No. 58 dated as 4th Jan .1733. Indeed Dürr dates it as 1725. BWV 3, 58

3 Cantata No. 4 presents another delightful problem await-
ing a solution from Dr. Dürr. It is assumed to have been
written for the 9th of April (Easter) 1724 but innumerable
signs point to an earlier origin. Spitta regards it as being in
the style of Buxtehude's sacred music and wonders whether
Bach purposely returned to an earlier school of composition
or worked up a youthful work. He feels that the type of
melody, the constant repetitions and the brevity (14 bars
only) of the Sinfonia all point towards an early work. On the
other hand he finds that the watermark puts the work into the
1724 – 27 period – this, of course, could be the case with the
copy known to us, not necessarily the original version.

Schmieder considers the possibility of the work having origin-
ated 'perhaps' in Weimar. Whittaker, also, is of the opinion
that the work has a pre-Leipzig, possibly Weimar, date and
mentions that it is the only cantata existing which is in the
manner or style of Buxtehude, Pachelbel and Kuhnau. He says
of the Bass solo (No. 6) Hier ist das rechte Osterlamm: —
'There are few solo voices which can deliver this remarkable
number adequately. It must have been written for the excep-
tional Hofcantor Wolfgang Christoph Alt in Weimar – Bach
has left a remarkable tribute to his powers'. (See Ex. 39.).

BWV 4

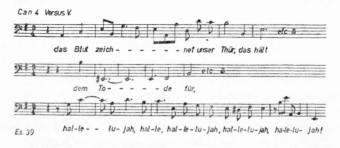

Can 4 Versus V.

das Blut zeich - - - - - - net unser Thür, das hält

dem To - - - - - de für,

Ex. 39 hal-le - - lu- jah, hal-le, hal-le-lu-jah, hal-le-lu-jah, ha-le-lu- jah!

4 In Spitta's day the original parts of Cantata No. 8 were
in the Thomas school in Leipzig. These parts are in the key
of D and the two oboes d'amore in the first Chor are reallotted
to two concertante violins. The original score is lost but copies
of it exist in the key of E.

Spitta says ' it is clear that Bach must have made the
arrangement – which greatly facilitates the labours of the

oboe players – soon after composing the cantata and, probably, before it was performed in public'.

If this is so should we not revert to the key of D when performing this work? It is far kinder than E, not only to the oboes d'amore, but to the transverse flutes and corno. BWV 8

5 Musicologists have remarked on the fact that the 'short' Masses are mere rearrangements and hotch-potches of other works. So much so that Spitta declares that they could not have been written for use in Leipzig – they must have been intended for somewhere else – perhaps Dresden.

Although one would hesitate to describe the Mass in B minor as a hotch-potch one must agree that it contains its fair share of borrowed movements. One of these was thought to be the Aria from Cantata No. 11 which Paul Steinitz refers to as 'the original and more profound version of the Agnus Dei'. Schmieder says that the Aria was 'fitted later' as the introduction to the Agnus Dei and Whittaker remarks that it is better known in its later form – the Agnus Dei. Although, in a casual way, we date the Mass as 1733, we must remember that this date applies only to what Bach called the Missa, ie. the Kyrie and Gloria. The remainder of the work dates from 1742 onwards – possibly as late as 1745 or even 47 – there is no reason, therefore, why the writers referred to should not be correct. (See Ex. 40.).

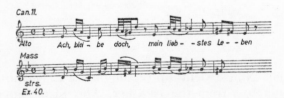

Ex. 40.

With regard to the first Chor, Lobet Gott, Whittaker feels that the awkward allocation of words suggest that it is derived from a lost secular work – perhaps a congratulatory ode written for a Prince. As he says: — 'knowing Bach's methods when writing occasional pieces, one may assume that this number again was borrowed. The unimportant word 'zu' would never have been set so in an original composition'!

Terry says that the metre of the Chor fits exactly the first Chor of 'Froher Tag' (BWV Appx. 18) of 5th June, 1732 – the music of which is now lost. (See Ex. 41.). BWV 11, 232

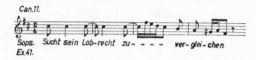

Ex.41.

6 Both Spitta and Schmieder believe that Cantata No. 12 for Easter, 30th April 1724, is a reworking of an earlier, Weimar, version dating from 22.4.1714. As the former mentions the Sinfonia is one of those broad, richly harmonised, Adagios which occur most frequently in his earlier sacred works. BWV 12

7 Back to the Mass in B minor again – this time for the original version of the Crucifixus. Tovey makes a good point when he says (Vol. 5): — 'It is a mistake to suppose that any number of such adaptations as this Crucifixus could prove that Bach was losing interest in the composition of the B minor Mass. . . . he spent quite as much pains and often as much original inspiration over adaptations as over new works. The original version of the Crucifixus is the first chorus of Cantata 12'. (See Ex. 42.). BWV 12, 232

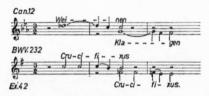

Ex.42

8 Cantata No. 12 yields up yet another of its treasures – the Passacaglia bass from the 1st Chor. This theme appears to have haunted the composer from his earliest days – it was not his in the first instance as we shall see later. (See Ex. 43.). BWV 12, 78

Ex. 43

9 Let us consider this Cantata as it was before Dürr pro-
nounced on its authenticity.
It was written for Easter Day, 1704, i.e. when Bach was 19
and is, therefore, his first known Cantata. Two revisions
followed, the first about 1724 and the second around 1735.
The Soprano Recit. (No. 2), Mein Jesus ware todt, and the
Soprano and Alto Duet (No. 3), Weichet, Furcht und
Schrecken, were added at the time of the 1735 remodelling –
No. 3 having first been taken from another Cantata written
possibly for the 2nd day of Easter.
The final Choral, Weil du vom Tod' erstanden bist, was
added in Leipzig. Its words and melody are both by N.
Herman. However – Dürr has now decided that Cantata 15 is
not by Bach! But what about the revisions of 1724 and 35?
Are they, too, spurious or Bach's own reconstructions of some-
one else's compositions? BWV 15, 189

10 Spitta refers to No. 15 as a work of Bach's youth –
remodelled for use in Leipzig 'but even this was when he was
but 30 years old'. Spitta is a little out in his reckoning here –
as Bach was born in 1685 he would have been 30 in 1715 –
during his Weimar period – and did not go to Leipzig until
he was 38. He was 50 in 1735 when, according to Schmieder,
he 'renewed' the work. BWV 15

11 As Spitta so rightly points out the Masses in G (BWV 236)
and G minor (BWV 235) were not new compositions – they
consist entirely of portions of Cantatas written previously.
 BWV 17, 236

12 This is one of two Masses thought to have been written
for Count Franz Anton von Sporck and, like those in G and
G minor, patched together from other sources – of which
Cantata 19 may have been one. (See Ex. 44.). BWV 19, 233

Can.19

Es er–hub sich ein Streit - - - - -

BWV.233

Glo- - - - - - - - - - - - - - - ri–a in ex-cel-

Ex. 44

13 Schmieder dates Cantata No. 20 as 'possibly 1735'. On the other hand Dürr says 1724. If Schmieder's 'possibility' turned out to be correct we should have to transfer the order of borrowing as Cantata No. 60 would have been written first.

BWV 20, 60

14 For several reasons Whittaker is inclined to think that Cantata No. 21 in its present form is not as first designed. It is possible that Part I was a complete Cantata in itself at one time. The Coro (No. 6), Was betrübst du dich, might well have closed a choral Cantata of proportions similar to the majority of the Weimar productions. The orchestration scheme of Part I is not followed out in Part II – nor does the text of Part II follow naturally on to Part I. 'It is, therefore, reasonable to suppose from the evidence given above that the second part was tacked on to the first when a work was required in a hurry for some particularly important event. The generally mixed orchestration of the second part suggests that it was wholly or partly compiled from already existing material'.

BWV 21

15 Although Cantata No. 23 is dated 1723 its first performance was for Quinquagesima in 1724. Whittaker thinks it possible that in the haste of production of the John Passion Bach may have borrowed this Chorus from the already completed Cantata. The Choral is equally appropriate to both works.

BWV 23, 245

16 The John Passion was written for Good Friday, 1723, but not performed until 1724. This Choral was added to the Passion in 1723 but, as the first performance was postponed, was transferred back to Cantata 23.

BWV 23, 245

17 This a capella Motett was added to a Motett, 'Jauchzet dem Herrn alle Welt', written by G. Ph. Telemann, as its second movement. Schmieder numbers Bach's contribution as BWV 231 and the other movements by Telemann appear as Appx 160.

BWV 28, 231

18 Two more borrowed items in the Mass in B minor or, rather, one item used twice. The time signatures, ₵, are the

same in each case but one is written in 2/2 and the other in 4/2.

The original form of the Chorus is unknown. Whittaker considers it as completely archaic in style – so unlike what one meets in Cantatas that it itself must have been borrowed from another work. (See Ex. 45.). BWV 29, 232

Ex.45

19 The tenor version was borrowed in the first instance (see Table V. No. 3) and the alto is just a transposition with change of voice, change of obbligato instrument (organ instead of violin) and minus the 21-bar introduction which was so effective before the entry of the tenor voice. BWV 29

20 Six numbers from Cantata No. 30a were transferred to No. 30. They are as follows: —

1. Chor. (No. 1), Angenehmes Wiederau, became Chor, Freue dich erlöste Schar.

2. Bass Aria (No. 3), Willkommen im Heil, became Bass Aria, Gelobet sei Gott.

3. Alto Aria (No. 5), Was die Seele kann argötzen, became Alto Aria, Kommt, ihr angefocht'nen Sünder.

4. Bass Aria (No. 7), Ich will dich halten, became Bass Aria (No. 8), Ich will nun hassen.

5. Soprano Aria (No. 9), Eilt, eilt, became Soprano Aria (No. 10). Eilt, eilt.

6. Final Chor (No. 13), Angenehmes Wiederau, became Final Chor (No. 12), Freue dich, geheilg'te Schar.

Johann Christian von Hennicke was created a Count and given the town of Wiederau as a fief. Cantata No. 30a was

written to celebrate his taking over and entering into his Squireship on 28 Sept. 1737.

Whittaker sums the position up very neatly when he says: —
' the greatest genius of the age had written splendid music for his (Hennicke's) house warming. Such music was too good to be wasted'. He feels, however, that the adaptation is quite a shameless one as the secular music is allowed to remain unaltered and the non-sacred origin of some of it is extremely obvious. He goes on to express his amazement that Bach could be so unscrupulous and submit his own music to such flagrant abuse. ' a trait in his character which defies explanation or exoneration'. He describes the transfer of Alto Aria No. 5 (3 above) as 'the worst crime Bach ever committed against himself'. BWV 30, 30a

21 If Cantata No. 210 dates from 1734 or 5 it is possible that the aria in No. 30a comes from it. On the other hand, if it dates from 1740 then, presumably, the 30a aria came first and was adapted four or five years later for No. 210. Neumann thinks it became aria No. 8 in Cantata 210a of 1738/40.

BWV 30a, 210

22 The first movement, *Sonata,* is scored for 3 trumpets and timpani, 3 oboes, taille and fagotto, violins I and II, violas I and II, cellos I and II and continuo – that is, 16 or 17 players even with only one to a part. This is a comparatively large orchestra by Bach's standards – did he really have all these players at his disposal at Weimar?

Spitta says that it was composed at Weimar but certainly not for his first Easter there. Does this remark, together with the instrumental forces required, suggest that the 1715 version was itself derived from a still earlier work – secular, perhaps, or of chamber music or orchestral type?

The 1731 revision included adding another vocal part to the opening chorus, strengthening the instrumental parts and changing the setting of the Soprano aria (No. 8), Letzte Stunde, brich herein. BWV 31

23 There is an assortment of dates attached to Cantata No. 34a. Dürr – '1726'; Whittaker – 'after 1731' but Spitta – 'Nov. 1728'.

No. 34a contains seven movements and is in two sections –

whereas No. 34 has only five – three main and two recitatives.

Chor (No. 1) of 34a, O ewiges Feuer, became Chor (No. 1) (same title) in No. 34.

Chor (No. 4) of 34a, Friede über Israel, became Chor (No. 5) (same title) in No. 34.

Alto Aria (No. 5) in 34a, Wohl euch ihr auserwählten Schafe, became Alto Aria (No. 3), Wohl euch, ihr auserwählten Seelen, in No. 34. (See Ex. 46.).

Spitta considers that No. 34 was written at the same time (1740?) as Kirnberger's copy of the Matthew Passion although Dürr dates it as 'after 1742'.

In spite of dating No. 34a as 'after 1731' Whittaker thinks that the Alto Aria may have come from a now-lost Christmas Cantata. BWV 34, 34a

24/5/6 Before Dürr's theories were known to us the four Cantatas grouped under No. 36 were dated as follows : —

1)	36a	– 30 Nov. 1726.
2)	36c	– 1733 – 34.
3) (or 4)	36	– 1728 – 36.
4) (or 3)	36b	– 28 July 1733.

The new order reverses them thus : —

1)	36c	– 1725(?).
2)	36a	– 1726.
3)	36	before 1731.
4)	36b	– 1735(?).

The pre-Dürr transfer of arias between the four Cantatas becomes fairly clear if set out so: —

1) Aria (No. 1), Steigt freudig in die Luft, in 36a became
 Coro (No. 1), Schwingt freudig euch empor, in 36c, 36
 and 36b.

2) Aria (No. 3), Die Sonne zieht mit Sanftem Triebe,
 in 36a became

Ten. Aria (No. 3), Die Liebe zieht mit sanften Schritten,
 in 36

Ten. Aria (No. 3), Die Liebe führt mit sanften Schritten,
 in 36b

Ten. Aria (No. 3), Aus Gottes milden Vater-händen in 36c

3) Aria (No. 5), Sei uns willkommen, schönster Tag
 in 36a became

Bass Aria (No. 5), Willkommen, willkommen, werter Schatz
 in 36

Bass Aria (No. 5), Der Tag, der dich vor dem gebar, in 36b

Alto Aria (No. 5), Das Gute, das dein Gott beschert, in 36c

4) Aria (No. 7), Auch mit gedämpften, schwachen Stimmen,
 in 36a became

Sop. Aria (No. 7), Auch mit gedämpften, schwachen Stimmen,
 in 36

Sop. Aria (No. 7), Auch mit gedämpften, schwachen Stimmen,
 in 36b

Sop. Aria (No. 7), Mit zarten und vergnügten Trieben,
 in 36c

5) Aria (No. 9), Grüne, blühe, lebe lange, in 36a became

Ten. Aria (No. 8), Bei solchen freuden vollen Stunden,
 in 36b.
(See Ex. 47.).

The new dating, of course, reverses the transfers between 36a and 36c.

Ex.47

So far as orchestration is concerned: —

No. 36 has 3 oboes d'amore,

No. 36b has 1 oboe and

No. 36c has 1 traverso.

The obbligati to No. 7 are: —

in No. 36 violino con sord.

No. 36b viola d'amore and

No. 36c traverso. BWV 36(a), (b), (c)

27 Whittaker refers to 'this choral cantata dating about
1740' as having borrowed a tenor aria from an unknown

source '. . . . the declamation is so faulty that one cannot conceive it to be an original setting'. Schweitzer goes so far as to recommend the omission of the movement on account of its wrong accentuation! (See Ex. 48.). BWV 38

Can. 38 No. 3

Ich hö-re mit-ten in dem Lei - den.

Ex.48

28 Schweitzer condemns Bach quite strongly for the manner in which he 'composed' the so-called 'short' Masses. 'As he was in a great hurry, he did not waste time in writing new works, but to a large extent made these Masses up out of Cantatas. *The adaptations are perfunctary and occasionally quite nonsensical'.*

He goes on to say that probably the only original section of these Masses is the Kyrie of the F major. Certainly the Qui Tollis and the Quoniam came from Cantata No. 102 and the Cum Sancto Spiritu from Cantata No. 40. BWV 40, 233

29 Whittaker says of Cantata No. 41 that the libretto could be conceived only for some national rejoicing and the ending of some war. The War of the Polish Succession, which had raged for several years, finished in 1736 so one might consider that as the year of composition. With regard to Cantata No. 171 he thinks that, as Picander's libretto was published in 1728, 1730 is a more likely date for its composition than 'after 1736'.

According to Spitta Bach commenced the composition of 171 in about 1730, left it unfinished and finally completed it sometime after 1736 when he transferred the newly-written choral from Cantata No. 41. The new dates, if accepted, do not change the order of events necessarily but certainly bring them forward as Dürr dates No. 41 as 1 Jan. 1725 and No. 171 as, possibly, 1729. BWV 41, 171

30 Here, again, Dürr's researches do not change the sequence

of transfer but merely bring it forward. Spitta says of the tenor choral in Cantata No. 44 that it is a free imitation of Böhm's style of choral treatment and that 'in a Cantata written much later' Bach worked out the choral melody in the same manner but for SATB instead of one voice. In fact, according to Dürr, the Cantata (No. 3), 'written much later', came after only one year. He dates No. 44 as 1724 and No. 3 as 1725. (See Ex. 49.). BWV 3, 44

Can. 44

Can. 3

Ex 49

31 Parry says that the Qui Tollis is one of Bach's most concentrated and deeply felt movements. The vocal subject seems to spring spontaneously from the verbal syllables and every individual note has its meaning and function.

This is, in its way, praise of Bach the borrower rather than the composer for Parry goes on to point out that 'the movement was not composed to the words, but is borrowed from the Cantata' (No. 46). ' it would scarcely be believed that music could be so aptly transferred from German to Latin unless it were here seen'. How very right Parry is!

The actual transfer involved enriching the texture and transposing the movement down a minor third in addition to the resetting of the music to the different text. BWV 46, 232

32 Cantata No. 47, dated by Dürr as 13 Oct. 1726 and rewritten for the 17th Sunday after Trinity, constitutes a revision rather than a borrowing as, in it, Bach substituted an organ obbligato for the original written for flute, oboe or violin. BWV 47

33 This work, Nun ist das Heil, written for double choir, is an enigma. As Spitta says, it is too short to be a Cantata and, because it has a heavily orchestrated accompaniment (3 trumpets and timpani, 3 oboes, strings and organ) cannot be considered as a Motett. Its subject does not fit it for use during a Communion Service. Most probably it formed the opening of a Michaelmas Cantata and, no doubt, had an orchestral prelude or Sinfonia. BWV 50

34 Dürr dates Cantata No. 51 as 1730 and cannot find any evidence of a later performance although Spitta thinks that Bach changed the text so that the work was suitable for Michaelmas. He wonders if 1737 was the year in question as then the 15th Sunday after Trinity fell upon the same day as St. Michael. BWV 51

35 Schmieder suggests that the Cantata 54 aria 'probably' came out of the lost Mark Passion. For this to be possible one must assume that parts of the Passion, including this aria, were written some years prior to Good Friday, 1731, as Schmieder dates Cantata No. 54 at 'about 1730'. Dürr, on the other hand, solves the problem very neatly by dating Cantata 54 back to the Weimar period and, furthermore, is unable to trace any performance of it in Leipzig. BWV 54, 247

36 Spitta considers that the water marks date Cantata No. 58 as 1729 or 1733 to 5 and Schmieder opts for 1733. As the latter gives that useful period 1735 – 44 to Cantata No. 3 we were quite safe in assuming that the two chorals were transferred from the higher to the lower number.
The difference in treatment is most interesting – the two versions of the melody in Cantata No. 58 being in 3/4 and 2/4 and in common time in Cantata No. 3. Dürr, however, has set the cat among the pigeons once again by dating Cantata No. 3 as 1725 and Cantata 58 as 1727, therefore we must revise our ideas and consider the possibility that the settings were transferred from No. 3 to No. 58! (See Ex. 50.). BWV 3, 58

Can.58 No.1

Ach Gott, wie man - ches Her - ze- leid

Can. 58 No.5

Ich hab' vor mir ein' schwe - re Reis'

Can.3 No.2

wie schwerlich lässt sich Fleisch und Blut

Can. 3 No.6

Ex.50 Er - halt' mein Herz im Glau - ben rein

37 Tradition suggests that Cantata No. 59 originated in Weimar as the autograph score has a watermark which does not appear in any Leipzig MS. On the other hand the parts carry a watermark of the 1723–27 period. Spitta explains this by assuming the original parts to be lost and a new set being prepared for a performance in Leipzig. Dürr feels that although there may be some truth in this story it cannot be confirmed in any way. Bearing in mind the lack of low bass normally associated with Weimar works, comparing No. 59 stylistically with Cantatas No. 172 and 31 (both dating from 1724) and considering Schering's article in the Bach Jahrbuch for 1938 he is almost certain that the work was written especially for the Whitsun Service in the University Church in 1724 or, (possibly), 1723.

He dates Cantata No. 74 as 1725 – it can, therefore, have been derived from Cantata No. 59. BWV 59, 74

38 Apart from extending the four movements of Cantata No. 59 to the eight of No. 74 Bach revised the instrumentation and orchestration.

No. 59 requires two trumpets, timpani and strings,

No. 74 requires three trumpets and timpani, two oboes and oboe da caccia and strings.

The accompaniment of the Cantata 59 aria is for violin and continuo whereas in No. 74 it is changed to oboe da caccia and continuo. Whittaker points out that the transfer was not a particularly happy one as the new words do not fit the old melody very comfortably.

On the other hand I feel that the long note on the first syllable of 'Herze' in No. 74 is more natural than the prolongation of the 'al' of 'allen' in No. 59. Could it be that 59 itself is derived from a still earlier source and that the underlaying of 74 is closer to that original than in 59? (See Ex. 51.). BWV 59, 74

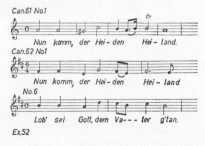

39 Dürr's redatings do not affect the order of borrowing in this case even if we accept 1723 or 24 for Cantata No. 59. He brings Cantata No. 175 forward by ten years to May 1725 but it still follows No. 59 by a year or so. BWV 59, 175

40 Cantata No. 61 was performed again on 28 Nov. 1723 (1st Sunday in Advent) and Cantata No. 62 on 3 Dec. 1724 (also 1st Sunday in Advent). Note that once again Dürr has brought a work out of that mysterious 1735 – 44 region!

The composer's different versions of the old tune are extremely interesting. For example he does not seem to mind whether the 4th is diminished as in Cantata 61 No. 1 or perfect as in 62 No. 1. (See Ex. 52.). BWV 61, 62

Can.61 No1

Nun komm, der Hei - den Hei - land.

Can.62 No1

Nun komm, der Hei - den Hei - land

No.6

Lob' sei Gott, dem Va - - - ter g'tan.

Ex.52

41 Whittaker suggests that the movements other than the choral ones in Cantata No. 64 may have been borrowed from some earlier work, shortage of time making the transfer necessary.

In addition to its possible borrowings Cantata No. 64 had to lend, for Cantata No. 91 (redated 1724 by Dürr) made use of Cantata 64's Choral No. 2. (See Ex. 53.). BWV 64, 91

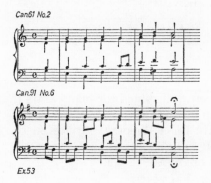

42 Cantata No. 94 also had to borrow from No. 64. The fact that Dürr brought No. 94 forward from 1735 to 6 Aug. 1724 does not change the general pattern. BWV 64, 94

43 Cantata No. 66 is supposed to be derived from a hitherto unnumbered and now lost birthday Cantata written for Prince Leopold, 10 Dec. 1718. Schmieder and Spitta date No. 66 as 1731 and 1735 respectively and Whittaker mentions that the libretto was published in 1731.

Obviously, if Dürr's 1724 date is accepted, one must assume that Bach had access to the libretto before its publication date!

Dürr has now renumbered the 1718 version as 66a and entitled it as 'Der Himmel dacht auf Anhalts Ruhm und Glück'. BWV 66, 66a

44 It is possible that the Mass in A is one of the works

commissioned by Reichsgraf Franz Anton von Sporck of Lissa in Bohemia. The transfer of No. 6 of Cantata 67 involved, amongst other problems, the amplification of a Bass solo into a full chorus. (See Ex. 54.). BWV 67, 234

45　It has been understood for many years that Cantata No. 69 was written for the 12th Sunday after Trinity, 27 Aug. 1724 and used again for a Ratswahl service on the following day (Aug. 28th). It was then revised as Cantata No. 69a for further Ratswahl use on 27 Aug. 1730.

Dürr, however, has reversed the order by dating No. 69a as 15 Aug. 1723 and No. 69 as between 1743 and 50.

Spitta's remark to the effect that references to the city government were greatly strengthened in the text of No. 69a – so rendering it unfit for use on the twelfth Sunday after Trinity – becomes unfounded. BWV 69, 69a

46　Bearing Dürr's transfer of borrowings in mind it will be realised that the No. 69a Recitative is a simplified version of the same movement in No. 69.

Tovey says that Bach NEVER borrowed a Recitative – he found it much quicker and simpler to rewrite completely – the fact that Bach saw fit to do so in this instance is well worth noting. (See Ex. 55.). BWV 69, 69a

47 The only differences between the two arias are key and a slight degree of ornamentation. (See Ex. 56.). BWV 69, 69a

Can.69a (Ten.)

Can.69 (Alto)

Ex.56

48 Although Bach saw no need to change the 1st Chor, Lobe den Herrn, nor the Bass aria (No. 5), Mein Erlöser und Erhalter, evidently he was not satisfied with the final Choral which he did change. BWV 69, 69a

49 Obviously Bach had no objection to Was Gott tut as a choral as he was quite happy to use it again ten years later in Cantata No. 100. (1732 – 35). BWV 69a, 100

50 This Cantata has seen some changes. It began life in Weimar in 1716, was rewritten with a choral and recitatives added in Leipzig in 1723 and used again in 1731. Schmieder mentions that the early (1716) version is lost. Whittaker, however, suggests that if one omits the 1st Choral and the recitatives (Nos. 2, 4, 6 and 9) one is left with the original. He is of the opinion that the Bass aria (No. 10), Seligster Erquikkungs-Tag, was written for Hofcantor Alt. Its tremendously wide intervals provide yet another tribute to his phenomenal voice. (See Ex. 57.). BWV 70

Can.70 No.10

Ex.57 Lust die Fül - - - - le

51 One can understand Bach's transfer of a complete Sinfonia, chor, aria or choral because the thought that such-and-such a movement was apt for a contemplated new position could easily come to his mind but what about the transfer or borrowing of a short phrase or even a few notes? Did he

consciously look these up in his records or did they well up
from his subconscious?

The following example is a case in point. Sixteen years
separate the two phrases – identical in shape if different in
application. Almost too small a case to be considered, perhaps,
yet the phrases are very similar! (See Ex. 58.). BWV 12, 71

52 Dürr is prepared to consider the possibility of Cantata
No. 72 having been written in Weimar in 1715. (The text by
Salomon Franck is dated 1715), Schmieder gives between 1723
and 25 for its Leipzig performance (after considerable revision)
but Dürr dates it as 1726.

Apart from a certain amount of rewriting the transfer involved
transposition from A minor to G minor. BWV 72, 235

53 Schmieder dates this Cantata as between 1723 and 27;
Whittaker as 'probably' 1725 and Dürr as 1723 or 23 Jan.
1724. A horn is used to support the Cantus Firmus in the 1st
Choral and to play a short Prelude. Later, (1732/5?), Bach
transferred this part to the Rückpositiv and Brust-Positiv of
the organ at St. Thomas'. Strictly speaking this transfer con-
stitutes a revision rather than a borrowing. BWV 73

54 Cantata No. 75 exists in an alternative and shortened
form known as 'Was hilft der Purpurs Majestät'. This version
commences with the Bass recitative (No. 2 of the full version).

There can be no doubt of the parentage of the borrowed choral although it is elaborated somewhat. N.B. Did the Bach of 1723 overlook the canonic possibilities of the theme?— certainly he didn't ten years later! (See Ex. 59.). BWV 75, 100

55 Part II of Cantata No. 76, commencing with the Bass recitative (No. 9), was revised as a Reformation Cantata, 'Gott segne noch die treue Schaar', (un-numbered by Schmieder and dated 1745). BWV 76

56 Dürr's redating of Cantata No. 69 means that the transfer of Choral No. 7 in Cantata No. 76 to Choral No. 6 in No. 69 did not occur after the lapse of about 14 months but after 20 – 27 years! It is, therefore, not surprising that his harmonisation of the tune should have become more simple with the years. (See Ex. 60.). BWV 69, 76

Ex.60

57 Schmieder gives the period 1735 – 44 for Cantata No. 78 and the Mass in B minor as 1733. If this were accepted then the borrowing of the bass theme would be from the Mass to the Cantata. Dürr very kindly solves this part of the problem for us by redating Cantata No. 78 as 1724 and the Credo of the Mass as 1747 – 50! Spitta says of the Mass: — ' here, the bass which had haunted the musician from his earliest youth, is cast in its final form'. (See Ex. 30.).
This, no doubt, is true, but other musicians had been haunted by a similar bass. Purcell, for example, who was about 26 years of age when Bach was born, used something very like

Bach's bass in Dido's famous lament, 'When I am laid in Earth'. It is inconceivable that 'Dido' should have been known to Bach and, in any case, as I have said, this bass and others closely resembling it occur in other 17th century scores, in Carissimi, for example. I trust, therefore, that no one will suggest that in this instance Bach borrowed from Purcell! (See Ex. 61.).

Ex.61

Handel is another composer who has used a very similar theme. The ground bass to the first chorus of his Oratorio Susanna is a good example. The greater part of this work dates from 1748 but Winton Dean suggests that the chorus was written much earlier. Did Bach know of this chorus? It is just possible if Handel had lifted it from a much earlier work which Bach may have seen or heard. BWV 78, 232

58 Again Dürr's change of date does not effect the order of transfer. He brings Cantata No. 79 forward by ten years to 1725 so giving the composer the task of looking through a 12-year accumulation of scores when seeking a suitable chorus for use in the Mass of 1737/8. (See Ex. 62.). BWV 79, 236

Ex.62

59 The same remarks apply to this transfer to the A major Mass. (See Ex. 63.). BWV 79, 234

Ex 63

60 The transfer in this case involved very little work. The lower of the two voices was changed from Bass to Alto and the duet lengthened from 121 to 129 bars. (See Ex. 64.).

BWV 79, 236

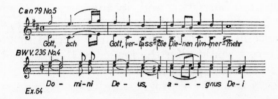

Ex.64

61 This 'borrow' provides an excellent example of the lengths to which Bach had to go on certain occasions when adapting earlier compositions. Certainly the transfers were not always made in order to save work. In this case, as Cantata No. 80a opened with the Soprano and Bass duet, Mit unsrer Macht, the composer added an enormous (228 bar) opening Chor based on verses of Luther's hymn. This is in the style of Pachelbel with the Cantus Firmus on 1st trumpet and 2 oboes played in canon with the Cantus Firmus in the continuo.

A choral fantasia on verse 3 of Luther's tune with the Cantus Firmus on unison chorus was added to Chor No. 5.

The text of the Alto and Tenor duet (No. 7) appears in Franck's libretto of 1714 or 15 but must have been reset for Leipzig as the music contains obbligati for oboe da caccia in F and violin.

Dürr can find no trace of Cantata No. 80a ever having been performed after 1716 but thinks there is a possibility of an earlier version of No. 80 being heard in 1724.

BWV 80, 80a

62 Schmieder dates Cantata No. 82 as 1731 or 2. On the

other hand Spitta says: — 'We can verify the date since in the original MS we find, beside the half-moon, the water-mark which distinguishes the group It is 1735'.

This remark bears out Dürr's contention that it is too risky to rely entirely upon the evidence of watermarks. He can trace at least four performances, 1727; 'about' 1731; 1735 and between 1745 and 1748. BWV 82

63 There is a resemblance between the opening of the Tenor aria in Cantata No. 93 – which, incidentally, Schmieder and Whittaker date as 1728 and Dürr as 1724 – and Miecke's aria in the Peasant Cantata of 1742. It is almost too slight to be a conscious borrowing and, in any case, as the melody of the aria is a diminution of the choral theme the resemblance must be coincidental. Beethoven, too, seemed to know this tune! Here I would refer the reader to Deryck Cooke's *The Language of Music* pp 119-121 and 124-129 which gives many examples of this type of progression. (See Ex. 65.). BWV 93, 212

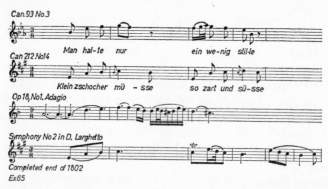

Ex.65

64 There is a strong probability that this Cantata (No. 97) is a remodelling of an earlier work of which only the opening chorus was retained. The first movement is in the form of a French overture with voices built into its fugal Vivace in a way very similar to that employed in the transfer of Suite No. 4 to Cantata use (No. 110) (See Chap. 7, No. 1).

Spitta says: — ' whether the greater part of the

work was written later than the beginning cannot be deter-
mined. It is quite possible that a different composition origin-
ally followed the opening Chor'. Of the original parts pre-
served in the Thomas School only the tenor and bass are
written on paper bearing the 1723 – 7 watermark. The other
parts are similar to the score which Bach himself has dated
1734.
There is, of course, no valid reason why Bach should not
have recopied the main body of the work (apart from the 1st
Chor) and dated the revised score 1734. This would not
conflict with the supposed 1723 – 7 date of the first movement.

<div align="right">BWV 97</div>

65 This is another case of Dürr's redatings upsetting the
established order! Cantata No. 98 was dated as 1731 or 2 and
Cantata No. 99 as 1733 suggesting that as Bach was setting
the same theme in two successive years the transfer of Samuel
Rodigast's hymn tune was quite logical. Dürr, however, has
dated Cantata 99 as 1724 and Cantata 98 as 1726 therefore the
order of borrowing is reversed by two years.
Note that the 21-bar introduction and choral in No. 99 are in
common time and in 3 – 4 in No. 98 and that the 17-bar
introduction of No. 98 bears no resemblance to its predecessor.
(See Ex. 66.).

<div align="right">BWV 98, 99</div>

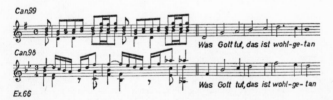

Ex.66

66 In this case the transfer is almost a straight one so far as
notes are concerned but not for orchestration. Chor No. 1 in
Cantata No. 99 is accompanied by traverso, oboe d'amore and
strings but in Cantata No. 100 it is increased by two horns and
timpani in addition to the original instrumentation.
Schmieder dates Cantata No. 100 as 1735 or 33 and Dürr as
1732 to 35.

<div align="right">BWV 99, 100</div>

67 Dürr brings the date of Cantata No. 102 forward by five

or six years. This does not affect the transfer to the Mass in any way as the latter's date remains as 1737. BWV 102, 235

68 The Mass in F also remains as 1737. Bach's new use of the 12-year-old material is quite interesting. BWV 102, 233
(See Ex. 67).

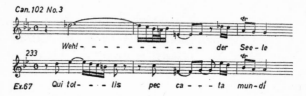

Ex.67 Qui tol- - - lis pec ca - - - ta mun-di

69 Here we have a fine example of the composer's ability to derive two completely different types of inspiration from the same stimulus.
The two introductions are almost identical but the arias which follow could hardly be more unalike. BWV 102, 233
(See Ex. 68.).

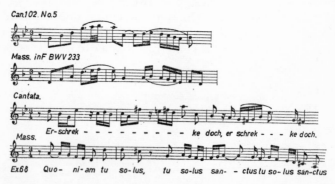

Ex.68 Quo- ni-am tu so-lus, tu so-lus san- - ctus tu so-lus san-ctus

70 Although contained within the Cantatas, No. 118 is, in fact, a Motette. It was used for the funeral service of Count Joachim Friedrich von Flemming who died on the 11th Oct. 1740 and whose funeral was on 19th Oct. of that year. It is probable that the funeral ceremony was in the open air and that the work was adapted for indoor use at a later date.
There are two different schemes of orchestration – the 1st certainly more suited to open spaces.
1) 2 Litui (horns). (Schmieder describes 'Litui' as horns but

the exact type of instrument Bach really required is not known
with any certainty. It was obviously of a fairly high tessitura
as its notes lie above those given to the cornetto which is
always considered as being in the soprano register). Cornetto,
3 trombones.

2) Litui, 2 violini, viola and continuo and '3 oboe e Bassono
se piace'.

Spitta dates the work at about 1737 and Dürr 1735 – 50. BWV 118

71 This chorus, Jauchzet, had an adventurous career as will
be seen. For the moment we note that it provided the basis for
part of the Credo in the Mass in B minor. Tovey says of this
movement: — 'The final chorus of the Credo is another
adaptation so ingenious that it escaped the notice of
several BG editors including the one who edited Cantata 129
of which this chorus was the original number'. This is very
interesting because Friedrich Smend gives Cantata No. 20 as
the source!

Cantata No. 120 itself also had several uses. A version was
used as the 2nd Jubilee Cantata for the centenary anniversary
of the Augsburg Confession on 26 June, 1730 and again as a
Ratswahl work in 1735. BWV 120, 232

72/3 Schmieder says that Nos. 1, 3 and 6 of Cantata No. 120a
were used later as Nos. 2, 4 and 1 of Cantata No. 120. On the
other hand Spitta says that Cantata No. 120a is founded partly
on No. 120 and partly on the Adagio from Sonata No. 6 in G
for Violin and Clavier (Dritter Satz, BWV 1019a). (The Sonata
dates from 1720 – the Adagio from its first revision).

If Dürr's dates are correct Cantata 120 preceded No. 120a
by two years – thus proving Spitta to be correct. Schmieder's
'used later' must, therefore, refer to the transfer of material
from Cantata 120 to No. 120a.

Certainly Spitta was on the right trail when he said that
comparison of the two texts with their music – especially in
view of the adaptation of the music to certain words and
phrases – suggested that the original text was intended only for
the Ratswahl Cantata No. 120 – 'hence', as he says, 'this must
be the earlier of the two'.

He finds that the text used for the Augsburg centenary in

1730 'suits the music so badly that one might doubt whether they were meant for each other'. Also that the text of No. 120a suits equally badly. He thinks that No. 120 as we know it to-day must be a later copy of a work which, probably, had been remodelled. Possibly it is the version used for the Rats-wahl in 1735. (See remarks on item 70).

Whittaker refers to No. 120a as 'this un-numbered and orchestrally incomplete wedding cantata' (Schmieder calls it 'unfinished'). It seems as though Bach made use of the already existing orchestral parts of No. 120 for the 14-bar introduction to the 1st Chor of No. 120a, the 12-bar introduction of No. 3 and the 9-bar introduction of No. 6, C. P. E. Bach writing out only exactly what was required for the wedding cantata – so saving both time and paper – and accounting for the fact that these parts do not appear with the remainder of the No. 120a material still in existence. BWV 120, 120a

74 Nothing could be more different than the Alto aria No. 1 of Cantata No. 120 and the Duet (No. 6) in No. 120a which follow the same introductory material. (See comment on item 68). BWV 120, 120a

75 Dürr upset things again here by redating Cantata No. 137 as 1725 thus bringing it five years in advance of No. 120a from which it is supposed to have borrowed its Choral No. 5. Obviously the transfer must have been from Cantata 120a! Note that this choral does not appear in Cantata No. 120.
 BWV 120a, 137

76 Whittaker is sure that the Tenor Aria (No. 2) is a borrow-ed movement on account of what Schweitzer calls the 'bar-barous declamation'. He thinks that a quite inappropriate roulade on the word 'erwerben' gives yet further proof of borrowing. (See Ex. 69.). (See bars 9 & 10 of voice part).
 BWV 121

Can 121 No.2

O du von Gott er-höb-te Cre - a - tur

Ex.69

77 It is interesting to compare the composer's two versions

of the Choral – at least 200 years old at the time of writing
Cantata No. 125 – Dürr brings it forward to 1725. Chor No. 1
is a slow choral for the sopranos over moving 12/8 quavers:
Choral No. 6, Er ist das Heil, is a fairly normal common-time
hymn setting. BWV 125, 382, 616

78 But for Dürr's researches we would have to conclude that
the Matthew Passion chorus provided the inspiration for the
second 6/8 section of the Bass aria. He has, however, redated
Cantata No. 127 as 1725, i.e. 3 to 4 years prior to the Passion.
Obviously the resemblance here is much too close to be
accidental. (See Ex. 70.). BWV 127, 244

79 The first Chor here is again a slow soprano choral over
running semiquavers in a 4/4 Vivace. It comes again as choral
No. 6, Darum wir billig loben dich, in a much simpler 3/4
hymn setting.
The same tune appears in Ludwig Erk's collection of Bach's
Choralgesänge where once again it is in 4/4 and accompanied
only by two clarini. (See BWV Appx. 31.).
Incidentally Dürr dates Cantata No. 130 as 1724. BWV 130

80 Franck's libretto of 1715 concluded with verse 5 of
Cruciger's hymn, Herr Christ, der ein'ge Gott's Sohn, but no
music for it is in existence.
Schweitzer is of the opinion that Bach substituted another
Choral when he performed the work in Leipzig – probably
distributing detached sheets of music, which are now lost, to
his choir. Dürr, however, says that no Leipzig performance
can be established. BWV 132

81 An early version of Cantata No. 134 was dated as between
1719 and 1726. Dürr pins it down to 1724. Its opening recita-

tive began with the words, Ein Herz, das Jesum lebend weiss,
whereas the 1731 version began:— Ein Herz, das seinen
Jesum lebend weiss. (See Ex. 71.).

This early (1724) version is, quite obviously, borrowed from
Cantata No. 134a of 1719. In fact a large amount of No. 134a
found its way into No. 134.

i) The first 144 bars (introduction) of the Tenor aria (No. 2),
Mit Gnaden bekröne der Himmel die Zeiten, were trans-
ferred to No. 134 as Tenor aria (No. 2), Auf, auf, auf, auf,
Gläubige!, with a 24-bar introduction.

ii) The Alto and Tenor Duetto (No. 4), Es streiten, es siegen
die künftigen Zeiten, became the Alto and Tenor Duetto
(No. 4), Wir danken, wir preisen dein brünstiges Lieben.

iii) Chor (No. 8), Ergötzet auf Erden, became Chor (No. 6),
Erschallet, ihr Himmel.

Whittaker says that the Alto aria (No. 6), Der Zeiten Herr hat
viel vergnügte Stunden, of No. 134a, is itself an adaptation.

It is said that the libretto of No. 134 has been found in
a book of *Texts for Easter and the next two Sundays* printed
in 1731. This is most interesting if it is the text used in 1724 as
it suggests that Bach had access to it seven or eight years before
it was published and, if correct, proves once again that the
date of publication or the date on a fair copy cannot be
accepted as the near-date of composition.

Whittaker is of the opinion that, although the faulty declama-

tion of the Tenor aria (No. 3) points to an adaptation of previously written material, the original text, on the other hand, must have been akin to the present words. (See Ex. 72.).

<div align="right">BWV 134, 134a</div>

82 In this case Whittaker points out that the new (Mass) text and the music have no particular qualities which bind them together. He feels that the spirit of the text in the first Chor does not coincide with the music of Cantata No. 136 and that another text must have been its first impulse.

The words, Es kommt ein Tag, of the Alto aria (No. 3) do not fit their tune too happily and suggest an adaptation. Similarly the Tenor and Bass duet (No. 5), Uns treffen zwar der Sünden Flecken, which, he says, 'is evidently patched up from some previous work'. This item has a curious feeling of Brandenburg No. 6 about it and causes the same difficulties regarding the correct tempo, i.e. if the semiquavers are clear the remainder can sound too slow and if the quavers move along the runs are confused. (See Ex. 73.). BWV 135

83 Spitta says a pointer to the year 1732 is that as verse 4 (set as Tenor aria (No. 4)) carries an allusion to a great war then being waged the years 1723 – 30 must be set aside as Europe was at peace during that period. Furthermore the watermark puts it in a group of ten Cantatas belonging to 1730 – 32.

The first use of the Cantata is for a Ratswahl and Dürr dates this as 1725. Later it appeared again for the 12th Sunday after Trinity. Schmieder says 1732 – 47 and Dürr 1744 – 50.

<div align="right">BWV 136, 234</div>

84 Dürr's redating of Cantata No. 137 as 1725 makes the transfer of the Choral from it to No. 120a possible. Previously there was a suggestion that No. 120a may have come first in which case the order of borrowing would have been reversed.

<div align="right">BWV 120a, 137</div>

85 Spitta feels that the date of composition of Cantata No. 138 cannot be fixed with certainty but it must have been before the Mass. Dürr settles his doubts by dating the Cantata as 1723!
Bach's slight ornamentation of the melody is interesting. (See Ex. 74.).

<div align="right">BWV 138, 236</div>

Ex.74

86 Here Spitta says that Bach worked up an earlier composition for the first chorus and that it is impossible to doubt that it is founded on what was originally a duet. Dürr, however, declares that the work is not by Bach at all and is probably by Telemann.

<div align="right">BWV 141</div>

87 It is Whittaker's opinion regarding this work that, although its authorship has been doubted, the case against Bach has not been proven but, if it is by him, then it must be a compilation. He feels that the 1st Chor, Nimm, was dein ist, is sufficiently interesting to make one consider that Bach did write it. He thinks also that the Alto aria (No. 2), Murre nicht, lieber Christ, must have been a slumber song originally.

<div align="right">BWV 144</div>

88 Schmieder thinks that this Cantata is derived from a secular work dating from the Cöthen period and that the Chor (No. 2), So du mit deinem Munde bekennest, is not by Bach but a work of Telemann's.

<div align="right">BWV 145</div>

89 When Bach revised this work for Leipzig (Schmieder says

1727 but Dürr dates it as 1723) he seems first to have written the new pieces (three recitatives), changed the final choral and then recopied the whole work. It should be noted that choral No. 6, Wohl mir, dass ich Jesum habe, and Choral No. 10, Jesus bleibet meine Freude, share the same music – better known, perhaps, as 'Jesu, Joy of Man's desiring.'

Four items were carried over from the original, these were: —

i) No. 1 Coro	Herz und Mund
ii) No. 3 Alto aria	Schäme dich, o Seele
iii) No. 5 Soprano aria	Bereite dir, Jesu
iv) No. 7 Tenor aria	Hilf, Jesu hilf

Aria Nos. 2 and 3 reversed places. No. 3 had an oboe d'amore part added: No. 4 was fitted with a new text. Most probably the original orchestra was oboe, fagotto, trumpet and strings. The 2nd oboe, oboe d'amore and two oboes da caccia were added for Leipzig.

Spitta says that the first 4 sheets of the score carry the Weimar watermark and the parts the mark for 1723 – 27. Cantata No. 18 for Queen Eberhardine, finished 15 Oct. 1727 has the same paper. Hence the new MS must have been written in the summer, probably, of 1727. Unfortunately, however, for this theory, Dürr dates Cantata No. 147 as 1723 and No. 18 as 1724(?). BWV 18, 147

90 Bach wrote an opening chorus for Cantata No. 149 and then discarded it in favour of the final Chor of Cantata No. 208, 'Was mir behagt', dating, possibly, from 1735 (Dürr). Later the discarded chorus was transferred to Cantata No. 201, 'Geschwinde, geschwinde, ihr wirbelnden Winde'. BWV 149, 201

91 Schmieder feels that the authenticity of Cantata No. 150 is doubtful. On the other hand Whittaker says: — 'Its authenticity has been doubted but support is not generally given to the theory that it comes from another hand'. He thinks that it may be a remodelled composition by another composer, there is, however, no evidence of this except that it is quite unlike any other Mühlhausen Cantata.

Spitta is of the opinion that the F sharp minor clavier Toccata (BWV 910) is a remodelling of this opening chorus.

Whittaker feels that if this theory is accepted the question of authenticity is beyond doubt. Tovey describes this Toccata as: — 'the richest and most beautiful of Bach's clavier toccatas'. He feels that it belongs to the period of the early Cantatas and points out that its phrases and forms resemble, in particular, Cantatas No. 95 (1723), and 106 and 131 both dating from Mühlhausen.

Dürr says the work dates from Weimar and that no performance in Leipzig can be traced. BWV 12, 150

92 Whittaker feels that there is a strong resemblance between these two arias. It is, I think, rather far-fetched and can hardly constitute a borrowing. (See Ex. 75.). BWV 152, 197

Ex.75

93/94 Dürr dates Cantata No. 60 as 1723 and not 1732 and, as Cantata No. 154 is 1724, it appears as though the borrowing is reversed as well as the last two figures of the date! It would seem that the Chor was not passed from No. 154 to both Nos. 20 and 60 but from No. 60 to No. 154 and then, possibly, on to No. 20.

Although Schmieder dates Cantata No. 20 as between 1723 and 27 (Dürr pinpoints it as 1724) he mentions that the form of the Cantata which he gives dates, probably, from 1735. This is interesting as, most probably, it explains why the chorus does not appear – i.e. it was dropped between 1724 and 1735! BWV 20, 60, 154

95 The redating here is quite drastic as Dürr brings Cantata

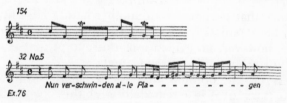

Ex.76

No. 32 forward from 1738 or 40 to 1726. It does not, however, affect the order of transfer. (See Ex. 76.). BWV 32, 154

96 It is thought that Cantata No. 157 was composed some time between Oct. 1726 (when Christoph von Ponikau died) and Feb. 1727 (when his memorial service was held (6 Feb.)) especially for the mourning ceremony, but before it could be used for that purpose Bach adapted it for the Purification Service held on 2 Feb. 1727 so that in actual fact the borrowed version was heard four days before its original. BWV 157

97 The first version of Cantata No. 158 dates from 1708 – 17 and the second about 1724. It was used for both the Purification and Easter Tuesday and is not particularly suited to either day in its present form. The Bass recitative (No. 1), Der Friede sei mit dir, and final choral, Hier ist das rechte Oster-lamm, are concerned only with Easter. The 'Aria mit Choral' (No. 2), Welt, ade! ich bin dein müde; Bass recitative (No. 3), Nun Herr, regiere meinen Sinn, and Arioso (No. 3), Da bleib' ich Vergnügen zu wohnen, deals solely with the spirit of the Purification.

Spitta feels that we cannot date this version prior to 1724 as, most likely, Bach would have prepared a new composition for his first Purification in Leipzig. This Feast is specified on the MS of the second version – the first must be regarded as lost. BWV 158

98 The Soprano aria has a different text from the original (Alto) version. BWV 161

99 This choral includes the words of the 7th verse of the hymn, Alle Menschen müssen sterben, set to a melody not known elsewhere in the Cantatas therefore it may or may not be by Bach. BWV 162

100 Whittaker says of this Cantata that it must have been reconstructed at Leipzig because the Tenor aria (No. 1), Nur jedem das Seine, includes an oboe d'amore in the score – an instrument which Bach had not met prior to his Cantorship i.e. 1723. The MS written by Carl Philipp does not mention the d'amore. (See item 102). BWV 163

101 Schmieder thinks it is possible that Cantata No. 164 was already in existence in Weimar and was revised for performances in Leipzig; the first being 22 Aug. 1723. Whittaker, too, says that 'possibly' it was composed in 1715.

Dürr, also, bases it in Weimar and says that it was greatly revised but gives its Leipzig date as 26 Aug. 1725. BWV 164

102 Whittaker is of the opinion that Cantata No. 168 was written in Weimar in 1715. Spitta, however, thinks it originated in Leipzig because of the two oboes d'amore used in the Tenor recitative (No. 2) and aria No. 3.

Dürr, on the contrary, says that the use of oboes d'amore is no proof against a Weimar origin. He thinks the addition of the word 'd'amore' to an existing Weimar oboe part was made purely as an aid to transposing the part a third!

Although Schmieder suggests 1723 or 4 for its Leipzig performance Dürr gives 1725. BWV 168

103 Whittaker suggests the possibility of the Alto aria being derived from an earlier work. It is interesting to note that the orchestra does not include flutes yet flauto traverso is indicated as an alternative to the obbligato organ in this aria.

Schmieder dates the work as 1731 or 2, Spitta as 1732, and Prof. B. F. Richter proves it to be 1731 in his article in the Bachjahrbuch for 1908 but Dürr also proves it to be 1726!
 BWV 170

104 The first version of Cantata No. 170 (and the one shown in Schmieder) is in the key of D. A later version consists of the Alto aria (No. 1), a new recitative in place of No. 2 and a final Chor (as No. 3) which is the first Chor of Cantata No. 147 with its time signature changed from 6/4 to 3/4 and with a slightly altered text. Dürr dates this second use as between 1735 and 50 but it is thought to have been 2nd July 1742.
 BWV 170

105 Schmieder says that, although Cantata No. 171 dates from the end of 1730, it was not completed until after 1736. Spitta, however, points out that Henrici's text was for the Cantata year 1729 and that the work was written for New Year 1729. He feels that the Latin text fits the melody rather better than the German Bible words. (See Ex. 77.). BWV 171, 232

Ex.77

106 Sometimes Spitta contradicts himself. After saying that Cantata No. 171 was written for 1st Jan. 1729 he says 'Bach probably began this Cantata towards the end of 1730, left it unfinished, and did not complete it until after 1736' so that he is now in posthumous agreement with Schmieder! It used to be thought that the final choral (in C) Dein ist allein die Ehre, in Cantata No. 41 was borrowed from No. 171 wherein it is in D but as Dürr dates Cantata No. 41 as 1725 and No. 171 as 1729 the order of borrowing must be reversed. BWV 41, 171

107 There are three versions of Cantata No. 172. The first dates from 20 May, 1714. The second, shorter and incomplete, was for Whitsun 1724 or 5 – possibly in the University Church of St. Paul. (Spitta gives 1725 for this as 1st performance). Whittaker says the precise date cannot be ascertained but that as the libretto points to an early date 1724 or 5 is probable. Dürr gives 1724 for the 2nd performance.
The third version was performed in St. Thomas' in 1730 or 31 after the separate Rückpositiv was added to the organ in that building.
The Soprano and Alto Duet (No. 5), Komm, lass mich nicht länger warten, makes use of the Whitsun choral melody, Komm heiliger Geist, Herre Gott, as an independent instrumental part. In the later version this melody and the semi-ostinato bass were set for an obbligato organ. BWV 172

108-9-10-11-12-13 The secular birthday Cantata No. 173a of 1717 which contained 8 items yielded six of them to the 6-movement Cantata No. 173, dated by Schmieder as 'about' 1730 and by Dürr as 1724(?).
It is interesting to notice how very often Bach changes voices as well as texts. In the two works under discussion for instance: —

Soprano recitative No. 1 becomes Tenor Aria No. 1.
Soprano aria No. 2 becomes Tenor Aria No. 2.
Bass aria No. 3 becomes Alto aria No. 3.
Soprano and Bass duet No. 4 stays as a Soprano and Bass duet
but Soprano and Bass recitative No. 5 becomes Soprano and
Tenor recitative No. 5 and
Soprano and Bass Coro No. 8 becomes SATB Coro No. 6.
Whittaker thinks that Coro No. 8 'must have existed pre-
viously in some other form'. This is suggested by the uncom-
fortable position of the words. Further he suggests of No. 6
that 'as all the other numbers were utilized for other purposes
it may be that this aria found its way into some lost church
Cantata'. BWV 173, 173a

114 One item, a Bass aria, strayed from Cantata No. 173a
to become a Tenor aria (again a change of voice) in Cantata
No. 175 dated originally as 1735/6 but brought forward to
1725 by Dürr.
Whittaker says:— 'In 1731 Bach had borrowed six numbers
from the secular Cantata 'Durchlaucht'ster Leopold' for the
Whitsun Cantata 173 and now (1735/6) he took one of the
two remaining for No. 175'. Unfortunately, as I have just
pointed out, these dates and, therefore, Whittaker's remarks,
no longer hold good. The borrowing must be set back by some
years. This is yet another example of the rethinking and
rewriting which Dürr's books have forced upon us.
Whittaker is of the opinion that parts, even, of No. 173a were
borrowed from some now-lost work – especially the Bass aria
No. 7 – now in No. 175. BWV 173a, 175

115 Spitta says of Cantata No. 175 that it was written in 1735
and used again in 1738. Those portions of the score which
had been lost in the meantime were then replaced. He finds
that amongst the instrumental parts a few sheets occur which
show them to be contemporaneous with the score of the
Easter Oratorio (BWV 249) dated 1736 – 9.
Dürr, however, dates the first performance of No. 175 as 1725
and the later as 1735 – 50. BWV 175

116/7 Dürr dates Cantata No. 179 as 1723. This slight

change makes no difference to the order of borrowing as the Mass still dates from the late 1730's. The Chor is almost a straight transfer but the Tenor aria has a few modifications. (See Ex. 78.). BWV 179, 236

Ex. 78

118 This is a transfer to a different Mass. It involves a transposition from A minor to B minor and, although the instrumental introduction is very similar there is little resemblance between the two voice parts. (See Ex. 79.). BWV 179, 234

Ex. 79

119 Spitta says of this that it is a fugue with a simple and popular subject. It must have belonged to a secular work originally. Whittaker supports this by pointing out that there are no male voices in the middle section. In his view this absence strengthens Spitta's theory. (See Ex. 80.). BWV 181

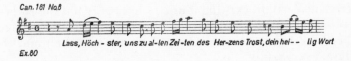

Ex. 80

120 The work was revised and the orchestration of the final Chor changed in Leipzig for 25 Mar. 1725 (Schmieder) and 1724 (Dürr). Whittaker feels that the 1st and last choruses and the Bass aria (No. 4) are the original versions but that the Alto aria (No. 5) and Tenor aria (No. 6) may have been

rewritten for Leipzig. A note on the original violin part is to the effect that the opening Chor is to be repeated after No. 6 in order to close the work. It is possible that the Schlusschor (No. 8) was added at a later date in Weimar to make the repetition of the opening Chor unnecessary and that the choral fantasia (No. 7) originated in Leipzig.

Dürr thinks that the work received further revision for its 1728 performance. BWV 182

121 Spitta, Schmieder and Whittaker are all in agreement that Cantata No. 184, although written for Whitsun 1724, is derived from an earlier (Cöthen) secular work.

Spitta says that the popular dance-like character of the duet (No. 2) and the gavotte measure of the final chorus proves this to be so. Whittaker feels that the duet has obvious Cöthen connections and that 'indifference to the significance of words, together with obvious makeshifts in the instrumental lines are additional evidences that some secular composition must have been pressed into service – not as successfully as usual'.

The Choral (No. 5) which precedes the Gavotte is a later addition, inserted at the time when the work was adapted to church use. Neumann dates it as 1722 and numbers it as 184a.

 BWV 184

122 It seems that Bach likes his gavotte well enough to transfer it to Cantata No. 213 in 1733 and to add to and change its orchestration slightly. Cantata No. 184 is for two flutes and strings whereas No. 213 is for two horns, two oboes and strings. BWV 184, 213

123 This revision involved adding a choral and recitatives and remodelling texts. One assumes, as a general rule, that a fresh text will fit existing music rather badly but the reverse applies in this case. Spitta says: — 'There are many passages where the music fits the remodelled text very well and the original very badly'.

The final Choral, Darum ob ich schon, of the 1716 version was dropped from the revision and the work now ends with the Duetto (No. 10) for Soprano and Alto. Whittaker regards this as being a Weimar product, remodelled for 1723 and with a taille added to the orchestration. Neumann numbers the 1716 version as 186a. BWV 186

124 Dürr brings the date of Cantata No. 187 forward six years to 4 Aug. 1726. This does not affect the transfer in any way but one must assume that Bach built up a tremendous library of his own works with the years and that he had a most efficiently cross-referenced filing system! BWV 187, 235

125 Whittaker remarks that the Alto aria (No. 3) is unusually direct and tuneful and a popular harvest song. He doubts if its present form is the original. (See Ex. 81.). BWV 187, 235

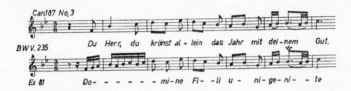

126 This is one instance of a transfer not changing the voice but only the character of the borrowed material. (See Ex. 82). BWV 187, 235

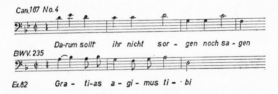

127 Here the composer reverts to his more normal practice of changing the voice at the receiving end. BWV 187, 235

128 Dörffel, Terry and Whittaker date Cantata No. 189 as 1707 – 10; Spitta says: — 'late Leipzig'; Schweitzer: — 'late Weimar'; Schmieder: — 'authenticity doubtful' and Dürr: — 'not Bach'.
Whittaker feels that the work has come to us only in a revised form. The remainder of the Cantata does not keep to the level of the opening aria – an argument in favour of its being added at a later date. BWV 189

129 Wilhelm Rust believed that only parts for four voices and two violins ever existed. Spitta, however, thought that a considerable portion of the autograph score was embodied in a separate Cantata, 'Lobe Zion deinen Gott', at one time in the Berlin Library.

He acknowledges that this MS is not complete as it opens with an aria in A and closes with a choral in D to the accompaniment of which three oboes, three trumpets and timpani are added whereas the remainder of the work has an accompaniment for strings only.

In Schmieder's catalogue the Alto aria (in A), Lobe, Zion, deinen Gott, is No. 3 of Cantata No. 190 which now opens with a chor – Singet dem Herrn – (in D) accompanied by three trumpets and timpani, three oboes, strings and continuo. Schmieder describes this orchestration as 'es fehlen' (added in error). He prefers two violins only. Neumann numbers the 1730/5 version as 190a. BWV 190

130/1/2 This is another case of Dürr's discoveries having changed the established order. It has always been imagined that Cantata No. 193a of 1727 provided some material for Cantata No. 193 of 1738 but now we learn that No. 193 of 1726 passed three items to No. 193a of 1727!

No. 193a was supposed to have been written for the Nameday of Friedrich August II on 3rd Aug. 1727 and Dürr confirms that Cantata No. 193 turned up at a Ratswahl on 26 Aug. 1726 – a year earlier! BWV 193, 193a

133 Bach saw no reason for wasting good material so Cantata No. 194 – itself derived from an instrumental Suite (see Part VII, item 3) – was put to further use in later years as a church cantata for Trinity – 4 June, 1724, 16 June, 1726 and 20 May, 1731. Numbered by Neumann as 194a. Dürr thinks the original may have been a secular Cantata – No. 194a. BWV 194

134 Cantata No. 195 may exist in at least two versions, possibly three. Schmieder dates the unknown 'early' form as 1724 and the 2nd (as known at the present time) as about 1730. Terry prefers about 1726 for the 1st and Dürr 1728 – 31.

Spitta feels that the present version cannot be regarded as the original and that it must be a revision of a work belonging to the very earliest Leipzig period.

Whittaker is quite scathing. He surmises that, whatever the general sources may have been, the Bass aria (No. 3), Rühmet Gottes Güt' und Treu', must have been derived from a secular – possibly comic – work. He says: — 'through the disappearance of the original text we are denied one of Bach's best secular songs'. He feels that the many errors suggest the Cantata was written in a hurry and that the text fits so badly that haste made the composer reckless. He thinks the adaptation shows 'deplorable taste'! He goes on to say that although one cannot be sure whether the original source was sacred or secular the accompaniment (two traversi, two oboes d'amore and continuo) of the Soprano (No. 4), Wohlan, so knüpfet denn ein Band, suggests that it was a secular work.

The setting of the text of Coro No. 5 most definitely suggests an adaptation. (See Ex. 83. and footnote at end of chapter).

BWV 195

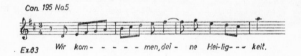

Con. 195 No.5

Ex.83 Wir kom - - - - - men, dei - ne Hei-lig- - - keit.

135/6 Cantata No. 197a appears to be rather difficult to date. Schmieder says 1730 or 32, Spitta: — 1728, 29 or 30 and Dürr: — 'about' 1728.

The first three numbers of No. 197a were transferred to No. 197 so that the Alto aria, O du angenehmes Schatz, which Schmieder gives as No. 1, is, in reality, the original No. 4 and it is so numbered in Werner Neumann's handbook of Cantatas (Breitkopf, 1947).

True to form the vocal transfers involved changes of voice. This Alto aria became the Bass aria (No. 6) and the Bass aria (No. 3) became a Soprano aria (No. 8). BWV 197, 197a

137 Whittaker considers that some long runs in this aria are 'quite obviously inappropriate' and deduces therefrom that it is an adaptation – possibly from a lost Christmas Cantata.

BWV 197

138/9 Cantata No. 198 was written as a Funeral Ode for the death of Christiane Eberhardine, Queen-Electress of Poland and Duchess of Saxony who died 6 Sept. 1727. It was com-

missioned by Hans Karl von Kirchbach and completed on
15 Oct.

Whittaker finds Chor No. 7 at the end of Part I so different
in style from the rest of the Ode that he thinks already
existing music may have been used for it.

Items from it were borrowed three times over, first as the
first chorus in No. 247 in 1731 and second as part of the
Kyrie in No. 232 in 1733. (See Ex. 84.). BWV 198, 232, 247

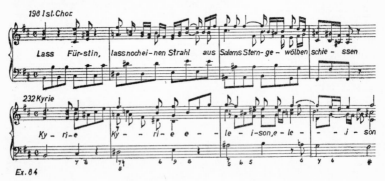

Ex. 84

140/1/2/3 These four borrowings from Cantata No. 198
are amongst the few which Bach did not change so far as the
choice of voices is concerned.

The new text does not fit so untidily as in some cases for the
reason that – as Spitta says – 'there is no doubt that Picander
adapted his Mark Passion text to the music (of No. 198)
already composed by Bach'. Neumann considers that No. 10
also became aria (No. 7) of Cantata 244a. BWV 198, 247

144 Here is the third borrowing referred to in 138/9.
Funeral music again but for a different person and two years
later. BWV 198, 244a

145 Dürr changes the dates of Cantata No. 201 from 1731
to a possible 1729 but leaves No. 212 as 1742.

Spitta complains that the transfer from 201 is made 'not
without some violence'.

The characters in No. 201 are: —

Momus – Soprano Tmolus – Tenor I
Mercurius – Alto Midas – Tenor II

Phoebus or Apollo – Bass I Pan – Bass II

(See Ex 85.). BWV 201, 212

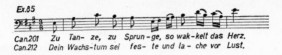

Can.201 Zu Tan- ze, zu Sprun-ge, so wak-kelt das Herz.
Can.212 Dein Wachs-tum sei fes- te und la- che vor Lust.

146 Another borrowing from Cantata No. 201. This time to a much nearer work, i.e. Appx. 19 of 1734, written to greet Rector Johann August Ernesti on the 21st of November. There is also a possibility that choral (No. 15) of Cantata 201 provided the basis of aria (No. 7) of Appendix 10. (1731).

 BWV 201, Appx. 19

147 Soprano to Bass again in this instance. On the other hand the resemblance is not particularly close but possibly close enough. (See Ex. 86.). BWV 8, 202

148 At one time it was suggested that Cantata No. 204 was written for his own domestic use (von der Vergnügsamkeit) i.e. for Anna Magdalena. This happy idea is now thought to be somewhat old-fashioned! The Wedding Cantata No. 216 was written for Johann Heinrich Wolff and – Hempel of Zittau who were married on 5 Feb. 1728. It is of interest to note that Terry dates No. 204 as circa. 1730 which would make it later than No. 216. BWV 204, 216

149 These Cantatas were both written for Augusts. No. 205 for the birthday of Prof. August Friedrich Müller and No. 205a for the Coronation of August III of Poland.

Considerable changes were necessary: —

Aeolus in 205 became 'Gnade' (Favour or Grace) in 205a
Zephyrus in 205 became 'Gerechtigkeit' (Justice) in 205a
Pomona in 205 became 'Tapferkeit' (Bravery or Valour) in 205a but Pallas in 205 stayed as Pallas in 205a.

Whittaker feels that the bad mis-accentuation in the fugal
subject of the first Chor in No. 205 points to an adaptation
although the source is not known. BWV 205, 205a

150 Spitta is of the opinion that Cantata No. 205 lay
unfinished for a long time after the completion of the first
Chorus.
The connection between this Chor and 'et resurrexit' is fairly
tenuous, I feel, but Whittaker was sure that it existed. So, too,
was Tovey who says: — 'The resurrection is proclaimed in a
phrase of which Schweitzer specially commends the declama-
tion. Nevertheless I believe he would readily entertain the
supposition that there is a lost original work behind this
chorus'. BWV 205, 232

151 The Soprano aria is in E in Cantata No. 205 but a tone
lower (D) in No. 171. Spitta tells us that No. 171 was begun
about 1730 and finished later when some new arias were
inserted but Dürr dates No. 171 as 1729/30.
It is interesting to see how Zephyrus' greeting becomes a New
Year aria. BWV 171, 205

152 A double change here. The voices go from Alto and
Tenor to Soprano and Alto and the characters from Pomona
and Zephyrus to Neisse and Pleisse. (Whittaker points out
that a folksong melody is quoted in this duet).
The Miss Hempel, referred to in item 148, was the daughter
of one Hempel, 'Royal and Electoral Commissioner of Excise',
at Zittau. (See Ex. 87, the folk-song referred to above).
BWV 205, 216

Can. 205 No.13

Ex.87

153 Cantata No. 206 was written for the Birthday of August
III, 7 Oct. 1733. It received minor alterations and revisions
and was repeated on the King's Nameday (3 Aug) in 1736 or 7
and for another, unnamed, occasion on 7 Oct. 1736. BWV 206

154/5/6/7/8/9 Cantata No. 207 was written to celebrate
the promotion of Dr. Gottlieb Kortte to Professor Extra-

ordinary of Roman Law. It contains the choral arrangement of the Allegro from Brandenburg Concerto No. 1 referred to in Chap. 6, item 5.

Three recitatives were added to the six movements taken from Cantata No. 207 to make up Cantata No. 207a written for the Nameday of King August III, 3 Aug. 1734.

The librettist was rather fond of naming his characters in the secular Cantatas: in this case they are: —

'Glück'	(Fortune)	Soprano
'Dankbarkeit'	(Gratitude)	Alto
'Fleiss'	(Industry)	Tenor
'Ehre'	(Honour or Reputation)	Bass

These, however, are not carried over into No. 207a – neither is the Ritornello derived from Trio II of Brandenburg No. I.

BWV 207, 207a

160/1 Although we understand that Cantata No. 208 was written for the Birthday of Duke Christian of Sachsen-Weissenfels, 23 Feb. 1716 and was intended to be performed as Tafelmusick, i.e. background music during dinner in the hunting lodge, Dürr thinks it probable that it originated as early as 1713. The actual commission came from Duke Wilhelm Ernst of Weimar and it is interesting to note that Bach appears to have retained all rights in the composition. He used it again for the Birthday of Prince Ernst August of Sachsen-Weimar (Possibly also in 1716). Later certain numbers from it were adapted to produce Cantata No. 208a for the Nameday of August III in Aug. 1735. BWV 208, 208a

162/3/4 It has been assumed for many years that Pan's aria, Ein Fürst ist seines Landes Pan, and Pales' aria, Weil die wollenreichen Heerden, were transferred to Cantata No. 68 for Whitsun 1735. Unfortunately, however, for this assumption Dürr has redated No. 68 as 1724 which means that this particular borrow took place before No. 208a was compiled. Cantata No. 208 is another example of the naming of characters which are: —

'Diana'	– Soprano
'Pales'	– Alto
'Endymion'	– Tenor and
'Pan'	– Bass

BWV 68, 208

165 Cantata No. 149 was thought to have been written for Michaelmas 1731 but Dürr dates it as 'about' 1729. It opens with the chorus which ended No. 208. The transfer involved changing two horns into three trumpets and timpani, transposing the work from F to D and largely rewriting the vocal parts – not a great saving of time one would have imagined! (See Ex. 88.).

BWV 149, 208

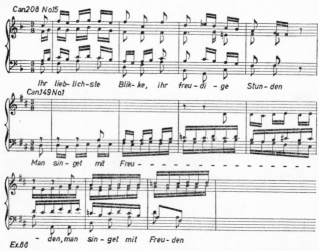

Ex.88

166/7 At one time it was accepted that Cantata No. 210 was written for the wedding of Prof. Friedrich Zoller, of Leipzig University, in 1746. Schmieder contradicts this by assigning it to 1734 or 5. Spitta, on the other hand, says: — 'not before 1740' and Dürr puts it back to the last years of Bach's life.

If we accept Schmieder's dates as correct then certain items from No. 210 (Nos. 1, 2, 4, 6, 8, 9 and 10) were transferred to 210a as Nos. 1, 2, 4, 6, 8, 9 and 10. Of these, Nos. 8 (Soprano aria), 9 (Soprano recit) and 10, (Soprano aria), of No. 210a carry a double text which suggests that although it appeared originally as a greeting to Count Joachim Friedrich von Flemming in 1738/9 it was used also on another quite different occasion.

The texts of Aria No. 8 are: —

210	'Grosser	Gönner,	dein	Vergnügen'
210a i	'Grosser	Flemming,	al –	les Wissen'
ii	'Werte	Gönner,	al –	les Wissen'

It will be remembered that this aria was, in its turn, supposed
to have been transferred to Nos. 210 and 210a from No. 30a,
Angenehmes Wiederau, dated 1737. This can only be the case
if we ignore Schmieder's dates and substitute Spitta's 'not
before 1740'! This then makes nonsense of the transfer of
No. 210 material to 210a – in fact, it reverses the order and
makes No. 210a the origin of No. 210. BWV 210, 210a

168/9/70/1/2 Cantata No. 213 was written for the Birthday
of Prince Friedrich Christian of Saxony in 1733. Six items
were transferred to the Christmas Oratorio of 1734 and the
New Year of 1735. It will be remembered that the final Chor,
Lust der Volker, Lust der Deinen, came from Cantata No. 184
of 1724 and the Alto (Hercules) aria (No. 5), Treues Echo,
from Cantata Appx. 11 of 1732.

Spitta says of No. 213 that its feeling suits neither the subject
nor the purpose of the work and that we congratulate ourselves
that some of it was transferred to the Christmas Oratorio.
Chor No. 1 was transferred to Part IV (New Year); No. 3 (the
lullaby for the Crown Prince) to Part II (the 2nd Day of
Christmas); Nos. 5 and 7 also to Part IV. (Spitta says of No. 7
'the original music with its floating and soaring effects suited
the 'on my pinions shall he be carried' but is not so effective
when associated with 'I would be praising ever'). No. 9 went
to Part I for Christmas Day. The accompaniment of Hercules'
aria (No. 9) is intended to depict twisting snakes – these are
not very appropriate to the words 'Strengthen me, that Thy
mercy' etc. No. 11 was moved to Part III for the 3rd day of
Christmas.

Again in No. 213 Bach's librettist names his voices. Soprano
is 'Wollust' (Pleasure): Alto is 'Hercules': Tenor, 'Tugend'
(Virtue) and Bass – 'Merkur' (Mercury). As happens so often
the transfers, with the exception of Tugend's aria (No. 7) and
Hercules' aria (No. 9) involve changes of voice. Soprano to
Alto, Alto to Soprano and Alto/Tenor duet to Soprano/Bass
duet. BWV 213, 248

174/5/6/7 Cantata No. 214 also contributed four items to
the Christmas Oratorio. Nos. 1 and 7 to Part I (Christmas

Day), No. 5 to Part II (second day of Christmas) and No. 9 to Part III (Third day of Christmas).

The cantata was written for the Birthday of Maria Josepha of Habsburg, the Queen of Poland and Duchess of Saxony, 8 Dec. 1733. Spitta reminds us that Bach finished the work only on the day prior to the performance – it is dated by the composer '1733, 7 Dec'.

Once again No. 214 names its characters. Soprano is 'Bellona' (Goddess of War); Alto is 'Pales' or 'Athene'; Tenor is 'Irene' (Goddess of Peace) and Bass 'Fama', and equally once again a voice is changed – Alto to Tenor. One cannot help wondering why the Tenor should have to be 'Irene'! BWV 214, 248

178 Cantata No. 215 was written as a greeting to King August III of Poland on the anniversary, 5 Oct. 1734, of his election to the Polish throne.

It is yet another, but very small, source of the Christmas Oratorio. Soprano aria No. 7 became Bass aria No. 47 in Part V for the Sunday after the New Year – (Festival of Circumcision). BWV 215, 248

179 The Osanna of Cantata No. 215 may have been derived from an earlier and now lost cantata. We do not know if Bach added it to the B minor Mass in 1745 – 50 (having taken it from the problematical earlier work) or borrowed it from the Mass to use in No. 215.

Spitta sums the position up in these words: — 'The opening chorus (Preise dein Glücke) came from an earlier, unknown work. It was extended to 418 bars for No. 215, later, in its original and shorter (148 bar) form it was moved to the Mass in B minor as No. 22, Osanna, for double choir'. Another comment is that '215 bears conspicuous marks of arrangement and must be more unlike the true original than the Mass Osanna'.

Against the theories set out above (which are supported by von Winterfeld, Mosewius, Rust, Spitta and Schweitzer) must be put the views of Parry, Terry and Whittaker. They are as follows: —Cantata No. 206, 'Schleicht, spielende Wellen' of, probably, 1736, is almost wholly original, due to the fact that Augustus III and his wife were present at its performance.

They were not, present, however, for Nos. 213 and 214, therefore these two need not have been new works and could have been borrowed from the Christmas Oratorio instead of supplying numbers to it. No. 215 was performed before Augustus and his wife but, as it was written at about three day's notice, Whittaker says 'here there is no reasonable doubt that Bach took the Osanna from the score of the Mass in B minor now completed or nearing completion'. He thinks it reasonable to assume that when Bach was ordered to produce a Cantata (No. 213) for Friedrich Christian, the Crown Prince's 11th Birthday in Sept. 1733, he borrowed five numbers from Parts I – IV of the Christmas Oratorio and from Cantata No. 184 which Dürr dates as 1724.

He finds it inconceivable that the first Chor 'with its great and broad character', 'its majestic sweep of movement', 'its lofty dignity', 'its immense spaciousness' should have been written for the Birthday of an absent, sickly, child!

Bach wrote No. 206 for the Birthday of August III, 7 Oct. 1734 (see 153) but the King decided to celebrate the 1st anniversary of his coronation (5 Oct. 1733). Therefore the hard-pressed composer had to produce a new work at very few day's notice.

Tovey's comments are:— 'Bach had just written it (the Hosanna) as the opening chorus of an Accession-day Cantata for Augustus of Saxony (No. 215) Beyond omitting the opening symphony Bach found few details to alter in turning this into an Osanna. Smend agrees with the choice of No. 215 as the original source. And of the Benedictus which follows the Osanna he remarks:— 'Schweitzer suspects it of being another adaptation from a lost original' Schmieder, however, gives no such indication.

Whittaker says of the Osanna:— 'One is driven to the speculation which has not been advanced before, that both numbers may have been derived from some already existing chorus now lost – written for what purpose we are unable to guess. Whatever our conclusions as to priority we can only wonder to this astounding feat'.

Truly one may regard this as an understatement! BWV 215, 232

180 As mentioned in connection with items 168 – 172,

Cantata numbered Appx. 11 yielded one number to Cantata
213 before it, in its turn, was passed on to the Christmas
Oratorio. Also Appx. 11 is thought to have provided the 1st
Chor. of Can 215.

'Es lebe der König' was yet another work composed for a
Polish King – the Nameday of Augustus II, 3 Aug. 1732.

<div align="right">BWV 213, Appx. II</div>

181 Appx. 11 is thought to have provided the Bass aria (No.
7) in Cantata No. 30a of 1737. BWV 80a, Appx. II

182 We noted in item 152 that Cantata No. 216 was written
for the wedding of J. H. Wolff and Fraulein Hempel in 1728.
The two characters in No. 216 are: — 'Neisse' (Soprano) and
'Pleisse (Alto). In No. 216a these became 'Merkur' (Alto) and
'Apollo' (Tenor) – the former representing Commerce and the
latter Learning. No. 216a was written in honour of the Leipzig
Town Council but neither Schmieder nor Dürr can provide a
date for it. It is just possible, therefore, that it precedes No.
216. Nos. 1, 3, 5 and 7 were transferred. Nos. 2, 4 and 6 are
recitatives and so were not required in No. 216a.

No information regarding the orchestration of either No. 216
or 216a is to hand. In the case of No. 216 only the vocal parts
have survived and for No. 216a only the text. BWV 216, 216a

183/4/5 Regarding Cantata No. 191 Spitta tells us that
Bach made an arrangement of the Gloria for *Festo Nativitatis
Christi* of which a score copied in and dated 1740 is in
existence. It contains the 1st and last choruses with a duet
between. The text of the 1st chorus was unchanged but the
words of the Doxology – Gloria patri et filio and Sicut erat
in principio – were transferred to the duet and final chorus
respectively, i.e. the duet, Domine Deus, become duet Gloria
patri and Cum Sancto Spiritu emerged as Sicut erat (Et nunc
et semper). BWV 191, 232

186 It has always been assumed that the ostinato bass of
Cantata No. 78 was taken from the Crucifixus in the B minor
Mass but, as we noted in item 57, Dürr's redating of the
Cantata from between 1735 and 44 to 1724 renders this
impossible and, in fact, reverses the procedure. In any case

this bass was such common property that we cannot consider
its every appearance as a 'borrow'. BWV 48, 232

187 The Mass in F – a real hotch-potch – borrowed its Kyrie
from an earlier, 3-section, Kyrie written, possibly, for the 1st
Sunday in Advent, 1734. The original version was in five parts
(two Sopranos) and was accompanied by continuo only. For
Count von Sporck's Mass Bach reduced the voice parts to four
and added an orchestration of 2 oboes and bassoon, 2 horns,
strings and continuo. In the early version the Choral melody
was sung but in the Mass the voice was replaced by the oboes.
It is possible that this change was made in order to fit the
work for a Catholic instead of Lutheran service. BWV 233, 233a

188 The Magnificat in D is a revised and shortened version
of the Magnificat in E flat. The new work omitted four move-
ments, these were i, Choral – Vom Himmel hoch da komm ich
her, which lay between the Soprano aria (No 2), Et exultavit,
and Soprano aria (No. 3), Quia respexit.
ii, Chor, Freut euch und jubiliert, which came between the
Bass aria (No. 5), Quia fecit, and Alto and Tenor duet (No. 6),
Et misericordia.
iii. Gloria which was between Chor (No. 7), Fecit potentiam,
and Tenor aria (No. 8), Deposuit.
iv. Soprano and Bass duet, Virga Jesse floruit, between Alto
aria (No. 9), Esurientes implevit bonis, and Terzett of 2
Sopranos and Alto (No. 10), Suscepit Israel.
In the second half of the eighteenth century, i.e. after Bach's
death, the first two of these four discarded movements were
combined with a movement for a double chor 'Kündlich gross
ist das gottselige Geheimnis by Carl Heinrich Graun and
issued as a Christmas Motette. BWV 243, 243a

189 The last of the four movements discussed in 188 became
a Soprano and Tenor duet in Cantata No. 110, written for
Christmas Day and dated by Schmieder as 'not prior to 1735'
but revised by Dürr to 1725 – two years after the E flat
Magnificat. The soprano line is changed somewhat and made
even more florid. Also it is extended from the incomplete
$29\frac{1}{2}$ bars of the early version to 54 bars. (See Ex. 89.).
BWV 110, 243

Ex.89

190 – 98 Quite obviously the Matthew Passion was far too monumental a work to have been written in the two or three days preceding its performance and its composition must have been spread over a considerable period. Normally this is thought to have been the winter of 1728/9 so that parts of it were available early in the New Year of 1729. This would permit of aria No. 10 being transferred to Cantata No. 244a in readiness for Prince Leopold's memorial service on 24 March 1729, i.e. before Good Friday which, in that year, was on 15 April. Dürr puts forward the possibility of the whole of the St. Matthew having been performed in 1727 because some notes from the Passion (written in an unknown hand) appear in the viola part of the Sanctus of the B minor Mass (written by Headcopyist C.). Dürr dates the Sanctus as 1724 and gives its first performance as 1726 – 7. No fewer than nine items were transferred from the Passion to Cantata 244a. These are: — No. 10 which we have discussed already and Nos. 47, 58, 66, 29, 26, 75, 19 and 78 in that order. Regarding No. 75 Dürr gives four possibilities.

1) That it belonged to another work and was included in the 'Parody' St. Matthew, 'Erbauliche Gedanken auf den Grünen Donnerstag und Charfreitag über den Leidenden Jesum', Appx. 169 dated 1725.

2) That it belonged originally to a different Passion and was absorbed later into the St. Matthew.

3) The St. Matthew was performed in 1727.

4) The Sanctus was not performed in 1727 after all but in 1729.

He suggests that No. 4 is unlikely but as information regarding the period 1728/9 is so scanty it cannot be dismissed too lightly. BWV 244, 244a

199 At first glance it appears impossible for a Matthew chorus, written 1728/9, to be transferred to a work dating 1723 – 7. It is just feasible if the Matthew date is brought forward to 1727 and Cantata No. 46 dates from the extreme end of its date bracket. Dürr, however, upsets even this remote possibility by dating No. 46 as 1723!

Spitta now comes to our rescue by reminding us that as the Matthew choral was written originally for inclusion in the John Passion it must have been in existance at the time when No. 46 was composed. BWV 46, 244

200 Whittaker describes the Passion aria as yet a further variant of the 'Have mercy, Lord' theme. (See Ex. 90.). BWV 140, 244

201 Now the Christmas Oratorio borrows yet another number – this time from St. Matthew and one which Bach himself had borrowed originally for that work. BWV 244, 248

202 Schmieder dates the John Passion as 1722/3. Spitta says that it was projected during Bach's last months in Cöthen and was first performed on Good Friday, 1724. Dürr also dates it as 1724.

This first Chor was not used in performances of the John Passion in 1727 or 36 and must, therefore, have been removed between 1724 and 1727. The first item in that year was Herr unser Herrscher. It was transferred to the Matthew Passion at the time of the 1740 revision in place of the choral Jesum lass ich nicht von mir.

The choral, O Mensch, bewein' dein Sünde gross, dating from about 1526, seems to have been used for the first time in Wilhelm Friedemann's little organ book of 1708 – 17 and 1717 – 23 (BWV 622) and later appeared in the collection of 4-part chorals made by Kirnberger and C. P. E. Bach (BWV 402). BWV 244, 245

203 We read that nine items were transferred from the
Matthew Passion to the memorial music for Prince Leopold
(BWV 244a). Another of its eleven movements came from the
John Passion of 1723/4. Originally this duet lay between the
Choral (No. 15), Wer hat dich so geschlagen, and the Tenor
recitative (No. 16), Und Hannas sandte ihn gebunden.

<div align="right">BWV 245a, 247</div>

204 The Tenor aria, Zerschmettert mich, (BWV 245b) was
removed from the John Passion and replaced by No. 19, Ach,
mein Sinn. BWV 245, 245b

205 The Tenor aria, Ach windet, (BWV 245c) also was
removed and replaced by the Bass aria No. 31, Betrachte, and
Tenor aria No. 32, Erwäge.
It is possible that Nos. 245a, 245b and 245c were part of the
now lost music of the 4th (Mark) Passion (BWV 247) written
for Good Friday 1731. BWV 245, 245c

206 Spitta tells us that the score of the Luke Passion consists
of 14 sheets. It seems to have been written at different times
and on three varieties of paper. The watermarks on this paper
are associated with the years 1731 – 34. He thinks it probable
that the work was begun towards the end of 1732 in readiness
for its performance on Good Friday 1733. The King-Elector,
however, died on Feb. 1st 1733 and general mourning ensued
until the 4th Sunday after Trinity. He considers that Bach
left the Passion for a time, took it up again towards the end
of 1733 and completed it early in 1734 for performance on
the Good Friday of that year. He goes on to say 'it is evident,
both from the style of the work and from the aspect of the MS,
that the score, as we possess it, was a revised copy from some
quite early work'.
Schmieder dates this source as 1712 but doubts its authenticity.
Spitta describes the music as being strange and puzzling, very
simple in form, tender and expressive, which also casts doubts
on its genuineness. But, as he says, when compared with a
mass of other works dating from Bach's youth, it appears in a
different light. He assigns the source to the first half of the
Weimar period.
Picander wrote a Passion text for Good Friday 1725. Was this

Luke? And did the Luke Passion, which Dürr dates as
'1730(?)' also include the choral, O Mensch? BWV 246

207 The Passion chor was transferred to Part V of the
Oratorio intended for the Festival of Circumcision, 1735.
 BWV 247, 248

208 It would seem to be just possible for a work written in
advance for Easter 1731 to predate another work dated rather
vaguely as 1730 so that the aria could have been transferred
from No. 247 to No. 54. Dürr, however, dates No. 54 as
'Weimar' and says that no performance can be traced to
Leipzig. This, then, would suggest that the transfer must have
been from No. 54 to No. 247. BWV 54, 247

209 The *Kritischer Bericht* on the Christmas Oratorio by
Walter Blankenburg and Alfred Dürr refers to 'an unknown
Church Cantata' which yielded the movements listed on page
116 leaving only the three recitatives Nos. 55, 58 and 60
together with the Choral No. 59 as composed especially for the
Oratorio.
 Dürr states 'we refer to this Cantata as No. 248a from
now on' BWV 248, Appx. 10

210/11/12/13/14 Five numbers from the Birthday Cantata
No. 249a were transferred to the Easter Oratorio. No. 249a is
yet another work whose voices are named. They are 'Doris'
(Soprano); 'Sylvia' (Alto); 'Menalcas' (Tenor) and 'Damoetas'
(Bass). It was written for the Birthday of Duke Christian von
Sachsen-Weissenfels, 23 Feb. 1725.
Whittaker says of No. 249 'We know that it originally existed
in a different form with characters and that the composer
reshaped it'. It seems that what we have now is a mixture of
the second and third versions – it is impossible for us to know
what Bach had in his mind at first – the present version is
very like any other Cantata. The 1st version dates from 1 Apr.
1725. The 2nd from 1732/5 and the 3rd from Bach's last years.
This is one of the few known instances of vocal numbers
transferred from an earlier source retaining their original
form. BWV 249, 249a

215 Bach hated to waste good material especially when it was suitable for a birthday so 18 months after No. 249a saw the light for Duke Christian it became No. 249b for the Birthday of Count von Flemming on 25 Aug. 1726. BWV 249, 249a

216 The Birthday Cantata written for Prince Leopold of Cöthen and dated 10 Dec. 1718 is, unfortunately, now lost. It formed the basis of Cantata No. 66, supposedly written for the 2nd day of Easter 1731 but dated by Dürr as 'probably' 1724.

BWV 66

217 Bach obviously found the music of the now-lost Cantata Appx. 4 very useful:— Ratswahl Aug. 1727; Augsburg Jubilee, June 1730 and Ratswahl again in Aug. 1741.

BWV Appx. 4, Appx. 4a

218 Only the first chorus of Appx. 10, written as a greetings work for the Birthday of Count von Flemming 25 Aug. 1731, survives and that because, luckily, the composer transferred it as the first Chor of Part VI in the Christmas Oratorio, Epiphany, 1735. This Appx. 10 chorus had come, in the first instance, from Cantata No. 248a referred to in 209.

BWV 248, Appx. 10

219 Cantata Appx. 11 was written for the Nameday of Augustus II (3rd Aug. 1732). The transferred aria become one for a named part i.e. Soprano – 'Zeit'; Alto – 'Glück'; Tenor – 'Elster' and Bass – 'Schicksal'. BWV 30a, Appx. II

220 Again a transfer to a named part (Alto – 'Hercules'). Remember that the Bass in Cantata No. 30a represented 'Schicksal' (Fate) and the aria in Appx. 11, from which No. 213 is taken, is addressed to 'Frommes Schicksal'.

BWV 213, Appx. II

221/2/3/4/5 Appx. 18, written for the consecration of the rebuilt and enlarged St. Thomas's School, was useful in many ways. It provided a storehouse which was raided for quite a number of works.
i The Mass in F dating from about 1727.
ii The Mass in B minor 1745 – 50.
iii Cantata No. 11 dated by Dürr as 1735. Spitta suggests that

the first chorus may have been transferred to Appx. 18 from 'some occasional music'.

iv Cantata No. 30a of 1737. Again a named part (Alto – 'Glück').

v Appx. 12 written for the Nameday of Augustus III, 3rd Aug. 1733. BWV 232, 233, II, 30a, Appx. 12, 18

226 Appx. 19 was written as a greeting to Rector Johann August Ernesti on 21 Nov. 1734. Cantata No. 6 for the 2nd day of Easter is dated by Schmieder as 'possibly' 1736 but is redated by Dürr as 1725. This makes the accepted order of transfer impossible and it must, therefore, be reversed. This, of course, makes more sense of Spitta's remark that 'Cantata No. 6 was written in Bach's 30th year' – that is in 1715.

BWV 6, Appx. 19

227 Again Dürr's redating of Cantata No. 201 as 1729 makes this transfer impossible as the year 1734 stands for Appx. 19. On the other hand, as in the case of item 226, it is quite in order if Spitta's 1715 is correct. BWV 201, Appx. 19

228 Whittaker asks: — 'Did Bach ever write an original Sinfonia to a Leipzig Cantata?' He feels that this one is borrowed but it is difficult to say from what. Incidentally why are the 1st and 2nd violins in unison for all but 26 bars?

BWV 42

229 Neumann considers that the six numbers from Can. No. 248a were transferred to No. 249^{iv}. On the other hand Schmieder gives No. 1 of Appx. 10 as becoming No. 1 of the Oratorio and points out that the remainder of the work is lost. (See item 218).

Footnote to 134.
 Werner Neumann refers to Nos. 6 & 8 of Cantata 195 pt. 2. No. 6 (aria) and No. 8 (chor.) as having come from Nos. 5 and 1 of Cantata 30a but, according to Schmieder, there is only one item in 195 pt. 2 – that being No. 6 – a choral.

CHAPTER X

TABLE X. CANTATA, ETC. TO WORK FOR
SOLO INSTRUMENT
NOTES ON TABLE X.

TABLE X

FROM CANTATA ETC. TO WORK FOR SOLO INSTRUMENT

Source	New Version &/or Position
1 Soprano Choral (No. 3) Ach, bleib' bei uns from Cantata No. 6 'Bleib' bei uns, denn es will Abend werden'. 1736. Dürr, 1725.	Organ Prelude (Schübler) No. 5. (BWV 649). Dated between 1730 & 1735. Published between 1746 & 1750.
2 Alto/Tenor Duet (No. 5) Er denket der Barmherzigkeit from Cantata No. 10 'Meine Seel' erhebt den Herren'. 1735-44. Dürr, 1724.	Organ Prelude (Schübler) No. 4. (BWV 648). Dated between 1746 & '50.
3 First Chor. from Cantata No. 38 'Aus tiefer Not schrei' ich zu dir'. 1735-44. Dürr, 24.	(i) Choral Prelude from Pt. III of Clavier-Ubung 'a 6 in Organo pleno con pedale doppio'. (BWV 686). (ii) Alio modo Manualiter. BWV 687.
4 First Chor. from Cantata No. 47 'Wer sich selbst erhöhet, der soll erniedriget werden'. 1720. Dürr, 1726.	Prelude of Organ Prelude and Fugue in C minor. (BWV 546). Prelude 1730. Fugue 1716.
5 Sinfonia to 2nd Part (No.	First Movement (Adagio-Viv-

8) of Cantata No. 76 'Die Him-
mel erzählen die Ehre Gottes'.
1723.

ace) of Trio-Sonata No. 4 in E
minor. (BWV 528). 1723-27.

6 Soprano/Alto Duet (No. 4)
Er kennt die rechten Freuden-
stunden from Cantata No.
93 'Wer nur den lieben Gott
lasst walten'. 1728. Dürr, 1724.

Organ Prelude (Schübler) No.
3 'Wer nur den lieben Gott'.
(BWV 647). 1746-50.

7 Allegro section of Chor.
(No. 5) from Cantata 131. 1707.

Fugue for Organ. (BWV 131a.).

8 Alto Aria (No. 2) Lobe, den
Herren from Ratswahl Can-
tata No. 137 'Lobe den Herren'.
1732. Dürr, 1725.

Organ Prelude (Schübler) No.
6 'Kommst du nun, Jesu'. (BWV
650). 1730-35.

9 Tenor Choral Aria (No. 4)
Zion hört die Wächter singen
from Cantata No. 140 'Wachet
auf'. 1731 or 42. Dürr, '31.

Organ Prelude (Schübler) No.
1 'Wachet auf, ruft uns die
Stimme'. BWV 645. 1730-35.

10 First Chor. Nach dir from
Cantata No. 150 'Nach dir,
Herr, verlanget mich'. 1712.

Toccata in F sharp minor for
clavier. BWV 910. 1720 or prior
to 1717.

11 Allegro ma non Presto in
1st Movt. (Concerto) from Can-
tata No. 152 'Tritt auf die
Glaubensbahn'. 1715.

Fugue from Prelude and Fugue
in A for organ. BWV 536. 1716.

12 Choral Melody Komm,
heiliger Geist, Herre Gott from
Cantata No. 172 'Erschallet, ihr
Lieder, erklinget, ihr Saiten'
1724.

Choral Fantasia for organ.
BWV 651. Dated(?).

13 Vocal Work ?

Fugue (No. 7) in E flat for
clavier. BWV 876.

14 Vocal Work ?

Fugue (No. 9) in E for clavier.
BWV 878.

NOTES ON TABLE X

1 Cantata No. 6 was thought to have been written for the second day of Easter 1736 but it is redated by Dürr as 1725.
There is an attractive obbligato for piccolo cello to the choral, a lot of the character of this is lost in the transfer to organ.
These arrangements were made between 1730 and 1735, but were not published by Schübler until 1746 – 50. BWV 6, 649

2 Cantata No. 10 is another of that large group dated vaguely as between 1735 and 1744. Dürr has redated it as 1724, which is more reasonable when we remember that the organ versions were prepared between 1730 and 1735. BWV 10, 648

3 The two organ versions of this motett-type chorus are very interesting, shewing, as they do, that although Bach was prepared to adhere to the shape of a theme he was equally prepared to experiment widely in speed and general layout. See remarks in 2 above re datings. (See Ex. 91.). BWV 38, 686

Ex. 91

4 Whittaker points out that the cantata could not have been performed in the Cöthen chapel and must, therefore, have been composed for some other purpose such as for use on one of Bach's organ virtuoso trips. Spitta suggests that this could have been to Carlsbad in May 1720 for later use in Hamburg. Terry, however disagrees with Spitta as the seventeenth Sunday after Trinity (for which the work was intended) came before his Hamburg trip.
In Whittaker's opinion, the second part of the fugal subject in

the chorus coincides with bar 8 of the organ prelude and the 1st part with bar 14 of the prelude. He feels that 'these resemblances are too close to be merely accidental'. (See Ex. 92.). BWV 47, 546

5 Cantata No. 76 was composed for the second Sunday after Trinity, 6th June, 1723. The Sinfonia to Part 11 is written for oboe d'amore, viola da gamba and continuo. Whittaker regards it as a 'delicate piece of chamber music'. Later it was incorporated into the 4th sonata for pedal clavier and is now generally regarded as a work for organ. BWV 76, 528

6 Cantata No. 93 was intended for the fifth Sunday after Trinity. Schmieder dates it as 1728, but Dürr brings it forward to 1724. BWV 93, 647

7 Schmieder says that Bach's authorship of 131a is doubtful and he can give no date for its composition. He says, moreover, that the suggestion that the organ version is the earlier cannot be contradicted.

Spitta feels that although Bach's pupils and admirers took pleasure in performing the organ work, it could not possibly have come from the hand of the Master, for it uses only the voice parts and often not even these without alteration.

The figured bass is quite independent in the cantata form and the instruments take part in the fugue in a striking manner.

In the organ fugue the arranger – whoever he may have been – goes back to the introduction for his four concluding bars. The work is published by Peters from manuscripts by Kittel and Dröbs. BWV 131, 131a

8 Cantata No. 137 is dated by Schmieder as between 1732 and 1747, which would tend to place it after the Prelude (1730 – 35).

Dürr, however, brings the date forward to 1725. In addition

to its Ratswahl duties it was used also for the twelfth Sunday after Trinity. It is possible that this was its first use as Schmieder is positive that the Ratswahl performance was on 25th August 1732. BWV 137, 650

9 Schmieder suggests as two possible dates for Cantata No. 140 – written for the twenty-seventh Sunday after Trinity – 1731 or 1742. Dürr confirms the former as correct. BWV 140, 645

10 In chapter IX we noted the relationship between Bach's Passacaglia bass in Cantata No. 12, Cantata 78 and the B minor Mass. (Items 7 & 8). Now it is considered by Spitta as being responsible for part of the F sharp minor clavier toccata of 1720 or prior to 1717. There is just one major snag here which is that Schmieder doubts the authenticity of Cantata 150. On the other hand there is great similarity between the themes. (See Ex. 93.). BWV 150, 910

Can 150 No 2

BWV 910 Nach dir, Herr, ver – lang – get mich, ver-lang.

and

Ex.93

11 Cantata 152 was written for the first Sunday after Christmas 1715. Bach must have been very fond of his Allegro for in 1716 he produced BWV 536 which has a most delightful fugue that has been likened to a happy child tripping along a woodland path. BWV 152, 536

12 Bach's addition of the choral melody, Komm, heiliger Geist, Herre Gott, to the Soprano and Alto voices and obbligato cello is masterly. Not only does he turn a trio into a quartet but his elaboration of the choral is an object lesson to all would-be decorators!

Whittaker sums the situation up so perfectly that I must quote him in full: — ' the cantus firmus is so much transfigured by the richness of Bach's soaring invention, that even the most devout worshipper at St. Thomas's, however

familiar with the hymns of the Festival (Whitsun), could scarcely have recognised it'.
Here is a 6-bar extract from the middle section of the movement. (See Ex. 94.).

Ex.94

The melody is used again, but in a totally different manner, in the *Achtzehn Choräle von verschiedener Art* BWV 651, 651a, 652, 652a. BWV 172, 651

13 Cecil Gray says of 876: — 'It is positively vocal in character and would sound much better sung than played!'
Did it commence life as a vocal work? Dr. Riemann is another who favours the vocal theory and, in order to be as helpful as possible, has fitted words to it;—'Lob! Preis und Dank sei dem Herrn, der uns erlöst von dem Tod!' BWV 876

14 Cecil Gray says of this: — 'Like the E flat Fugue, (876) only more so, this great Fugue seems to demand the medium of unaccompanied voices for its proper realization'. One wonders if Bach felt the same about it and if it really began that way?
I think not! Although almost any pre-Bach Ricercare for organ would have the same 'vocal' look about it vocal polyphony has a spacing which does not transfer readily to a keyboard. A strict fugue for voices is unknown in Bach's output and it is most probable that he wrote these two fugues in the old style deliberately. BWV 878

CHAPTER XI

TABLE XI

CHAMBER MUSIC TO CHAMBER MUSIC INCLUDING KEYBOARD WORKS

Source	*New Version &/or Position*
1 Duet for Violin and Cello (?).	Fugue (No. 10) in E minor. BWV 855.
2 Trio for Oboe, ?, and Cello (?).	Prelude (No. 4) in C sharp minor (Book II). BWV 873.
3 Adagio from Sonata in G minor for Violin (or Flute) and Clavier. BWV 1020. Dated 1720.	Largo, ma non tanto in Concerto in D minor for 2 Violins. BWV 1043. Dated about 1720.
4 Allegro Moderato from Sonata No. 1 in G for Viola da Gamba and Clavier. BWV 1027. Dated about 1720.	Trio in G for organ. BWV 1027a.
5 Bass Line from Sonata in G for Flute, Violin and Clavier. BWV 1038. Dated about 1720 or from Weimar.	Bass Line in Sonata in G for Violin and Figured Bass. BWV 1021. Dated 1720 or '26.
6 Bass of Sonata in G (see 5).	Bass of Sonata in F for Violin and Clavier. BWV 1022. Dated 1720(?).

7 Sonata in G for two Tra-
versi and continuo. BWV 1039.
Dated 1720.

Sonata No. 1 for Viola da
Gamba and Clavier. BWV 1027.
Dated about 1720.

NOTES ON TABLE XI

1 In his book on the '48' Cecil Gray says of this Fugue: —
'The theme strongly suggests a canonic duet for violin
and cello and it is more than likely that it was thus originally
conceived'.

Its a nice thought and, certainly, the violin can make good
use of his open E string in his first entry but, unfortunately,
the cellist would have to tune his top string up to B in order
to achieve a similar effect! Gray's remarks would apply much
more strongly to some of the two part inventions. BWV 855

2 Gray suggests that this prelude began life as a piece of
chamber music for three instruments. He points out that the
bass 'behaves like a cello' and the treble 'resembles an oboe
part'. Basil Lam, too, believes that this movement was in a
Trio-Sonata for violin, oboe and keyboard.

It is possible, but the same can be said for so many of the '48'.
(See Ex. 95.). BWV 873

Ex. 95

3 Spitta points out that although, in its present form, BWV
1020 is intended for violin and harpsichord the composer
certainly intended it for the flute. The similarity between
half-a-dozen notes in the two works is very noticeable! (May

G

we regard the double concerto as being chamber music for this example?) (See Ex. 96.). BWV 1020, 1043

Ex 96

4 The Gamba version is 142 bars in length and the Organ Trio 131 bars. This has no bearing on the order of composition, sometimes Bach extended the length of his borrowings, at others he contracted them. Naturally the pedal line of the Trio is less ornate than the bass line of the clavier. (See Ex. 97.). BWV 1027, 1027a

Ex 97

5/6 The resemblances between BWV 1038, 1021 and 1022 are most interesting. 1038 and 1021 are almost identical so far as the Largo is concerned. 1038 is longer by 1 bar, but the bass of 1022 is simplified. The 2nd bar of the Vivace is different between 1038 and 1021, but 1022 is exactly the same (apart from key) as 1038. The main difference here is that the Vivace of 1038 is 52 bars in length and the Allegro and Presto of 1022 runs to 160 bars. The Adagio of 1038 is similar (again apart from key) to the corresponding movement in 1022. On the other hand although the bass of 1038 and 1021 is the same the top line is quite different. The lengths of the three final prestos are 1021 = 34 bars, 1022 = 69 bars and 1038 = 35 bars. Otherwise they are remarkably alike. I quote the openings of the first movement. (See Ex. 98.).

Ex. 90

The authenticity of these three works has been questioned. On the other hand, if they are not by Bach, are we to assume that he based No. 9 of Motette 227, (Jesu meine Freude), on (borrowed) Adagios of 1022 and 1038? BWV 1021, 1022, 1038

7 Although these two works are both dated as 'about 1720' Schmieder considers that the 1039 version is the original. Certainly it is the more successful as two identical instruments, i.e. 2 flutes, must match better than one gamba and the right hand part of a harpsichord. The very first bar, with its sustained D, is a good example. Even though the keyboard gave an effect of sostenuto by trilling on the long note the result would be poor by comparison. BWV 1027, 1039

CHAPTER XII

TABLE XII

FROM CANTATA ETC. TO CHAMBER MUSIC

Source	New Version &/or Position
1 Soprano Aria (No. 3) Phöbus eilt mit schnellen Pferden from Cantata No. 202 'Weichet nur, betrübte Schatten'. Cöthen period(?).	Allegro (No. 5) in Sonata No. 6 in G for Violin and Clavier. BWV 1019. Dated 1720 or '30.
2 Cello Continuo to Soprano Aria (No. 13) Weil die wollenreichen Herden from Cantata No. 208 'Was mir behagt'. 1716.	Instrumental Movement (Trio) in F for Violin, Oboe & Continuo (cello & clavier). BWV 1040. Dated 1716(?).

NOTES ON TABLE XII

1 Whittaker mentions that the soprano theme is to be found in 'a contemporary work – the Allegro movement of the sixth violin and clavier sonata'. This is very interesting as it has always been understood that the Allegro was added to the Sonata at the time of its final revision – about 1730.

Dürr gives no date for 202; Schmieder, however, hazards a wide guess as 'possibly Cöthen'. Between 1717 & 1723 would certainly make it contemporary with the first version of the Sonata presumed to date from about 1720.

Whittaker goes on to wonder whether Bach adapted the Allegro for the Cantata aria or whether a special liking for the theme induced him to base another composition on it after the Cantata was completed.

If the Allegro does date from circa 1730, there can be no doubt as to which came first; but if it was, in fact, one of the original movements laid aside and restored later, it may well have inspired Phöbus eilt. BWV 202, 1019

2 Cantata 208 was written by order of Duke Wilhelm Ernst of Weimar as a birthday greeting for Duke Christian of Sachsen – Weissenfels and was performed as Tafelmusik (incidental music during dinner) at the latter's hunting lodge on 23 Feb. 1716. It was used a second time for the birthday of Ernst August, Duke Wilhelm Ernst's nephew. Later, and with a slightly altered text, it did duty for Duke Christian's wife, Christine Louise. Finally, subtitled Verlockender Götterstreit, it honoured the nameday of Augustus III, 3 Aug. 1735.

One of the best known of all Bach's melodies, My heart ever faithful, is part of one of the composer's most successful borrowings. It appears in Can. 68, 'Also hat Gott die Welt geliebt', dated by Schmieder as 1736 and by Dürr as 1725. The complete history of this particular transfer is as follows: — the composer wrote an aria (No. 13) for Pales (sop.) which had a very florid continuo line. Later he wrote a completely fresh vocal line above the florid bass which he used as a cello obbligato and added a new bass line to it. This became the aria in Can. 68. Finally he set the obbligato as a duet for oboe and violin and added yet another bass to it as a continuo for the new Trio which is to follow the aria. BWV 208, 1040 (See Ex. 99.).

Ex.99

CHAPTER XIII

TABLE XIII ARIA OR MOTETTE TO CANTATA,
MOTETTE OR MASS
NOTES ON TABLE XIII.

TABLE XIII

FROM ARIA OR MOTETTE TO CANTATA, MOTETTE OR MASS

Source	New Position &/or Version
1 Fugal Chor. (No. 21) (Part II) Pleni sunt coeli in Mass in B minor. BWV 232. Dated 1733. (Dürr, 1724).	Final Chor. Alles, was Odem hat, lobe den Herrn from Motette 'Singet dem Herrn ein neues Lied'. BWV 225. Dated between 1723 & '34, or 1745/6. (Dürr, 1726 or 7).
2 Motette 'Der Geist hilft uns- rer Schwachheit auf'. Ernesti. BWV 226. 24th Oct. 1729.	Motette (BWV 226a) for strings, wind and organ.
3 Arias Nos. 34 and 38 from Anna Magdalena's 2nd note- book. Dated 1727.	(i) Bass Aria (No. 1) Ich habe genug . (ii) Aria (No. 3) Schlummert ein in Cantata No. 82 'Ich habe genug'. 1731 or 2. (Dürr, 1727).

NOTES ON TABLE XIII

1 Schmieder's possible dates for BWV 225 cover a period of 23 years but Dürr narrows this down to two. Regardless of that there is a strong kinship between the two movements and the

suggested new dates merely serve to help us decide which of them came first. Obviously, if Dürr is correct, it must have been the Pleni sunt coeli section of the Sanctus as, although the main body of the Mass dates from 1733 and 1745 – 50 he dates the Sanctus as 1724. (See Ex. 100.). BWV 225, 232

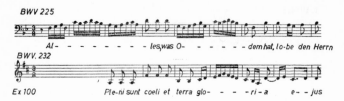

Ex 100

2 Strictly speaking this item should not be in this chapter but there seems to be no other logical place for it! 226 is an eight-part Motette – presumably for two *a capella* choirs, 226a is written for two oboes, taille and bassoon, and string quartet with a figured continuo line for violone and organ. It provides accompaniment to the three main sections of 226 but has nothing for the final choral, Du heilige Brunst, which is verse three of Komm, heiliger Geist, Herre Gott. One must assume that the continuo instruments – even if not the others – would join in this movement automatically.

This, of course, is not a 'borrow'. It is a happy accident that orchestral parts prepared, no doubt, for an open air performance, have survived. They provide yet more proof, if any were still needed, that Motettes should always be performed accompanied! BWV 226, 226a

3 Schmieder dates Cantata 82 as 1731 or 32. Dürr, however, brings it forward to 1727, ie. two years after the presumed date of the second Notebook (or its commencement).
Whittaker thinks that the versions in the Notebook are copies of part of an already existing and complete work and that they were inserted some years after the little collection was begun.

The autograph of 82 shows the 1st aria as for mezzo-soprano or alto and the alto clef is used for the voice part. Bach has

appended a footnote saying: — 'The voice part must be transposed into the bass' — the remainder of the work continues for bass voice and in the correct clef.

There are three known versions of the arias: —

i In E minor for soprano with flute obbligato.
ii In C minor for alto with oboe obbligato.
iii In C minor for bass.

<div align="right">BWV 82</div>

CHAPTER XIV

TABLE XIV. SOLO (KEYBOARD) INSTRUMENT TO
INSTRUMENTAL CONCERTO
NOTES ON TABLE XIV.

TABLE XIV

FROM SOLO (KEYBOARD) INSTRUMENT TO INSTRUMENTAL CONCERTO

Source	New Position &/or Version
1 2nd Movement, Adagio e dolce, from No. 3 of Six Sonatas. BWV 527. Dated 1723 or '27.	2nd Movement, Adagio ma non tanto e dolce, in Concerto in A minor for (Transverse) Flute, Violin and Clavier with Orchestra. BWV 1044. Dated 1730.
2 Prelude of Prelude & Fugue in A minor for Clavier. BWV 894. Dated about 1717.	1st Movement, Allegro, in Concerto in A minor. BWV 1044 (see above).

NOTES ON TABLE XIV

1 The Sechs Sonaten were written first for pedal clavichord or pedal harpsichord. Forkel tells us that later, when Bach reset them for organ for his eldest son Wilhelm Friedemann, very little, if any, revision would be needed. It is interesting to note how the composer divides the thirds of the opening between the flute & clavier, gives an accompanying arpeggio passage to the violin and leaves the clavier to provide the bass unaided. (Note that the orchestra is silent throughout this

(slow) movement as it is also in Brandenburg Concerto No. 5). (See Ex. 101.).

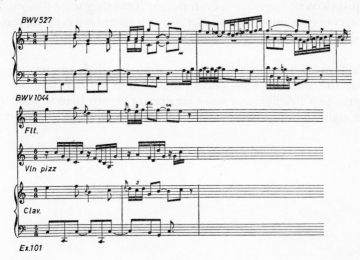

Ex.101

2 It is strange that Bach should have waited thirteen years or so before turning this clavier prelude & fugue into a triple concerto. Again one wonders if 894 was in constant use – perhaps as a teaching piece – and so freshly in mind, or

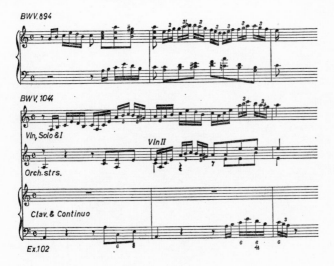

Ex.102

whether the composer had to thumb once more through piles
of old MS in order to find something suitable for conversion.
Spitta says of 894: '.... even in that form they seem designed
for concerto movements'. Certainly it transfers very success-
fully. (See Ex. 102.).

Professor Thurston Dart suggests that the whole of BWV 1044
was the work of Friedemann Bach. If it is then one must
agree that Friedemann was a far greater genius than is usually
thought to be the case! BWV 894, 1044

INDICES TO PART I

A. NAMES and PLACES

B. WORKS (other than Cantatas)

C. GENERAL

D. NUMERICAL LIST of CANTATAS

E. ALPHABETICAL LIST of CANTATAS

INDEX A

Names and Places

INDEX B

WORKS (other than Cantatas)

INDEX C

General

INDEX D

Numerical (Schmieder) list of Cantatas noted in Part I

INDEX E

Alphabetical list of Cantatas noted in Part I.

CAN.

Ich habe meine Zuversicht.	188.	58, 62, 70, 75, 88
Ich hatte viel Bekümmernis.	21.	57, 60, 91, 132
Ich lasse dich nicht, du segnest mich denn.	157.	103, 126, 161
Ich liebe den Höchsten von ganzem Gemüte.	174.	70, 74, 81
Ich steh' mit einem Fuss im Grabe.	156.	71, 75, 76
Ihr, die ihr euch von Christo nennet.	164.	103, 162
Ihr Häuser des Himmels, ihr scheinenden Lichter.	193a.	107, 126, 168
Ihr Tore (Pforten) zu Zion.	193.	107, 126, 168
In allen meinen Taten.	97.	63, 64, 79, 80, 98, 127, 150, 160
Jauchzet Gott in allen Landen.	51.	70, 76, 94, 140
Jesu, der du meine Seele.	78.	71, 78, 91, 98, 113, 130, 147, 178, 190
Jesu, nun sei gepreiset.	41.	93, 104, 138, 163
Klagt, Kinder, klagt es aller Welt.	244a.	108, 114, 126, 170, 180, 182
Komm, du süsse Todesstunde.	161.	103, 161
Lass, Fürstin, lass noch einen Strahl.	198.	108, 126, 169, 170
Lasst uns sorgen, lasst uns wachen.	213.	106, 111, 112, 117, 127, 166, 175, 178, 184
Leichtgesinnte Flattergeister.	181.	105, 165
Liebster Gott, wann werd' ich sterben.	8.	90, 109, 128, 171
Liebster Jesu, mein Verlangen.	32.	102, 161
Lobe den Herren, den mächtigen König der Ehren.	137.	100, 101, 154, 158, 187, 189
Lobe den Herrn, meine Seele.	69.	96, 97, 144, 147
Lobe den Herrn, meine Seele.	69a.	96, 144
Lobet Gott in seinen Reichen.	11.	90, 118, 129, 184
Man singet mit Freuden vom Sieg.	149.	102, 111, 159, 173
Mein liebster Jesus ist verloren.	154.	66, 67, 102, 160
Meine Seel' erhebt den Herren.	10.	186, 188
Meine Seele rühmt und preist.	189.	91, 106, 131, 167
Mer hahn en neue Oberkeet.	212.	58, 61, 98, 108, 127, 150, 170
Mit Fried' und Freud' ich fahr dahin.	125.	100, 155
Nach dir, Herr, verlanget mich.	150.	58, 62, 66, 67, 102, 159, 187, 190
Nimm, was dein ist, und gehe hin.	144.	101, 158
Nun ist das Heil und die Kraft.	50.	94, 140
Nun komm, der Heiden Heiland.	61.	29, 36, 95, 142
Nun komm, der Heiden Heiland.	62.	29, 37, 95, 142
Nur jedem das Seine.	163.	103, 161
O angenehme Melodei.	210a.	111, 174
O ewiges Feuer, o Ursprung der Liebe.	34.	93, 135
O ewiges Feuer, o Ursprung der Liebe.	34a.	93, 126, 134, 135
O Ewigkeit, du Donnerwort.	20.	91, 102, 126, 132, 153, 160
O Ewigkeit, du Donnerwort.	60.	91, 102, 160

PART II

BORROWINGS FROM OTHERS

CHAPTER I

TABLE I. KEYBOARD TO KEYBOARD
NOTES ON TABLE I

TABLE 1

FROM KEYBOARD TO KEYBOARD

Source	*New Position &/or Version*
1 Fugue in D by Pachelbel (or Buxtehude?).	Fugue from Prelude & Fugue in D for Organ. BWV 532. Dated 1709 or before.
2 Eight Preludes by Krebs. Before 1710.	Eight Little Preludes & Fugues for Organ. BWV 553-560. Dated before 1710.
3 Work by Vivaldi or Buxtehude(?).	Toccata, Adagio & Fuga in C. BWV 564. Dated 1709.
4 Work by a pupil(?).	Prelude in C for Organ. BWV 567. Dated 1709.
5 Work by Kuhnau.	Fantasia in G. BWV 571. Dated 1705/6.
6 Theme by Giovanni Legrenzi.	(i) Fugue in C minor for Organ. BWV 574. Dated 1708/9 or from Lüneburg (1700-1703).

7 Theme by Giovanni Legrenzi.

(ii) Fugue in C minor for Organ. BWV 574a.

8 Passacaglia by André Raison. Dated 1700.

Passacaglia in C minor for Organ or Cembalo. BWV 582. Dated 1716/7 or Cöthen.

9 Work by Georg Philipp Telemann.

Trio-Sonata in G for Organ. BWV 586. Dated 1723-30(?).

10 Work by Johann David Heinichen.

'Kleines harmonisches Labyrinth'. BWV 591.

11 Work by Johann Pachelbel.

Choral-Prelude 'Christ lag in Todesbanden'. BWV 625.

12 Choral 'Wer nur den lieben Gott lässt walten', by Georg Neumark. BWV 434. 1640.

Choral 'Wer nur den lieben Gott lässt walten'. BWV 642. Dated 1708-17.

13 Work(s) by J. G. Walther.

Three Choral Preludes 'Ach Gott und Herr'. BWV 692, 692a, & 692b.

14 Work by Ludwig Krebs.

Choral-Prelude 'Wir Christenleut'. BWV 710.

15 Work by Bernhard Bach.

Choral-Prelude 'Allein Gott in der Höh' sei Ehr'. BWV 711.

16 Work by Johann Christoph Bach.

Choral-Prelude 'Ach Gott, vom Himmel sieh' darein'. BWV 741.

17 Work by Johann Christoph Bach.

Choral-Prelude 'Aus der Tiefe rufe ich'. BWV 745.

18 Work by J. K. F. Fischer.

Choral-Prelude 'Christ ist erstanden'. BWV 746.

19 Work by Johann Christoph Bach or J. G. Walther.

Choral-Prelude 'Gott der Vater wohn' uns bei'. BWV 748.

20 Work by Johann Christoph Bach or G. A. Homilius.

Choral-Prelude 'Schmücke dich, o liebe Seele'. BWV 759.

21 Work by Johann Christoph Bach or Georg Böhm.

Choral-Prelude 'Vater unser im Himmelreich'. BWV 760.

22 Work by Johann Christoph Bach or Georg Böhm.

Choral-Prelude 'Vater unser im Himmelreich'. BWV 761.

23 Two Variations on 'Allein Gott in der Höh' sei Ehr'' by Andreas Nikolaus Vetter.

Variations on 'Allein Gott'. BWV 771.

24 Gigue from 1st Suite in A by Dieupart.

Prelude in 1st English Suite in A. BWV 806. Dated prior to 1722.

25 Pieces by Georg Philipp Telemann.

Suite in A (fragment). BWV 824. Dated prior to 1720/1.

26 Fugue by Froberger.

Prelude No. 9 in E. BWV 878.

27 Work by Gottlieb Kirchhoff.

Fantasie und Fughetta in B flat. BWV 907.

28 Work by Gottlieb Kirchhoff.

Fantasie und Fughetta in D. BWV 908.

29 Work by Wilhelm Hieronymus Pachelbel.

Prelude in B minor. BWV 923. Dated about 1709.

30 Work by Wilhelm Hieronymus Pachelbel.

Prelude in A minor. BWV 923a. Dated about 1709.

31 Partita in G minor by G. H. Stölzel.

Trio from 'Nine little Preludes'. BWV 929. Dated about 1720/21.

32 Fugue by Johann Christoph Ersilius.

Fugue in B flat. BWV 955. Dated 1703-7.

33 Work by Johann Caspar Vogler.

Organ Prelude in E flat 'Jesu Leiden, Pein und Tod'. BWV Appx. 57.

| 34 | Work by Dobenecker(?). | Toccata in F minor. BWV Appx. 85. |
| 35 | Work by Dobenecker(?). | Fugue in G minor. BWV Appx. 101. |

NOTES ON TABLE I

1 Schmieder says that the origination of BWV 532 is a Fugue by Pachelbel. On the other hand Spitta says that 532 has been influenced by a Fugue in F by Buxtehude and also that it has borrowed certain figures from the same composer's Fantasia in F sharp minor.

The resemblances between Bach's Fugue in D and Buxtehude's Fugue in F (Wilhelm Hansen, København, *Sämtliche Orgelwerke, Vol 2. No. 15*), consist, mainly, of groups of semiquavers. Buxtehude's fugal theme is: —

Ex.103

While Bach makes considerable use of this semiquaver figure: —

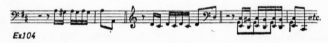

Ex.104

Bach is assumed to have received considerable stimulus from Pachelbel's Fuga in D, (DTB. IV i. p 43), but the likeness is rather superficial. Bars 4 and 5 of Pachelbel's fugue are: —

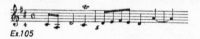

Ex.105

and his bars 2 and 3: —

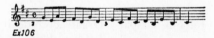

Ex.106

Bach's bar I is: — (compare with Pachelbel's bar 5).

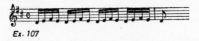

Ex. 107

and his bars 3 and 4: — (compare with Pachelbel's 2 and 3).

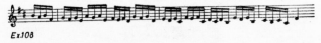

Ex.108

Does this constitute a deliberate borrowing or is it a passing resemblance?

The Alle breve section of Bach's Prelude also contains many quaver passages derived from Ex. 106. BWV 532

2 Schmieder points out that the authorship of BWV 553 – 560 is doubtful and thinks it possible that they were written by either Johann Tobias Krebs or his son Johann Ludwig before 1710.

Spitta, however, says that 'most of the Preludes, both in general outline and their surprising and irregular figures, show clearly the influence of Vivaldi's violin concertos'. He goes on to say, rather naively, 'that the influence is so evident that it would be superfluous to trace it in particular cases'.

 BWV 553-560

3 Spitta mentions that 564 is no mere imitation but a masterly adaptation. He says that the Adagio – a beautiful, unbroken cantabile – is unlike any other work by Bach and points out that the pedal figure and accompanimental chords remind us of a violin solo with clavier. But is it 'after' Vivaldi or Buxtehude? (See Ex. 109.). BWV 564

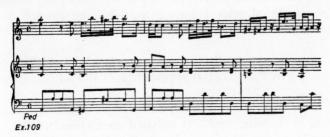

Ped
Ex.109

4 Schmieder casts doubts on the authenticity of 567 and

suggests the possibility of it being the work of one of Bach's
pupils. BWV 567

5 This Fantasia is dated as early in the Arnstadt period
following a visit to Buxtehude in 1705 or 6. It is based on a
theme from a work by Kuhnau. (See Ex. 110.). BWV 571

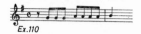

Ex.110

6/7 Schmieder dates 574 as 1708 – 9 or, even, earlier. 574a is
an alternative version or variant. Spitta feels that the imitative
counterpoint at the beginning of the work must certainly be
referred to Legrenzi and that Bach's own methods do not begin
to show until about bar 34. BWV 574, 574a

8 This Passacaglia and Fugue for organ or pedal clavier
takes the first four bars of its theme from a work by André
Raison dating from about 1700. The original MS, which was
copied for the Griepenkerl edition, is now lost. BWV 582

9 586 is an arrangement made by Bach for two keyboards and
pedal i.e. in Trio form. The original composition is by
Telemann. BWV 586

10 The *Kleines harmonisches Labyrinth* is in three sections
– Introitus, Centrum and Exitus. Schmieder doubts its
authenticity and, in referring to it as an organ work, considers
it to be a composition by Johann David Heinichen. Spitta,
on the other hand, says it is a harpsichord piece but mentions
that on the slender evidence available he cannot decide
whether it is by Bach or not! BWV 591

11 625, one of the Preludes in the organ book, is thought to
be a work by Pachelbel. It appears also in BG XL. BWV 625

12 642, also to be found in the organ book, is dated by
Spitta as 'approx. 1706'. It is based on a choral of the same
name by Georg Neumark dated 1640 (BWV 434 – one of the
4-part chorals in the Kirnberger collection). BWV 642, 434

13 Schmieder numbers these three Preludes as 692, 692a and 693, and mentions that 692 and 693 are to be credited to J. G. Walther. Whether we number the third as 692b or 693 is, I feel, immaterial but we must certainly give 692 the responsibility for 692a in addition to the others.

BWV 692, 692a, 692b

14 710 is, according to Schmieder, to be considered as a work of Johann Ludwig Krebs.

BWV 710

15 711 also has another parent, this time a relative of Bach's: — Bernard Bach.

BWV 711

16/17 741 and 745 came from another relative: — Johann Christoph, son of Heinrich Bach.

BWV 741, 745

18 Not the work of a relative on this occasion, but a piece by J. K. F. Fischer.

BWV 746

19/20/21/22 All these four Preludes, – 748, 759, 760 and 761, – have been ascribed to Johann Christoph Bach. On the other hand J. G. Walther has also been considered as the composer of 748; G. A. Homilius as responsible for 759; and 760 and 761 as coming from the pen of Georg Böhm.

BWV 748, 759, 760, 761

23 The authenticity of 771 is doubtful. It is known that variations 3 and 8 are by Andreas Nikolaus Vetter and it is extremely probable that the whole work is by him. If not, however, then Bach can be said to have 'borrowed' (lifted!) Nos. 3 and 8. Of course, if the whole work is by Vetter then it is not a case of borrowing but of incorrect attribution.

BWV 771

24 There can be no doubt that Bach derived the inspiration for this Prelude from Dieupart's Gigue.

Although published in an edition for keyboard Charles Dieupart's Suite No I is from *Six suites de clavessin divisees en ouvertures, allemandes, courantes, sarabandes, gavottes, menuets, rondeaux et gigues, pour un violin et flute avec un basse de viole et un archilut etc.* (See Ex. 111.).

BWV 806

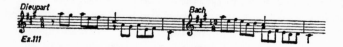

Ex.111

25 824, described as 'Fragment', consists of an Allemande, Courante and Gigue; they were, most probably, the second, third and last movements of the Suite. It must be considered as 'fragmentary' in the sense that the other movements are missing, not that the existing movements are incomplete, for they run to 64, 112 and 192 bars respectively.

Schmieder thinks the work is 'possibly' by Georg Philipp Telemann. It was included in W. F. Bach's clavier book.

BWV 824

26 S. W. Dehn has discovered a Fugue in the Phrygian mode by Froberger built on almost the same theme as Prelude No. 9. and using similar counterpoint.

Spitta feels that as Bach was familiar with Froberger's composition, the similarity cannot be completely accidental and that the work or the theme was borrowed from him. BWV 878

27/28 These two works, 907 and 908, are unusual in that they are figured. There is nothing strange, of course, in figuring an accompaniment or continuo, but it is surprising to find solos treated in this way. Schmieder points out that the authenticity of both works is doubted and suggests the possibility that they may be by Gottlieb Kirchhoff. BWV 907, 908

29/30 923 (and 923a — its variant) is considered to be by Wilhelm Hieronymus Pachelbel. In one known MS it is joined with the Fugue on a theme by Albinoni, BWV 951. In another — the 'Fischhofschen Autograph' — its first 15 bars appear in with Part I of the '48'. BWV 923, 923a

31 The Nine little Preludes (BWV 924 – 932) are in Wilhelm Friedemann's clavierbook. Also in the book is a Partita in G minor by G. H. Stölzel. Bach amused himself by setting No. 6 as a Trio to Stölzel's Minuet. One Bach MS (P 514) shows it, transposed into B minor, as a movement of the French Suite No. 3. (BWV 814). BWV 929

32 Erselius was an organist in Freiberg. His work was originally in G and was headed *Fuga di Erselio*. His version, transposed into B flat, is on page 298 of BG XLII. Bach's own version, much more ornate, is printed on page 55 of the same volume. He spends 4 bars over his coda and Erselius only three. A comparison of them both gives a good general indication of the differences between the two versions. (See Ex. 112.).

BWV 955

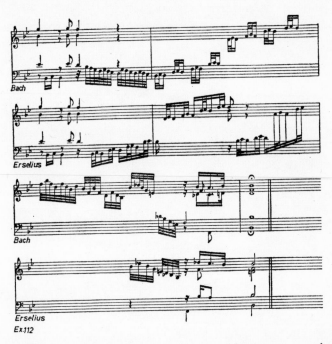

Ex.112

33 Of the 26 Choral Preludes contained between BWV Appx. 47 and 72 one, No 57, is thought to be based on a work by Johann Caspar Vogler (1696 – 1763), who, although only one year Bach's junior, was one of his pupils. Two others in the collection are believed not to be by Bach. No. 56 is assigned to Telemann and No. 60 to Krebs. BWV Appx. 57

34 Of three copies of the MS of BWV Appx. 85, one gives no composer, one Dobenecker and one J. S. Bach. Schmieder says that, if it is genuine, it dates from the Arnstadt period. BWV Appx. 85

35 BWV Appx. 101 is No. 14 of Nineteen Fugues grouped under Appx. 88 – 106. It appears – not in Bach's handwriting – in the same MS as the Toccata in F minor ascribed to Dobenecker (See 34.). BWV Appx. 101

CHAPTER II

TABLE II. KEYBOARD TO CANTATA OR ARIA
NOTES ON TABLE II

TABLE II

KEYBOARD TO CANTATA

Source	*New Position & /or Version*
1 No. 91 of 'Musicalischer Kirch-und Haus-Ergötzlichkeit' Part II by Daniel Vetter. Dated 1713.	Choral (No. 6) Herrscher über Tod und Leben in Cantata No. 8 'Liebster Gott, wann werd' ich sterben'. 1724.
2 No. 91 of 'Musicalischer Kirch-und Haus-Ergötzlichkeit' Part II by Daniel Vetter. Dated 1713.	Aria with figured bass: Liebster Gott, wann werd' ich sterben. No. 45 of 'Die geistlichen Lieder und Arien'. BWV 483. Dated 1736.
3 Polish Dance (Polonaise).	Soprano Aria (No. 4) Ach es schmeckt doch gar zu gut in Cantata 212. 'Mer hahn en neue Oberkeet'. Dated 1742.
4 Polish Dance (Polonaise).	Bass Aria (No. 6) Ach Herr Schösser, geht nicht gar zu schlimm in Cantata 212.
5 Sarabande (Les folies d'Espagne).	Soprano Aria (No. 8) Unser trefflicher lieber Kammerherr in Cantata 212.
6 Polish Dance (Mazurka).	Bass Aria (No. 12) Fünfzig Taler bares Geld in Cantata 212.

7 Slow Minuet.	Soprano Aria (No. 14) Kleinzschocher müsse, so zart und süsse in Cantata No. 212.
8 Rüpeltanz or Paysanne.	Soprano Aria (No. 22) Und dass ihr's alle wisst in Cantata 212.
9 Bourrée.	Soprano & Bass 'Coro' (No. 24) Wir gehn nun wo der Tudelsack, der Tudel . . . in Cantata 212.
10 2nd Movt. of Organ concerto No. 5, Op. 4. Handel.	Sop. Aria (No. 3). Ich bin vergnügt in meinem Leiden in Cantata No. 58 'Ach Gott, wie manches Herzeleid' (II). 1727.

NOTES ON TABLE II

1/2 Cantata No. 8 was written for the 16th Sunday after Trinity 1724. Daniel Vetter was organist of the Nicholas Church in Leipzig in 1721.

In addition to Choral No. 6 the Choral melody in Chor No. 1, (but in 12/8 rhythm), is also based on Vetter's tune. (See Ex. 113..

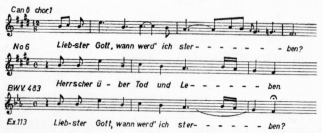

The *geistlichen Lieder und Arien* is a collection of 69 sacred melodies fitted with figured basses which Bach prepared for a songbook to be published by Breitkopf for George Christian Schemelli in 1736. As will be seen from the example given above, BWV 483 is identical (apart from key) with the melody of chor No. 6 in Can. 8. BWV 8, 483

3/4/5/6/7/8/9 One gains the impression that Bach had access to a collection of country dances, possibly arranged for

a keyboard instrument, judging by the way in which they are set in two parts.

We know that the composer was very fond of using such

Ex 114

melodies in his keyboard Suites etc. and arrangements of them
are not unknown in his Church Cantatas.

This, however, is a particularly good example of their
extensive use in a secular work. Actual music examples give,
I think, a far better idea of Bach's use of the tunes than lengthy
description. (See Ex. 114.).

Handel, amongst several other composers, used the tune of the
Sarabande (No. 8) in his harpsichord Suites No. 7 Vol. I (one
note changed) and No. 4 Vol. II (no change). (Eight of these
are dated as 1720 and nine more were first published in 1733)
and there is a close resemblance to it in the aria, Lascia ch'io
pianga from his opera 'Rinaldo' dated about 1711. This
suggests two possibilities – one, that the collection of dance
tunes referred to was sufficiently popular to be known to
Handel as early as 1710 or 1711 and two, that by 1742 Bach
may have heard or seen Rinaldo and have taken his Sarabande
idea from the aria and not the dance tune book. BWV 212

10 Walsh published Handel's Op. 4, a set of six organ
concertos, in 1738 and one would consider Bach's having
seen or heard the work in time to borrow from it for his 1727
Cantata as being quite impossible. It appears, however, that
Handel's well-known habit of self-borrowing was of assistance
to Bach for the organ movement existed as the 2nd movement
of Sonata No. XI for Recorder and Continuo, published as
Op. 1 in Amsterdam, in 1724. It is quite probable, therefore,
that a MS copy of the collection was known to Bach even
before he left Cöthen. The extremely close resemblance
between the two works appears to be more than purely
co-incidental. BWV 58

CHAPTER III

TABLE III

CONCERTO OR CONCERTO GROSSO TO CONCERTO OR CONCERTO GROSSO

Source	New Version &/or Position
1 Concerto for Viola d'amore Vivaldi or ?	Concerto in D minor for Clavier and Orchestra. BWV 1052.
2 Triple Concerto for Flute, Violin & Oboe Concertino. (Composer unknown).	Concerto in D minor for Three Claviers & Orchestra. BWV 1063. Dated 1730-33.
3 Concerto for Three Violins. (Composer unknown).	Concerto in C for Three Claviers & Orchestra. BWV 1064. Dated 1730-33.
4 Concerto in B minor for Four Violins & Strings, Op. 3 No. 10 (L'Estro Armonico) by Antonio Vivaldi.	Concerto in A minor for Four Claviers & Orchestra. BWV 1065. Dated 1730-33.

NOTES ON TABLE III

1 In Chapter VIII of Pt. 1 we noted that BWV 1052 was derived from a violin concerto not of Bach's own composition

and that that concerto was itself an adaptation. Our problem now is to consider for what instrument the original from which that adaptation was made was written.

Paul Hirsch and Adolf Aber have given several indications. To examine all their pros and cons in detail is beyond the scope of this book but Hirsch's conclusions may be summed up as follows: —

It is most probable that the work was for viola d'amore and written by a virtuoso of that instrument. The ease of writing suggests that he must have written a number of similar works. Aber wonders if the composer of the first original could be Vivaldi but both Hirsch and Schering consider it to be so different from Vivaldi's known works that they find acceptance of this suggestion almost impossible and think that 'the author of the D minor concerto is, presumably, to be sought for amongst the masters whom Vivaldi took as his pattern or who, at all events, had an appreciable influence on his work'.

<div align="right">BWV 1052</div>

2 Although BWV 1063 & 1064 are both dated as between 1730 & 33, Spitta considers that 1063 is slightly the earlier of the two. Schmieder is of the opinion that the composition is derived from a work with flute, oboe & violin concertino by an unknown composer – certainly not Bach. BWV 1063

3 Spitta regards BWV 1064 as one of the most imposing of all Bach's instrumental compositions. Schmieder thinks that it is based on a work (not by Bach), probably a concerto for three violins, whose composer is unknown. Although 1064, as we know it today, is in C, there is another version in D and Spitta is inclined to regard this (D) version as the original of the two on account of the passages for violins in bar 33 of the

Ex.115

Adagio. The difference between violins and viola in this bar is particularly worthy of note; the substitution of A for F in the violins would not be necessary in the key of D. (See Ex. 115.).

<div align="right">BWV 1064</div>

4 One is compelled to wonder whether Forkel really had little knowledge of Bach's works or whether he deliberately refused to face facts; in effect, did he choose to behave like an ostrich with its head in the sand? 1065 is a good case in point, for Forkel considered it to be an original work of Bach's, yet Vivaldi's Op. 3 was published, as we have seen, as early as 1712! C. L. Hilgenfeldt* in 1850 commented on the association between Bach and Vivaldi in this work and the circumstances must have been known to the senior members of Bach's family at least 100 years prior to Hilgenfeldt's book. The fact that the arrangement is a masterly one does not change the situation in any way.

<div align="right">BWV 1065</div>

* *Joh. Seb. Bach's Leben, Wirken und Werke.*

CHAPTER IV

TABLE IV. CHAMBER WORK OR CONCERTO GROSSO
TO KEYBOARD

NOTES ON TABLE IV

TABLE IV

FROM CHAMBER WORK OR CONCERTO GROSSO TO KEYBOARD

Source	*New Position &/or Version*
1 Sonata No. 5 by Jan Adams Reinken.	Fugue in G minor for Organ. BWV 542. Dated 1720.
2 Sonata No. 4 for Two Violins and Continuo by Corelli.	Fugue in B minor for Organ. BWV 579. Dated about 1709.
3 ?	Trio-Sonata in C minor for Organ. (BWV 585). Dated 1723-30(?).
4 Trio for Two Violins and Basso continuo from *'Les Nations, sonades et suites de symphonies en Trio'* by François Couperin. (Published in 1726.	Aria in F for Organ. (BWV 587). Dated 1723-30(?).
5 Concerto for Two Violins by Prince Johann-Ernst or Telemann.	Concerto No. 1 in G for Organ. BWV 592.

6 Concerto Grosso for Two Violins and Strings. (Op. 3, No. 8) by Antonio Vivaldi.

Concerto No. 2 in A minor for Organ. BWV 593. Dated 1708-17.

7 Concerto for Violin and Strings in D (Op. 7, Pt. 2, No. 5) by Antonio Vivaldi.

Concerto No. 3 in C for Organ. BWV 594. Dated 1708-17.

8 Concerto for Two Violins by Prince Johann-Ernst.

Concerto No. 4 in C for Organ. BWV 595 (see BWV 934).

9 Concerto Grosso for Two Violins and Continuo (Op. 3, No. 11) by Antonio Vivaldi.

Concerto No. 5 in D minor for Organ. BWV 596. Dated 1708-17.

10 Work by (Composer unknown).

Concerto No. 6 in E flat for Organ. BWV 597.

11 Sonata da Chiesa Op. 3, No. 12 for Two Violins and Continuo by Corelli. Dated about 1695.

Fugue in A for Clavier. BWV 864. Dated 1720.

12 Theme from Sonata for Two Violins and Continuo by Albinoni.

Fugue in A for Clavier. BWV 950. Dated 1709.

13 Sonata in B minor for Two Violins and Continuo by Albinoni.

Fugue in B minor for Clavier. BWV 951a. Dated prior to 1709.

14 Allegro from Sonata No. 6 by Jan Adams Reinken.

Fugue in B flat. BWV 954. Dated about 1720.

15 Sonata No. 1 by Jan Adams Reinken.

Sonata in A minor for Clavier. BWV 965. Dated 1720.

16 Sonata No. 11 by Jan Adams Reinken.

Sonata in C for Clavier. BWV 966. Dated 1720.

17 Concerto for Four Violins and Cello Continuo (Op. 3, No. 9) by Antonio Vivaldi.

Clavier Concerto No. 1 in D. BWV 972. Dated 1708-11.

18 Concerto for Solo Violin with Two Violins, Cello & Harpsichord (Op. 7, Pt. 2, No. 2) by Antonio Vivaldi.

Clavier Concerto No. 2 in G. BWV 973. Dated 1708-11.

19 Concerto for Oboe by Benedetto Marcello.

Clavier Concerto No. 3 in D minor. BWV 974. Dated 1708-11.

20 Concerto Grosso for Three Violins, Viola, Cello & Organ (Op. 4, No. 6) by Antonio Vivaldi.

Clavier Concerto No. 4 in G minor. BWV 975. Dated 1708-11.

21 Concerto for Solo Violin (Op. 3, No. 12) by Vivaldi.

Clavier Concerto No. 5 in C. BWV 976. Dated 1708-11.

22 Concerto for ? by Benedetto Marcello(?).

Clavier Concerto No. 6 in C. BWV 977. Dated 1708-11.

23 Concerto in G for Violin (Op. 3, No. 3) by Antonio Vivaldi.

Clavier Concerto No. 7 in F. BWV 978. Dated 1708-11.

24 Work by unknown Composer – possibly German.

Clavier Concerto No. 8 in B minor. BWV 979.

25 Concerto in B flat for Three Violins, Viola, Cello & Organ (Op. 4, No. 1) by Vivaldi.

Clavier Concerto No. 9 in G. BWV 980.

26 Work by unknown Composer – possibly Italian – Gregori or Torelli.

Clavier Concerto No. 10 in C minor. BWV 981.

27 Concerto by Prince Johann-Ernst.

Clavier Concerto No. 11 in B flat. BWV 982.

28 Work by unknown Composer – possibly German.

Clavier Concerto No. 12 in G minor. BWV 983.

29 Concerto by Prince Johann-Ernst.

Clavier Concerto No. 13 in C. BWV 984.

30 Work by Telemann.	Clavier Concerto No. 14 in G minor. BWV 985.
31 Work by unknown Composer – possibly German. Telemann?	Clavier Concerto No. 15 in G major. BWV 986.
32 Concerto by Prince Johann-Ernst.	Clavier Concerto No. 16 in D minor. BWV 987.

VIVALDI

We must, I feel, agree that the great debt owed by Bach to the Italian composer has been considerably underestimated.

Apart from the six organ concertos (BWV 592 – 7) (three of which are derived from Vivaldi's works) and the 16 clavier concertos (BWV 972 – 87) (for six of which he provided the stimulus), *Vivaldiana* can be traced to very many other works.

Forkel, in his book on Bach, tells us that Bach found the violin concerti of Vivaldi provided him with a very necessary guide to the solution of many problems connected with his keyboard compositions – the consequence of which was his happy idea of arranging them for keyboard use. Although we assign the years 1708 – 17 (i.e. the Weimar period) to these arrangements, it is thought that most of them date back to the early part as it is known that Vivaldi's MSS were in circulation prior to their publication. His Op. III *l'Estro Armonico,* for example, was published in 1712. Arnold Schering has mentioned that Bach's versions of Vivaldi's Op. VII (clavier concerto No. 2, BWV 973 and Organ concerto No. 3, BWV 594) were made before it was published and Waldersee points out that Bach's concerto No. 4 (BWV 975) is obviously taken from a text which varies quite considerably from Vivaldi's published Op. IV, in which it is No. 6.

The young Prince Johann-Ernst was brought up in a very musical atmosphere as his brother maintained an orchestra of sixteen professional musicians at Saxe – Weimar. Johann-Ernst, violinist and composer, delighted in Italian instrumental music and it would have been most surprising if Bach

had not joined him in his explorations of that fascinating territory. As Marc Pincherle so rightly says: — it was through the mastery gained by his study of, and work on Vivaldi's compositions, that Bach was enabled to produce such a magnificent piece as the Italian concerto in about 1735.

The Brandenburg concertos Nos 2, 4 and 5 are written very much on Vivaldi lines and although Nos. 1, 3 and 6 incline more towards the concerto grosso form of Corelli, they do, as mentioned above, contain traces of the former master's influence. A good example is provided by the opening tutti of No. 3. The following phrase appears in Vivaldi's Op. 1. (See Ex. 116.).

The violin concertos, also, contain their share of quotations: The E major is indebted to Op. XI, No. 2. The concerto in D minor for 2 violins (BWV 1043) seems to have derived its initial idea from Vivaldi's Op. 1, No. 11. (See Ex. 117.).

Another of Bach's pieces which bears a very close resemblance to a Vivaldi theme is the two-part Invention No. 8 in F. (BWV 779) (See Ex. 118.).

Bach did very little apart from his favourite trick of changing the mode.

NOTES ON TABLE IV

1 The work by Reinken from which BWV 542 was taken is in his *Hortus Musicus,* a collection of Suites or Sonatas for two violins, viola (da gamba, of course) and continuo. Bach had the greatest admiration for his work both as organist and composer. Spitta points out that as the resemblances between the two works are obviously intentional we must look upon them as homage to Reinken. (See Ex. 119.). BWV 542

Ex.119

2 Spitta thinks it significant that Corelli had exhausted his ideas on the development of his themes in 39 bars, whereas Bach over 100 bars to cope with the wealth of his inspiration! Corelli's work is No. 4 of 12 *Sonata da chiesa à tre* Op. 3 and dates from 1689. (See Ex. 120.). BWV 579

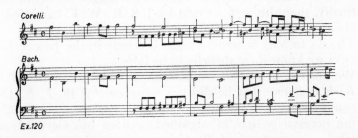

Ex.120

3 The authorship of BWV 585 is very doubtful. The work is thought to be by Johann Ludwig Krebs – probably one of his student exercises. BWV 585

4 No doubts seem to have been cast on the authorship of this work. It comes from a collection of Couperin's pieces published in Paris in 1726. BWV 587

5 Six items in this Table are *Sechs Konzerte nach verschie-*

denen Meistern BWV 592 – 97. There is a certain amount of doubt regarding the parentage of the original of No. 1. Schmieder ascribes it to Prince Johann-Ernst of Sachsen-Weimar and Pincherle, while agreeing that a German composer was involved, inclines towards Telemann. BWV 592

6 Concerto No. 2, BWV 593, comes from one of Vivaldi's Op. 3 concerti. This set, named *L'Estro Armonica*, consists of twelve concerti *per strumenti vari*. No. 8 is for two violins and cello. BWV 593

7 Vivaldi's Op. 7 is 12 concerti *per tre Violini, Alto Viola & Basso Continuo,* from which Bach took No. 5 in Pt. II for his BWV 594. BWV 594

8 BWV 595 constitutes a second-hand borrowing as it is Bach's Organ transcription of his own clavier arrangement of Prince Johann-Ernst's concerto which will be noted under BWV 934. BWV 595, 934

9 For many years it was thought that BWV 596 was by Wilhelm Friedemann Bach; later that it was a harpsichord work by W. F. which J. S. B. had re-arranged for organ and, finally, that although written by J. S. B., W. F. had tried to claim it as his own.

Thanks to Max Schneider and his article in the Jahrbuch of 1911 we know these theories to be false.

We must remember, I think, that W. F. wrote *di (of) W. F. Bach* and note that he did not write *da (by) W. F. B.* This could mean 'of' in the sense of 'belonging to' or 'property of' – not necessarily that 'of' signified 'written by'. Certainly we say ' . . . concerto of Bach' meaning 'concerto written or composed by Bach'; on the other hand when we say ' . . . house (or any other object) of Bach' we mean ' . . . (something), *the property of* 'Bach'. We cannot dispute the fact that the MS which, as W. F. says, was written by J. S. B. ('Manu mei Patris descript(um)') was *the property of* W. F. No one examining the Autograph would suppose for one moment that the hand which wrote *di W. F. Bach,* etc. had anything to do with the main body of the MS, the two sets of writing are so completely different. (See Ex. 121.). BWV 596

Ex.121

10 Not only do we not know the composer of the original version but we are not sure that Bach wrote BWV 597. Schmieder, for one, has his doubts! BWV 597

11 Corelli's collection of Church Sonatas, Op. 3, was well known by the early 18th century and Bach's other use of Corelli themes suggests that the works were in the Cöthen library and, no doubt, performed at Prince Leopold's musical evenings.

The extreme likeness of Bach's 9/8 fugal theme, with its rising 4ths, to Corelli's 6/8 movement (also with rising 4ths and in the same key) is, surely, too close to be purely accidental? BWV 864

12 Tomaso Albinoni's work from which his theme is taken was his Trio Sonata, Op. 1. As was the case with Corelli he did not feel the need to extend his movement to any great length – his is 48 bars – Bach's version runs to 99. Nor did Albinoni think it necessary to provide more than one counter-

Ex.122

point to his theme. Spitta remarks that 'he thought he had
done enough . . . and considered the matter at an end' . . .
(when he had supplied one counterpoint).
I show his counterpoint and Bach's. How much stronger the
latter's second bar is! (See Ex. 122.). BWV 950

13 BWV 951a is considered to be an early form of 951, which
is dated about 1709 so that – if really by Bach – it would date
from his very early 20's. Dr. Howard Ferguson is quite
convinced that it is the work of one of Bach's pupils to whom
the theme was given as a fugal exercise. It is interesting to
note the varying lengths of the different versions. Albinoni's
original (from his Op. 1) is 36 bars, 951a is 87 (or 88 with its
alternative ending) and 950 is 112 bars – a full length, highly
developed, composition. BWV 951a

14 Reinken's *Hortus Musicus* provides a further stimulus
via the Allegro of its No. 6. Schmieder doubts the authenticity
of BWV 954, 6 & 7 but, knowing the high regard in which
Bach held Reinken, one should not be in the least surprised
if he did make use of the elder composer's work. BWV 954

15/16 Two more borrowings from *Hortus Musicus*. It is
very interesting to note how Bach builds up and expands what
he borrows – for example Reinken's A minor second move-
ment has 50 bars whereas Bach's Fuga has 85 and in the C
major Reinken's second movement has 47 bars and Bach's
Fuga, (BWV 966), 97.
Spitta says that a glance at Reinken's works is enough to show
that Bach's two sonatas are not original pieces but clavier
arrangements of the older man's sonatas. On the other hand,
as Spitta allows: Bach 'disports himself most freely, he avails
himself of hardly anything but the theme'! BWV 965 BWV 966

17 Many of the clavier concerti which follow come from
Sechzehn Konzerte nach verschiedenen Meistern and, mostly,
are derived from works of Vivaldi, who, living from 1675 –
1741 was Bach's senior by ten years. BWV 972

18 Vivaldi Op. 7, Pt. II No. 2 is again for *tre violini, alto*

viola & basso continuo. Spitta tells us that Bach filled in the middle parts, turned the original crotchets of the bass into flowing quavers and semiquavers and added semiquaver runs to the violin parts. He adds that all the quavers in the left hand part from bar 91 to the end originate from J. S. Bach.

Vivaldi's Larghetto (Largo in Bach's version) becomes almost a new composition in the latter's hands. Many sections of the Finale were newly devised and the whole movement made richer and more brilliant. Bach's handiwork shows in the easy bass progressions, the melodic nature of the inner parts and the free imitative passage work. BWV 973

19 Marcello was Bach's junior by one year, having been born in Venice in 1686 and, good composer though he was, one must confess that his works cannot compare with his German contemporary. On the other hand one cannot deny that the Adagio of his concerto is much more effective on the oboe than even Bach's version for the harpsichord with its complete lack of cantabile and sostenuto. BWV 974

20 Concerto No. 4 comes from Vivaldi's Op. 4, known as *La Stravaganza* which has cello and 'organo' as its continuo.
 BWV 975

21 976 is from another concerto, contained in Op. 3, which, this time, is for solo violin. It is, therefore, on a par with Bach's transcriptions of his own E maj. & A minor violin concertos.
 BWV 976

22 It is possible that if the source of BWV 977 is by Marcello it, also, may have been for oboe. It is, in its way, as effective as that noted in item 19. BWV 977

23 No. 3 of Op. 3 is, like the work mentioned in item 19, for solo violin. The Largo is a particularly attractive movement which comes off well in its harpsichord transcription. BWV 978

24 Schering described the source of concerto No. 8 as by an unknown master. Pincherle, for his part, says 'possibly German'. Apart from not knowing the composer, we do not, of course, know the instrument for which the work was written. BWV 979

25 Here we have a transposition in addition to the transfer
to a keyboard instrument. The reason for the former is not
immediately apparent. Possibly Bach's original version was
in B flat and he found later that certain passages were more
comfortable under the fingers in the sharp key. BWV 980

26 Pincherle thinks that an Italian composer – possibly
Gregori or Torelli – is responsible for the source of BWV 981.
 BWV 981

27 Back to Johann-Ernst for the origins of BWV 982. His is an
attractive and well written work. BWV 982

28 Pincherle inclines toward a German for the 'unknown'
composer of the source of BWV 983, which, unlike some of
the other concertos in this set, reverts to the more normal
(for the period) 3-movement form. (BWV 979 – almost a Suite
– consisted of (1) Intro. (3/4) and Allegro; (2) Adagio (C) and
Allegro. (3/4); (3) Andante (3/2) and Allegro (₵); (4)
Adagio.) The Adagio of BWV 983 has an interesting Canon at
a bar's distance between the upper and lower voices. (See
Ex. 123.). BWV 983, BWV 979

Ex.123

29 Johann-Ernst again (see item 8). These clavier arrange-
ments date from 1708 – 17 and the organ set from 1708 – 11.

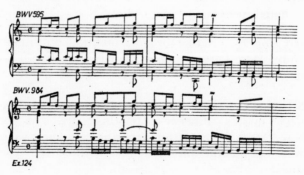

Ex.124

It is therefore, impossible to say which of the two came first. BWV 595 is a one-movement piece of 81 bars. On the other hand BWV 984 contains three movements, the first on the same theme as 595, but of 66 bars only, an Adagio e affetuoso of 31 bars and a 95-bar Allegro Assai. Comparison of the two settings is instructive. (See Ex. 124.). BWV 984

30/31 There seems to be no doubt that BWV 985 originates with Telemann but the position regarding BWV 986 is not quite so clear. Pincherle thinks that possibly the composer was German and, equally possibly, Telemann again, but this, in the present state of our knowledge, is supposition.

BWV 985 BWV 986

32 The last work in this section is again by Prince Johann-Ernst, who seems to delight in diversity of movement. This concerto has a 6-bar Introduction (C), followed by a Presto, 2/4; Allegro, (3/4); and finally, a 2-bar Adagio (C), leading into a 3/8 Vivace. BWV 987

CHAPTER V

I do not claim that this chapter is exhaustive or that it can compete with Terry's monumental study of the chorals. I hope, however, that certain points will be of interest and, possibly, new to some readers. Dürr's researches, for example, were unknown at the time when Terry was working on his book; they do not, as a rule, affect Terry's findings so far as the actual choral tunes are concerned, but do change earlier views on chronology.

TABLE V

VOCAL WORK TO CANTATA

Source	New Position &/or Version
1 Hymn Wie schön leuchtet der Morgenstern by Philipp Nicolai. (1599) (?).	(i) Choral in first item (Choral fantasia). (ii) Final Choral (No. 6) Wie bin ich doch so herzlich froh, in Cantata No. 1 'Wie schön leuchtet der Morgenstern'. Annunciation. 1733-44.

2 Cantata?

Tenor Aria (No. 5) Unser Mund und Ton der Saiten in Cantata No. 1 (see 1).

3 Hymn Melody Ach Gott, vom Himmel sieh' darein by Martin Luther.

Cantata No. 2 'Ach Gott, vom Himmel sieh darein' for 2nd Sunday after Trinity. 1735-44. Dürr, 1724.

4 Hymn Melody Ach Gott, wie manches Herzeleid . (Anon.).

(i) First Chor. Ach Gott, wie manches Herzeleid .
(ii) Recitativ mit Choral (No. 2) Wie schwerlich lässt sich Fleisch und Blut, in Cantata No. 3 'Ach Gott, wie manches Herzeleid'.

5 Hymn Melody O Jesu Christ, mein's Lebens Licht or Hilf mir, Herr Jesu, weil ich leb', words by Martin Luther.

Cantata No. 4 'Christ lag in Todesbanden'. Easter, 1724.

6 Hymn Melody Wo soll ich fliehen hin by J. Heerman.

Cantata No. 5 'Wo soll ich fliehen hin' for 19th Sunday after Trinity. 1735-44. (Dürr, 1724).

7 (i) Hymn Melody Danket dem Herrn, heut' und allzeit (Anon.) normally associated with this choral text.
(ii) Hymn Melody (Anon.) normally associated with Luther's hymn.

(i) Choral (No. 3) Ach, bleib bei uns .

(ii) Choral (No. 6) Beweis' dein Macht, Herr Jesu Christ in Cantata No. 6 'Bleib bei uns, denn es will Abend werden' for 2nd Easter Day. 1736. (Dürr, 1725).

8 Hymn Melody Christ unser Herr by J. Walther.

Chor. (No. 1) Christ unser Herr and Choral (No. 7) Das Aug' allein das Wasser sieht in Cantata No. 7 'Christ unser Herr zum Jordan kam' for John the Baptist. 1735-44. (Dürr, 1724).

J

9 Choral Herrscher über Tod und Leben by Daniel Vetter.

Final Choral Herrscher über Tod und Leben in Cantata No. 8 'Liebster Gott, wann werd' ich sterben' for 16th Sunday after Trinity. 1724/5.

10 Hymn Melody Es ist das Heil uns kommen her by Paul Speratus(?). (1524).

First Chor. Es ist das Heil and Choral No. 7 Ob sich's anliess, als wollt' er nicht in Cantata No. 9 'Es ist das Heil uns kommen her', for 6th Sunday after Trinity. 1731-5.

11 Melody Tonus Peregrinus associated with the Magnificat. (Luke 1, 46-55).

Cantata No. 10 'Meine Seel' erhebt den Herren', for Visitation. 1735-44. (Dürr, 1724).

12 (i) Hymn Melody Ermuntre dich, mein schwacher Geist by J. Schop.
(ii) Melody Von Gott will ich nicht lassen (Anon.). 1572.

(i) Choral (No. 6) Nun lieget alles unter dir .

(ii) Choral (No. 11) Wann soll es doch geschehen in Cantata No. 11 'Lobet Gott in seinen Reichen' for Ascension. 1735.

13 (i) Choral Jesu meine Freude .
(ii) Hymn Melody Was Gott tut . (Anon.).

(i) Tenor Aria (No. 6) Sei getreu .
(ii) Final Choral (No. 7) Was Gott tut in Cantata No. 12 'Weinen, Klagen, Sorgen, Zagen', for Jubilate Sunday. 1724.

14 (i) Melody Ainsi qu'on oit le cerf bruire by L. Bourgeois. 1542.
(ii) Melody O Welt, ich muss dich lassen by H. Isaak. 1539.

(i) Choral (No. 3) Der Gott, der mir hat versprochen .

(ii) Choral (No. 6) So sei nun, Seele, deine, und traue dem alleine in Cantata No. 13 'Meine Seufzer, meine Tränen' for 2nd Sunday after Epiphany. 1740. (Dürr, 1726).

15 Choral Melody Wär Gott nicht mit uns diese Zeit , by J.

First Chor. Wär Gott nicht mit uns diese Zeit and Choral

Walther(?). or, possibly, Luther. 1524.

(No. 5) Gott Lob und Dank in Cantata No. 14 'Wär Gott nicht mit uns diese Zeit' for 4th Sunday after Epiphany. 1735.

16 Hymn Tune Wenn mein Stündlein vorhanden ist by Nicolaus Herman. 1569.

Recitativ und Chor. nebst Choral (No. 9) in Cantata No. 15 'Denn du wirst meine Seele nicht in der Hölle lassen'. 1704 & 1735. (Dürr, 1726).

17 Hymn Melody Helft mir Gottes Güte preisen by W. Figulus.

Final Choral (No. 6) All' solch' dein' Güt' wir preisen in Cantata No. 16 'Herr Gott, dich loben wir' for Circumcision. 1724-26.

18 Hymn Melody Nun lob', mein Seel, den Herren, by J. Kugelmann(?). 1540.

Choral (No. 7) Wie sich ein Vat'r erbarmet in Cantata No. 17 'Wer Dank opfert, der preiset mich' for 14th Sunday after Trinity. 1737 or 2. (Dürr, 1726).

19 Hymn Melody (Anon.). 1535, possibly Luther.

Recit und Chor. (No. 3) Du wollest deinen Geist und Kraft and Final Choral (No. 5) Ich bitt', o Herr, aus Herzens Grund in Cantata No. 18, 'Gleich wie der Regen', for Sexagesima. 1714. (Dürr, 1724).

20 (i) Hymn Melody Herzlich lieb hab' ich dich, o Herr. (Anon.). 1577.
(ii) Hymn Melody Ainsi qu'on oit le cerf bruire, by L. Bourgeois.

(i) Tenor Aria (No. 5) Bleibt, ihr Engel, bleibt bei mir, in Cantata No. 19.
(ii) Choral (No. 7) Lass dein' Engel mit mir fahren, in Cantata No. 19. 'Es erhub sich ein Streit', for Michaelmas. 1725/6.

21 Hymn Melody by J. Schop. 1642.

First Chor. O Ewigkeit, du Donnerwort, and Choral (No.

7) So lang ein Gott im Himmel lebt in Cantata No. 20, 'O Ewigkeit, du Donnerwort' for 1st Sunday after Trinity. 1723-4.

22 Hymn Melody Wer nur den lieben Gott lässt walten, by Georg Neumark. 1657.

Coro (No. 9) Sei nun wieder zufrieden, meine Seele, in Cantata No. 21, 'Ich hatte viel Bekümmernis'. 1714 & 1723.

23 Hymn Melody Herr Christ, der einig' Gott's Sohn. (Anon.). 1524.

Final Choral (No. 5) Ertöt' uns durch dein' Güte, in Cantata No. 22, 'Jesus nahm zu sich die Zwölfe'. 1723.

24 Hymn Melody Christe, du Lamm Gottes. (Anon.).

Tenor Recit. (No. 2) Ach, gehe nicht vorüber and Choral (No. 4) Christe, du Lamm Gottes in Cantata No. 23, 'Du wahrer Gott und Davids Sohn' for Estomihi. 1723/4.

25 Hymn Melody O Gott, du frommer Gott. (Anon.). 1693.

Final Choral (No. 6) O Gott, du frommer Gott in Cantata No. 24, 'Ein ungefärbt Gemüte' for 4th Sunday after Trinity. 1723.

26 (i) Hymn Melody Ach Herr, mich armen Sünder (The Passion Choral) by H. L. Hassler. 1601.
(ii) Melody Ainsi qu'on oit le cerf bruire, by L. Bourgeois.

(i) First Chor. Es ist nichts Gesundes an meinem Leibe.

(ii) Final Choral (No. 6) Ich will alle meine Tage rühmen deine starke Hand, in Cantata No. 25, 'Es ist nichts Gesundes an meinem Leibe' for 14th Sunday after Trinity. 1728-36. (Dürr, 1723).

27 Choral Melody Ach wie flüchtig, by Michael Franck

First Chor. Ach wie flüchtig and Final Choral (No. 6) Ach

1652, reconstructed by J. Crüger(?). 1661.

wie flüchtig in Cantata No. 26, 'Ach wie flüchtig, ach wie nichtig' for 24th Sunday after Trinity. 1735-44. (Dürr, 1724).

28 (i) Hymn Melody Wer nur den lieben Gott lässt walten , by Georg Neumark. 1657.
(ii) Choral Melody Welt ade! ich bin dein müde by Johann Rosenmüller. 1682.

(i) First Chor. Wer weiss, wie nahe mir mein Ende?

(ii) Final Choral (No. 6) Welt ade! ich bin dein müde, in Cantata No. 27, 'Wer weiss, wie nahe mir mein Ende' for 16th Sunday after Trinity. 1731. (Dürr, 1726).

29 (i) Hymn Melody (Anon.), associated with Nun lob', mein' Seel'
(ii) Hymn Melody 'Helft mir Gottes Güte preisen', by W. Figulus.

(i) Choral (No. 2) Nun lob', mein' Seel' .

(ii) Choral (No. 6) All' solch' dein' Güt' wir preisen in Cantata No. 28, 'Gottlob! Nun geht das Jahr zu Ende' for 1st Sunday after Christmas. 1723-7 or 1736. (Dürr, 1725).

30 Choral Melody Nun lob', mein' Seel' , by J. Kugelmann.

Choral (No. 8) Sei Lob und Preis mit Ehren in Cantata No. 29, 'Wir danken dir, Gott'. (Ratswahl, 1731).

31 Melody Ainsi qu'on oit le cerf , by L. Bourgeois.

Choral (No. 6) Eine Stimme lässt sich hören in Cantata No. 30, 'Freue dich, erlöste Schar' for John the Baptist'. 1738(?).

32 Choral Wenn mein Stünd-lein vorhanden ist, by N. Herman.

Soprano Aria (No. 8) Letzte Stunde, brich herein and Final Choral (No. 9), So fahr' ich hin zu Jesu Christ, in Cantata No. 31, 'Der Himmel lacht' for Easterday, 1715 & 1731. (Dürr, 1724(?)).

33 Melody Ainsi qu'on oit le cerf bruire, by L. Bourgeois.

Choral (No. 6) Mein Gott, öffne mir die Pforten in Cantata No. 32, 'Liebster Jesu, mein Verlangen'. 1740. (Dürr, 1726).

34 Hymn Melody Allein zu dir, Herr Jesu Christ. (Anon.). 1541 & 45. Possibly by Johannes Schneesing.

(i) First Chor. Allein zu dir, Herr Jesu Christ (in 3/4). (ii) Final Choral (No. 6) Ehr' sei Gott in dem höchsten Thron' (in common time) in Cantata No. 33, 'Allein zu dir, Herr Jesu Christ'. 1735-44. (Dürr, 1724).

35 Hymn M e l o d y Nun komm, der Heiden Heiland. (Anon.). 1524. Possibly by Luther.

(i) Choral Fantasia (No. 1) Schwingt freudig. (ii) Motet (Choral) (No. 2) Nun komm, der Heiden Heiland in Cantata No. 36, 'Schwingt freudig euch empor'. Advent, 1728-36.

36 Hymn Melody Wie schön leuchet der Morgenstern, by Philipp Nicolai.

(i) Tenor Aria (No. 3) Die Liebe zieht mit sanften Schritten. (ii) Choral No. 4) Zwingt die Saiten in Cythara in Cantata 36 (see 35).

37 Nun komm, der Heiden Heiland.

(i) Choral (No. 6) Der du bist dem Vater gleich. (ii) Choral (No. 8) Lob sei Gott dem Vater g'tan in Cantata 36 (see 35).

38 (i) Hymn Melody Wie schön leuchtet der Morgenstern, by P. Nicolai. (ii) Secular Song Erlaubt ist uns die Walde of 1532. Recon. 1662 as Ich dank' dir, lieber Herre.

(i) Choral (No. 3) Herr Gott Vater, mein starker Held. (ii) Choral (No. 6) Den Glauben mir verleihe an dein'n Sohn, Jesum Christ in Cantata No. 37, 'Wer da glaubet und

getauf wird'. 1727 or 9. (Dürr,
1724).

39 Hymn Melody Aus tiefer Not schrei' ich zu dir, by Luther.	(i) Chor. (No. 1) Aus tiefer Not. (ii) Choral (No. 6) Ob bei uns ist der Sünden viel in Cantata No. 38, 'Aus tiefer Not schrei' ich zu dir'. 1735-44. (Dürr, 1724).
40 Melody Ainsi qu'on oit le cerf bruire, by L. Bourgeois.	Final Choral (No. 7) Selig sind, die aus Erbarmen in Cantata No. 39, 'Brich dem Hungrigen dein Brot'. 1732-35-44. (Dürr, 1726).
41 (i) Hymn Melody Wir Christenleut, by Caspar Fuger. Jnr. 1593. (ii) Hymn Melody Bleiches Antlitz, sei gegrüsset, by F. Funcke(?). (iii) Hymn Melody Freuet euch, ihr Christen alle!, by A. Hammerschmidt(?). 1646.	(i) Choral (No. 3) Die Sünd' macht Leid. (ii) (No. 6) Schüttle deinen Kopf und sprich. (iii) Choral (No. 8) Jesu, nimm dich deiner Glieder in Cantata No. 40, 'Dazu ist erschienen der Sohn Gottes'. 1723.
42 Hymn Melody Jesu, nun sei gepreiset. (Anon.). 1591.	(i) First Chor. Jesu, nun sei gepreiset. (ii) Final Choral (No. 6) Dein ist allein die Ehre, in Cantata No. 41, 'Jesu, nun sei gepreiset'. 1735/6. (Dürr, 1725).
43 Hymn Melody (Anon.), normally associated with Luther's words. (1529).	Final Choral (No. 7) Verleih' uns Frieden gnädiglich in Cantata No. 42, 'Am Abend aber desselbigen Sabbats'. 1731. (Dürr, 1725).
44 Hymn Melody Ermuntre dich, mein schwacher Geist, by	Choral (No. 11) Du Lebensfürst, Herr Jesu Christ in Can-

Johann Schop. 1641.

tata No. 43, 'Gott fähret auf mit Jauchzen'. 1735. (Dürr, 1726).

45 (i) Hymn Melody Ach Gott, wie manches Herzeleid. (Anon.).
(ii) Secular Melody O Welt, ich muss dich lassen, by Heinrich Isaak. 1539.

(i) Choral (No. 4) Ach Gott, wie manches Herzeleid.

(ii) Choral (No. 7) So sei nun, Seele, deine und traue dem alleine in Cantata No. 44, 'Sie werden euch in den Bann tun'. (Dürr, 1724).

46 Hymn Melody Die Wollust dieser Welt. (Anon.). 1679.

Choral (No. 7) Gib, dass ich tu' mit Fleiss in Cantata No. 45, 'Es ist dir gesagt, Mensch, was gut ist'. 1735-44. (Dürr, 1726).

47 Hymn Melody O grosser Gott von Macht, by M. Franck(?). 1632.

Choral (No. 6) O grosser Gott der Treu', weil vor dir Niemand gilt in Cantata No. 46, 'Schauet doch und sehet'. (Dürr, 1723).

48 Melody Warum betrübst du dich, by the Meistersingers. 1565.

Final Chor. (No. 5) Der zeitlichen Ehr' will ich gern entbehr'n in Cantata No. 47, 'Wer sich selbst erhöhet, der soll erniedriget werden'. (Dürr, 1726).

49 (i) and (ii) Hymn Melody Ach Gott und Herr. (Anon.). 1625.

(iii) Hymn Melody Herr Jesu Christ, du höchstes Gut. (Anon.). 1593.

(i) First Chor. Ich elender Mensch, wer wird mich erlösen.
(ii) Choral (No. 3) Soll's ja so sein, dass Straf' und Pein.
(iii) Final Choral (No. 7) Herr Jesu Christ, einiger Trost in Cantata No. 48, 'Ich elender Mensch, wer wird mich erlösen'. 1732. (Dürr, 1723).

50 Hymn Melody Wie schön leuchtet der Morgenstern, by P. Nicolai.	Soprano and Bass Duet (No. 6) Wie bin ich doch so herzlich froh in Cantata No. 49, 'Ich geh' und suche mit Verlangen. 1731. (Dürr, 1726).
51 Hymn Melody Nun lob', mein Seel', by J. Kugelmann (?). 1540.	Soprano Choral (No. 4) Sei Lob und Preis mit Ehren in Cantata No. 51, 'Jauchzet Gott in allen Landen'. (Dürr, 1730).
52 Choral Melody In dich hab' ich gehoffet, Herr, by Seth. Calvisius. 1581.	Final Choral (No. 6) In dich hab' ich gehoffet, Herr in Cantata No. 52, 'Falsche Welt, dir trau' ich nicht'. 1730. (Dürr, 1726).
53 Unknown work(?).	Cantata No. 53 'Schlage doch'. 1730.
54 Hymn Melody Werde munter, mein Gemüthe, by Johann Schop. 1642.	Final Choral (No. 5) Bin ich gleich von dir gewichen in Cantata No. 55, 'Ich armer Mensch, ich Sündenknecht'. 1731/2. (Dürr, 1726).
55 Hymn Melody Christ lag in Todesbanden, by Johann Crüger. 1649.	Final Choral (No. 5) Komm, O Tod, du Schlafes Bruder in Cantata No. 56, 'Ich will den Kreuzstab gerne tragen'. 1731/2. (Dürr, 1726).
56 Hymn Melody to Hast du denn, Jesu. (Anon.). 1665.	Choral (No. 8) Richte dich, Liebste, nach meinen Gefallen und gläube in Cantata No. 57, 'Selig ist der Mann'. 1740. (Dürr, 1725).
57 Choral Ach Gott, wie manches Herzeleid.	(i) Soprano and Bass Duetto (No. 1) Ach Gott, wie manches Herzeleid and (ii) Soprano and Bass Duetto (No. 5) Ich hab' vor mir ein'

schwere Reis' in Cantata No. 58, 'Ach Gott, wie manches Herzeleid'. 1733. (Dürr, 1727).

58 Hymn Melody Komm, heiliger Geist, Herre Gott. (Anon.) or Luther. 1535.

Choral (No. 3) Komm, heiliger Geist, Herre Gott in Cantata No. 59, 'Wer mich liebet, der wird mein Wort halten'. 1716, 1723 & 1731. (Dürr, 1723 or 4 & 1725).

59 (i) Hymn Melody Wach auf, mein Geist, by J. Schop, reconstructed by J. Crüger. (ii) Hymn Melody Es ist genug, by Johann Rudolph Ahle. 1662.

(i) Alto and Tenor Duetto (No. 1) O Ewigkeit, du Donnerwort. (ii) Choral (No. 5) Es ist genug in Cantata No. 60, 'O Ewigkeit, du Donnerwort'. 1732. (Dürr, 1723).

60 (i) Hymn Melody Nun komm, der Heiden Heiland. (Anon.). (ii) Hymn Melody Wie schön leuchet der Morgenstern, by P. Nicolai.

(i) Ouverture (Chor.) (No. 1) Nun komm, der Heiden Heiland. (ii) Final Choral (No. 6) Komm, komm, du schöne Freudenkrone' in Cantata No. 61, 'Nun komm, der Heiden Heiland'. 1714, 1717, 1722, 1723.

61 Hymn Melody Nun komm, der Heiden Heiland. (Anon.).

(i) First Chor. Nun komm, der Heiden Heiland and (ii) Final Choral (No. 6) Lob sei Gott, dem Vater, g'tan in Cantata No. 62, 'Nun komm, der Heiden Heiland'. 1735-44. (Dürr, 1724).

62 (i) Hymn Melody Grates nunc omnes. (Anon.). (ii) Hymn Melody Die Wollust dieser Welt or O Gott, du frommer Gott. (Anon.). (iii) Hymn Melody Jesu, meine Freude, by J. Crüger. 1653.

(i) Choral (No. 2) Das hat er Alles uns getan. (ii) Choral (No. 4) Was frag' ich nach der Welt. (iii) Choral (No. 8) Gute Nacht, o Wesen, das die Welt

erlesen in Cantata No. 64, 'Sehet, welch' eine Liebe hat uns der Vater erzeiget'. 1723.

63 (i) Latin Hymn Puer natus in Bethlehem . (Anon.). (ii) Hymn Melody Ich hab' in Gottes Herz und Sinn . (Anon.)

(i) Choral (No. 2) Die Kön'ge aus Saba kamen dar . (ii) Choral (No. 7) Ei nun, mein Gott, so fall' ich dir in Cantata No. 65, 'Sie werden aus Saba alle kommen'. 1724.

64 Easter Hymn Christ ist erstanden .

Final Choral(No. 6) Alleluja in Cantata No. 66, 'Erfreut euch, ihr Herzen'. 1724.

65 (i) Hymn Melody Erschienen ist der herrlich' Tag, by N. Herman. (ii) Hymn Melody Du Friedefürst, Herr Jesu Christ, by Jak. Ebert or B. Gesius.

(i) Choral (No. 4) Erschienen ist der herrlich' Tag . (ii) Choral (No. 7) Du Friedefürst, Herr Jesu Christ in Cantata No. 67, 'Halt im Gedächtnis Jesum Christ'. 1723-7.

66 Hymn Melody Also hat Gott die Welt geliebt, by G. Vopelius.

Chor. (No. 1) Also hat Gott die Welt geliebt in Cantata No. 68, 'Also hat Gott die Welt geliebt'. 1735. (Dürr, 1725).

67 Hymn Melody Es woll' uns Gott genädig sein . (Anon.). 1525.

Choral (No. 6) Es danke, Gott, und lobe dich in Cantata No. 69, 'Lobe den Herrn, meine Seele'. 1724/30. Dürr, 1743/50.

68 Bass Aria Gönne nach den Thränen güssen in 'Almira', by G. F. Handel.

Soprano Aria (No. 5) Lass der Spötter Zungen schmähen in Cantata No. 70, 'Wachet, betet, seid bereit allezeit'. 1716.

69 (i) Hymn Melody Ainsi qu'on oit le cerf, by L. Bourgeois. (ii) Advent Hymn Es ist gewisslich an der Zeit, by B.

(i) Choral (No. 7) Freu' dich sehr, o meine Seele . (ii) Bass Aria (No. 9) Ach, soll nicht dieser grosse Tag .

Ringwaldt.
(iii) Hymn Melody Meinen Jesum lass ich nicht, by A. Hammerschmidt.

(iii) Final Choral (No. 11) Nicht nach Welt in Cantata No. 70, 'Wachet, betet, seid bereit allezeit'. 1723.

70 Hymn Melody O Gott, du frommer Gott.

Soprano and Tenor Aria (Aria con Corale in Canto) Ich bin nun achtzig Jahr in Cantata No. 71, 'Gott ist mein König'. 1708, 1726.

71 Hymn Melody Was mein Gott will. (Anon.).

Final Choral (No. 5) Was mein Gott will, das g'scheh' allzeit in Cantata No. 72, 'Alles nur nach Gottes Willen'. 1723-5. (Dürr, 1726).

72 (i) Choral Melody Wo Gott der Herr nicht bei uns hält.
(ii) Hymn Melody to Von Gott will ich nicht lassen. (Anon.).

(i) Chor. (No. 1) Herr, wie du willt, so schick's mit mir.
(ii) Final Choral (No. 6) Das ist des Vaters Wille in Cantata No. 73, 'Herr, wie du willt, so schick's mit mir'. 1723-27.

73 Hymn Melody Kommt her zu mir, spricht Gottes Sohn. (Anon.).

Final Choral (No 8) Menschenkind hier auf der Erd' ist dieser edlen Gabe wert in Cantata No. 74, 'Wer mich liebet, der wird mein Wort halten'. 1735/1. (Dürr, 1725).

74 Hymn Melody Was Gott tut, das ist wohlgetan.

Choral (No. 7) Was Gott tut, das ist wohlgetan (repeated as No. 14) in Cantata No. 75, 'Die Elenden sollen essen'. 1723.

75 Hymn Melody Es woll' uns Gott genädig sein. (Anon.)

(i) Choral (No. 7) Es woll' uns Gott genädig sein.
(ii) Choral (No. 14) Es danke, Gott, und lobe dich in Cantata No. 76, 'Die Himmel

erzählen die Ehre Gottes'.
1723.

76 (i) Hymn Melody Dies sind die heil'gen zehn Gebot', by Luther or 'Anon'.
(ii) Tenor Aria (No. 5) Jesu, dir sei Dank gesungen from Cantata No. 142 'Uns ist ein Kind geboren', by Kuhnau(?). 1712/3.
(iii) Hymn Melody Ach Gott, vom Himmel sieh' darein. (Anon.).

(i) First Chor. Du sollst Gott.

(ii) Soprano Aria (No. 3) Mein Gott, ich liebe dich.

(iii) Final Choral (No. 6) Du stellst, mein Jesu, selber dich zum Vorbild wahrer Liebe in Cantata No. 77, 'Du sollst Gott, deinen Herren, lieben'. 1723-7.

77 Hymn Melody Wachet doch, erwacht, ihr Schläfer. (Anon.). 1662.

(i) First Chor. Jesu, der du meine Seele.
(ii) Choral (No. 7) Herr! ich glaube, hilf mir Schwachen in Cantata No. 78, 'Jesu, der du meine Seele'. 1735-44. (Dürr, 1724).

78 (i) Hymn Melody Nun danket, by J. Crüger. 1648.
(ii) Hymn Melody Nun lasst uns Gott, dem Herren. (Anon.). 1575.

(i) Choral (No. 3) Nun danket alle Gott.
(ii) Choral (No. 6) Erhalt uns in der Wahrheit in Cantata No. 79, 'Gott, der Herr, ist Sonn' und Schild'. 1735. (Dürr, 1725).

79 Choral Melody Ein' feste Burg, by Luther(?). 1535.

(i) First Chor. Ein' feste Burg.
(ii) Soprano and Bass Aria (No. 2), Mit unsrer Macht.
(iii) Choral (No. 5) Und wenn die Welt voll Teufel wär.
(iv) Choral (No. 8) Das Wort sie sollen lassen stahn in Cantata No. 80, 'Ein' feste Burg ist unser Gott'. 1730-9. (Dürr, 1724).

80 Hymn Melody, by J. Crüger.

Choral (No. 7) Unter deinen Schirmen bin ich vor den Stürmen in Cantata No. 81, 'Jesus schläft, was soll ich hoffen'. 1724.

81 (i) Nunc Dimittis.

(ii) Choral Melody Mit Fried' und Freud' ich fahr' dahin, by Luther(?). 1524.

(i) Bass 'Intonazione (Nunc Dimittis) e Recitative' (No. 2). (ii) Choral (No. 5) Er ist das Heil und selig' Licht in Cantata No. 83, 'Erfreute Zeit'. 1724.

82 Hymn Melody Wer nur den lieben Gott lässt walten, by G. Neumark.

Final Choral (No. 5) Ich leb' indess in dir vergnüget in Cantata No. 84, 'Ich bin vergnügt mit meinem Glücke'. 1731/2. (Dürr, 1727).

83 (i) Hymn Melody Allein Gott in der Höh' sei Ehr, by N. Decius.
(ii) Hymn Melody Ist Gott mein Schild und Helfersmann. (Anon.). 1694.

(i) Soprano Choral (No. 3) Der Herr ist mein getreuer Hirt.

(ii) Choral (No. 6) Ist Gott mein Schutz und treuer Hirt in Cantata No. 85, 'Ich bin ein guter Hirt'. 1735. (Dürr, 1725).

84 Hymn Melody Kommt her zu mir, spricht Gottes Sohn. (Anon.).
(ii) Hymn Melody Es ist das Heil uns kommen her. (Anon.)

(i) Soprano Choral (No. 3) Und was der ewig güt'ge Gott?
(ii) Final Choral (No. 6) Die Hoffnung wart't der rechten Zeit in Cantata No. 86, 'Wahrlich, wahrlich, ich sage euch'. 1723-7.

85 Hymn Melody Jesu, meine Freude, by J. Crüger.

Choral (No. 7) Muss ich sein betrübet? in Cantata No. 87, 'Bisher habt ihr nichts geboten in meinem Namen'. 1735. (Dürr, 1725).

86 Melody associated with G. Neumark's Hymn: — Wer nur den lieben Gott lässt walten. (Anon.).

Final Choral (No. 7) Sing', bet' und geh' auf Gottes Wegen in Cantata No. 88, 'Siehe, ich will viel Fischer aussenden, spricht der Herr'. 1732. (Dürr, 1726).

87 Old Folk-Tune Venus du und dein Kind.

Final Chor. (No. 6) Mir mangelt zwar sehr viel in Cantata No. 89, 'Was soll ich aus dir machen, Ephraim?'. 1732. (Dürr, 1723).

88 Hymn Melody Vater unser, by Luther or 'Anon'. 1539.

Final Choral (No. 5) Leit' uns mit deiner rechten Hand in Cantata No. 90, 'Es reifet euch ein schrecklich Ende'. 1740 (Dürr, 1723).

89 Hymn Melody Gelobet seist du, Jesu Christ.

(i) First Chor. Gelobet seist du.
(ii) Soprano Recitativo e Chorale (No. 2), Der Glanz der höchsten Herrlichkeit.
(iii) Final Choral (No. 6) Das hat er Alles uns getan in Cantata No. 91, 'Gelobet seist du, Jesu Christ'. 1735-44. (Dürr, 1724).

90 Hymn Melody Was mein Gott will. (Anon.).

(i) First Choral Ich hab' in Gottes Herz und Sinn.
(ii) Bass Recitativo e Corale (No. 2) Es kann mir fehlen nimmermehr.
(iii) Alto Choral (No. 4) Zudem ist Weisheit und Verstand.
(iv) Corale e Recitative (No. 7) Ei nun, mein Gott, so fall' ich dir.
(v) Final Choral (No. 9) Soll ich denn auch des Todes Weg in Cantata No. 92, 'Ich hab' in Gottes Herz und Sinn'. 1735-44. (Dürr, 1725).

91 Choral Melody Wer nur den lieben Gott lässt walten, by Georg Neumark.

(i) First Chor. Wer nur den lieben Gott lässt walten.
(ii) Bass Recitativo e Corale (No. 2) Was helfen uns die schweren Sorgen?
(iii) Tenor Aria (No. 3) Man halte nur ein wenig stille.
(iv) Soprano & Alto Aria (Duetto) e Corale (No. 4), Er kennt die rechten Freudenstunden, er weiss wohl.
(v) Tenor Recitativo e Corale (No. 5) Denk' nicht in deiner Drangsals-Hitze.
(vi) Final Choral (No. 7) Sing', bet' und geh' auf Gottes Wegen in Cantata No. 93, 'Wer nur den lieben Gott lässt walten'. 1728. (Dürr, 1724).

92 Hymn Melody O Gott, du frommer Gott or Die Wollust dieser Welt!

(i) First Chor. Was frag' ich nach der Welt!
(ii) Tenor Recitativo e Corale (No. 3) Die Welt sucht Ehr' und Ruhm.
(iii) Bass Recitativo e Corale (No. 5) Die Welt bekümmert sich.
(iv) Final Choral (No. 8) Was frag' ich nach der Welt! in Cantata No. 94, 'Was frag' ich nach der Welt!' 1735. (Dürr, 1724).

93 (i) Hymn Melody Christus, der ist mein Leben, by M. Vulpius. 1609.

(ii) Hymn Melody Mit Fried und Freud' ich fahr' dahin, by Luther(?).

(iii) Hymn Melody Valet will ich dir geben, by Melchior Teschner. 1614.

(i) First Chor. Christus, der ist mein Leben.

(ii) Allegro & Choral (No. 1, Part II) Mit Fried' und Freud' ich fahr' dahin.

(iii) Soprano Recitativo e Corale (No. 2) Valet will ich dir geben.

(iv) Hymn Melody Wenn mein Stündlein vorhanden ist, by N. Herman.

(iv) Final Choral (No. 6) Weil du vom Tod erstanden bist in Cantata No. 95, 'Christus, der ist mein Leben'. 1732. (Dürr, 1723).

94 Hymn Melody Herr Christ, der ein'ge Gottes-Sohn.

(i) First Chor. Herr Christ, der ein'ge Gottes-Sohn.
(ii) Final Choral (No. 6) Ertöt' uns durch dein' Güte in Cantata No. 96, 'Herr Christ, der ein'ge Gottes-Sohn'. 1735-44. (Dürr, 1724).

95 Hymn Melody O Welt, ich muss dich lassen, by H. Isaak. 1633.

(i) First Chor. In allen meinen Taten.
(ii) Final Choral (No. 6) So sei nun, Seele, deine in Cantata No. 97, 'In allen meinen Taten'. 1734.

96 (i) Hymn Melody Was Gott tut. (Anon.).
(ii) Melody by Hammerschmidt.

(i) First Chor. Was Gott tut.

(ii) Bass Aria (No. 5) Meinen Jesum lass' ich nicht in Cantata No. 98, 'Was Gott tut, das ist wohlgetan'. 1731/2. (Dürr, 1726).

97 Hymn Melody Was Gott tut. (Anon.).

(i) First Chor. Was Gott tut.
(ii) Final Choral (No. 6) Was Gott tut in Cantata No. 99, 'Was Gott tut, das ist wohlgetan'. 1733. (Dürr, 1724).

98 Hymn Melody Was Gott tut. (Anon.).

(i) First Chor. Was Gott tut
(ii) Final Choral (No. 6) Was Gott tut in Cantata No. 100, 'Was Gott tut, das ist wohlgetan'. 1735-33. (Dürr, 1732).

99 Hymn Melody Vater unser. (Anon.) or Luther(?).

(i) First Chor. Nimm von uns.
(ii) Soprano Recitativo e Corale

(No. 3) Ach! Herr Gott die Treue.

(iii) Bass Aria (No. 4) Warum willst du so zornig sein.

(iv) Tenor Recitativo e Corale (No. 5) Die Sünd' hat uns verderbet sehr.

(v) Soprano & Alto Aria (Duetto) (No. 6) Gedenk' an Jesu bittern Tod.

(vi) Final Choral (No. 7) Leit' uns mit deiner rechten Hand in Cantata No. 101, 'Nimm von uns, Herr, du treuer Gott'. 1735-44. (Dürr, 1724).

100 Hymn Melody Vater unser (see 99).

Final Choral (No. 7) Heut' lebst du, heut' bekehre dich in Cantata No. 102, 'Herr, deine Augen sehen nach dem Glauben'. 1731/2. (Dürr, 1726).

101 Hymn Melody Was mein Gott will, das g'scheh' allzeit. (Anon.).

Final Choral (No. 6) Ich hab' dich einen Augenblick in Cantata No. 103, 'Ihr werdet weinen und heulen'. 1735. (Dürr, 1725).

102 Hymn Melody Allein Gott in der Höh' sei Ehr, by N. Decius.

Final Choral (No. 6) Der Herr ist mein getreuer Hirt in Cantata No. 104, 'Du Hirte Israel, höre'. 1724.

103 (i) Passion Music by G. F. Handel.

(i) Soprano Aria (No. 3) Wie zittern und wanken der Sünder Gedanken.

(ii) Hymn Melody Wachet, doch, erwacht, ihr Schläfer. (Anon.).

(ii) Final Choral (No. 6) Nun, ich weiss, du wirst mir stillen in Cantata No. 105, 'Herr, gehe nicht ins Gericht'. 1723-7.

104 (i) Hymn Melody Ich hab' mein Sach' Gott heim-

(i) Chor. (No. 2). (Section 5 (Trio)) Es ist der alte Bund.

gestellt, by Melchior Vulpius.
1609.

(ii) Hymn Melody Mit Fried'
und Freud' ich fahr' dahin,
by Luther.

(iii) Hymn Melody Christus
der ist mein Leben, by
Vulpius.

(iv) Choral Melody In dich
hab' ich gehoffet, Herr, by S.
Calvisius and Glorie, Lob,
Ehr', by A. Reissner.

105 Hymn Melody Was willst
du dich betrüben, by Johann
Heermann.

106 Hymn Melody Kommt
her zu mir, spricht Gottes
Sohn. (Anon.).

107 Choral Melody Durch
Adams Fall ist ganz verderbt.
(Anon.).

108 Hymn Melody Wir
Christenleut, by C. Fuger Jnr.

109 Hymn Melody Was mein
Gott will. (Anon.).

(ii) Alto & Bass Duetto (No. 3)
In deine Hände.

(iii) Final Chor. (No. 4) Glorie,
Lob, Ehr' und Herrlichkeit

(iv) Final Chor. Glorie, Lob,
Ehr' und Herrlichkeit in Can-
tata No. 106, 'Gottes Zeit ist
die allerbeste Zeit'. 1711(?).
(Dürr, 1724).

(i) First Chor. Was willst du
dich betrüben.

(ii) Final Choral (No. 7) Herr,
gib, dass ich dein' Ehre in
Cantata No. 107, 'Was willst
du dich betrüben'. 1735. (Dürr,
1724).

Final Choral (No. 6) Dein
Geist, den Gott vom Himmel
gibt in Cantata No. 108, 'Es
ist euch gut, dass ich hingehe'.
1735. (Dürr, 1725).

Final Choral (No. 6) Wer
hofft in Gott und dem vertraut
in Cantata No. 109, 'Ich glaube,
lieber Herr, hilf meinem Un-
glauben'. 1727-36. (Dürr, 1723).

Final Choral (No. 7) Alleluja
in Cantata No. 110, 'Unser
Mund sei voll Lachens'. After
1734. (Dürr, 1725).

(i) First Chor. Was mein Gott
will.

(ii) Final Choral (No. 6) Noch
eins, Herr, will ich bitten dich
in Cantata No. 111, 'Was mein
Gott will, das g'scheh' allzeit'.
1735-44. (Dürr, 1725).

110 Choral Melody Allein Gott in der Höh' sei Ehr, by N. Decius.

(i) First Chor. Der Herr ist mein getreuer Hirt.
(ii) Final Choral (No. 5) Gutes und die Barmherzigkeit in Cantata No. 112, 'Der Herr ist mein getreuer Hirt'. 1731.

111 Hymn Melody Kreuz und Trostlied. (Anon.) or Herr Jesu Christ.

(i) First Chor. Herr Jesu Christ, du höchstes Gut.
(ii) Alto Choral (No. 2) Erbarm' dich mein in solcher Last.
(iii) Bass Recitativo (mit Choral) (No. 4) Jedoch dein heilsam Wort.
(iv) Soprano & Alto Aria (Duetto) (No. 7) Ach Herr, mein Gott, vergib mir's doch.
(v) Final Choral (No. 8) Stärk' mich mit deinem Freudengeist in Cantata No. 113, 'Herr Jesu Christ, du höchstes Gut'. 1735-44. (Dürr, 1724).

112 Hymn Melody Wo Gott der Herr nicht bei uns hält. (Anon.). 1535.

(i) First Chor. Ach, lieben Christen.
(ii) Soprano Choral (No. 4) Kein Frucht das Weizenkörnlein bringt.
(iii) Alto Aria (No. 5) Du machst, o Tod.
(iv) Final Choral (No. 7) Wir wachen oder schlafen ein in Cantata No. 114, 'Ach, lieben Christen, seid getrost'. 1735-44. (Dürr, 1724).

113 Hymn Melody Straf mich nicht in deinem Zorn. (Anon.). 1694.

(i) First Chor. Mache dich, mein Geist, bereit.
(ii) Final Choral (No. 6) Drum so lasst uns immerdar in Can-

114 Hymn Melody Du Friedefürst, Herr Jesu Christ, by Barth. Gesius.

115 Hymn Melody Sei Lob und Ehr' dem höchsten Gut. (Anon.) or Es ist das Heil.

116 Hymn Melody Ach Gott, wie manches Herzeleid. (Anon.).

117 (i) Choral Melody Nun danket. Johann Crüger. 1647. (ii) Te Deum or Herr Gott, dich loben wir. (Anon.). 1535.

118 Melody to Herr Gott, dich loben wir (see 117).

119 Choral Melody Lobe den Herren.

120 Melody to Christum wir sollen loben schon. (Anon.).

tata No. 115, 'Mache dich, mein Geist, bereit'. 1735-44. (Dürr, 1724).

(i) First Chor. Du Friedefürst, Herr Jesu Christ.
(ii) Final Choral (No. 6) Erleucht' auch unsern Sinn und Herz in Cantata No. 116, 'Du Friedefürst, Herr Jesu Christ'. 1745. (Dürr, 1724).

(i) First Chor. Sei Lob und Ehr' dem höchsten Gut.
(ii) Choral (No. 4) Ich rief dem Herrn in meiner Not.
(iii) Final Choral (No. 9) So kommet vor sein Angesicht in Cantata No. 117, 'Sei Lob und Ehr' dem höchsten Gut'. 1733.

Motette No. 118 'O Jesu Christ, mein's Lebens Licht'. 1740. (Dürr, 1735-50).

(i) Chor. (No. 7) Der Herr hat Gut's an uns getan.
(ii) Final Choral (No. 9). Hilf deinem Volk, Herr Jesu Christ in Cantata No. 119, 'Preise, Jerusalem, den Herrn'. 1723.

Final Choral (No. 6) Nun hilf uns, Herr, den Dienern dein in Cantata No. 120, 'Gott, man lobet dich in der Stille'. 1728.

Final Choral (No. 8) Lobe den Herren in Cantata No. 120a, 'Herr Gott, Beherrscher aller Dinge'. 1730.

(i) First Chor. Christum wir sollen loben schon.

(ii) Final Choral (No. 6) Lob, Ehr' und Dank sei dir gesagt in Cantata No. 121, 'Christum wir sollen loben schon'. 1735-44. (Dürr, 1724).

121 Choral Melody Das neugebor'ne Kindelein . (Anon.).

(i) First Chor. Das neugebor'ne Kindelein .
(ii) Soprano Recitativo Die Engel, welche sich zuvor vor euch .
(iii) Soprano, Alto & Tenor Aria (Terzett) (No. 4) Ist Gott versöhnt und unser Freund .
(iv) Final Choral (No. 6) Es bringt das rechte Jubeljahr in Cantata No. 122, 'Das neugebor'ne Kindelein'. 1742. (Dürr, 1724).

122 Hymn Melody Liebster Immanuel . (Anon.). 1679.

(i) First Chor. Liebster Immanuel .
(ii) Final Choral (No. 6) Drum fahrt nur immerhin in Cantata No. 123, 'Liebster Immanuel'. 1735-44. (Dürr, 1725).

123 Hymn Melody Meinen Jesum .

(i) First Chor. Meinen Jesum lass' ich nicht .
(ii) Final Choral (No. 6) Jesum lass' ich nicht von mir in Cantata No. 124, 'Meinen Jesum lass' ich nicht'. 1735-44. (Dürr, 1725).

124 Choral Melody Mit Fried' und Freud' ich fahr' dahin , by Luther (?).

(i) First Chor. Mit Fried' und Freud' .
(ii) Bass Recitativo (No. 3) O Wunder, dass ein Herz .
(iii) Final Choral (No. 6) Er ist das Heil und sel'ge Licht in Cantata No. 125, 'Mit Fried' und Freud' ich fahr' dahin'. 1735-44. (Dürr, 1725).

125 (i) Hymn Melody Erhalt uns, Herr, by Luther (?).
(ii) Verleih' uns Frieden gnädiglich. Luther (?).

(i) First Chor. Erhalt' uns, Herr.
(ii) Alto & Tenor Recitativo (No. 3) Der Menschen Gunst und Macht.
(iii) Final Choral (No. 6) Verleih' uns Frieden gnädiglich in Cantata No. 126, 'Erhalt' uns, Herr, bei deinem Wort'. 1735-44. (Dürr, 1725).

126 (i) Hymn Melodies Herr Jesu Christ (?) and
(ii) On a beau son maison bastir, by L. Bourgeois. 1551.

(i) First Chor. Herr Jesu Christ.
(ii) Bass Recitativo ed Aria (No. 4), Fürwahr, fürwahr, euch sage ich.
(iii) Final Choral (No. 5) Ach Herr, vergib all' uns're Schuld in Cantata No. 127, 'Herr Jesu Christ, wahr'r Mensch und Gott'. 1725-44. (Dürr, 1725).

127 (i) Hymn Melody Allein Gott in der Höh' sei Ehr', by N. Decius.
(ii) Hymn Melody O Gott, du frommer Gott. (Anon.). 1679.

(i) First Chor. Auf Christi Himmelfahrt allein.

(ii) Final Choral (No. 5) Alsdann so wirst du mich zu deiner Rechten stellen in Cantata No. 128, 'Auf Christi Himmelfahrt allein'. 1735. (Dürr, 1725).

128 (i) Hymn Melody Gelobet sei der Herr, mein Gott, mein Licht, by Johann Olearius. 1665.
(ii) Hymn Melody O Gott, du frommer Gott. (Anon.).

(i) First Chor. Gelobet sei der Herr, mein Gott, mein Licht.

(ii) Final Choral (No. 5) Dem wir das Heilig itzt in Cantata No. 129, 'Gelobet sei der Herr, mein Gott'. 1732. (Dürr, 1726 or 27).

129 Hymn Melody Or sus serviteurs du Seigneur, by L.

(i) First Chor. Herr Gott, dich loben alle wir.

Bourgeois. 1551.

130 (i) Hymn Melody Erbarm'
dich.

(ii) Und weil ich denn or
Herr Jesu Christ, by Ring-
waldt.

131 Hymn Melody Herr
Christ, der einig' Gott's Sohn.
(Anon.). 1524.

132 Hymn Melody Ich freue
mich in dir, by (?) Bach.

133 Hymn Melody Herzlich
tut mich verlangen, by A. L.
Hassler.

134 Secular Melody. (Anon.).

(ii) Final Choral (No. 6)
Darum wir billig loben dich
in Cantata No. 130, 'Herr Gott,
dich loben alle wir'. 1735-44.
(Dürr, 1724).

(i) Aria Basso, Soprano mit
Cantus Firmus (No. 2), So du
willst, Herr.

(ii) Aria. Tenor, Alto mit Can-
tus Firmus (No. 4), Meine
Seele wartet auf den Herrn
in Cantata No. 131, 'Aus der
Tiefe rufe ich, Herr, zu dir'.
1707.

Final Choral (No. 6) Ertöt' uns
durch dein' Güte in Cantata
No. 132, 'Bereitet die Wege,
bereitet die Bahn'.

(i) First Chor. Ich freue mich
in dir.

(ii) Final Choral (No. 6)
Wohlan! so will ich mich an
dich, o Jesu, halten in Cantata
No. 133, 'Ich freue mich in dir'.
1735-7. (Dürr, 1724).

(i) First Chor. Ach Herr, mich
armen Sünder.

(ii) Final Choral (No. 6) Ehr'
sei in's Himmels Throne in
Cantata No. 135, 'Ach Herr,
mich armen Sünder'. 1735-44.
(Dürr, 1724).

Final Choral (No. 6) Dein
Blut, der edle Saft in Cantata
No. 136, 'Erforsche mich, Gott,
und erfahre mein Herz'. 1723/
7 or 1737/8. (Dürr, 1723).

135 Hymn Melody Lobe den Herrn, den mächtigen König der Ehren, by J. Neander or Hast du denn, Liebster, dein Angesicht. (Anon.).

(i) First Chor. Lobe den Herren.

(ii) Alto Aria (No. 2) Lobe den Herren.

(iii) Soprano & Bass Aria (Duetto). (No. 3) Lobe den Herren.

(iv) Tenor Aria (No. 4) Lobe den Herren.

(v) Final Choral (No. 5) Lobe den Herren in Cantata No. 137, 'Lobe den Herren'. 1731/ 2. (Dürr, 1725).

136 Choral Melody Warum betrübst du dich.

(i) First Chor. Warum betrübst du dich.

(ii) Chor. (No. 3) Er kann und will dich lassen nicht.

(iii) Final Choral (No. 7) Weil du mein Gott und Vater bist in Cantata No. 138, 'Warum betrübst du dich, mein Herz'. 1732-40. (Dürr, 1723).

137 Choral Melody Mach's mit mir, Gott, nach deiner Güt', by J. H. Schein. 1628.

(i) First Coro Wohl dem, der sich auf seinen Gott.

(ii) Final Choral (No. 6) Dahero Trotz der Höllen Heer in Cantata No. 139, 'Wohl dem, der sich auf seinen Gott'. 1735- 44. (Dürr, 1724).

138 Hymn Melody Wachet auf, ruft uns die Stimme, by Philipp Nicolai. 1599.

(i) First Chor. Wachet auf.

(ii) Choral (No. 4) Zion hört die Wächter singen.

(iii) Final Choral (No. 7) Gloria sei dir gesungen in Cantata No. 140, 'Wachet auf, ruft uns die Stimme'. 1731 or 42. (Dürr, 1731).

139 Cantata (?) by Telemann (?).

Cantata No. 141 'Das ist je gewisslich wahr'. 1720-22.

140 Cantata (?) by Johann Kuhnau (?).

Cantata No. 142 'Uns ist ein Kind geboren'. 1712-20.

141 Hymn Melody Du Friede-fürst, by Jakob Ebert (Spitta) or by B. Gesius (Whittaker & Terry).

(i) Soprano Choral (No. 2) Du Friedefürst, Herr Jesu Christ . (ii) Tenor (Aria mit Choral-melodie) (No. 6) Jesu, Ritter deiner Herde . (iii) Final Coro (No. 7) Hal-leluja in Cantata No. 143, 'Lobe den Herrn, meine Seele'. 1735.

142 (i) Hymn Melody Was Gott tut . (Anon.). (ii) Secular Melody Il me souffit de tous mes maulx . (Anon.).

(i) Choral (No. 3) Was Gott tut . (ii) Final Choral (No. 6) Was mein Gott will, das g'scheh' allzeit in Cantata No. 144, 'Nimm, was dein ist, und gehe hin'. 1723-7. (Dürr, 1724).

143 (i) Hymn Melody Jesus, meine Zuversicht , by J. Crüger. (ii) Chorus by Telemann (?).

(iii) Hymn Melody Erschienen ist der herrlich' Tag' , by N. Herman.

(i) First Choral Auf, mein Herz .

(ii) Coro (No. 2) So du mit deinem Munde bekennest . (iii) Final Choral (No. 7) Drum mir auch billig fröhlich sein in Cantata No. 145, 'Auf, mein Herz, des Herren Tag'. ('So du mit deinem Munde bekennest'). 1729-30.

144 Hymn Melody Werde munter, mein Gemüthe, by J. Schop.

Final Choral (No. 8) Denn wer selig dahin fähret in Cantata No. 146, 'Wir müssen durch viel Trübsal in das Reich Gottes eingehen'. 1740.

145 Hymn Melody Werde munter, mein Gemüthe, by J. Schop.

(i) Choral (No. 6) Wohl mir, dass ich Jesum habe.
(ii) Choral (No. 10) Jesus bleibet meine Freude in Cantata No. 147, 'Herz und Mund und Tat und Leben'. 1727. (Dürr, 1723).

146 Hymn Melody Auf meinen lieben Gott. (Anon.).

Final Choral (No. 6) Führ' auch mein Herz und Sinn in Cantata No. 148, 'Bringet dem Herrn Ehre seines Namens'. 1725. (Dürr, 1723(?)).

147 Hymn Melody Herzlich lieb hab' ich dich, o Herr. (Anon.).

Final Choral (No. 7) Ach Herr, lass dein' lieb' Engelein in Cantata No. 149, 'Man singet mit Freuden vom Sieg'. 1731. (Dürr, 1728).

148 Hymn Melody Lobt Gott, ihr Christen alle gleich, by Nicolaus Herman. 1554.

Final Choral (No. 5) Heut' schleusst er wieder auf die Tür in Cantata No. 151, 'Süsser Trost, mein Jesus kommt'. 1735-40. (Dürr, 1725).

149 (i) Hymn Melodies Ach Gott, vom Himmel sieh' darein. (Anon.).
(ii) Herzlich thut mich verlangen, by H. L. Hassler.
(iii) Drum will ich, weil ich lebe noch also known as Herr Jesu Christ, mein's Lebenslicht.

(i) First Choral Schau', lieber Gott, wie meine Feind.

(ii) Choral (No. 5) Und obgleich alle Teufel.
(iii) Final Choral (No. 9) Drum will ich, weil ich lebe noch in Cantata No. 153, 'Schau', lieber Gott, wie meine Feind'. 1724-7. (Dürr, 1724).

150 (i) Hymn Melody Werde munter, mein Gemüthe by J. Schop.
(ii) Meinen Jesum lass ich nicht, by A. Hammerschmidt.

(i) Choral (No. 3) Jesu, mein Hort und Erretter.
(ii) Final Choral (No. 8) Meinen Jesum lass ich nicht in Cantata No. 154, 'Mein liebster Jesus ist verloren'. 1724.

151 Hymn Melody Es ist das Heil uns kommen her, by Paul Speratus(?). 1524.

Final Choral (No. 5) Ob sich's anliess', als wollt' er nicht in Cantata No. 155, 'Mein Gott, wie lang', ach lange'. 1724(?).

152 (i) Choral Melody Mach's mit mir, Gott, by J. H. Schein. 1628.
(ii) Herr, wie du willt. (Anon.) 1525.

(i) Soprano Aria mit Choral Ich steh' mit einem Fuss im Grabe.
(ii) Final Choral (No. 6) Herr, wie du willt in Cantata No. 156, 'Ich steh' mit einem Fuss im Grabe'. 1729 or 30.

153 Hymn Melody Meinen Jesum lass ich nicht (see 150, ii).

Final Choral (No. 5) Meinen Jesum lass' ich nicht in Cantata No. 157, 'Ich lasse dich nicht, du segnest mich denn'. 1727.

154 (i) Hymn Melody Welt, ade! ich bin dein müde, by J. Rosenmüller.
(ii) Christ lag in Todesbanden, by Johann Walther. 1524.

(i) Soprano Aria mit Choral (No. 2) Welt, ade! ich bin dein müde.
(ii) Final Choral (No. 4) Hier ist das rechte Osterlamm in Cantata No. 158, 'Der Friede sei mit dir'. 1708-17 and Leipzig.

155 (i) Passion Hymn O Haupt voll Blut und Wunden, by H. L. Hassler. 1656.
(ii) Hymn Melody Jesu Leiden, Pein und Tod, by M. Vulpius. 1609.

(i) Soprano Aria mit Choral (No. 2) Ich will hier bei dir stehen.
(ii) Final Choral (No. 5) Jesu, deine Passion ist mir lauter Freude in Cantata No. 159, 'Sehet, wir geh'n hinauf gen Jerusalem'. 1729.

156 Cantata ?, by Telemann.	Cantata No. 160 'Ich weiss, dass mein Erlöser lebt'. 1713 or 14.
157 (i) Choral Melody Wenn ich einmal soll scheiden. (ii) Herzlich thut mich verlangen.	(i) Alto Aria (No. 1) Komm, du süsse Todesstunde. (ii) Final Choral (No. 6) Der Leib zwar in der Erden in Cantata No. 161, 'Komm, du süsse Todesstunde'. 1715 and 1735.
158 An old Melody Alle Menschen müssen sterben, by Rosenmüller. 1652(?).	Final Choral (No. 6) Ach, ich habe schon erblikket in Cantata No. 162, 'Ach, ich sehe, itzt, da ich zur Hochzeit gehe'. 1715 and 1723.
159 (i) Melody Meinen Jesum lass' ich nicht, by Hammerschmidt. (ii) Choral Melody, by Pachelbel(?).	(i) Soprano and Alto Aria (Duett) (No. 5) Nimm mich mir, und gib mich dir. (ii) Choral in simplice stylo (No. 6) Führ' auch mein Herz und Sinn in Cantata No. 163, 'Nur jedem das Seine'. 1715 and 1723.
160 Choral Melody Herr Christ, der einig' Gott's Sohn.	Final Choral (No. 6) Ertöt' uns durch dein' Güte in Cantata No. 164, 'Ihr, die ihr euch von Christo nennet'. 1723 or 4. (Dürr, 1725).
161 Hymn Melody Nun lässt uns Gott dem Herren.	Final Choral (No. 6) Sein Wort, sein Taufe, sein Nachtmahl in Cantata No. 165, 'O heil'ges Geist-und Wasserbad'. 1724.
162 (i) Hymn Melody Herr Jesu Christ, du höchstes Gut, 1593. (ii) Hymn Melody Wer nur den lieben Gott lässt walten,	(i) Choral (No. 3) Ich bitte dich, Herr Jesu Christ. (ii) Final Choral (No. 6) Wer weiss, wie nahe mir mein

by G. Neumark. 1657.

Ende in Cantata No. 166, 'Wo gehest du hin'. 1723-7. (Dürr, 1724).

163 Hymn Melody Nun lob', mein' Seel' .

Final Choral (No. 5) Sei Lob und Preis mit Ehren in Cantata No. 167, 'Ihr Menschen, rühmet Gottes Liebe'. 1723-27. (Dürr, 1723).

164 Hymn Melody Herr Jesu Christ .

Final Choral (No. 6) Stärk' mich mit deinem Freudengeist in Cantata No. 168, 'Tue Rechnung, Donnerwort'. 1723 or 44. (Dürr, 1725).

165 Hymn Melody Nun bitten wir den heiligen Geist . (Anon.).

Final Choral (No. 7) Du süsse Liebe, schenk' uns deine Gunst in Cantata No. 169, 'Gott soll allein mein Herze haben'. 1731 or 2. (Dürr, 1726).

166 Hymn Melody Jesu, nun sei gepreiset .

Final Choral (No. 6) Dein ist allein die Ehre in Cantata No. 171, 'Gott, wie dein Name, so ist auch dein Ruhm'. 1730-36. (Dürr, 1729(?)).

167 (i) First Chor. from Cantata 'Das ist je gewisslich wahr', by Telemann.
(ii) Whitsun Choral Komm, heiliger Geist, Herre Gott .

(i) First Coro Erschallet, ihr Lieder, erklinget, ihr Saiten .

(ii) Final Choral (No. 6) Von Gott kommt mir ein Freudenschein in Cantata No. 172, 'Erschallet, ihr Lieder'. 1724.

168 Traditional H y m n Melody Herzlich lieb hab' ich dich, O Herr , by Schalling or (Anon.).

Final Choral (No. 5) Herzlich lieb hab' ich dich, O Herr in Cantata No. 174, 'Ich liebe den Höchsten von ganzem Gemüte'. 1729.

169 Hymn Melody Komm,

Final Choral (No. 7) Nun,

heiliger Geist, Herre Gott. 1651.	werter Geist, ich folg' dir in Cantata No. 175, 'Er rufet seinen Schafen mit Namen'. 1735-6. (Dürr, 1725).
170 Hymn Melody Christ unser Herr zum Jordan kam, by J. Walther(?). 1653.	Final Choral (No. 6) Auf dass wir also allzugleich in Cantata No. 176, 'Es ist ein trotzig und verzagt Ding'. 1735 or 2. (Dürr, 1725).
171 Hymn Melody Ich ruf' zu dir, Herr Jesu Christ. (Anon.). 1535.	(i) First Chor. Ich ruf' zu dir, Herr Jesu Christ. (ii) Final Choral (No. 5) Ich lieg' im Streit und widerstreb in Cantata No. 177, 'Ich ruf' zu dir, Herr Jesu Christ'. 1732.
172 Hymn Melody Wo Gott der Herr nicht bei uns hält. (Anon.). 1529 or '35.	(i) First Chor. Wo Gott der Herr nicht bei uns hält. (ii) Alto Recitative (No. 2) Was Menschen Kraft und Witz anfäht. (iii) Tenor Choral (No. 4) Sie stellen uns wie Ketzern nach. (iv) Choral und Recitativ (No. 5) Aufsperren sie den Rachen weit. (v) Final Choral (No. 7) Die Feind' sind all' in deiner Hand in Cantata No. 178, 'Wo Gott der Herr nicht bei uns hält'. 1735-44. (Dürr, 1724).
173 Hymn Melody Wer nur den lieben Gott lässt walten, by G. Neumark.	Final Choral (No. 6) Ich armer Mensch, ich armer Sünder in Cantata No. 179, 'Siehe zu, dass deine Gottesfurcht nicht Heuchelei sei'. 1724. (Dürr, 1723).
174 Hymn Melody Schmücke dich, by J. Crüger.	(i) First Chor. Schmücke dich, o liebe Seele.

(ii) Soprano Recitativo (No. 3) Ach, wie hungert mein Gemüte .

(iii) Final Choral (No. 7) Jesu, wahres Brot des Lebens in Cantata No. 180, 'Schmücke dich, o liebe Seele'. 1735-44. (Dürr, 1724).

175 Hymn Melody Jesu Leiden, Pein und Tod or Jesu Kreuz, Leiden und Pein , by M. Vulpius.

Choral (No. 7) Jesu, deine Passion ist mir lauter Freude in Cantata No. 182, 'Himmelskönig, sei willkommen'. 1725. (Dürr, 1724).

176 Hymn Melody Helft mir Gott's Güte preisen . (Anon.). or Figulius.

Final Choral (No. 5) Du bist ein Geist, der lehret in Cantata No. 183, 'Sie werden euch in den Bann tun'. 1735. (Dürr, 1725).

177 Hymn Melody O Herr Gott, dein göttlich Wort . (Anon.). 1527.

Choral (No. 5) Herr, ich hoff' je in Cantata No. 184, 'Erwünschtes Freudenlicht'. 1724 or 31. (Dürr, 1724).

178 Hymn Melody Ich ruf' zu dir, Herr Jesu Christ . (Anon.).

(i) Soprano & Tenor Aria (Duett) Barmherziges Herze der ewigen Liebe .

(ii) Final Choral (No. 6) Ich ruf' zu dir, Herr Jesu Christ in Cantata No. 185, 'Barmherziges Herze der ewigen Liebe'. 1715 and 1723.

179 Hymn Melody Es ist das Heil uns kommen her , by Paul Speratus(?). 1524.

Final Choral (No. 6) (Part I) Ob sich's anliess' als wollt' er nicht in Cantata No. 186, 'Ärgre dich, o Seele, nicht'. 1723.

180 Hymn Melody Da Christus geboren war . (Anon.). 1544.

Final Choral (No. 7) Gott hat die End' schön zugericht't in

Cantata No. 187, 'Es wartet
Alles auf dich'. 1732. (Dürr,
1726).

181 Secular Melody Venus
du und dein Kind adapted for
hymnal use as Auf meinen
lieben Gott .

Final Choral (No. 5) Auf
meinen lieben Gott in Cantata
No. 188, 'Ich habe meine Zuver-
sicht'. 1731. (Dürr, 'about
1728).

182 (i) Plainchant Herr Gott,
dich loben wir , by Luther.
(ii) Hymn Melody Nun lasst
sei gepreiset . (Anon.).

(i) First Chor. Singet dem
Herrn .
(ii) Final Choral (No. 7) Lass
uns das Jahr vollbringen in
Cantata No. 190, 'Singet dem
Herrn ein neues Lied'. 1724
and, as No. 190a, 1730.

183 Hymn Melody Nun
danket alle Gott , by J. Crüger.

(i) First Chor. Nun danket alle
Gott .
(ii) Final Choral (No. 3) Lob,
Ehr' und Preis sei Gott in
Cantata No. 192, 'Nun danket
alle Gott'. 1731-4 or 1746.
(Dürr, 1730).

184 (i) Hymn Melody Ainsi
qu'on oit le cerf , by L. Bour-
geois.
(ii) Hymn Melody Nun lasst
uns Gott, dem Herren . (Anon.)
or by N. Selnecker(?).

(i) Choral (No. 6) (Part I)
Heil'ger Geist in's Himmels
Throne .
(ii) Final Choral (No. 12)
Sprich Ja zu meinen Taten in
Cantata No. 194, 'Höchst-
erwünschtes Freudenfest'. 1723.

185 Christmas Hymn Lobt
Gott, ihr Christen alle gleich ,
by N. Herman.

Final Choral (No. 6) Nun
danket all' und bringet Ehr'
in Cantata No. 195, 'Dem
Gerechten muss das Licht'.
1724-30. (Dürr, 1728-31).

186 (i) Hymn Melody Nun
bitten wir den heil'gen Geist .
(Anon.).

(i) Choral (No. 5) Du süsse
Lieb', schenck' uns deine
Gunst .

K

(ii) Hymn Melody Wer nur den lieben Gott lässt walten, by G. Neumark.

(ii) Final Choral (No. 10) So wandelt froh auf Gottes Wegen in Cantata No. 197, 'Gott ist uns're Zuversicht'. 1737 or 8. (Dürr, 1735-50).

187 Hymn Melody O Gott, du frommer Gott. (Anon.) or Die Wollust dieser Welt.

Final Choral (No. 7) Wohlan! so will ich mich an dich, o Jesu, halten in Cantata No. 197a, 'Ehre sei Gott in der Höhe'. 1730-32. (Dürr, 1728).

188 Six Chorals taken from Cantatas Nos. 92, 145 and 179 and Choralgesänge 5, 219, 308 and 361.

Six Chorales in Cantata No. 198, 'Lass, Fürstin, lass noch einen Strahl'. 1727.

189 Cantata 'Mein Herze schwimmt im Blut', by Christopher Graupner.

Cantata No. 199 'Mein Herze schwimmt im Blut'. 1714/15. (Dürr, 1723).

190 (i) Popular Song Ich bin so lang nicht bei.

(ii) French Hunting Song Pour aller à la chasse faut être matineux. Circ. 1724. Revised by Anton Seeman.

(i) First Aria (Soprano & Basso) (No. 2) Mer hahn en neue Oberkeet.

(ii) Bass Aria (No. 16) Es nehme zehntausend Ducaten in Cantata No. 212, 'Mer hahn en neue Oberkeet.

191 Choral Melody Nun lob', mein Seel', den Herren, by Kugelmann(?).

Coro I Wie sich ein Vat'r erbarmet in Motette 225, 'Singet dem Herrn ein neues Lied'. 1723-34. (Dürr, 1726/7).

192 Choral Melody Komm, heiliger Geist, Herre Gott.

Choral Du heiliger Brunst, süsser Trost in Motette 226, 'Der Geist hilft unsrer Schwachheit auf'. 1729.

193 Hymn Melody Jesu, meine Freude, by Crüger.

(i) Choral (No. 1) Jesu, meine Freude.
(ii) Choral (No. 3) Unter deinen Schirmen.

(iii) Chor. (No. 5) Trotz, Trotz dem alten Drachen.
(iv) Choral (No. 7) Weg mit allen Schätzen.
(v) Chor. (No. 9) Gute Nacht.
(vi) Final Choral (No. 11) Weicht, ihr Trauergeister in Motette 227, 'Jesu, meine Freude'. 1723.

194 Hymn Melody Warum sollt' ich mich denn grämen.

Motette No. 228 'Fürchte dich nicht, ich bin bei dir'. 1723-34.

195 *Chorals*

Matthew Passion. BWV 244. 1729 and 40.

(i) O Lamm Gottes unschuldig, by Nicolaus Decius 1542. Reconstructed 1545.

(i) First Chor. Kommt, ihr Töchter, helft mir klagen.

(ii) Herzliebster Jesu, was hast du verbrochen, by John Crüger. 1640.

(ii) Choral No. 3 Herzliebster Jesu.

(iii) O Welt, ich muss dich lassen, by Heinrich Isaak(?). 1539. (the attribution is doubtful).

(iii) Choral No. 16 Ich bin's, ich sollte büssen.

(iv) Herzlich tut mich verlangen, by Hans Leo Hassler. 1601.

(iv) Choral No. 21 Erkenne mich, mein Hüter.

(v) Herzlich tut mich verlangen.
(vi) Herzliebster Jesu.

(v) Choral No. 23 Ich will hier bei dir stehen.

(vi) Recitative und Choral No. 25 Was ist die Ursach' aller solcher Plagen?.

(vii) Was mein Gott will, das g'scheh' allzeit. (Anon.). 1529.

(vii) Choral No. 31 Was mein Gott will, das g'scheh' allzeit.

(viii) O Mensch, bewein' dein' Sünde gross, by Sebaldus Heyden.

(viii) Choral a 2 Chori No. 35 O Mensch, bewein' dein' Sünde gross.

(ix) In dich hab' ich gehoffet, Herr, by Seth Calvisius. 1581.

(ix) Choral No. 38 Mir hat die Welt trüglich gericht't.

(x) O Welt, ich muss dich lassen.

(x) Choral No. 44 Wer hat dich so geschlagen.

(xi) Werde munter, mein Ge-
müthe·, by Johann Schop. 1642.

(xii) Herzlich tut mich ver-
langen .

(xiii) Herzliebster Jesu, was
hast du verbrochen .

(xiv) Herzlich tut mich ver-
langen .

(xv) Herzlich tut mich ver-
langen .

196 Chorals.

(i) Herzliebster Jesu, was
hast du verbrochen , by Johann
Crüger. 1640.
(ii) Vater unser im Himmel-
reich·. (Anon.). (? Luther).
1539.
(iii) O Welt, ich muss dich
lassen , by Heinrich Isaak.
1539.
(iv) Jesu Leiden, Pein und
Tod , by Stockmann.
(v) Christus, der uns selig
macht. (Anon.). 1531.
(vi) Herzliebster Jesu, was hast
du verbrochen .
(vii) Mach's mit mir, Gott,
nach deiner Güt·, by Johann
Herman Schein. 1628.
(viii) Valet will ich dir geben ,
by Melchior Teschner. 1614.
(ix) Jesu Leiden, Pein und
Tod .
(x) Jesu Leiden, Pein und
Tod .
(xi) Christus, der uns selig
macht .
(xii) Herzlich Lieb hab' ich
dich, O Herr·. (Anon.). 1577.

(xi) Choral No. 48 Bin ich
gleich von dir gewichen .

(xii) Choral No. 53 Befiehl du
deine Wege .

(xiii) Choral No. 55 Wie
wunderbarlich ist doch diese
Strafe .

(xiv) Choral No. 63 O Haupt
voll Blut und Wunden .

(xv) Choral No. 72 Wenn ich
einmal soll scheiden.

John Passion. BWV 245. 1723.
(N.B. 1st performance – 1724).

(i) Choral No. 7 O grosse Lieb',
o Lieb' ohn' alle Masse .

(ii) Choral No. 9 Dein Will'
gescheh', Herr Gott, zugleich .

(iii) Choral No. 15 Wer hat
dich so geschlagen·.

(iv) Choral No. 20 Petrus der
nicht denkt zurück .

(v) Choral No. 21 Christus, der
uns selig macht .

(vi) Choral No. 27 Ach grosser
König, gross zu allen Zeiten .

(vii) Choral No. 40 Durch dein
Gefängnis, Gottes Sohn .

(viii) Choral No. 52 In meines
Herzens Grunde .

(ix) Choral No. 56 Er nahm
Alles wohl in Acht .

(x) Aria No. 60 Jesu, der du
warest tot.

(xi) Choral No. 65 O hilf,
Christe, Gottes Sohn·.

(xii) Choral No. 68 Ach Herr,
lass dein' lieb' Engelein·.

197 Chorals (29).

198 Chorals.

(i) Herzlich tut mich verlangen, by Hans Leo Hassler.
(ii) Gelobet seist du, Jesu Christ. (Anon.). 1524.
(iii) Vom Himmel hoch da komm ich her. (Anon.).
? Luther. 1539.
(iv) Ermuntre dich, mein schwacher Geist, by Johann Schop.
(v) Vom Himmel hoch da komm ich her.
(vi) Vom Himmel hoch da komm ich her.
(vii) Gelobet seist du, Jesu Christ.
(viii) Warum sollt' ich mich denn grämen, by Johannes Georg Ebeling.
(ix) Wir Christenleut, by Caspar Fuger the Younger. 1593.
(x) Heilig, heilig, heilig, 'possibly' by Bach himself.
(xi) In dich hab' ich gehoffet, Herr, by Calvisius.
(xii) Gott des Himmels und der Erden, by Heinrich Albert. 1642.
(xiii) Nun freut euch, lieben Christen g'mein. (Anon.).
? Luther. 1535.
(xiv) Herzlich tut mich verlangen.

199 Choral Warum betrübst du dich, mein Herz, by Barth. Monoetius.

Luke Passion. (NOT by Bach). BWV 246.

Christmas Oratorio. BWV 248. 1734 and 35.

(i) Choral No. 5 Wie soll ich dich empfangen.
(ii) Choral No. 7 Er ist auf Erden kommen arm.
(iii) Choral No. 9 Ach mein herzliebes Jesulein.
(iv) Choral No. 12 Brich an, o schönes Morgenlicht.
(v) Choral No. 17 Schaut hin! dort liegt im finstern Stall.
(vi) Choral No. 23 Wir singen dir in deinem Heer.
(vii) Choral No. 28 Dies hat er Alles uns getan.
(viii) Choral No. 33 Ich will dich mit Fleiss bewahren.
(ix) Choral No. 35 Seid froh, dieweil.
(x) Choral No. 42 Jesus richte mein Beginnen
(xi) Choral No. 46 Dein Glanz all' Finsternis verzehrt.
(xii) Choral No. 53 Zwar ist solche Herzensstube.
(xiii) Choral No. 59 Ich steh' an deiner Krippen hier.
(xiv) Choral No. 64 Nun seid ihr wohl gerochen.

Choral Dir, Jesu, Gottes Sohn sei Preis in Motette, 'Ich lasse dich nicht, du segnest mich denn'. Appx. 159.

200 ?	Motette 'Jauchzet dem Herrn alle Welt'. Appx. 160. 1723-7.
201 (i) Kündlich gross ist das gottselige Geheimnis, by Carl Heinrich Graun. (ii) Coro Unser Wandel ist im Himmel. (iii) Choral Wie du mir, Herr, befohlen hast.	Motette 'Kündlich gross ist das gottselige Geheimnis'. Appx. 161.
202 Hymn Nun danket alle Gott, by Martin Rinkart. 1653.	(i) First Chor. Nun danket alle Gott.. (ii) Choral Lob Ehr' und Preis sei Gott in Motette, 'Nun danket alle Gott'. Appx. 164.
203 Choral 'Herr Gott, nun schleuss den Himmel auf'. BWV 617.	Choral (No. 2) Wie du mir, Herr, befohlen hast in Motette, 'Unser Wandel ist im Himmel'. Appx. 165.

TABLE B

An alphabetical list of Choral tunes with, in column i, Cantata numbers and, in column ii, the numbers (according to Schmieder) of the *vierstimmige Choralgesänge* in which they appear.

Title	i	ii
Ach! dass mein Glaube.	38	
Ach Gott und Herr.	48	
Ach Gott, vom Himmel sieh darein.	2, 77, 153	
Ach wie flüchtig, ache wie nichtig.	26	
Ainsi qu'on oit le cerf.	13, 70	
Allein Gott in der Höh' sei Ehr.	85, 104, 112, 128	260
Allein zu dir, Herr Jesu Christ.	33	261
Alle Menschen müssen sterben.		
Also hat Gott die Welt geliebt.	68	
Auf meinen lieben Gott.	5, 89, 126, 148 188	
Aus tiefer Not schrei' ich zu dir.	38	
Christ ist erstanden.	66	276

Table B (*Continued*)

Christ lag in Todesbanden.	4, 158	277, 278, 279
Christe, du Lamm Gottes.	23, 127	
Christum wir sollen loben schon.	121	
Christ unser Herr zum Jordan kam.	7, 176	280
Christus der ist mein Leben.	95	281, 282
Danket dem Herren.	6	286
Das neugebor'ne Kindelein.	122	
Die Wollust dieser Welt.	45, 64, 94, 128, 129, 197a.	
Dies sind die heil'gen zehn Gebot.	77	298
Du Friedefürst, Herr Jesu Christ.	67, 116, 143	
Du, o schönes Weltgebäude.	56	301
Durch Adams Fall ist ganz verderbt.	18, 109	
Ein' feste Burg ist unser Gott.	80	302, 303
Erbarm' dich mein, o Herre Gott.		
Erhalt' uns, Herr, bei deinem Wort.	6, 126	
Ermuntre dich, mein schwacher Geist.	11, 43	454 (Schemelli's Arien)
Erschienen ist der herrlich' Tag.	67, 145	
Es ist das Heil uns kommen her.	9, 86, 117, 155, 186	
Es ist genug! so nimm, Herr.		
Es ist gewisslich an der Zeit.		
Es woll' uns Gott genädig sein.	69, 76	311, 312
Freu' dich sehr, o meine Seele.	13, 19, 25, 30, 32, 39, 70, 194	
Freuet euch, ihr Christen alle.	40	
Gelobet seist du, Jesu Christ.	64, 91	314
Gib unsern Fürsten.	42, 126	
Hast du denn, Jesu, dein Angesicht.	57, 137	
Helft mir Gottes Güte preisen.	11, 16, 28, 183	
Herr Christ, der ein'ge Gottes Sohn.	22, 96, 132, 164	
Herr Gott, dich loben alle wir.	16, 119, 120, 130, 190	326
Herr Jesu Christ, du höchstes Gut.	48, 113, 131, 166, 168	334
Herr Jesu Christ, mein's Lebens Licht.		
Herr Jesu Christ, wahr'r Mensch und Gott.	127	336
Herr, wie du willt.	156	339
Herzlich lieb hab' ich dich, o Herr.	19, 149, 174	340
Herzlich tut mich verlangen.	13, 25, 30, 135, 153, 159, 161	
Herzliebster Jesu, was hast du verbrochen.		

Table B (*Continued*)

Ich dank' dir, lieber Herre.	37	347, 348
Ich freue mich in dir.	133	
Ich hab' in Gottes Herz und Sinn.	65, 92, 103	
Ich hab' mein Sach' Gott heimgestellt.	106	
Ich ruf' zu dir, Herr Jesu Christ.		
In dich hab' ich gehoffet, Herr.	52, 106	
Ist Gott mein Schild und Helfersmann.	85	
Jesu Leiden, Pein und Tod.	159, 182	
Jesu, meine Freude.	64, 81, 87	358
Jesu, der du meine Seele.	162	352, 353, 354
Jesu, meines Herzens Freud'.		
Jesus, meine Zuversicht.	145	
Jesu, nun sei gepreiset.	41, 171, 190	362
Komm, heiliger Geist, Herre Gott.	59, 172, 175	
Kommt her zu mir, spricht Gottes Sohn.	74, 86, 108	
Liebster Immanuel, Herzog der Frommen.	123	
Liebster Gott, wann werd' ich sterben.	8, 39	483 (Schemelli's Arien)
Lobt Gott, ihr Christen allzugleich.	151, 195	375, 376
Mach's mit mir, Gott, nach deiner Güt'.	139, 156	377
Meinen Jesum lass' ich nicht.	70, 124, 154, 157, 163	380
Mit Fried' und Freud' ich fahr' dahin.	83, 95, 106, 125	382
Nun bitten wir den heil'igen Geist.		
Nun danket alle Gott.	79, 192	252, 386
Nun freut euch, lieben Christen g'mein.	70	307
Nun komm, der Heiden Heiland.	36, 61, 62	
Nun lasst uns Gott, dem Herren.	79, 165, 194	
Nun lob', mein' Seel', den Herren.	17, 28, 29, 51, 167	389, 390
Nun ruhen alle Wälder.	13, 44, 97	392, 393, 394, 395
O Ewigkeit, du Donnerwort.	20, 60	397
O Gott, du frommer Gott.	24, 45, 71, 128, 129, 164	399
O grosser Gott von Macht.	46	
O Haupt voll Blut und Wunden.		

Table B *(Continued)*

O Mensch, bewein' dein' Sünde gross.		
O Welt, ich muss dich lassen.	13, 44, 97	392, 393, 394, 395
O Welt, sieh hier dein Leben.		
Puer natus in Bethlehem.	65	
Schmücke dich, o liebe Seele.		
Schwing' dich auf zu deinem Gott.	40	
Sei Lob und Ehr' dem höchsten Gut.		
Straf' mich nicht in deinem Zorn.	115	
Tonus Peregrinus.	10	323, 324
Valet will ich dir geben.	95	415
Vater unser im Himmelreich.	90, 101, 102	416
Verleih', uns Frieden gnädiglich.	42, 126	
Vom Himmel hoch, da komm ich her.		
Von Gott will ich nicht lassen.	11, 73, 107	417, 418, 419
Wach auf, mein Geist.	20, 60	397
Wachet auf, ruft uns die Stimme.	140	
Wachet doch, erwacht, ihr Schläfer.	78, 105	352, 353, 354
Wär Gott nicht mit uns diese Zeit.	14	
Warum betrübst du dich, mein Herz.	47, 138	420, 421
Warum sollt ich mich denn grämen.		
Was betrübst du dich, mein Herze.		
Was frag' ich nach der Welt.	64, 94	
Was Gott tut, das ist wohl getan.	12, 69, 75, 98, 99, 100, 144	250 (Drei choräle)
Was mein Gott will, das g'scheh' allzeit.	65, 72, 92, 103, 111, 144	
Welt, ade! ich bin dein müde.	27, 158	
Wenn mein Stündlein vorhanden ist.	15, 31, 95	428, 429, 430
Werde munter, mein Gemüte.	55, 146, 147, 154	359, 360
Wer nur den lieben Gott lässt walten.	21, 27, 84, 88, 93, 166, 179, 197	434
Wie schön leuchtet der Morgenstern.	1, 36, 37, 49, 61, 172	436
Wir Christenleut'.	40, 110, 142	
Wo Gott der Herr nicht bei uns hält.	73, 114, 178	256, 257, 258
Wo soll ich fliehen hin.	5, 136, 163, 199	

THE LITTLE ORGAN BOOK

Schmieder gives a total of forty-six choral melodies in the little organ book (BWV 599 – 644 inclusive) plus two older versions making forty-eight in all. Terry, however, includes all those tunes which Bach indicated that he would have used had the collection been completed and his (Terry's) total, therefore, reaches 164.

In Table C I have numbered the melodies from 1 – 46 to the left of the page, put Terry's number (in brackets) in the centre and added the BWV number to the right of Terry's.

Table D shows those Terry numbers which are missing from Schmieder's list. In this case the Terry numbers are to the left and any BWV numbers available are in the centre.

TABLE C

Hymn and Choral Melodies in *Orgelbüchlein*

	Choral or Hymn Melody	Terry.	BWV.	Schmieder name and number
1	Nun komm, der Heiden Heiland.	(1)	599.	Nun komm, der Heiden Heiland.
2	Gott, durch deine Güte or Gottes Sohn ist kommen.	(2)	600.	Gott, durch deine Güte or, Gottes Sohn ist kommen.
3	Herr Christ, der ein'ge Gottes-Sohn or Herr Gott nun sei gepreiset.	(3)	601.	Herr Christ, der ein'ge Gottes-Sohn or Herr Gott, nun sei gepreiset.
4	Lob sei dem allmächtigen Gott.	(4)	602.	Lob sei dem allmächtigen Gott.
5	Puer natus in Bethlehem. (Lob sei Gott in des Himmels Thron) by J. Michael Altenburg. 1623.	(5)	603.	Puer natus in Bethlehem.
6	Gelobet seist du, Jesu Christ.	(7)	604.	Gelobet seist du, Jesu Christ.

Table C (*Continued*)

Choral or Hymn Melody	Terry.	BWV.	Schmieder name and number
7 Der Tag, der ist so freudenreich.	(8)	605.	Der Tag, der ist so freudenreich.
8 Vom Himmel hoch, da komm ich her.	(9)	606.	Vom Himmel hoch, da komm ich her.
9 Vom Himmel kam der Engel Schar.	(10)	607.	Vom Himmel kam der Engel Schar.
10 In dulci jubilo.	(11)	608.	In dulci jubilo.
11 Lobt Gott, ihr Christen, allzugleich.	(12)	609.	Lobt Gott, ihr Christen, allzugleich.
12 Jesu, meine Freude.	(13)	610.	Jesu, meine Freude.
13 Christen wir sollen loben schon.	(14)	611.	Christen wir sollen loben schon.
14 Wir Christenleut'.	(15)	612.	Wir Christenleut'.
15 Helft mir Gott's Güte preisen by (?) Wolfgang Figulus. 1575.	(16)	613.	Helft mir Gottes Güte preisen.
16 Das alte Jahr vergangen ist.	(17)	614.	Das alte Jahr vergangen ist.
17 In dir ist Freude.	(18)	615.	In dir ist Freude.
18 Mit Fried' und Freud' ich fahr' dahin.	(19)	616.	Mit Fried' und Freud' ich fahr' dahin.
19 Herr Gott, nun schleuss den Himmel auf.	(20)	617.	Herr Gott, nun schleuss den Himmel auf.
20 O Lamm Gottes unschulding.	(21)	618.	O Lamm Gottes unschuldig.
21 Christe, du Lamm Gottes.	(22)	619.	Christe, du L a m m Gottes.
22 Christus, der uns selig macht.	(23)	620.	Christus, der uns selig macht.
22a.		620a	Christus, der uns selig macht. (Early form).
23 Da Jesus an dem Kreuze stund.	(24)	621.	Da Jesus an dem Kreuze stund.
24 O Mensch, bewein' dein' Sünde gross.	(25)	622.	O Mensch, bewein' dein' Sünde gross.
25 Wir danken dir, Herr Jesu Christ.	(26)	623.	Wir danken dir, Herr Jesu Christ.
26 Hilf Gott, dass mir's gelinge.	(27)	624.	Hilf Gott, das mir's gelinge.
27 Christ lag in Todesbanden.	(34)	625.	Christ lag in Todesbanden.
28 Jesus Christus, unser Heiland.	(35)	626.	Jesus Christus, unser Heiland.
29 Christ ist erstanden.	(36)	627.	Christ ist erstanden.

Table C (*Continued*)

	Choral or Hymn Melody	Terry.	BWV.	Schmieder name and number
30	Erstanden ist der heil'ge Christ.	(37)	628.	Erstanden ist der heil'ge Christ.
31	Erschienen ist der herrliche Tag.	(38)	629.	Erschienen ist der herrliche Tag.
32	Heut' triumphieret Gottes Sohn.	(39)	630.	Heut' triumphieret Gottes Sohn.
33	Komm, Gott, Schöpfer, heiliger Geist.	(44)	631.	Komm, Gott Schöpfer, heiliger Geist.
33a.			631a	Komm, Gott Schöpfer, heiliger Geist. (Early form).
34	Herr Jesu Christ, dich zu uns wend'.	(49)	632.	Herr Jesu Christ, dich zu uns wend'.
35		(50)	633.	Liebster Jesu, wir sind hier.
36	Liebster Jesu, wir sind hier.	(51)	634.	Liebster Jesu, wir sind hier.
37	Dies sind die heil'gen zehn Gebot'.	(61)	635.	Dies sind die heil'gen zehn Gebot'.
38	Vater unser im Himmelreich.	(65)	636.	Vater unser im Himmelreich.
39	Durch Adam's Fall ist ganz verderbt.	(76)	637.	Durch Adam's Fall ist ganz verderbt.
40	Es ist das Heil uns kommen her.	(77)	638.	Es ist das Heil uns kommen her.
41	Ich ruf' zu dir, Herr Jesu Christ.	(91)	639.	Ich ruf' zu dir, Herr Jesu Christ.
42	In dich hab' ich gehoffet, Herr.	(98)	640.	In dich hab' ich gehoffet, Herr.
43	Wenn wir in höchsten Nöthen sein, by Louis Bourgeois. 1547.	(100)	641.	Wenn wir in höchsten Nöten sein.
44	Wer nur den lieben Gott lässt walten.	(113)	642.	Wer nur den lieben Gott lässt walten.
45	Alle Menschen müssen sterben.	(131)	643.	Alle Menschen müssen sterben.
46	Ach wie flüchtig.	(159)	644.	Ach wie nichtig, ach wie flüchtig.

TABLE D

Hymn and Choral Melodies intended for the *Orgelbüchlein*

	Choral or Hymn Melody	Schmieder name and number
6	Lob sei Gott in des Himmels Thron. by J. Michael Altenburg. 1623.	
28	O Jesu, wie ist dein' Gestalt. by Melchior Franck. 1627.	
29	O Traurigkeit, O Herzeleid. by ? Johann Rist. 1641.	404.
30	Allein nach dir, Herr Jesu Christ, verlanget mich. by ? Witt.	
31	O (or Ach) wir armen Sünder. by Lucas Lossius. 1561.	407.
32	Herzliebster Jesu, was hast du verbrochen. by Johann Crüger. 1640.	244 (No. 3).
33	Nun gibt mein Jesu gute Nacht.	Herr Jesu Christ, wahr' Mensch und Gott. 336.
40	Gen Himmel auf gefahren ist. by Melchior Franck. 1627.	
41	Nun freut euch, Gottes Kinder, all. (published 1546).	387.
42	Komm, heiliger Geist, erfüll' die Herzen deiner Gläubigen. Latin melody to Veni Sancte Spiritus reple tuorum.	
43	Komm, heiliger Geist, Herre Gott. (see 42, same melody).	Du heilige Brunst, süsser Trost. 226.
45	Nun bitten wir den heil'gen Geist.	385.
46	Spiritus Sancti gratia or Des heil'gen Geistes reiche Gnad'. tunes by Melchior Vulpius. 1609. and another by Johann Schein. 1627.	295.
47	O heil'ger Geist, O heiliger Gott. 1650 and 1704.	
52	Gott, der Vater, wohn' uns bei.	317.
53	Allein Gott in der Höh' sei Ehr. by Nikolaus Decius.	260.
54	Der du bist Drei in Einigkeit. Tune—O lux beata trinitas. Reconstructed by Schein.	293.

Table D (*Continued*)

Choral or Hymn Melody	Schmieder name and number
55 Gelobet sei der Herr, der Gott Israel. 1564.	
56 Meine Seel' erhebt den Herren. Tonus Peregrinus.	323 & 324.
57 Herr Gott, dich loben alle wir. by Louis Bourgeois.	326 & 327.
58 Es steh'n vor Gottes Throne. by Joachim von Burck. 1594.	309.
59 Herr Gott, dich loben wir. by Luther.	328.
60 O Herre Gott, dein göttlich Wort.	
62 Mensch, willst du leben seliglich. ? Luther. 1524.	
63 Herr Gott, erhalt' uns für und für. by Joachim von Burck. 1594.	
64 Wir glauben all' an einen Gott, Vater.	
66 Christ, unser Herr, zum Jordan kam.	280.
67 Aus tiefer Noth schrei' ich zu dir. ? Luther.	686.
68 Erbarm' dich mein, O Herre Gott. ? Joachim Walther. 1524.	305.
69 Jesu, der du meine Seele. 1662.	352, 353 & 354.
70 Allein zu dir, Herr Jesu Christ. by Johannes Schneesing.	261.
71 Ach Gott und Herr.	255.
72 Herr Jesu Christ, du höchstes Gut. Tune taken from Tenor line of 'Wenn mein Stündlein'.	334.
73 Ach Herr, mich armen Sünder. Tune also known as 'Herzlich thut mich verlangen'.	270 & 271.
74 Wo soll ich fliehen hin. by Caspar Stieler (?).	163 & 199.
75 Wir haben schwerlich. (Anon.). 1648.	
78 Jesu Christus, unser Heiland, der von uns. ? Luther.	363.
79 Gott sei gelobet und gebenedeiet. (Anon.).	322.
80 Der Herr ist mein getreuer Hirt.	
81 Jetzt komm ich als ein armer Gast.	334.
82 O Jesu, du edle Gabe.	

Table D (*Continued*)

	Choral or Hymn Melody	Schmieder name and number
83	Wir danken dir, Herr Jesu Christ, dass du das Lämmlein.	
84	Ich weiss ein Blümlein hübsch und fein.	Ich hab' mein sach' Gott heimgestellt. 351.
85	Nun freut euch, lieben Christen. g'mein. Has two melodies, one 1524, the other (? Luther). 1529 or '35.	307 & 388.
86	Nun lob', mein' Seel', den Herren. ? Johann Kugelmann.	389 & 390.
87	Wohl dem, der in Gottes Furcht steht. ? Luther.	
88	Wo Gott zum Haus nicht gibt sein' Gunst. ? Luther. 1535.	438.
89	Was mein Gott will, das g'scheh' allzeit. French melody.	244, No. 31.
90	Kommt her zu mir, spricht Gottes Sohn.	108.
92	Weltlich Ehr' und zeitlich Gut.	426.
93	Von Gott will ich nicht lassen.	417, 418 & 419.
94	Wer Gott vertraut by Calvisius. 1597.	433.
95	Wie's Gott gefällt, so gefällt mir's auch. Melody very similar to that used for 89.	
96	O Gott, du frommer Gott. (Anon.).	399.
97	In dich hab' ich gehoffet, Herr. by Calvisius.	640 & 712.
99	Mag ich Unglück nicht widerstehn. (Anon.).	
101	An Wasserflüssen Babylon. by Wolfgang Dachstein.	267.
102	Warum betrübst du dich, mein Herz. (Anon.).	420 & 421.
103	Frisch auf, mein' Seel' verzage nicht. (Anon.). 1648.	
104	Ach Gott, wie manches Herzeleid.	
105	Ach Gott, erhör' mein Seufzen und Wehklagen. (Anon.).	254.

Table D (*Continued*)

Choral or Hymn Melody	Schmieder name and number
106 So wünsch' ich nun sein' gute Nacht.	
107 Ach lieben Christen, seid getrost.	258.
Bach sets it to the tune of 'Wo Gott der Herr nicht bei uns hält'.	
108 Wenn dich Unglück thut greifen an. (Anon.).	
109 Keinen hat Gott verlassen.	369.
Tune, 'Rolandslied' (reconstructed).	
110 Gott ist mein Heil, mein' Hülf' und Trost.	
by Bartholomäus Gesius.	
111 Was Gott tut, das ist wohlgetan, Kein einig.	Kommt her zu mir, spricht Gottes Sohn. 108.
1648.	
112 Was Gott tut, das ist wohlgetan, Es bleibt gericht.	250.
114 Ach Gott, vom Himmel sieh darein.	153.
? Luther.	
115 Es spricht der Unweisen Mund wohl.	308.
? Luther.	
116 Ein' feste Burg ist unser Gott.	302 & 303.
? Luther.	
117 Es woll' uns Gott genädig sein.	311 & 312.
118 Wär' Gott nicht mit uns diese Zeit.	14.
by Luther or Johann Walther.	
119 Wo Gott der Herr nicht bei uns hält.	256, 257 & 258.
120 Wie schön leuchtet der Morgenstern.	436.
by Philipp Nicolai.	
121 Wie nach einem Wasserquelle.	194.
(Ainsi qu'on oit le cerf bruire).	
by Louis Bourgeois.	
122 Erhalt' uns, Herr, bei deinem Wort.	126.
123 Lass' mich dein sein und bleiben. (Anon.) – secular origin.	Ich dank' dir, lieber Herre, or Ich freu' mich in dem Herren.
	347 & 348.
124 Gieb' Fried', o frommer, treuer Gott.	Durch Adams Fall. 18.
1648.	
125 Du Friedefürst, Herr Jesu Christ.	143.
by Bartholomäus Gesius.	
126 O grosser Gott von Macht.	46.
by Melchior Franck.	
127 Wenn mein Stündlein vorhanden ist.	428, 429 & 430.
by Nikolaus Herman.	

Table D (*Continued*)

	Choral or Hymn Melody	Schmieder name and number
128	Herr Jesu Christ, wahr'r Mensch und Gott. (?) Eccard.	336.
129	Mitten wir im Leben sind.	383.
130	Alle Menschen müssen sterben. by Jakob Hintze.	262.
132	Valet will ich dir geben. by Melchior Teschner.	415.
133	Nun lasst uns den Leib begraben.	
134	Christus, der ist mein Leben.	281 & 282.
135	Herzlich lieb hab' ich dich, O Herr.	340.
136	Auf meinen lieben Gott.	Wo soll ich fliehen hin. 188.
137	Herr Jesu Christ, ich weiss gar wohl.	Herr Jesu Christ, du höchstes Gut. 334.
138	Mach's mit mir, Gott, nach deiner Güt'. by Johann Hermann Schein.	377.
139	Herr (O) Jesu Christ, mein's Lebens Licht.	335.
140	Mein's Wallfahrt ich vollendet hab'.	Was mein Gott will. 244 (No. 31)
141	Gott hat das Evangelium.	319.
142	Ach Gott, thu' dich erbarmen.	
143	Gott des Himmels und der Erden. by Heinrich Albert.	Freu' dich sehr, O meine Seele. 194.
144	Ich dank' dir, lieber Herre. (secular).	347 & 348.
145	Auf meines Herzens Grunde. Tune=Herzlich thut mich erfreuen.	269.
146	Ich dank' dir schon durch deinen Sohn.	349.
147	Das walt' mein Gott.	291.
148	Christ, der du bist der helle Tag.	273.
149	Christe, der du bist Tag und Licht.	274.
150	Werde munter, mein Gemüthe.	359 & 360.
151	Nun ruhen alle Wälder Known also as:— O Welt, ich muss dich lassen.	392, 393, 394 & 395.
152	Danket dem Herrn, denn er ist sehr freundlich. Tune—Vitam quae faciunt beatiorem.	286.

Table D (*Continued*)

	Choral or Hymn Melody	Schmieder name and number	
153	Nun lasst uns Gott, dem Herren.		194.
	Known also as: —		
	Wach auf, mein Herz, und singe.		
154	Lobet den Herrn, denn er ist sehr freundlich. (Anon.).		374.
155	Singen wir aus Herzensgrund.	Gott hat die Erd' schön zugericht't.	187.
156	Gott Vater, der du deine Sonn. by Nikolaus Herman.		
157	Jesu, meines Herzens Freud'.		361.
158	Ach, was soll ich Sünder machen.		259.
160	Ach, was ist doch unser Leben.		
161	Allenthalben, wo ich gehe.		
162	Hast du denn, Jesu, dein Angesicht.	Kommst du nun, Jesu, vom Himmel herunter.	650.
163	Sei gegrüsset, Jesu gütig. (?) Gottfried Vopelius.		410.
164	Schmücke dich, O liebe Seele. Crüger.		180.

TABLE E

Hymn and Choral Melodies used in *Choralgesänge*.

Schmieder gives 186 four-part choral settings (BWV 253 – 438). Reference to forty-eight of these is made by Terry. Schmieder has arranged them in alphabetical order and numbered them accordingly. This arrangement conflicts with the C. P. E. Bach and Kirnberger numberings and also, to a certain extent, with those of B. F. Richter. (Terry's references are, in most cases, to the Richter numbers as Schmieder was unknown at the time (1921) when Terry's *Bach's Chorals*. Part III was published).

TABLE E

Hymn and Choral Melodies used in *Choralgesänge*

Choral or Hymn Melody	Schmieder No.	Terry title and No.
1 Ach bleib bei uns, Herr Jesu Christ. by Seth. Calvisius. 1594.	253.	1 Danket dem Herrn, heut' und allzeit.
2 Ach Gott, erhör' mein Seufzen. 1662.	254.	
3 Ach Gott und Herr. (Anon.) reconstructed Crüger. 1640.	255.	2 Same title.
4 Ach lieben Christen, seid getrost. 1535.	256.	
5 ?	257.	
6 ?	258.	
7 Ach, was soll ich Sünder machen.	259.	
8 Allein Gott in der Höh' sei Ehr'.	260.	3 Originally Easter Plainsong, Gloria in excelsis and adapted by Nikolaus Decius. 1539.
9 Allein zu dir, Herr Jesu Christ.	261.	
10 Alle Menschen müssen sterben.	262.	4 N.B. This is not the same tune as that quoted by Terry under this title and noted as being by Johann Rosenmüller. 1652.
11 Alles ist an Gottes Segen.	263.	
12 Als der gütige Gott.	264.	
13 Als Jesus Christus in der Nacht.	265.	
14 Als vierzig Tag nach Ostern.	266.	
15 An Wasserflüssen Babylon.	267.	5 Same title. By Wolfgang Dachstein. 1525.
16 Auf, auf, mein Herz und du mein ganzer Sinn.	268.	
17 Aus meines Herzens Grunde.	269.	
18 Befiehl du deine Wege.	270.	
19 Befiehl du deine Wege.	271.	

Table E (*Continued*)

	Choral or Hymn Melody	Schmieder No.		Terry title and No.
20	Befiehl du deine Wege.	272.		
21	Christ, der du bist der helle Tag.	273.	6	Same title. (Anon.). 1568.
22	Christ, der du bist Tag und Licht.	274.		
23	Christ, du Beistand deiner Kreuzgemeinde.	275.		
24	Christ ist erstanden.	276.	7	Same title. (Anon.). 1535.
25	Christ lag in Todesbanden.	277.	8	Same title. (Anon.). 1524.
26	Christ lag in Todesbanden.	278.		
27	Christ lag in Todesbanden.	279.		
28	Christ unser Herr zum Jordan kam.	280.	9	Same title. Johann Walther(?). 1524.
29	Christus der ist mein Leben.	281.		
30	Christus der ist mein Leben.	282.		
31	Christus, der uns selig macht.	283.	10	Same title. Tune – Patris Sapientia. 1531.
32	Christus ist erstanden, hat überwanden.	284.		
33	Da der Herr Christ zu Tische sass.	285.		
34	Danket dem Herren.	286.		
35	Dank sei Gott in der Höhe.	287.		
36	Das alte Jahr vergangen ist.	288.		
37	Das alte Jahr vergangen ist.	289.	11	Same title. N.B. Tune was known as Gott Vater, der du deine Sonn, by Johannes Steurlein. (1588) up till 1608.
38	Das walt Gott Vater und Gott Sohn.	290.		
39	Das walt mein Gott, Vater, Sohn und heiliger Geist.	291.		
40	Den Vater dort oben.	292.		
41	Der du bist drei in Einigkeit.	293.		

Table E (*Continued*)

	Choral or Hymn Melody	Schmieder No.		Terry title and No.
42	Der Tag, der ist so freud-enreich.	294.	12	Same title. (Anon.). 1535.
43	Des heil'gen Geistes reiche Gnad'.	295.		
44	Die Nacht ist kommen.	296.		
45	Die Sonn' hat sich mit ihrem Glanz.	297.		
46	Dies sind die heil'gen zehn Gebot'.	298.	13	Same title. N.B. Tune adapted from the pilgrim song, In Gottes Namen fahren wir,' by Johann Walther (?). (Anon.). 1524.
47	Dir, dir, Jehova will ich singen.	299.		
48	Du grosser Schmerzensmann.	300.		
49	Du, o schönes Weltgebäude.	301.		
50	Ein' feste Burg ist unser Gott.	302.	14	Same title. Martin Luther, 1531 & 1535.
51	Ein' feste Burg ist unser Gott.	303.		
52	Eins ist Not, ach Herr, dies eine.	304.		
53	Erbarm' dich mein, O Herre Gott.	305.	15	Same title. ? Johann Walther. 1524.
54	Erstanden ist der heil'ge Christ.	306.	16	Original tune is — Surrexit Christus hodie. (Anon.). 1531. Bach uses a tune by Valentin Triller which was the descant in a 3-part setting (C. F. in tenor). 1555.
55	Es ist gewisslich an der Zeit.	307.		
56	Es spricht der Unweisen Mund wohl.	308.		
57	Es steh'n vor Gottes Throne.	309.		
58	Es wird schier der letzte Tag herkommen.	310.		

Table E (*Continued*)

	Choral or Hymn Melody	Schmieder No.		Terry title and No.
59	Es woll' uns Gott genädig sein.	311.		
60	Es woll' uns Gott genädig sein.	312.		
61	Für Freuden lasst uns springen.	313.		
62	Gelobet seist du, Jesu Christ.	314.	17	Originally a Christmas plainsong, Grates nunc omnes reddamus of 1524. Melody adapted by J. Walther.
63	Gib dich zufrieden und sei stille.	315.		
64	Gott, der du selber bist das Licht.	316.		
65	Gott, der Vater, wohn' uns bei.	317.		
66	Gottes Sohn ist kommen.	318.	18	Originally a Latin hymn Ave ierarchia celestis et pia of 1531. Set to hymn Menschenkind, merk eben . In 1544 set to Gottes Sohn ist kommen and Gott, durch deine Güte .
67	Gott hat das Evangelium.	319.		
68	Gott lebet noch.	320.		
69	Gottlob, es geht nun mehr zu Ende.	321.		
70	Gott sei gelobet und gebenedeiet.	322.		
71	Gott sei uns gnädig.	323.		
72	Meine Seele erhebet den Herrn.	324.	19	Same title. From Tonus Peregrinus . (16th century).
73	Heilig, heilig.	325.		
74	Herr Gott, dich loben alle wir.	326.	20	Same title. Tune—a simplified form of Latin plainsong Te Deum laudamus . 1529/35.
75	?	327.		

Table E (Continued)

	Choral or Hymn Melody	Schmieder No.		Terry title and No.
76	Herr Gott, dich loben wir.	328.		
77	Herr, ich denk' an jene Zeit.	329.		
78	Herr, ich habe missge-handelt.	330.		
79	Herr, ich habe missge-handelt.	331.		
80	Herr Jesu Christ, dich zu uns wend'.	332.	21	Same title. (Anon.). 1648 and 1651 and is of earlier origination.
81	Herr Jesu Christ, du hast bereit't.	333.		
82	Herr Jesu Christ, du höchstes Gut.	334.		
83	Herr Jesu Christ, mein's Lebens Licht.	335.		
84	Herr Jesu Christ, wahr'r Mensch und Gott.	336.		
85	Herr, nun lass in Friede.	337.		
86	Herr, straf mich nicht in deinem Zorn.	338.		
87	Herr, wie du willt, so schick's mit mir.	339.		
88	Herzlich lieb hab ich dich, o Herr.	340.		
89	Heut' ist, o Mensch, ein grosser Trauertag.	341.		
90	Heut' triumphieret Gottes Sohn.	342.	22	Same title. By Bartho-lomäus Gesius. 1601.
91	Hilf, Gott, dass mir's gelinge.	343.	23	Same title. (Anon.). 1545 & 1573 and Crüger's version (used here). 1653.
92	Hilf, Herr Jesu, lass ge-lingen.	344.		
93	Ich bin ja, Herr, in deiner Macht.	345.		
94	Ich dank' dir, Gott, für all' Wohltat'.	346.		
95	Ich dank' dir, lieber Herre.	347.		
96	Hilf, Herr Jesu, lass ge-lingen.	348.		

Table E (*Continued*)

	Choral or Hymn Melody	Schmieder No.		Terry title and No.
97	Ich dank' dir schon durch deinen Sohn.	349.		
98	Ich danke dir, o Gott, in deinem Throne.	350.		
99	Ich hab' mein Sach' Gott heimgestellt.	351.	24	Same title. Original is a secular song Ich weiss mir ein Röslein hübsch und fein of 1589. It was a 4-part setting and the tenor became the hymn tune in 1609, the descant was set to the same hymn in 1598. This (1598) version is the one Bach uses here.
100	Jesu, der du meine Seele.	352.		
101	Jesu, der du meine Seele.	353.		
102	Jesu, der du meine Seele.	354.		
103	Jesu, der du selbsten wohl.	355.		
104	Jesu, du mein liebstes Leben.	356.		
105	Jesu, Jesu, du bist mein.	357.		
106	Jesu, meine Freude.	358.	25	Same title. By Johann Crüger. 1653.
107	Jesu meiner Seelen Wonne.	359.		
108	Jesu meiner Seelen Wonne.	360.		
109	Jesu, meines Herzens Freud'.	361.		
110	Jesu, nun sei gepreiset.	362.		
111	Jesus Christus, unser Heiland.	363.	26	Same title. By Johann Walther(?). 1524. Two versions of the melody, both dated 1524, were the tenor lines of 4-part settings. A new melody appeared in 1535 — this is the one used by Bach in BWV 363.
112	Jesus Christus, unser Heiland.	364.	27	Same title. Luther. 1524.
113	Jesus, meine Zuversicht.	365.	28	Same title. By Johann Crüger(?). 1653.

Table E (*Continued*)

	Choral or Hymn Melody	Schmieder No.		Terry title and No.
114	Ihr Gestern, ihr hohen Lüfte.	366.		
115	In allen meinen Taten.	367.		
116	In dulci jubilo.	368.	29	Same title. (Anon.). 1535. A mediaeval Christmas hymn.
117	Keinen hat Gott verlassen.	369.		
118	Komm, Gott, Schöpfer, heiliger Geist.	370.	30	Same title. (Anon.). 1535 and Crüger 1640. This latter used by Bach in BWV 370.
119	Kyrie, Gott Vater in Ewigkeit.	371.	31	Same title. Tune adapted from Latin plainsong. 1525.
120	Lass, o Herr, dein Ohr sich neigen.	372.		
121	Liebster Jesu, wir sind hier.	373.	32	Tune – Ja, er ists, das Heil der Welt by Johann Rodolph Ahle 1664. Reconstructed 1687.
122	Lobet den Herren, denn er ist freundlich.	374.		
123	Lobt Gott, ihr Christen allzugleich.	375.	33	Tune – Lobt Gott, ihr Christen alle gleich by Nikolaus Herman. 1554.
124	Lobt Gott, ihr Christen allzugleich.	376.		
125	Mach's mit mir, Gott, nach deiner Güt'.	377.		
126	Mein' Augen schliess ich jetzt.	378.		
127	Meinen Jesum lass ich nicht.	379.		
128	Meinen Jesum lass ich nicht.	380.		
129	Meines Lebens letzte Zeit.	381.		
130	Mit Fried' und Freud' ich fahr dahin.	382.	34	Same title. By Luther (?). 1524.
131	Mitten wir im Leben sind.	383.		
132	Nicht so traurig, nicht so sehr.	384.		
133	Nun bitten wir den heiligen Geist.	385.		

Table E (*Continued*)

	Choral or Hymn Melody	Schmieder No.		Terry title and No.
134	Nun danket alle Gott.	386.	35	Same title. By Johann Crüger 1648 or, possibly, by Martin Rinkart or Luca Marenzio.
135	Nun freut euch, Gottes Kinder all.	387.		
136	Nun freut euch, lieben Christen g'mein.	388.	36	Same title. Based on a secular song Wach auf, wach auf, du schöne 1535/55 and also used with Es ist gewisslich an der Zeit . 1582.
137	Nun lob', mein' Seel', den Herren.	389.		
138	Nun lob', mein' Seel', den Herren.	390.		
139	Nun preiset alle Gottes Barmherzigkeit.	391.		
140	Nun ruhen alle Wälder.	392.		
141	O Welt, sieh hier dein Leben.	393.		
142	O Welt, sieh hier dein Leben.	394.		
143	O Welt, sieh hier dein Leben.	395.		
144	Nun sich der Tag geendet hat.	396.		
145	O Ewigkeit, du Donnerwort.	397.		
146	O Gott, du frommer Gott.	398.	37	Tune – 'Gross ist, O grosser Gott'. (Anon). 1646.
147	O Gott, du frommer Gott.	399.		
148	O Herzensangst, o Bangigkeit.	400.		
149	O Lamm Gottes, unschuldig.	401.	38	Same title. (Anon.). 1598. Originally 'Agnus Dei'. Adapted by Nikolaus Decius, 1542 & 1545. Bach uses the latter version.

Table E (*Continued*)

Choral or Hymn Melody	Schmieder No.		Terry title and No.
150 O Mensch, bewein' dein' Sünde gross.	402.	39	Tune – Es sind doch selig alle by Matthäus Grietter. 1525.
151 O Mensch, schau Jesum Christum an.	403.		
152 O Traurigkeit, o Herzeleid	404.		
153 O wie selig seid ihr doch ihr Frommen.	405.		
154 O wie selig seid ihr doch ihr Frommen.	406.		
155 O wir armen Sünder.	407.		
156 Schaut, ihr Sünder.	408.		
157 Seelen Bräutigam.	409.		
158 Sei gegrüsset, Jesu gütig.	410.	40	Same title. (?) by Gottfried Vopelius. 1682.
159 Singet dem Herrn ein neues Lied.	411.		
160 So gibst du nun, mein Jesu, gute Nacht.	412.		
161 Sollt' ich meinem Gott nicht singen.	413.		
162 Uns ist ein Kindlein heut' gebor'n.	414.		
163 Valet will ich dir geben.	415.	41	Same title. By Melchior Teschner. 1614.
164 Vater unser im Himmelreich.	416.	42	Same title. (Anon.). 1539.
165 Von Gott will ich nicht lassen.	417.	43	Same title. (Anon.). 1572 or 71.
166 Von Gott will ich nicht lassen.	418.		
167 Von Gott will ich nicht lassen.	419.		
168 Warum betrübst du dich, mein Herz.	420.		
169 Warum betrübst du dich, mein Herz.	421.		
170 Warum sollt ich mich denn grämen.	422.		
171 Was betrübst du dich, mein Herze.	423.		
172 Was bist du doch, o Seele, so betrübet.	424.		

Table E (*Continued*)

	Choral or Hymn Melody	Schmieder No.		Terry title and No.
173	Was willst du dich, o meine Seele.	425.		
174	Weltlich Ehr' und zeitlich Gut.	426.		
175	Wenn ich in Angst und Not.	427.		
176	Wenn mein Stündlein vorhanden ist.	428.		
177	Wenn mein Stündlein vorhanden ist.	429.		
178	Wenn mein Stündlein vorhanden ist.	430.		
179	Wenn wir in höchsten Nöten sein.	431.	44	Same title. Original tune is Lève le coeur by Louis Bourgeois. 1547.
180	Wenn wir in höchsten Nöten sein.	432.	45	Same title. Tune attached to this hymn in 1588.
181	Wer Gott vertraut, hat wohl gebaut.	433.		
182	Wer nur den lieben Gott lässt walten.	434.	46	Same title. By Georg Neumark. 1657.
183	Wie bist du, Seele, in mir so gar betrübt.	435.		
184	Wie schön leuchtet der Morgenstern.	436.	47	Same title. By Philipp Nicolai. 1599. Adapted from Jauchzet dem Herren, alle Land'. (Anon.). 1538.
185	Wir glauben all' an einen Gott.	437.	48	Same title. (Anon.). 1599. Adapted from plainsong of the Nicene Creed.
186	Wo Gott zum Haus nicht gibt sein' Gunst.	438.		

NOTES ON TABLE V

Terry, in Part II of his 'Bach's Chorals', groups 97 Cantatas as dating between 1723 and 1734. It is, of course, reasonably

safe to assign a work to 'somewhere' within an eleven-year overspread but, even so, Dürr puts No. 69 as 1743 – 50 and No. 191 as 'after 1742'.

Terry goes on to apportion the following Cantatas (72) to the period 1735 – 1750: —

1, 2, 3, 5, 6, 7, 10, 11, 13, 14, 17, 26, 30, 32, 33, 34, 38, 39, 41, 43, 45, 48, 50, 53, 54, 57, 62, 68, 74, 78, 79, 85, 87, 90, 91, 92, 94, 96, 100, 101, 103, 108, 110, 111, 113, 114, 115, 116, 118, 121, 122, 123, 124, 125, 126, 127, 128, 130, 133, 135, 138, 139, 143, 146, 151, 175, 176, 178, 180, 183, 193, 197.

Dürr, however, redates these as follows: —

(year) 1723	1724	1725	1726
48	2	1	13
90	5	3	17
138	7	6	32
	10	41	39
	26	57	43
	33	68	45
	38	74	193
	62	79	
	78	85	
	91	87	
	94	92	
	96	103	
	101	108	
	113	110	
	114	111	
	115	123	
	116	124	
	121	125	
	122	126	
	130	127	
	133	128	
	135	151	
	139	175	
	178	176	
	180	183	
3	25	25	7

with Nos. 11 and 14 in 1735 and

No.	30 as between	1735 and 1750	(pre 1742?)
„ 34 „	„	„ „ „	(after 1742?)
„ 100 „	„	1732 and 1735	
„ 118 „	„	1735 „ 1750	
„ 197 „	„	„ „ „	(pre 1742?)

Regarding the following Dr. Dürr says: —
of (i) No. 50 – no fresh information re performance date available. (Schmieder – 'about' 1740).
(ii) No. 53 – not by Bach.
(iii) „ 54 – Weimar, no evidence of a Leipzig performance
(Schmieder – 'about' 1730).
(iv) „ 143 – no fresh performance information available.
(Schmieder – 1735).
(v) „ 146 – no fresh performance information available.
(Schmieder – 'about' 1740).

With regard to the 'Choral' Cantatas, thirty-nine of which Terry allots to the later Leipzig period, ie. 1735 – 50, Dürr proves that only two, Nos. 14 and 100, are later than 1725 (No. 14 is 1735 and No. 100 1732 – 5).

Bach's inspiration was, therefore, at white heat around the years 1724/5 – in fact, as he came up to his prime in his fortieth year. This is much more understandable than that he should have written so copiously between the ages of fifty and sixty-five.

In Part III of 'Bach's Chorals' (1921) Terry gives an addenda and errata to Part II (published in 1917). It includes revised dates for ten Cantatas which serve to bring them a little closer to Dürr's findings.

No.	Terry's revised dates	Dürr's dates
4	1724	1724.
8	1725	1724.
20	1725	1724.
40	1723	1723.
93	1728	1724.
112	1731	1731.
133	1735 – 37	1724.
156	1729/30	1729(?).

No.	Terry's revised dates	Dürr's dates
171	1730/31	1729(?).
187	1735	1726.

If we accept the results of Dürr's investigations as correct we must, equally, agree that Terry was misinformed in certain cases. Arising from this is a legitimate doubt as to the accuracy of the information he gives on Choral tunes (it will be noted that Whittaker disagrees with him on occasions just as he (Terry) disagreed with Spitta).

One has always regarded Terry's writings and choral studies as embodying all that was to be learnt on the subject but one must admit that the sources of his information on the chorals could be as out-of-date as the sources of the information on the chronology of the whole body of Cantatas which he and so many other writers have followed and quoted for the past 100 years or so.

In spite of these passing doubts, however, one must continue to use and quote from him until such time as more recently acquired information is made readily available.

1　Schmieder dates Cantata No. 1 as 1733 – 4 or between 1735 and 1744. Whittaker says 'about' 1740 but Dürr gives 25th March 1725! Whittaker considers that the Choral Fantasia resembles the (similar) great chorus in Cantata 65 'Sie werden aus Saba' which Dürr redates as 1724.
Terry regards the authorship of Nicolai as 'improbable'.
The melody appears in Cantatas 36, 37, 49, 61 and 172.　BWV 1

2　Whittaker feels that the trill on 'und' plus a few other points where the treatment of the text is concerned suggests either that No. 5 was borrowed or that the text was rewritten after the music was composed. He says: — 'It was probably an 'angel' aria in the first instance'. He does not, however, offer any opinion as to whether it was a Bachian 'angel' or someone else's! (See Ex. 125.).　BWV 1

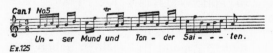

Ex.125 Can.1 No.5　Un - ser Mund und Ton - der Sai - - - ten.

3 Luther's tune appears twice in Cantata No. 2.
i) As a Cantus Firmus in the alto voice in the great opening
Chor with its fugal layout and
ii) in the final simple 4-part choral. BWV 2

4 In the first Chor. the Cantus Firmus is in the bass. In the
second item the hymn is set in plain harmony over the moving
(fugal subject) bass. (See Ex. 126.).

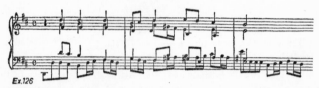

Ex.126

Although this melody is usually known as Ach Gott, wie
manches Herzeleid, it should be called O Jesu Christ, mein's
Lebens Licht, (anon. 1625) and first published in 1610. It is
so similar to another hymn melody, Hilf mir, Herr Jesu, weil
ich leb, of 1612 that it must either be derived from it or come
from the same source.
The real 'Wie manches' tune was written by Bartholomäus
Gesius and first published in 1605. BWV 3

5 Whittaker says that the hymn tune used in Cantata No. 4
is either O Jesu Christ, mein's Lebens Licht or Hilf mir, Herr
Jesu, weil ich leb, but Terry votes for Christ lag in Todes-
banden, (anon) dated 1524. A second or later version was
reconstructed by Johann Walther.
 The verses of Luther's hymn are used as follows: —

1. Chor	Verse No. 2
2. Soprano and Alto duet	3
3. Tenor aria	4
4. Chor	5
5. Bass aria	6
6. Soprano and Tenor duet	7
7. Choral	8

The hymn tune appears also in Cantata 158. BWV 4

6 Terry gives two melodies for Cantata No. 5. Venus du und
dein Kind, (anon) 1575 and Auf meinen lieben Gott, (anon)

1609 but Whittaker suggests Wo soll ich fliehen hin by J. Heerman which used to belong to Auf meinen lieben Gott and was first published in 1607. According to Terry 'Auf meinen' is used in the first and last items of Cantata No. 5. The tune is used again in Cantatas 89, 136, 148 and 188. Spitta and the BG attribute Auf meinen lieben Gott to J. Pachelbel (1653 – 1706). Terry, however, says that Venus du und dein Kind is its secular original. BWV 5

7 Terry thinks there can be no doubt that the four-part setting of Danket dem Herrn used by Bach is by Seth. Calvisius. The hymn tune used in Choral No. 6 is Erhalt uns, Herr, bei deinem Wort, (anon) 1543. It is very similar to Luther's tune, Verleih' uns Frieden gnädiglich, used in Cantatas 42 and 126. They are both derived from the Antiphon Da pacem Domine. (See Ex. 127.). BWV 6

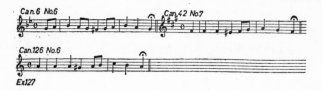

8 The hymn tune attributed to J. Walther and published in 1524 is known also by another title: — Es woll' uns Gott genädig sein. It is used in Cantata No. 176. BWV 7

9 Daniel Vetter composed his hymn tune in 1695 but it was reset in four parts and published in 1713. He was a predecessor of Bach's having been organist of Nicholas Church in 1721. His tune appears in Schmelli's collection as BWV 483. BWV 8

10 Terry describes Es ist das Heil as 'anon' but agrees in dating it as 1524. Bach uses it again in Cantatas 86, 117 and 155. BWV 9

L

11 Tonus Peregrinus appears in the Soprano and Alto in the first Chor; is played on oboe and trumpet in duet No. 5 and, in Soprano doubled by first violin, oboes and trumpet, again in the final choral. BWV 10

12 Ermuntre dich appears also in Cantata 43 and Choral No. 12 in Part II of the Christmas Oratorio, BWV 248. Also as Schmelli No. 187, BWV 454. Johann Schop's tune was published in 1641 but Bach used Johann Crüger's revision of 1648.
The melody of Von Gott is known also under another name – Helft mir Gott's Güte preisen – but this was by Wolfgang Figulus and published in 1575. They have a common source in a secular song, Ich ging einmal spazieren, which was known in 1569 and published as a hymn tune in 1572. Bach used Von Gott in Cantatas 73 and 107 and the Helft mir version in Nos. 16, 28 and 183. Von Gott appears also in Cantata No. 220, 'Lobt ihn mit Herz und Munde', which Dürr claims is not by Bach. BWV 11

13 Jesu, meine Freude, becomes an elaborate trumpet obbligato to the Tenor in item No. 6.
The tune, Was Gott tut, has been attributed to both Severius Gastorius and Johann Pachelbel at different times. The latter set it as a Motett. Bach used it in Cantatas 69, 75, 98, 99, 100 and 144 and in the first of Drei Choräle, BWV 250. BWV 12

14 Ainsi qu'on oit le cerf bruire, is almost identical with the melody of the third movement known as Freu' dich sehr, O meine Seele. Ainsi is used also in Cantatas 19, 25, 30, 32, 39, 70 and 194.
O Welt, ich muss dich lassen, appears in Cantatas 44 and 97; as Nos. 16 and 44 of the Matthew Passion and No. 8 of the John Passion.
Schmieder refers to this choral as Nun ruhen alle Wälder, by Georg Forster, 1539. BWV 13

15 Bach's use of the choral melody in Cantata No. 14 demonstrates his ability to diversify rhythmically and otherwise. (See Ex. 128.). BWV 14

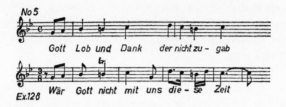

No 5

Gott Lob und Dank der nicht zu - gab

Ex.128 Wär Gott nicht mit uns die - se Zeit

16 The hymn tune appears in the last 30 bars of the final movement. It was used also in Cantatas 31 and 95. BWV 15

17 The melody used in Cantatas 16, 119, 120 and 190 is Herr Gott, dich loben wir, (anon), 1535. Helft mir Gott's Güte preisen, by W. Figulus, which is set also to another hymn text by Hembold, is used in Cantata No. 11. Herr Gott is a simplified version of the Ambrosian plainsong Te Deum Laudamus. BWV 16

18 This melody, attributed to Johann Kugelmann, was published in 1540. Bach used it in Cantatas 28, 29, 51 and 167 and Motetts 225 and 231. BWV 17

19 Durch Adams Fall, appears in the accompaniment to the Bass recitative Gleich wie der Regen immediately preceding No. 3 in which it is in the Soprano. The Cantata is of special interest as it has no parts for violins. Bach writes for four violas and, as he would most certainly not have four players in his Weimar orchestra, the violinists would have to take over the lower pitched instruments. BWV 18

20 An obbligato trumpet adds the hymn melody to the Tenor aria in Cantata No. 19. The other melody used is Ainsi qu'on oit le cerf bruire, which appeared in Cantata No. 13. BWV 19

21 Crüger reconstructed or revised Schop's melody and published his version, known as O Ewigkeit, du Donnerwort, in 1653. Bach used it in Cantata No. 60 and Anna Magdalena's notebook. BWV 20

22 Bach makes use of this melody in Cantatas 27, 84, 88, 93, 116, 179 and 197. In this chorus it appears first in the Tenor and later in Soprano. Mendelssohn 'borrowed' it for No. 9 of his St. Paul. BWV 21

23 The tune Herr Christ, employed in the final choral of Cantata No. 22, resembles very closely a secular song entitled Ich hört ein Fräulein klagen. The choral melody appears in Cantatas 96, 132 and 164. BWV 22

24 Cantata No. 23 dates from the same period (1723/4) as the St. John Passion and its final choral was, at one time, the last item in the Passion.
The melody is on the violins and oboes in the accompaniment to the Tenor Recit. In the Kyrie of the Mass in F (BWV 233) it appears in oboes and horns.
It is used also in Cantata No. 127 and the five part Kyrie Eleison (BWV 233a). BWV 23

25 The form of melody utilised in this Cantata, also in Nos. 71 and 164, is that published in 1693. In his Partite diverse sopra 'O Gott, du frommer Gott', BWV 767, Bach uses an earlier version of the tune dating from 1646. It was known originally as Gross ist, o grosser Gott. BWV 24

26 The first Chor is in the form of a double fugue and Bach adds the hymn tune, set in four part harmony, to the voices. It is scored for three recorders, cornetto and three trombones. Spitta says that 'The effect . . . when the sacred . . . hymn comes in . . . is indescribable and unfathomable!
The tune, Ach Herr, is better known by the other name Herzlich tut mich verlangen, under which it appears in Cantata No. 135. BWV 25

27 Obviously Bach had known and loved this tune for years as he used it in the little organ book of 1708 – 17 or 1717 – 23 wherein it is BWV 644. BWV 26

28 The tune, Wer nur den lieben Gott, was in Cantata No. 21 and Welt, ade! appears again in No. 158.

Rosenmüller was a native of Leipzig and his melody was published in the *Neuen Leipziger Gesangbuch* of 1682. ^{BWV 27}

29/30 Whittaker regards the hymn tune Nun lob', mein' Seel' as 'anon' but Terry attributes it to Johann Kugelmann (see Cantatas 17 and 29).
Helft mir appears also in Cantatas 11 and 16.
Terry dates Cantata No. 28 as 1736 because the text of choral No. 6 is a prayer for peace and so would have been particularly fitting for that year on account of the war of the Polish Election. Dürr, however, ignores the war (or peace) and suggests 1725. ^{BWV 28, 29}

31 Bach avails himself of Bourgeois' Ainsi once again for the closing movement of Part I. The work's final Coro is exactly the same (apart from the text) as the opening item. ^{BWV 30}

32 Terry gives Ainsi as the hymn tune for Cantata No. 31 in addition to No. 30 but Whittaker prefers Herman's Wenn mein Stündlein! The tune appears in unison violins and violas towards the end of the 3/4 Soprano aria and again – in common time – in the last item. ^{BWV 31}

33 Bach had a fondness for Ainsi – he used it in at least seven different Cantatas. This is certainly the same tune as that in Cantata No. 30 and differs from the one used in Cantata No. 31. It would seem, therefore, that Terry is incorrect in assigning the same tune to all three Cantatas. (See Ex. 129.). ^{BWV 32}

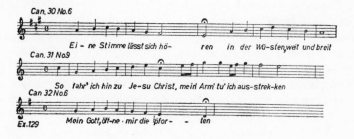

34 It is interesting to note that both versions – the 3/4 and

the 4/4 – sound correct. Most tunes resent being rebarred but Bach seems able to change whenever he pleases without destroying the essential quality of the melodies. (See Ex. 130.).

BWV 33

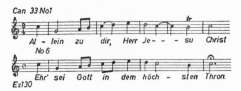

35/36/37 Nun komm – 'anon', or possibly, Luther – is used in Nos. 1, 2, 6 and 8 of Cantata No. 36 and in Cantatas 61 and 62. Wie schön leuchtet, appears in items 3 and 4 and in Cantatas No. 1 and 37. BWV 36

38 The practice of adapting or reconstructing secular tunes for sacred or hymnal use was wide-spread over a considerable span of years – this particular adaptation taking place twenty-three years before Bach's birth. BWV 37

39 In addition to the first and final choruses the choral melody is used as the continuo (accompaniment) line of the Soprano 'Recitative a battuta', (No. 4), Ach! dass mein Glaube noch so schwach. BWV 38

40 Yet another use of Ainsi and two more still to come!

BWV 39

41 The Christmas Cantata No. 40 makes use of three hymn melodies; Wir Christenleut, of Fuger the Younger, appears in Cantatas 110 and 142 and in choral No. 35 in Part III of the Christmas Oratorio.
There is some doubt about the second hymn. Whittaker gives it as Bleiches Antlitz, sei gegrüsset, possibly by F. Funcke, whereas Terry prefers Schwing' dich auf zu deinem Gott, by Paul Gerhardt, published in 1653. This latter hymn is very similar to two others : — Meine Hoffnung stehet feste, (anon) but attributed to Friedrich Funcke and dated 1680 and Vetter's, Einen guten Kampf hab' ich, of 1713. BWV 40

42 This early (1591) melody is used in Cantatas 171 and 190.

In this instance it appears in the opening and closing choruses of Cantata No. 41. BWV 41

43 The hymn melody, Verleih' uns Frieden gnädiglich, dating from 1535 is used again in Cantata 126. Also in Cantata 42 as well as in 126 is the choral tune, Gieb unsern Fürsten, (anon) of 1566.
The Bass aria (No. 6) is of special interest in that there are no 2nd violins or violas in the score. The two string lines are given to divisi 1st violins – were the others so bad in the earlier movements at rehearsal that Bach just could not stand them any longer? BWV 42

44 It will be remembered that Ermuntre dich was used in Cantata No. 11. BWV 43

45 Ach Gott, usually described as 'anon', is thought to have been written by Bartholomäus Gesius and first published in 1605. It appeared in Cantata No. 3.
Heinrich Isaak's tune was in Cantata No. 13. BWV 44

46 The year 1679 saw the publication of the tune Die Wollust dieser Welt. It was reconstructed and brought out again in 1698 and it is this latter version which is employed by Bach. The tune appears in Cantatas 64, 94, 128 and 129.
BWV 45

47 Melchior Franck was born between 1570 and 1580 and died in 1639. His hymn tune was published in 1632. BWV 46

48 The words of this hymn are supposed to be by Hans Sachs, the famous cobbler of Nüremburg, and the tune descended from the Meistersingers so beloved of Wagner. It dates from 1565 and was used again in Cantata No. 138. One assumes that Beckmesser could find no faults in it! BWV 47

49 Ach Gott und Herr, of 1625, was reconstructed and changed into the major mode in 1655. It is this revised version which is used by Bach in Choral No. 3. Originally the tune was a slightly altered version of the Tenor part in Wenn mein Stündlein vorhanden ist, used in Cantata No. 15 and again in 113, 131, 166 and 168.

In the first Chor it is given to trumpet and two oboes and treated canonically. BWV 48

50 The melody of Wie schön leuchtet is sung by the Soprano in the duet for that voice and Bass – the ornamented version in the latter voice provides a delightful counterpoint to the Choral. The tune was used in Cantata No. 1 and appears again in No. 110, 146, 169, 174 and 188. (See Ex. 131.). BWV 49

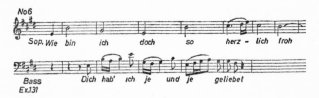

51 This melody, attributed to Kugelmann, was noted under item 18. Its treatment in Cantata 51 is particularly interesting as it is thought that No. 4 in that work is derived from a concerto for two violins. It is, therefore, a double borrowing – the general layout from the concerto movement and the soprano melody from Kugelmann. BWV 51

52 This Cantata, No. 52, again contains a double borrowing. The Sinfonia from Brandenburg No. 1 and the final Choral from Calvisius who lived from 1556 – 1615 and who was a predecessor of Bach's having, at one time, been a Cantor of St. Thomas' Church. The melody is used again in Cantata No. 106. It is No. 38, Mir hat die Welt trüglich gericht't, of the Matthew Passion and No. 46, Dein Glanz all' Finsternis verzehrt, in the Christmas Oratorio.
BWV 640, in the little organ book, also entitled, In dich hab' ich gehoffet, Herr, is not by Calvisius but is a 15th-Century Easter Hymn. BWV 52

53 Schmieder says that the authorship of Cantata No. 53 is very doubtful. Dürr is sure that it is not by Bach. Whittaker, however, while noting that the authorship has been doubted says: — ' . . . yet the main theme is so lovely . . . that one questions whether any other composer of the day could have

written it. It may be Bach's version of some other composer's work!'

The work is thought to have been composed for a child's funeral. What wonderfully appropriate music it is!　　BWV 53

54　Schop's melody was used again in Cantatas 146, 147 and 154 and it is No. 48, Bin ich gleich von dir gewichen, in the Matthew Passion.　　BWV 55

55　Crüger's melody is set here to verse 5 of Luther's hymn, Christ lag in Todesbanden.　　BWV 56

56　The melody Hast du denn, Liebster, dein Angesicht has a very familiar two opening bars and it is possible that it is of secular origin. In this Cantata it is set to words by Fritsch but it is usually associated with the hymn, Lobe den Herren, and it is used in this context in Cantata No. 137 and in the unfinished Cantata No. 120a.

Whittaker makes an interesting but, in the light of Dürr's discoveries, misguided, reference to this Cantata when he says that: — '. . . the simple chords in place of the immense choruses of the Christmas Cantata of 1734/5 point to a sad deterioration in the standard of St. Thomas's choir in 1740' Dürr, however, claims that Cantata 57 was first performed on 26 Dec. 1725 – that is when Bach had been in charge of the choir for under three years and had had barely time enough in which to build it up – were he so minded and able to find the right voices!　　BWV 57

57　The choral used in the opening Duetto was noted in connection with Cantata No. 3. Terry says that the melody used in the final movement is either Ach Gott or Herr Jesu but the similarity between the two movements is so close that

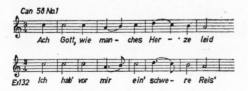

Can 58 No.1

Ach Gott, wie man - ches Her - · ze leid

Ex132　Ich hab' vor mir　ein' schwe - re Reis'

I cannot believe them to have been derived from different sources.
The melody is set to Martin Böhm's text in this Cantata. It is associated also with two other hymn texts – O Jesu Christ, mein's Lebens Licht and Hilf mir, Herr Jesu, weil ich leb'. (See Ex. 132.). BWV 58

58 Komm, heiliger Geist, appears also in Cantata No. 175 and Mottete No. 2, (BWV 226), 'Der Geist hilft unsrer Schwachheit auf', of 1729. Both Terry and Alfred Dörffel, in his foreword to BG XXXV (1888), point out that it appears in Cantata No. 172 as Cantus Firmus (in solo violin) to the Duet (No. 5). It is, however, in a highly ornamented version. (See Ex. 133.). BWV 59

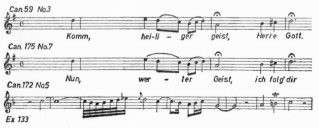

Ex 133

59 Crüger's? reconstruction of Schop's melody appears also in Cantata No. 20.
Terry gives Es ist genug, so nimm, Herr, meinen Geist, by J. R. Ahle as the choral melody used in the final item. Schmieder, however, gives this tune as Choral No. 5 in the Cantata 'Ich habe Lust zu scheiden', (composer unknown), Appx 157 and Es ist genug, Herr, wenn es dir gefällt in Cantata 60. The opening bars of the two melodies are very similar and can easily be confused one with the other. Incidentally Berg used the Cantata 60 version in his violin concerto. (See Ex. 134.). BWV 60

Ex 134

60 The first movement (Ouverture) of Cantata No. 61 is a choral fantasia in the form of a French Ouverture. With seemingly perfect ease Bach has fitted the choral melody into the opening and closing Grave sections of the overture. The choral was used also in Cantata No. 36.

The closing movement, as Terry points out, uses a different choral – Wie schön leuchtet – which appeared also in Cantata No. 1. Schmieder, however, thinks otherwise as he gives it only in connection with the 1st Cantata.

Cantata 61 was written for Advent 1714. It was heard again on the occasion of a visit to Leipzig which Bach made to report on the organ in the University Church. The date of this visit varies considerably according to different experts.

Spitta	says	1714.
Terry	,,	1717.
Richter	,,	1722.
Dürr	,,	1723.

BWV 61

61 Cantata No. 62, using the same choral tune as Nos. 36 and 61, seems to be hard to date. Dürr gives 1724; Schweitzer between 1728 and 34; Schmieder between 1735 and 44 and Wustmann 1740.

BWV 62

62 The melody based on the Latin hymn, Grates nunc omnes, appears again in Cantata No. 91 but with completely different harmony and treatment. In Cantata 64 the choral opens on the dominant of C and modulates to A minor in bar 2 but in Cantata 91 it opens in G and reaches the key of C in bar 2. (See Ex. 135.).

Ex.135

It is also chorals No. 7, Er ist auf Erden kommen arm, and
No. 28, Dies hat er Alles uns getan, in the Christmas Oratorio.
The melody (or its alternative) of the fourth movement was
used in Cantata No. 45. The words of this choral, Was frag ich,
are taken from G. M. Pfifferkorn's hymn, Was frag ich, which
has its own tune written by Jacob Hintze and one is forced to
wonder why Bach did not make use of it.

Crüger's melody is based on a secular song, Flora meine
Freude, meine Seele Weide, of 1641. It is used again in
Cantatas 81 and 87. BWV 64

63 The hymn, Puer natus in Bethlehem, dates from 1543.
There is, however, a slightly later version dating from 1553
and called 'Ein Kind geborn zu Bethlehem'. It is this second
version which Bach uses. Terry tells us that the 1553 tune
was the descant to the 1543 Cantus Firmus which later became
the tenor line in early four-part settings.

The second choral melody is Was mein Gott will, (Anon but
of secular French origin) (1571/2 or 1529), according to Terry
but Ich hab' in Gottes Herz und Sinn where Whittaker is
concerned as he refers to it by the title of Gerhardt's verses.
Schmieder, however, gives the melody title for both Cantatas,
72 and 92.

Terry says the tune is of French origin as it appeared in 1529
as the melody of a secular song, Il me souffit de tous mes maulx.
He allots it also to Cantatas 72, 92, 103, 111 and 144 and states
that the version used by Bach dates from 1647. It is also No.
31, Was mein Gott will, in the Matthew Passion. BWV 65

64 The final choral of Cantata No. 66 uses the tune, Christ
ist erstanden, (anon) and published in 1535. It is based on a
medieval Easter hymn dating back to the thirteenth century.
 BWV 66

65 The hymn tune Erschienen' der herrlich' Tag ist is by
Nicolaus Herman and dated 1560. It is very similar to the
Easter hymn, Erstanden ist der heil'ge Christ, dating from
1555 and appears again in the final choral of Cantata No. 145.
The second tune used in Cantata 67 is Du Friedefürst, Herr
Jesu Christ, by Bartholomäus Gesius, dated 1601. It was
revised by Crüger in 1649 and the version used by Bach in

this Cantata as well as in Nos. 116 and 143 is based partly on that revision. Spitta mentions Jakob Ebert as a possible alternative composer of the hymn melody. BWV 67

66 Also hat Gott die Welt geliebt, which appears in the first Chor of Cantata No. 68, is by Vopelius and dates from 1682. Spitta claims that it is one of Bach's own melodies but Terry denies this most strongly. BWV 68

67 It has always been assumed that Cantata No. 69 was written first of all as a work for the 12th Sunday after Trinity (27 Aug. 1724) and Ratswahl (28 Aug. 1724) and, in this version, included the tune Es woll' uns Gott genädig sein, (anon), 1525, attributed both to Luther and to Matthäus Greitter which appeared also in Cantata No. 76. Dürr, however, gives 1743/50 for its performance.

The work is supposed to have been revised in or about 1730 for further Ratswahl use but Dürr dates this performance as 1723. This (new), (BWV 69a), version adds Was Gott tut, (anon) of 1690, which appeared in Cantata No. 12. BWV 69

68/69 Cantata No. 70 contains several borrowings and a slight problem of identity. Certainly the similarity between the Handel Bass and the Bach Soprano arias is very strong and one must assume that Bach was aware of the Handel work. (See Ex. 134.).

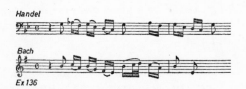

Ex 136

The tune by Bourgeois which ends Part I appeared also in Cantata No. 13 and Meinen Jesum lass' ich nicht, by Andreas Hammerschmidt, (1659), which closes Part II is used again in Cantatas No. 124, 154, 157 and 163.

At one time it was the concluding item of Part I of the Matthew Passion but later was discarded.

The small problem of identity concerns the tune used in the Bass recit. No. 9. Whittaker describes it as the Ringwaldt hymn associated with Luther's hymn tune whereas Terry votes for Luther's tune, Nun freut euch, lieben Christen g'mein, (1535 or 29), used again some years later as No. 59, Ich steh' an deiner Krippen hier, of the Christmas Oratorio. It was added to Cantata 70 at the time (1722 or 23) of a revision. What is likely to mislead is that Whittaker often refers to a choral by the writer of the words whereas Terry gives the composer (when known) of the tune. BWV 70

70 It will be remembered that O Gott, du frommer Gott, was used in Cantata No. 24 dating from 1723. BWV 71

71 And Was mein Gott will was in Cantata No. 65 of 1724.
 BWV 72

72 Justus Jonas' hymn text was usually sung to the tune, Ach lieben Christen, but, in 1709, Crüger joined it to the tune Wo Gott der Herr, (anon) 1535 and Bach followed this scheme in Cantatas 114 and 178. (It appears also in Cantata 219 which Dürr and Schmieder both say is not by Bach). For Cantata 73, however, although Bach used the tune Wo Gott der Herr, he discarded Jonas' text and used words by Caspar Beenemann (1540 – 91).
For the final choral see Cantata No. 11 (item 12). BWV 73

73 Cantata No. 74 is, as we noted in Chapter 9 of the first part of this book, based to a great extent on Cantata No. 59. The choral melody, Kommt her zu mir, appears also in Cantatas 86 and 108. BWV 74

74 In addition to chorals Nos. 7 and 14 Bach uses the melody, Was Gott tut, as a trumpet Cantus Firmus in the Sinfonia (No. 8) which opens Part II of Cantata No. 75.
In a list or record found amongst his papers in the year 1790 C. P. E. Bach notes this Cantata under the name of 'Was hilft des Purpurs Majestät' – the opening words of the Bass recit (No. 2). BWV 75

75 The tune, Es woll' uns, used in the chorals which con-

clude Parts I and II of Cantata No. 76 appeared also in
Cantata No. 69. BWV 76

76 Dies sind die heil'gen zehn Gebot is a reconstruction by
Walther of the tune, In Gottes Namen fahren wir, which may,
in its turn, have been an old Pilgrims' song. The melody is
introduced in the continuo and on trumpet da tirarsi; in
minims in the bass and crotchets on the trumpet.

Schmieder says of Cantata 142 that its authenticity is doubtful
and that it may be by Kuhnau. Dürr, also, says: — 'not Bach'.
Spitta, however, feels that 'the sentiment verges on that quiet
ecstasy which is peculiar to Bach's earliest church composi-
tions'. He suggests that, although the soprano aria reminds us
very strongly of the tenor aria, the condition of the autograph
offers no real evidence that Bach has remodelled an older
composition unless we go by the haste in which it seems to
have been written and the fact that it is a not very interesting
work. (See Ex. 137.).

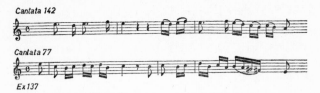

Cantata 142

Cantata 77

Ex 137

Note that the Tenor aria, (No. 5) of Cantata 142, is in A minor
with an accompaniment of two oboes and continuo whereas
the Alto aria, (No. 7), which has exactly the same music, is in
D minor but with two flutes and continuo.

The melody of Ach Gott, was used in Cantata No. 2. Bach's
MS of No. 77 lacked words and instrumentation for the final
choral. Those used are by David Denicke and were chosen
and fitted by Carl Friedrich Zelter, (1758 – 1833). BWV 77

77 The tune, published as set to the text which gave it its
present name in 1662, has been associated with several hymn
texts. Terry tells us that in 1642 it belonged to a secular
song: — Daphnis ging für wenig Tagen; in 1643 to Ferdinand,
du grosser Kaiser; in 1662 to Wachet doch and in 1663 to
Jesu, der du meine Seele.

It is used again in Cantata 105. Bach uses various forms of the melody; in Cantata 78 the ending follows a version made by Daniel Vetter in 1713 and in Cantata 105 that made by Telemann and published in 1730. BWV 78

78 Crüger's melody is adapted from a tune written by either Martin Rinkart or Luca Marenzio. It is used again in Cantata No. 192.

The melody of Nun lasst uns Gott dem Herren is in the tenor voice of the 1575 four-part setting. Later the descant was published as a melody in its own right and the tune used by Bach is a variant of that descant melody published in 1587. It comes again in Cantatas 165 and 194.

Spitta, Terry and Schmieder all date Cantata 79 as 1735 and associate it with the Polish war. Dürr, however, says 1725 and, therefore, disassociates it from the war! BWV 79

79 Although Cantata No. 80 of 1730 or 38 is known to be based on 80a, dated 1716, Dürr feels that there is a strong possibility of an early version of 80 being dated around 1724.

The melody, Ein' feste Burg, probably by Luther, is used in four of the eight movements in the Cantata. In No. 1, a choral fantasia, the Cantus Firmus appears in canon between the 1st trumpet with two oboes and the continuo. It is possible that all three trumpets and the timpani were added at a later date by either C. P. E. or W. F. Bach. There is no trace of them in the original version and their rather odd use does not suggest the hand of J. S.

In No. 2 (duet), the melody is in the Soprano.

No. 5, choral fantasia, has the tune in voices 'unisono' and No. 8, the final choral, is the normal four-part setting with no indication of the accompanying instruments.

A Latin version Gaudete omnes populi of the first Chor exists in the handwriting of Wilhelm Friedemann, in this the orchestra is minus its two oboes. Another Latin version, Manebit verbum Domini, was found amongst Kirnberger's MSS.

Is this a case of 'borrowing from the borrower'? BWV 80

80 Crüger's melody was used in Cantata No. 64 dating from 1723 – the year previous to Cantata 81. BWV 81

81 The Nunc Dimittis plainchant is given to a solo Bass in item 2.
Of the choral tune, Terry says (guardedly) 'with considerable probability the tune may be attributed to Luther'. It appears again later in Cantatas 95, 106 and 125. BWV 83

82 Spitta thinks that Bach wrote Cantata No. 84 for his own use, ie. in his own home and domestic surroundings. Terry disagrees with the idea just as Dürr disagrees with the accepted dating (1732/3) and substitutes 1727.
The tune, Wur nur den lieben Gott, was used in Cantata No. 21. BWV 84

83 The melody of Allein Gott in der Höh', used in the 3rd movement of Cantata No. 85, appears later in Nos. 104, 112 and 128.
Terry says of Ist Gott mein Schild und Helfersmann that it is quite definitely 'anon' and not by Bach. BWV 85

84 Kommt her zu mir, was in Cantata No. 74 and Es ist das Heil in No. 9. BWV 86

85 Crüger's melody, Jesu, meine Freude, was noted in item 62 (Cantata 64). BWV 87

86 The 'anon' melody associated with Neumark's text appeared in Cantata No. 21 (see item 22). BWV 88

87 For notes on Auf meinen lieben (Venus du und dein Kind) see under Cantata No. 5 (item 6). BWV 89

88 The hymn, Vater unser im Himmelreich, has been attributed to both Luther and 'anon'. The version used by Bach in Cantatas Nos. 90, 101 and 102 is dated 1539. It appeared as No. 5 in early performances of the St. John Passion – that is, a year later than Cantata No. 90 which Dürr brings forward to as early as 1723. BWV 90

89 The notes on Cantata No. 64 give two interesting versions of Gelobet seist du. In this Cantata (91) the Cantus Firmus is given to Soprano in the first Chor against very florid Alto, Tenor and Bass parts. (See Ex. 138.). BWV 91

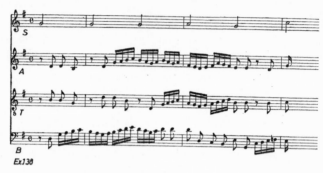

Ex.138

90 Just to remind readers that the melody of Ich hab' in Gottes Herz, appeared in Cantata No. 65 and was noted in the item on that work. BWV 92

91 The study of Bach's variation technique is not the main purpose of this book but I feel that the different versions of the choral, Wer nur den lieben Gott, (used also in Cantata No. 21) which he contrives for Cantata 93 are too interesting and

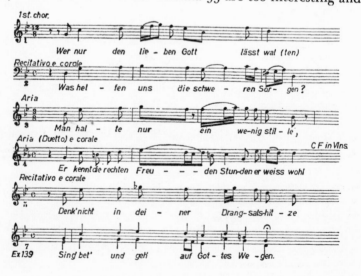

Ex.139

typical of his work in this direction to be passed over. It will
be remembered that the 4th movement become Schübler
Prelude No. 3. (See Ex. 139.). BWV 93

92 The tune, Was frag' ich, appeared in Cantata No. 64 and
Die Wollust dieser Welt, in No. 45.
Again a short example serves to show Bach's ability to make a
flowing melody or aria out of a simple choral tune. (See Ex.
140.). BWV 94

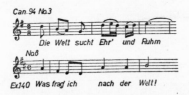

Ex.140 Was frag' ich nach der Welt!

93 Of the four choral tunes contained in Cantata No. 95,
Mit Fried' und Freud', was in Cantata 83; Valet will ich dir
geben was, at one time, No. 28 of the St. John Passion and
Wenn mein Stündlein was in Cantata No. 15.
Notice the similarity between Christus, (No. 1) and Valet will
ich dir, (No. 2). Did Teschner 'borrow' from Vulpius or did
they both enjoy a common source? (See Ex. 141.). BWV 95

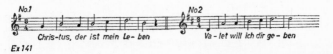

Ex 141

94 The tune Herr Christ was used in Cantata No. 22 of 1723.
 BWV 96

95 Isaak's melody has been used many times, for example: —

a) for a secular song, Innspruck, ich muss dich lassen,

b) for Hesse's hymn, O Welt, ich muss dich lassen,

c) for Gerhardt's hymn, Nun ruhen alle Wälder,

d) for Flemming's hymn, In allen meinen Taten (1642).

The first Chor of this Cantata (No. 97) resembles the first
movement of an orchestral Suite with the choral tune (in the
soprano) worked into the Vivace section. BWV 97

96/7/8 The melody, Was Gott tut, was noted under Cantata No. 12.

Notice that there is no final choral in Cantata No. 98.

The aria (No. 5) for Bass is definitely borrowed from Hammerschmidt's melody. Both Terry and Whittaker comment on this 'quotation'. (See Ex. 142.).

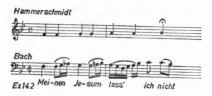

The first Chor of Cantata No. 100 is the same as the corresponding movement in Cantata No. 99 written eight years previously.

BWV 98, 99, 100

99 Whittaker has the following to say regarding Cantata No. 101: — 'If Terry's surmise be correct, Nimm von uns, was called into being as the result of Frederick the Great's second invasion of Saxony. To the sixty-year old composer the war was but one more of the many horrors he had experienced in his lifetime.

Was this strangely harmonised choral (No. 7) the last piece of vocal church music the master wrote? What were his thoughts on laying down his fertile pen after completing this mighty mass of church music – the greatest tribute ever paid by musician to his church and his religion'?

The answer, if Dürr's 1724 is correct, is that it was by no means the last vocal church music Bach wrote and that the composer was thirty-nine – not sixty!

The hymn melody, Vater unser, appeared in Cantata No. 90 and was noted under item 88. Bach uses it here in six out of the seven movements of the work.

BWV 101

100 Bach contents himself with using the choral melody once only in Cantata No. 102.

BWV 102

101 The melody, Was mein Gott will, was noted in connec-

tion with Cantata No. 65 and it appears again in Cantata
No. 144. Also it is No. 31 of the Matthew Passion. BWV 103

102 Allein Gott appears in Cantatas Nos. 104, 112 and 128.
It will be remembered that it was used also in Cantata No. 85
but in a heavily disguised version! (See Ex. 143.). BWV 104

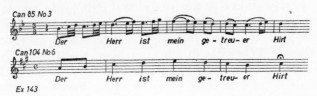

Ex 143

103 Spitta says:— 'Bach copied part of Handel's Passion
music during the Cöthen period. I feel convinced that he was
carried away by his remembrance of this very beautiful and
impressive passage'. (See Ex. 144.).

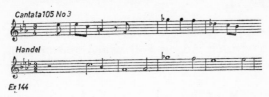

Ex 144

We might, I suppose, allow the possibility of the resemblance
not being accidental.
The choral, Wachet, doch, was used in Cantata No. 78. BWV 105

104 The melody, Ich weiss mir ein Röslein hübsch und fein,
(anon) 1589, is the tenor line of a four-part setting of the
secular tune which then became the melody of the hymn, Ich
hab' mein Sach' Gott heimgestellt, of 1609. The first part of
the melody is the same as Warum betrübst du, (1565), in
Cantata No. 47. It is played by flutes and gambas.
The descant of the 1589 setting was fitted to Warum betrübst
du, in 1598.
Mit Fried' und Freud' was used in Cantata No. 83 and In dich
hab' ich gehoffet, Herr, in No. 52.
In Duet (No. 3), the Alto sings Luther's melody towards the
end of the Bass section.

Pirro says of Cantata No. 106 that it was written for the
funeral of Bach's uncle, Tobias Lämmerhirt, Sept 1707.
Spitta, however, thinks it was for the funeral of Philipp
Grossegebauer, Rector of Weimar in 1711. Dürr dates the
Leipzig performance of the work as 1724. BWV 106

105 Terry thinks that the final choral (No. 7) of Cantata 107
uses the tune, Von Gott will ich nicht lassen, (of 1571) which
appeared in Cantata No. 11, and feels that the tune of
Heermann's, Was willst du dich betrüben, 'is clearly a deriva-
tive of Von Gott'. Whittaker, however, says:— 'In the BGS
score that choral melody is stated to be Von Gott, that is
incorrect, although the tune associated with Heermann's
hymn bears a close resemblance to it and was possibly derived
therefrom'. BWV 107

106 The 'anon' melody to Kommt her zu mir was used in
Cantata No. 74. BWV 108

107 The final choral (No. 6) of Cantata No. 109 is a choral
fantasia on Durch Adams Fall which appeared in Cantata
No. 18. BWV 109

108 Fuger's Wir Christenleut was used in Cantata No. 40.
Cantata No. 110 is one of the six Cantatas which make use of
material from orchestral Suites or instrumental concertos –
the others being:— 49, 146, 169, 174 and 188. BWV 110

109 Here we have an interesting example of several uses.
Terry states that the melody, Was mein Gott will, was used in
Cantata No. 72. Whittaker says that although it is described
as 'Anon' (the verses are by the Markgraf Albrecht of Bran-
denburg-Culmbach) it is of French secular origin and is
derived from Il me souffrit de tous mes maulx. It appears
also in Cantata No. 92.
Terry says of the choral in No. 92 that it is Gerhardt's verses,
Ich hab' in Gottes Herz, which came before in Cantata No. 65
and of No. 72 that the tune is Was mein Gott will, used also in
Cantata 65. Here are the melodies from Cantatas 65, 72, 92
and 111. (See Ex. 145.). BWV 111

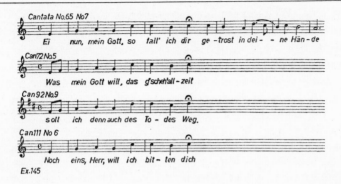

Ex.145

110 Allein Gott in der Höh', by Decius, appeared in Cantata No. 85. It is adapted from the Gloria in excelsis plainchant.

BWV 112

111 Another difference of opinion among the experts? Terry describes the hymn text used in Cantata No. 113 as Herr Jesu Christ, du höchstes Gut, (1593) – (that used previously in Cantata No. 48 was Herr Jesu Christ, ich schrei zu dir, (1620)). It should be noted that both texts make use of the same tune. Whittaker says that the (Anon) tune is Kreuz und Trostlied and points out that Bach introduced it into every number. Schmieder agrees that Herr Jesu Christ is in both Nos. 48 and 113 but does not mention Kreuz und Trostlied. Certainly the melody, whatever its name, is the same in both works. (See Ex. 146.).

BWV 113

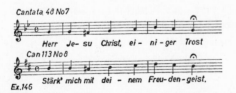

Ex.146

112 Whittaker states that the flute obbligato to the Tenor aria, (No. 2) Wo wird in diesem Jammertale, contains a quotation from the organ prelude on Vater unser im Himmelreich, (BWV 636). He asks:— 'Was it a deliberate quotation? One would like to think so!'
Certainly the phrase 'C sharp, D, E, F', repeated in bars 9, 10 & 11 of the continuo, appears in bars 5 of the choral melody.

The tune, Wo Gott der Herr, was used in Cantata No. 73.

<div align="right">BWV 114</div>

113 Schmieder says that Straf mich nicht is Choral No. 74 in the Luke Passion. One must agree that the Luke Choral uses the same words but the melody is quite different from that used by Bach in Cantata No. 115 and the examples in his four-part chorals, BWV 256, 257 and 258.

<div align="right">BWV 115</div>

114 Bartholomäus Gesius' tune was used in Cantata No. 67. It has been accepted up to quite recently that Cantata No. 116 is the latest of all as both recitatives refer to the horrors of war. Frederick the Great invaded Saxony in the autumn of 1744 and the 25th Sunday after Trinity was on November 15th in that year. Spitta thought the Alto recitative (No. 5) to be the last piece of church music written by Bach. Terry, after publishing his *Bach's Cantata Texts* decided that Cantata No. 101 came even a year later! (See notes on Cantata No. 101 in item 99).

<div align="right">BWV 116</div>

115 Whittaker refers to the hymn tune in Cantata No. 117 as Sei Lob und Ehr' dem höchsten Gut ie. the title of J. J. Schütz's text. Terry, however, prefers the tune title – Es ist das Heil – of 1524. It appeared in Cantata No. 9 and W. F. Bach's organ book. (BWV 638).

<div align="right">BWV 117</div>

116 The tune Ach Gott was in Cantata No. 3 of 1725. BWV 118

117 Both Terry and Whittaker agree that the tune used in the final choral is the Plainsong of the Te Deum. In addition Whittaker feels that the fugal subject of Chor No. 7 is derived from the old choral Nun danket. (See Ex. 147.).

<div align="right">BWV 119</div>

Fugue

Ex.147

118 Herr Gott, dich loben wir, was used also in Cantata No. 16.

<div align="right">BWV 120</div>

119 Lobe den Herren appears again in Cantata No. 139.

<div align="right">BWV 120a</div>

120 The tune, Christum wir sollen loben schon, (anon) or, perhaps, by Walther, is based on the 'anon' Latin melody, A solis ortus cardine, of 1537. If this came from a Gregorian melody the original must, of course, have been known much earlier than 1537.

<div align="right">BWV 121</div>

121 Terry gives Melchior Vulpius as the composer of Das neugebor'ne Kindelein, (1609).

<div align="right">BWV 122</div>

122 The melody of Liebster Immanuel seems to be derived from a dance for a similar tune appeared as a Courant in a collection of dances (in MS) dated 1681. Another version of the tune appeared in 1698 under the name of Schönster Immanuel. This version, printed in Darmstadt, is labelled 'anon' but is attributed to Johann Rodolph Ahle.

<div align="right">BWV 123</div>

123 Meinen Jesum was used in Cantata No. 70. (see item 68/9).

<div align="right">BWV 124</div>

124 Cantata No. 83 included Mit Fried' und Freud' ich fahr' dahin.

<div align="right">BWV 125</div>

125 The melody of Erhalt uns, Herr, was used in Cantata No. 6 and Verleih uns, in Cantata No. 42. Both melodies were derived from the Latin tune of the Antiphon.

<div align="right">BWV 126</div>

126 Chor. No. I, Herr Jesu Christ, in addition to having Bourgeois' tune as a Cantus Firmus in the Soprano, has Christe, du Lamm Gottes, (which appeared in Cantata No. 23), in the accompaniment.

Whittaker describes the choral melody used in the first Chor as Herr Jesu Christ, derived from the Agnus Dei.

It is interesting to compare Nos. 4 and 5 as a good example of Bach's treatment. (See Ex. 148.).

<div align="right">BWV 127</div>

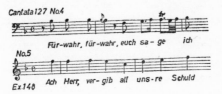

Cantata 127 No.4

Für-wahr, für-wahr, euch sa - ge ich

No.5

Ex.148 Ach Herr, ver- gib all uns-re Schuld

127 Allein Gott, was in Cantata No. 85 and O Gott, in No. 45. BWV 128

128 Terry tells us that the hymn text was set to the tune Nun danket alle Gott, in 1665 and reset to O Gott, du frommer Gott, in 1679. Bach used the latter setting. BWV 129

129 Bourgeois' tune, Or sus, serviteurs du Seigneur, of 1551 is very similar to a French song Il n'y a icy celluy, set to Psalm 100 in 1561 and now known (in this country) as The old 100th. It is quite possible that Bourgeois adapted his tune from the French song or that they had a source in common. There is also a setting by Sweelinck which may have been known to Bach. (See Ex. 149.). BWV 130

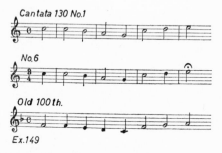

Cantata 130 No.1

No.6

Old 100th.

Ex.149

130 Terry gives Ringwaldt's tune, Herr Jesu Christ, as the Cantus Firmus in both duets of Cantata No. 131. Verse 2, Erbarm dich, for No. 2 and verse 4, Und weil ich denn, for No. 4. It will be remembered that the tune was used in Cantatas No. 48 and 118 where it was called Ach Gott, (used in Cantata No. 3). (See notes in item 4). (See Ex. 150.). BWV 131

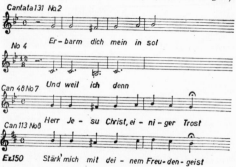

Cantata 131 No.2

No 4 Er - barm dich mein in sol

Can 48 No 7 Und weil ich denn

Can 113 No 8 Herr Je - su Christ, ei - ni - ger Trost

Ex.150 Stärk' mich mit dei - nem Freu - den - geist

131 The final Choral was written in Leipzig in place of the one used originally in Weimar. It appears also in Cantata No. 22.

BWV 132

132 Terry feels that Bach is not the composer of Ich freue mich in dir. The melody is very similar to Melchior Franck's O grosser Gott von Macht, of 1632 which Bach used in Cantata No. 46 and O Gott, du frommer Gott, of 1694, used in Cantata No. 24. The text was set to O Gott and published in 1697. Also it is very much like the tune O stilles Gottes Lamm, published by König in 1738. (See Ex. 151.).

BWV 133

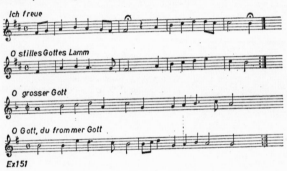

Ex 151

133 The tune, Herzlich tut mich verlangen, had a busy life. It appears in Cantatas 25, 135, 153, 159 and 161 and in Nos. 21, (Erkenne mich, mein Hüter); 23, (Ich will hier bei dir stehen); 53, (Befiehl du deine Wege); 63, (O Haupt voll Blut und Wunden) and 72, (Wenn ich einmal soll scheiden) of the Matthew Passion and Nos. 5, (Wie soll ich dich empfangen) and 64, (Nun seid ihr wohl gerochen) of the Christmas Oratorio.

BWV 135

134 The tune used in Cantata No. 136 is known by two names,

i) Auf meinen lieben Gott, and

ii) Wo soll ich fliehen hin.

It is under the latter name that it appears in Cantata No. 5.

BWV 136

135 Terry refers to the choral melody in this Cantata (137)

as Hast du denn, Liebster, dein Angesicht. In this connection
see item 56 on Cantata No. 57.

The Alto aria (No. 2) was used later as the basis of Schübler
Prelude No. 6.

Tenor aria No. 4 is the only movement which does not have
the melody in one form or another in the voice – here it is on
the obbligato trumpet.

It is interesting again to compare one of Bach's fairly florid
versions of the tune with its more simple form. (See Ex. 152.).

<div align="right">BWV 137</div>

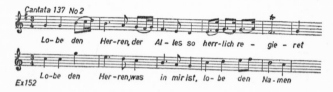

Cantata 137 No 2

Lo-be den Her-ren, der Al - les so herr-lich re - gie - ret

Lo-be den Her -ren,was in mir ist. lo- be den Na-men
Ex152

136 Warum betrübst du dich appeared in Cantata No. 47.

<div align="right">BWV 138</div>

137 Johann Hermann Schein's tune is used again in Cantata
No. 156.

<div align="right">BWV 139</div>

138 Terry says of Wachet auf:— 'Whether Nicolai com-
posed it or not cannot be determined positively it is
probable that he adapted old material to his purpose'.

The opening line is almost identical with O Lamm Gottes,
and very similar to In dulci jubilo.

The fourth movement became Schübler Prelude No. 1.
(See Ex. 153.).

<div align="right">BWV 140</div>

Wachet auf

O Lamm Gottes

In dulci-jubilo

Ex.153

139 Schmieder regards the authenticity of Cantata No. 141
as doubtful. Dürr suggests that Telemann is the composer and

Whittaker that 'it is almost certain that (it) is not by Bach'. Certainly two copies of the score which were in the Prussian Staatsbibliothek (now P 192 in Marburg) do not mention Bach's name. On the other hand the Cantata could be Bach's reworking of someone else's composition. (The final Choral is missing). BWV 141

140 Schmieder also regards Cantata No. 142 as doubtful and thinks it may be by Johann Kuhnau. In the Jahrbuch for 1912 Schering made the same suggestion. Whittaker says:—
'Wherever and whenever Bach produced it, it was, without doubt, only an adaptation for it is extremely unlikely that he was the composer'.
The choral tune Wir Christenleut' by Caspar Fuger, was used by Bach in Cantata No. 40. BWV 142

141 Terry confirms that the melody of Du Friedefürst is by Bartholomäus Gesius, the words being written by Jakob Ebert. Spitta ascribes the melody to Ebert and the words to Ludwig Helmbold.
The melody appears in the upper strings in the Soprano choral (No. 2) and in the Soprano in the final choral. It is on violins and violas in octaves in the Tenor aria (No. 6). BWV 143

142 We noted the origins of Was mein Gott will when discussing Cantata No. 65. (Item 63). BWV 144

143 The melody, Jesus, meine Zuversicht, in Cantata No. 145, was published twice in the year 1653 – the second being

Ex154

in a collection of Crüger's. It appeared again in 1668 over his initials. It is interesting to note the differences between the two versions of 1653 – the first from Runge's *Geistliche Lieder und Psalmen*. The first two bars are very similar but differ considerably after that. (Runge's example is 6 bars in length but Crüger's only 4). (See Ex. 154.).

Spitta says of the chorus (No. 2): — '. . . . the mode of working out the melody and the fugue is not Bach's but more like Telemann's'. In spite of this remark, however, he thinks the chorus is by Wilhelm Friedemann. Schmieder joins with Spitta in considering the movement to be like Telemann and goes one step further by ascribing it to that composer. Whittaker is not so sure, he says: — 'Knowing Bach's passion for copying the methods of every composer who could teach him anything, we need not be surprised if he essayed a number in the style of his popular and fertile contemporary'.
Herman's choral melody was used in Cantata No. 67. BWV 145

144 The text of the final Choral of Cantata No. 146 is missing but the melody is by Schop. What is most interesting in this Cantata is that, although the Sinfonia is based on the D minor clavier concerto (1st movement) and the first chorus is a most beautiful and moving choral version of the 2nd movement of the concerto, the authorship of the whole concerto is doubtful. Schmieder dates it as 1740 but Dürr can find no information concerning a Leipzig performance.
 BWV 146

145 It is most probable that Schop's melody is better known in its various arrangements than in its own Bachian form. Jesu, joy of man's desiring, is very familiar as a piano solo! The tune appeared earlier on in Cantata No. 55. BWV 147

146 Auf meinen lieben Gott was used in Cantata No. 5.
 BWV 148

147 The tune, Herzlich lieb hab' ich dich, appears once more in Cantata No. 174 and as No. 68, Ach Herr, lass dein' lieb' Engelein, in the John Passion. As the Passion is dated 1724 and Cantata No. 149 as 1728 (174 is dated 1729) the Passion version is the earliest of the three. BWV 149

148 Dürr brings the date of Cantata No. 151 forward by from ten to fifteen years. This means that the use of the tune Lobt Gott, in this Cantata, precedes its appearance in Cantata No. 195 by at least three years as the later work is dated 1728 – 31.

BWV 151

149 Whittaker feels that the inclusion of three choral melodies implies a composite work.
Spitta dates it as with Cantatas Nos. 81 and 154, ie. – 1724. Terry, however, suggests that, as the Sunday after Circumcision (for which it was written) fell only in 1727 and 28 and that in the latter year there was Court mourning for the Queen, it must be 1727. Dürr prefers the earlier date of 1724. The three melodies are also in Cantatas Nos. 2, 135 and 3.

BWV 153

150 The two chorals in Cantata No. 154 were used in Cantatas Nos. 55 and 70 respectively and Hammerschmidt's tune again in 157.

BWV 154

151 Es ist das Heil was noted in Cantata No. 9, but as Cantata No. 155 is dated 1724(?) and No. 9 is 1732/5, the later numbered use comes first.

BWV 155

152 J. H. Schein's tune is used in the Soprano of the Soprano/Tenor choral. It appeared a few years previously in Cantata No. 139.
Herr, wie du willt does not seem to have been used in any Soprano/Tenor choral. It appeared a few years previously in chorals (BWV 339).

BWV 156

153 The melody by Hammerschmidt was used three years earlier in Cantata No. 154 and now it appears twice in four days – for the Feast of the Purification on Feb. 2nd, 1727 and in the memorial service to Christoph von Ponickau on Feb. 6th, 1727 – he having died on Oct. 31st, 1726.

BWV 157

154 Welt, ade! was used in Cantata No. 27. In this instance it is in the soprano line of the Soprano/Tenor choral duet. Walther's tune, said to have been 'improved' by Luther, was in Cantata No. 4.

BWV 158

155 The melody associated with Gerhardt's poem, O Haupt voll Blut und Wunden, is a secular one – Mein G'mut ist mir verwirret von einer Jungfrau zart, by Hans Leo Hassler. Later it was used for three different hymns : — Herzlich thut mich verlangen (1613); Ach Herr, mich armen Sünder (1620) and O Haupt, of 1656.

Bach uses the tune in the soprano of the Soprano / Alto choral and doubles the voices on oboe and bassoon.

The final Choral uses a melody by Melchior Vulpius known in connection with this Cantata as Jesu Kreuz, Leiden und Pein. It was reconstructed by Gottfried Vopelius and published in 1682 set to a different text – Jesu Leiden, Pein und Tod. It was used previously in Cantata 182 in the Vopelius version and also in No. 20, Petrus, der nicht denkt zurück, of the John Passion. BWV 159

156 Schmieder says of Cantata No. 160 that its authenticity is doubtful and Dürr attributes it to Telemann.

Whittaker remarks that 'As the libretto did not appear in print until he (Bach) was 31 (ie. 1716) the work cannot have been a youthful effort. It may possibly be by another hand, touched up by Bach'. BWV 160

157 The Alto aria (No. I) has the choral melody Herzlich thut mich verlangen, (ie, the final Choral), played on the organ Sesquialtera ad organo as a counterpoint. Schmieder describes this tune as Wenn ich einmal soll scheiden. BWV 161

158 The experts are divided in their views on this melody. Erk says : — 'it is Jesu, der du meine Seele, by Johann Schop, 1641'.

Spitta says : — ' . . . nothing more than a compound produced by the fusion of the melodies 'Herr, ich habe missgehandelt' (1649) and 'Jesu, der du meine Seele', (1641)' and is convinced that Bach is the author.

Terry, however, says : — ' . . . the hymn 'Alle Menschen müssen sterben', had a 5-part setting by Johann Rosenmüller in 1652 the tune is derivative and with great probability may be regarded as the Tenor (line) of an original setting now lost'. (See Ex. 155.). BWV 162

Ex.155

159 The fifth movement of Cantata No. 163 has Meinen
Jesum in the upper strings (*Violini e Viole all' unisono*) to
accompany the voices.

Spitta says that the melody of the final Choral is Auf meinen
lieben Gott, by Pachelbel, (see Cantata No. 5) but in the major
mode. He appears to be mistaken in this as Zahn gives the
melody as Wo soll ich fliehen hin by Stiller (1679). Schmieder,
however, allots this tune to Cantatas No. 89, 136 and 148.
Terry states that the tune appears again in Cantata No. 199
but, for this, Schmieder gives Nun bitten wir den heiligen
Geist. Terry goes on to point out that Auf meinen lieben Gott
is used in Cantatas No. 5, 89, 136, 148 and 188. His explana-
tion is that the secular tune was attached to the hymn Auf
meinen lieben Gott from 1609 but from 1630, when the hymn,
Wo soll ich fliehen hin, was published, it was transferred to
that particular text. The version of the tune shown below is a
revised one and was published by J. H. Schein in 1627.
(See Ex. 156.). BWV 163

Ex.156

160 The second item in Cantata No. 164 (Bass recitative)

M

Wir hören zwar) has a passing reference to the tune O Gott,
du frommer Gott, of 1693, which appeared in Cantata No. 24.
The melody of the final Choral was in Cantata 22. BWV 164

161 The tune of the final Choral is also in Cantata No. 79
which dates from the following year – 1725.
Whittaker says that in Cantata No. 165 Bach uses a libretto
published in 1715 and wonders if this suggests a reconstruc-
tion of an earlier work. BWV 165

162 In the third movement of Cantata No. 166 the Soprano
sings the choral melody while upper strings in unison and
continuo provide a two-part counterpoint.
Whittaker agrees with the two melodies I have noted in the
Table. Terry reminds us that Herr Jesu Christ, du höchstes
Gut, was in Cantata No. 48 and points out that the tune, Wer
nur den lieben Gott, (it was in Cantata No. 21), is set to the
words of Wer weiss, wie nahe mir mein Ende, (see also Cantata
No. 27). (See Ex. 157.). BWV 166

Ex.157

163 The tune of Nun lob' mein' Seel' is used again in
Cantata No. 17 of 1726 and the text in Cantata No. 29 which
appeared eight years later in 1731. BWV 167

164 We considered the tune, Herr Jesu Christ, in connection
with Cantatas No. 48 and 113. BWV 168

165 The tune Nun bitten wir den heil'gen Geist is an
anonymous one which was reconstructed by Walther from a
pre-Reformation hymn melody. It was used again many years
later in Cantata No. 197. BWV 169

166 The hymn melody of Cantata No. 171 was used a few
years earlier in Cantata No. 41 of 1725. BWV 171

167 Schmieder says of the unfinished Cantata No. 141 'Das ist je gewisslich wahr' that its authenticity is doubtful. It is now known to be by Telemann. Cantata No. 172 is in two versions:— the first – unfinished – was dated 1724 and the second, 1731. This, later, revised, version has as its first Chor a setting borrowed from Telemann.

In the 1724 version the Soprano/Alto duet (No. 5) had an ornamented setting of Komm, heiliger Geist, played by an obbligato violin and an obbligato cello provided the bottom line – there was no continuo as such. These two obbligato lines were transferred to organ in 1731. (See Ex. 158.). BWV 172

Ex.158

168 As Cantata No. 174 is dated 1729 and No. 149 is 1728 or 29 we have here an instance of a hymn tune being used twice in the same or consecutive years. BWV 174

169 Bach used this hymn in Cantata No. 59 in 1723 or 4.
 BWV 175

170 The dating of Cantata No. 176 has given a certain amount of trouble.

Schmieder says		1735 or 32.
Terry	„	1735.
Spitta	„	'later than' 1732.
Dürr	„	1725.

The tune, Christ unser Herr, was used in the previous year, (1724) in Cantata No. 7. BWV 176

171 Ich ruf' zu dir, Herr Jesu Christ, was published in 1535. Bach's treatment of the old tune in Cantatas 177 and 185, plus the organ book (BWV 639), is very interesting – he sticks extremely closely to the general outline of the melody but

achieves variety by subtle rhythmic changes and ornamenta-
tion. (See Ex. 159.). BWV 177

172 Bach uses the tune, Wo Gott der Herr nicht bei uns
hält, in no less than five of the seven movements of Cantata
No. 178 in addition to its appearance in Cantata No. 73
written a year previously (1723). BWV 178

173 It was usual for this hymn to be sung to the tune Wohl
dem, der weit von hohen Dingen, but it appeared in print
in 1709 set to Neumark's melody. Bach used it again in
the same year (1723) in Cantata No. 21. BWV 179

174 Bach's treatment of the tune Schmücke dich stays closely
to the original in the three movements of Cantata No. 180 in
which it appears but he uses far greater freedom in the Organ
Choral BWV 654. (See Ex. 160.). BWV 180

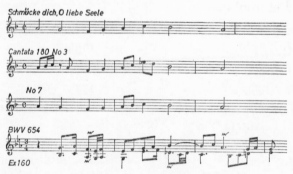

175 The hymn melody by Vulpius was used again later
in Cantata No. 159 of 1729 (?) and noted in item 155. BWV 182

176 Helft mir was noted in connection with Cantata No. 11, (item 12). BWV 183

177 It is possible that Cantata No. 184 stems from a secular work dating from the Cöthen period (1717 – 23). Spitta is of the opinion that the Choral (No. 5) was inserted immediately prior to the final Chor at the time (1724) when the work was converted to sacred use. Schweitzer, however, disagrees with this theory. BWV 184

178 Cantata No. 185 was written for the 4th Sunday after Trinity, 14 July, 1715 and used again for the same Sunday on 20 June, 1723. The melody, Ich ruf' zu dir, appeared as a counterpoint on oboe or trumpet to the opening duet and again in the final Choral – see also Cantata No. 177.
 BWV 185

179 The original version of Cantata No. 186 dates from Weimar (1716). The Leipzig (1723) reconstruction is without a Choral to close Part II. The work finishes with a Soprano/Alto Aria Duett and Spitta feels that the Choral which closed Part I should be used again to conclude Part II.
The tune, which is an old Easter Hymn, is used again in Cantata No. 9. (1732 – 5). BWV 186

180 This tune is adapted from a Latin In natali Domini dating from the fourteenth or fifteenth century. It was associated with the text Da Christus geboren war in 1544 but in 1569 this text was set to a new tune – Singen wir aus Herzensgrund. This continued until 1589 when the text was reunited with its original tune. BWV 187

181 Auf meinen lieben Gott was used some years earlier in Cantata No. 5.
Wustman doubts the authenticity of Cantata No. 188 and ascribes most of it to Wilhelm Friedemann. Dürr mentions the possibility of the work having been performed on the 21st Sunday after Trinity 'about' 1728. It is interesting to note that, if the work is by W. F. Bach, Joh. Seb. found it necessary to add an organ version (transposed into C minor) of the D minor clavier concerto – the original source of which was certainly not by J. S. – as a Sinfonia. BWV 188

182 Luther's Te Deum is used again in Cantata No. 16
(1726) and Jesu, nun sei gepreiset, in Cantata No. 41 which
was performed in 1725. BWV 190, 190a

183 The tune, Nun danket alle Gott, was noted under
Cantata No. 79. BWV 192

184 Bourgeois' tune is used again three years later in
Cantata No. 13 and Nun lasst uns is also included in Cantata
No. 79 (1725). BWV 194

185 Lobt Gott appeared some years before Cantata No. 195
was performed in Cantata No. 151 (1725). BWV 195

186 It is possible that Nun bitten wir, is by Luther. It was
used in Cantata No. 169 of 1726 and Wer nur den lieben Gott
in Cantata No. 21 which dates from 1723. BWV 197

187 The unfinished Christmas Cantata 'Ehre sei Gott in der
Höhe' (numbered by Schmieder as 197a) and dated by Dürr
as 'about' 1728, is incorporated in part in Cantata 197. The
final Choral of 197a is O Gott, du frommer Gott, or Die
Wollust dieser Welt. BWV 197a

188 Cantata No. 198, 'Lass, Fürstin, lass noch einen Strahl',
the Trauer-Ode for Queen Christiane Eberhardine, which
dates from 18 Oct. 1727, is an interesting example of a possible
borrowing.
Forkel was one of the first to stress the work's importance and
to suggest – unsuccessfully, it would seem – that it was worthy
of further performances. This was back in 1802 and the next
person of note to campaign on the work's behalf was Wilhelm
Rust in his foreword to BG XIII 3 in 1865. He points out that
the original text stands in the way of the work's acceptance
into the general repertoire and suggests taking a hint from
the composer's own methods and substituting fresh words.
He goes on to mention that certain of Bach's Cantatas are
known to have contained chorals in actual performance
although their position is indicated only by the words *choral
simplice stylo* and not by the actual music. Cantata No. 163,
'Nur Jedem das Seine' is a case in point.

Rust suggests that the Trauer-Ode, also, would have contained chorals and mentions six possible ones. These are: —

1 'Es ist gewisslich an der Zeit' Choralgesänge No. 361.
2 Wer nur den lieben Gott lässt walten. Cantata No. 179, 'Siehe zu, dass deine Gottesfurcht nicht Heuchelei sei'.
3 Was mein Gott will. Cantata No. 92, 'Ich hab' in Gottes Herz und Sinn'.
4 'Ein Lämmlein geht und tragt die Schuld'. Choralgesänge 5 & 308.
5 'O wie selig' Choralgesänge No. 219.
6 Jesus, meine Zuvericht. Cantata No. 145. 'So du mit deinem Munde bekennest Jesum'.
No. 1 is to come between Soprano Aria No. 3 and Alto Recit. No. 4.
No. 2 after that Recit. and before the Alto Aria No. 5.
No. 3 after Chor. No. 7 but only if there is a reasonable pause between Parts 1 and 2 of the Cantata.
No. 4 to open Part 2 and so precede the Tenor Aria.
No. 5 after the Tenor Aria No. 1 and before the Bass Recit. No. 2.
No. 6 after the final Chor.

189 Whittaker says of Cantata No. 199: — 'according to an article by Dr. F. Noack, Bach's music bears certain resemblances to a previous setting by Christopher Graupner. It is evidently, then, one of the numerous instances where Bach 'worked over' the compositions of other people – a practice which was accepted as quite permissible and honest at that time'.
No. 6 is a *Chorale con Viola obligata*. In the Leipzig version (which Dürr dates as 1723 (?)) this *obligata* is written for cello-piccolo.
There is in existance an alternative score with no second violin. One wonders if the second violinist was required to take over the viola part as was the case with Brandenburg Concerto No. 5?
The choral tune used by Bach is Wo soll ich fliehen hin, which was in Cantata No. 136, and the words in Cantata No. 5. ᴮᵂⱽ 199

190 The popular song, Ich bin so lang nicht bei, is one of the two used in the Quodlibet of the Goldberg Variations. Anton

Seemann, who was Kapellmeister to Count von Sporck, based his song on a French hunting song.

The so-called Peasant Cantata (No. 212) was written to greet Kammerherr (Chamberlain) Carl Heinrich von Dieskau on his induction as Lord of the Manor at Kleinzschocher bei Leipzig in 1742. (See Ex. 161.). BWV 212

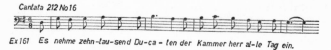

Cantata 212 No 16

Ex 161 Es nehme zehn-tau-send Du-ca - ten der Kammer herr al-le Tag ein.

191 The tune, Nun lob', mein Seel', is in the second choir of the 1st chorus of Motette No. 1. It is used also in Cantata No. 17 dating from about the same year (1726) as the Motette.

BWV 225

192 Motette No. 2 was written for the funeral of Rector Ernesti, Oct. 24, 1729. Those Bach lovers who insist that Motettes should be sung unaccompanied may care to be reminded that BWV 226a is an instrumental accompaniment to the first three movements (i.e, excluding the final Choral in which, no doubt, the instruments would double the voices). The reason is a simple one, Rector Ernesti's Motette contained only three movements. The final Choral which uses the words of the third verse of the old hymn was added to the other movements at a later date when Bach adapted the work for Whitsun and/or the 4th Sunday after Trinity.

The instruments required are oboes 1 and 2; Taille (or Oboe da Caccia); Bassoon (*Bassono*); Strings and Continuo (Violone and Organ). The choral tune is Komm, heiliger Geist which Bach was to use the following year, (1730), in Cantata No. 59.

BWV 226

193 Head Postmistress Kees inspired Motette No. 3. It was written for her memorial service held on July 18, 1723 and the hymn tune included in the work is Crüger's, Jesu meine Freude. This same tune had formed the nucleus of a Motette in E minor composed by Michael Bach. It is very possible that J. S. knew Michael's work and had it in mind when writing his own piece.

The choral was used in Cantata No. 64 in the same year (1723) and, in addition, it provided the basis of the third Movt.

(Presto) of the Trio-Sonata in G, BWV 1038, dating from Weimar or about 1720. BWV 227, 1038

194 It is possible that Motette No. 4 also was written for a memorial service. This time for the wife of Burgomaster Winkler who died in Jan. 1726.

Two chorals are included – one borrowed, the other not. The borrowed one is Warum sollt' ich mich denn grämen, by Johann Georg Ebeling, (1666), which was reconstructed by Vetter in 1713. Bach uses the Vetter version both here and in No. 33 (Ich will dich mit Fleiss bewahren) of the Christmas Oratorio.

The second choral, Komm, Jesu, komm, is by Bach himself.
 BWV 228

195 The choral, O Mensch, bewein' dein' Sünde gross, now No. 35 of the Matthew Passion, was the original No. 1 of the John Passion. Did Bach think his Matthew to be a so much greater work than his John that he was prepared to weaken the latter by despoiling it of one of its finest movements? One can think of many reasons for what he did but none is very convincing! BWV 244

196 The Matthew Passion contained fifteen chorals (counting O Mensch bewein) and the John has twelve (not counting O Mensch). Many are common to both works just as they are to the spurious Luke Passion. It is, of course, not extraordinary that a choral melody and verse appropriate to one version of a Gospel story should be equally appropriate to another. BWV 245

197 There are twenty-nine chorals in the Luke Passion – more than in Matthew and John combined. As, however, the work listed by Schmieder as BWV 246 is generally acknowledged as coming from a pen other than Bach's I see no point in listing them in detail.

With regard to the authenticity of the work Terry, in the 1928 edition of Grove, said;— 'The 'Lukaspassion' published by the Bachgesellschaft is certainly not his composition. Apart from internal evidence, only twenty-three of its fifty-seven pages are in his handwriting'.

Doubts were being cast on the work at least 150 years ago for

did not Mendelssohn write to a friend who had just bought a
score of the Luke and sent it to Felix as a great treasure in
some such terms as 'My dear friend, you have been swindled!
Bach never wrote one single note of this piece! !'
And yet, of course, Bach did write a Luke Passion – but,
unfortunately, the score, which Dürr dates as 1730, is lost to us.

<div align="right">BWV 246</div>

198 The six sections of the Christmas Oratorio written for
the Christmas week of 1724 and New Year of 1735 contain
fourteen chorals – again many of them being in the two
Passions. The variety Bach is able to achieve by slight
rhythmic or harmonic changes is, however, quite remarkable.

<div align="right">BWV 248</div>

199 The choral melody by Barth. Monoetius, dated 1565,
was set in four parts by J. S. Bach but to the words Dir,
Jesu, Gottes Sohn sei Preis, whereas in the C. P. E. Bach –
Kirnberger collection it bears the words shown in the Table
(BWV 421). The Motette to which it is attached is thought to
be by Johann Christoph Bach. BWV Appx. 159

200 Appx. 160 is quite a mixture. It is assumed that Part I
was assembled or put together by C. P. E. Bach. Part II is
certainly by J. S. Bach. It is 'Sei Lob und Preis mit Ehren'
BWV 231, dated between 1723 and 1727 and also is the second
movement (Chor) Nun lob' mein Seel' in Cantata No. 28,
'Gottlob! Nun geht das Jahr zu Ende' dated by Dürr as 1725.
Part III is an eight-part double chorus, Amen Lob und Ehre,
by Telemann. BWV Appx. 160

201 Here is another combined effort. Part I is, most prob-
ably, by Carl Heinrich Graun and is set for double (eight-part)
choir. Part II is in two parts: —
a) Vom Himmel hoch, (in D), which was in an early score of
the Magnificat in D (BWV 243) wherein it followed the second
aria, Et exultavit. It appears as Appx. A in the key of E flat.
b) Freut euch und jubiliert, (in A) comes also from the Mag-
nificat in which it followed No. 5, Bass aria, Quia fecit. It is
Appx. B in B flat. BWV Appx. 161

202 The first of the three sections into which Appx. 164 is
divided is an elaborate five-part variation of the choral tune

which is set in a simple, four-part form in the final choral. (See Ex. 162.).

BWV Appx. 164

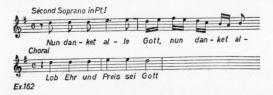

Ex.162

203 BWV 617 appears in Wilhelm Friedemann's little organ book of 1708 – 17 and also as No. 3. 'Coro', Unser Wandel in Cantata No. 222 'Mein Odem ist schwach' which is not by Bach. In Appx. 165 it is sandwiched between two vocal fugues — Welcher unsern nichtigen lieg, and Wir aber sind getrost.

BWV Appx. 165

CHAPTER VI

Again a short chapter with only two items but, I think, of interest.

TABLE VI

FROM VOCAL WORK TO KEYBOARD

Source	New Version &/or Position
1 Ich bin so lang nicht bei dir gewest and Kraut und Rüben.	Quodlibet (Var. 30) in Goldberg Variations. BWV 988.
2 Medieval Easter Hymn. Christ ist erstanden. No. 6 Alleluja of Cantata No. 66, 'Erfreut euch, ihr Herzen'. Dürr, 1724(?).	Organ Prelude. BWV 627.

NOTES ON TABLE VI

1 These two popular songs were combined and worked out in imitation above the moving bass.

Pölchau put a note in his copy of the original edition to the

effect that the words of the songs were handed down by Bach's
pupil, Kittel. (See Ex. 163.).

BWV 988

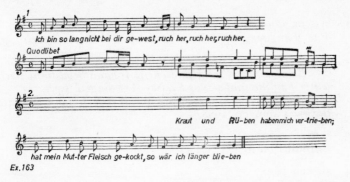

Ex. 163

2 I do not propose to go into all the items contained in the
Orgelbüchlein in detail but cite the third verse of this
particular Choral as a good example of Bach's treatment.
(See Ex. 164.).

BWV 627

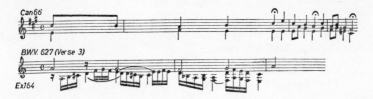

Ex. 164

WRITERS AND THEIR WORKS REFERRED TO IN THIS BOOK

1 DERYCK COOKE
 The Language of Music. Oxford University Press. 1959.

2 GEORG VON DADELSEN
 (i) *Bemerkungen zur Handschrift Johann Sebastians Bachs, seiner Familie und seines Kreises.* Trassingen, 1957.
 (ii) *Beiträge zur Chronologie der Werke Johann Sebastian Bachs.* Tübingen, 1958.

3 ALFRED DÖRFFEL
 Introduction to BG XXXV of 1888.

4 ALFRED DÜRR
 (i) *Studien über die frühen Kantaten J. S. Bachs.* Leipzig, 1951.
 (ii) *Zur Chronologie der Leipziger Vokalwerke J. S. Bachs.* Berlin, 1958.

5 JOH. NIKOLAUS FORKEL
 Uber Johann Sebastian Bachs Leben, Kunst und Kunstwerke. Leipzig, 1802. Eng. Ed. by Terry.

6 J. A. FULLER-MAITLAND
 The '48'. Bach's Wohltemperiertes Clavier. 2 Vols. Musical Pilgrim. Milford, 1925.

7 KARL GEIRINGER
 The Bach Family. Allen & Unwin. London, 1954.

8 CECIL GRAY
 The Forty-eight Preludes and Fugues of J. S. Bach. Oxford University Press, New York, 1938.

9 C. L. HILGENFELDT
 Joh. Seb. Bach's Leben, Wirken und Werke. 1850.

10 JOHANN MATTHESON (1681-1764)
 Grosse Generalbass-Schule, known also as *Exemplarische Organisten-Probe.* Hamburg, 1731.

 WERNER NEUMANN
 Article *Uber Ausmass und wesen des Bachschen Parodieverfahrens* in *Jahrbuch* for 1965.

11 C. HUBERT H. PARRY
 Johann Sebastian Bach. New York, G. P. Putnam's Sons, 1909.

12 K. L. PARRY (Ed. by)
Companion to Congregational Praise. London, Independent
Press Ltd., 1953.

13 MARC PINCHERLE
Antonio Vivaldi et la Musique Instrumentale. Pt. I. Paris,
Librairie Floury, 1948.

14 WOLFGANG SCHMIEDER
Thematisch-systematisches Verzeichnis der Werke J. S. Bachs.
Leipzig, 1950.

15 MAX SCHNEIDER
Article on D Minor Concerto in *Jahrbuch for 1911.*

16 ALBERT SCHWEITZER
Johann Sebastian Bach. Eng. Ed. 2 Vols. London, A. & C.
Black, 1923. First published 1905.

17 PHILIPP SPITTA
*J. S. Bach. His Work and Influence on the Music of Germany
1685-1750.* Eng. Ed. 3 Vols. London, Novello, 1884.

18 CHARLES SANFORD TERRY
(i) *J. S. Bach. Cantata Texts Sacred and Secular.* London,
Constable, 1926.
(ii) *Bach's Chorals.* 3 Parts. Pt. 1 – 1915. Pt. 2 – 1917.
Pt. 3 – 1921. Cambridge University Press.

19 DONALD FRANCIS TOVEY
Essays in Musical Analysis. Vol. 5 (Vocal Music). Vol. 7
(Chamber Music). Oxford University Press, 1937 and 1943.

20 W. GILLIES WHITTAKER
The Cantatas of Johann Sebastian Bach. 2 Vols. Oxford
University Press, 1959.

21 CHARLES W. WILKINSON
How to play Bach's 48 Preludes and Fugues. London, 1939.

22 RUDOLF WUSTMANN
*Joh. Seb. Bachs Kantatentexte im Auftrage der Neuen
Bachgesellschaft.* Leipzig, 1913.

Albinoni, Tommaso 1671 – 1750
Anhalt-Cöthen, Leopold of, 1694 – 1728
Augustus II 1670 – 1733
Augustus III 1696 – 1763

Bach, Anna Magdalena 1701 – 1760
Bach, Bernhard 1700
Bach, C.P.E. 1714 – 1788
Bach, Johann Christian 1735 – 1782
Bach, Johann Christoph 1649 – 1693
Bach, Wilhelm Friedemann 1710 – 1784
Bach, Johann Sebastian 1685 – 1750
Becker, Cornelius 1561 – 1604
Böhm, Georg 1661 – 1733/4 or 9
Bourgeois, Louis c 1510 – 1561
Brandenburg-Culmbach, Albrecht of . . 1522 – 1557
Burmeister, Franz J. 1633? – 1672
Buxtehude, Dietrich 1637 – 1707

Calvisius, Seth 1556 – 1615
Christiane Eberhardine ? – 1727
Corelli, Arcangelo 1653 – 1713
Crüger, Johann 1598 – 1662

Decius, Nicklaus ? – 1541

Ernesti, Johann August 1707 – ?
Ernesti, Johann Heinrich 1652 – 1729

Flemming, Paul 1609 – 1640
Fuger, Caspar (Snr.) ? – c 1592
Fuger, Caspar (Jnr.) ? – 1617

Gerber, Heinrich Nikolaus 1702 – 1775
Gerhardt, Paul 1607 – 1676
Gesius, Bartolomäus 1555? – 1613/4
Gessner, Johann Matthius 1691 – ?
Giovannini ? – 1782

Görner, Johann Gottlieb	1697 – ?
Graumann, Johann	1487 – 1541
Graun, Carl Heinrich	1701 – 1759
Graupner, Christoph	1683 – 1760
Grünwald, Georg	? – 1530
Hasse, Johann Adolph	1699 – 1783
Hassler, Hans Leo	1564 – 1612
Heermann, Johann	1585 – 1647
Helmbold, Ludwig	1532 – 1598
Herberger, Valerius	1562 – 1627
Herman, Nicklaus	c 1485 – 1561
Hermann, Johann	1548? – 1563
Isaak, Heinrich	c 1440 – 1517
Keimann, Christian	1607 – 1662
Keiser, Reinhard	1674 – 1739
Kirchhoff, Gottlieb	1685 – 1746
Kirnberger, Johann Philipp	1721 – 1783
Kittel, Johann Christian	1732 – 1809
Krebs, Johann Tobias	?1690 –
Krebs, Johann Ludwig	
Kuhnau, Johann	1660 – 1722
Legrenzi, Giovanni	1625 – 1690
Luther, Martin	1483 – 1546
Marcello, Benedetto	1686 – 1739
Marchand, Louis	1669 – 1732
Mattheson, Johann	1681 – 1764
Müller, Heinrich	1631 – 1675
Neumann, Caspar	1648 – 1715
Neander, Joachim	1650 – 1680
Neumark, Georg	1621 – 1681
Neumeister, Erdmann	1671 – 1765
Nicolai, Philipp	1556 – 1608
Pachelbel, Johann	1653 – 1706
Raison, A.	late 17 cent.

INDICES TO PART II

A. NAMES and PLACES

B. WORKS (other than Cantatas)
 (See also Tables B, C, D & E)

C. GENERAL

D. NUMERICAL LIST of CANTATAS

E. ALPHABETICAL LIST of CANTATAS

INDEX A

Names and Places

INDEX B

Works other than Cantatas

Fugue in D.	BWV 532. 227, 230, 231
Fugue for Organ in G minor.	BWV 542. 244, 249
Fugue for Organ in C minor.	BWV 574. 227, 232
Fugue for Organ in C minor.	BWV 574a. 228, 232
Fugue for Organ in B minor.	BWV 579. 244, 249
Fugue for Clavier in A.	BWV 864. 245, 251
Fugue for Clavier in A.	BWV 950. 245, 251
Fugue for Clavier.	BWV 951. 234, 252
Fugue for Clavier in B minor.	BWV 951a. 245, 252
Fugue for Clavier in B-flat.	BWV 954. 245, 252
Fugue for Clavier in B-flat.	BWV 955. 229, 235
Fugue in G minor.	Appx. 101. 230, 236
Fugue.	Ersilius. 229, 235
Fugue.	Froberger. 229, 234
Fugue in D.	Pachelbel or Buxtehude.
	227, 230, 231
Fürchte dich nicht, ich bin bei dir.	BWV 228. 291
Für Freuden lasst uns springen.	310
Gaudete omnes populi.	336
Gelobet sei der Herr, der Gott Israel.	302
Gelobet sei der Herr, mein Gott, mein Licht.	Olearius. 279
Gelobet seist du, Jesu Christ.	Anon. 271, 293, 295, 298,
	310, 338
Gen Himmel auf gefahren ist.	Franck. 301
Gib dich zufrieden und sei stille.	310
Gieb Fried', o frommer, treuer Gott.	304
Gieb unsern Fürsten.	295, 327
Gigue.	Dieupart. 229, 233
Gloria in excelsis.	343
Glorie, Lob, Ehr'.	Reissner. 275
Gönne nach den Thränen güssen.	Handel. 267, 333
Gott, der die selber bist das Licht.	310
Gott der Vater wohn' uns bei.	BWV 748. 228, 233, 301, 310
Gott des Himmels und der Erden.	Albert. 293, 305
Gott durch deine Güte.	298, 310
Gottes sohn ist kommen.	298, 310
Gott hat das Evengelium.	305, 310
Gott hat die Erd' schön zugericht't.	306
Gott ist mein Heil, mein' Hülf' und Trost.	Gesius. 304
Gott lebet noch.	310
Gottlob, es geht nun mehr zu Ende.	310
Gott sei gelobet und gebenedeiet.	Anon. 302, 310
Gott sei uns gnädig.	310
Gott Vater, der du deine Sonn.	Herman. 306
Grates nunc omnes.	Anon. 266, 310, 331
Gross ist, O grosser Gott.	Anon. 314, 324
Hast du denn, Jesu.	Anon. 265
Hast du denn, Liebster, dein Angesicht.	Anon. 281, 295, 306, 328,
	348
Heilig, heilig, heilig.	Bach(?) 293, 310
Helft mir Gott's Güte preisen.	Figulus. 259, 261, 288, 295,
	299, 322, 323, 325, 357
Herr Christ, der einig' Gott's Sohn.	Anon. 260, 280, 285, 324,
	347, 354
Herr Christ, der ein'ge Gottes-Sohn.	Anon. 273, 295, 298, 339
Herr Gott dich loben alle wir.	Bourgeois. 302, 310, 323
Herr Gott, dich loben wir.	Anon. 277, 295, 311, 344

INDEX C

General

N*

INDEX E

Cantatas in Alphabetical order

No.